REMBRANDT'S
SELF-PORTRAITS

REMBRANDT'S SELF-PORTRAITS

A Study in Seventeenth-Century Identity

H. Perry Chapman

PRINCETON UNIVERSITY PRESS ~ PRINCETON, NEW JERSEY

Copyright © 1990 by Princeton University Press

Published by Princeton University Press, 41 William Street,
Princeton, New Jersey 08540
In the United Kingdom: Princeton University Press,
Guildford, Surrey

All Rights Reserved

Published with the assistance of the Getty Grant Program

This book has been composed in Linotron Sabon type

Printed in the United States of America by Princeton
University Press, Princeton, New Jersey

Library of Congress Cataloging-in-Publication Data
Chapman, H. Perry, 1954–
Rembrandt's self-portraits : a study in seventeenth-century
identity / H. Perry Chapman.
p. cm.
Revision and expansion of thesis.
Bibliography: p.
Includes index.
ISBN 0-691-04061-3 (alk. paper)
1. Rembrandt Harmenszoon van Rijn, 1606–1669—Self-portraits.
2. Identity (Psychology) in art. 3. Identity (Psychology)—
Netherlands. I. Rembrandt Harmenszoon van Rijn,
1606–1669. II. Title.
N6953.R4C48 1990
760'.092'4—dc19 89-31150

To C.M.N. and A.C.N.

Contents

Illustrations

Unless otherwise indicated, works are by Rembrandt and photographs
have been provided by the owners of the works.

COLOR PLATES

FIGURES

Preface

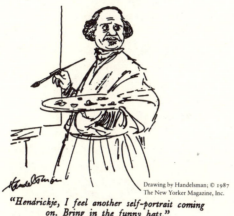

Drawing by Handelsman; © 1987
The New Yorker Magazine, Inc.

"Hendrickje, I feel another self-portrait coming on. Bring in the funny hats."

THIS STUDY began ten years ago in my doctoral dissertation as a study of Rembrandt's funny hats, that is, of the varied roles and guises he assumes in his self-portraits. In its present form, much rethought, revised and expanded, it focuses on a larger question, perhaps the most puzzling of Rembrandt's whole career: why did he portray himself so many times and in so many different ways? It may surprise the uninitiated reader to learn that it is now unacceptable to think of Rembrandt as feeling his self-portraits "coming on." The notion that he was motivated by a preoccupation with his inner life has been discredited as being founded on modern psychology. Rembrandt, current scholarship would have it, portrayed himself for a number of reasons—to display his social status and artistic eminence or to assert the dignity of his profession—but not out of some deep-seated need. This study suggests otherwise: viewed in its historical and cultural context, Rembrandt's lifelong preoccupation with self-portraiture can be seen as a necessary process of identity formation or self-definition. Conjoined, his temperament, circumstances, and times compelled him to shape and assert his personal and artistic individuality. Rembrandt's life coincided with the rise, or invention, of a new kind of autonomous individual, and his self-portraits were part and parcel of this phenomenon. However extraordinary the man, however unique his endeavor to represent himself, and however profound his impact on his culture, Rembrandt was nevertheless a product of that culture. This book, then, is a study in seventeenth-century identity.

A few words are in order about what this book is not. It is not a catalogue, and it makes no claim to be all-inclusive. While I treat most of Rembrandt's self-portraits, some more thoroughly than others, I have omitted a few. And

xvii

although the problem of Rembrandt attributions is currently a topic of heated debate, the reader will find little discussion of it here. This does not mean the issue has been ignored. In my research and study I gave serious consideration to problems of authenticity that arose: each of the self-portraits included here as by Rembrandt I firmly believe to be by his hand.

A book that has taken so long to write incurs many debts. I am, first of all, immensely grateful to my dissertation advisers, John Rupert Martin and Egbert Haverkamp-Begemann, for their intellectual guidance, criticism, and encouragement. I hope they will not be too displeased with what they find here. The text as it now stands has been much improved thanks to critical readings by two people: Alison McNeil Kettering, who first introduced me to the study of Dutch art during my undergraduate years and has been a source of intellectual friendship ever since, and Arthur K. Wheelock, Jr., whose challenging criticism and ideas have been essential to the formation of my own attitude toward my material. I am deeply indebted to Ernst van de Wetering and Josua Bruyn for their generosity in sharing their thoughts and the findings of the Rembrandt Research Project. I have also benefited greatly from discussions with the following people: Stephanie S. Dickey, Laurinda Dixon, Barbara Haeger, Patricia Leighten, and Joan Williams. I owe a profound debt to my colleagues at the University of Delaware for their friendly encouragement and support. Special thanks are reserved for my students, who have stimulated my thinking in several seminars on Rembrandt and Dutch portraiture. My thanks, too, to Meg Taylor, who read and commented on part of the text, and Elizabeth Moodey Bickley, who provided research assistance in the final stages of this project.

I would like to thank all those museums, libraries, and collections that supplied me with photographs and granted me permission to publish their works. I wish to acknowledge the staffs of the following institutions for their invaluable assistance: the Rijksbureau voor Kunsthistorische Documentatie and the Koninklijke Bibliotheek in The Hague; the Rijksprentenkabinet, Amsterdam; the Print Room of the British Museum; the University of Delaware Library; the Library of the National Gallery of Art; the Folger Shakespeare Library; and the Library of Congress. My research was carried out with the support of the University of Delaware General University Research Fund and with a Summer Stipend from the National Endowment for the Humanities. I am especially grateful to Elizabeth Powers, Eric Van Tassel, and Cynthia Parsons at Princeton University Press for their attention and enthusiasm.

Finally, I must thank my mother and model, Janet G. Chapman, and my father, John W. Chapman, critic and editor of the highest order. My husband, Christopher Niemczewski, contributed, beyond any reasonable call of duty, to every aspect of this project. I thank him for his loving friendship and high expectations. Last but not least, my daughter Alexandra spent the first year of her life vying with this book for my attention. I can only hope she reads it some day.

Abbreviations

B. Adam Bartsch. *Catalogue raisonné de toutes les estampes qui forment l'oeuvre de Rembrandt.* 2 vols. Vienna, 1797. The order of individual states follows those given in Christopher White and K. G. Boon, *Rembrandt's Etchings. An Illustrated Catalogue.* 2 vols. Amsterdam, 1969. (Also published as *Hollstein's Dutch and Flemish Etchings, Engravings and Woodcuts,* XVIII: *Rembrandt van Rijn*).

Ben. Otto Benesch. *The Drawings of Rembrandt.* Enlarged and edited by Eva Benesch. 6 vols. London, 1973.

Br. A. Bredius. *Rembrandt. The Complete Edition of the Paintings.* Revised by H. Gerson. London, 1969.

Corpus *A Corpus of Rembrandt Paintings.* By the Stichting Foundation Rembrandt Research Project, J. Bruyn, B. Haak, S. H. Levie, P.J.J. van Thiel and E. van de Wetering. Vol. I (1625–1631), vol. II (1632–1634). The Hague, 1982–.

Documents Walter L. Strauss and Marjon van der Meulen. *The Rembrandt Documents.* New York, 1979.

Urk. C. Hofstede de Groot. *Die Urkunden über Rembrandt (1575–1721).* The Hague, 1906.

REMBRANDT'S
SELF-PORTRAITS

Introduction

REMBRANDT was, and has remained, a self-portraitist of unmatched power. He painted, etched, and drew his own likeness at least seventy-five times over more than forty years. But the extraordinary extent of his preoccupation with self-portrayal is revealed more in the intensity and tremendous variety of these images than in their numbers. Each, from his quickest sketch to his most imposing painting, is convincing as the product of penetrating self-scrutiny. And no two are alike. During the course of his life Rembrandt portrayed himself in an astonishing number of roles. He repeatedly enhanced his image with fanciful costumes or expressive lighting and shaped his identity by assuming the guise of beggar, Renaissance courtier, saint, or artist in the studio. He often fashioned himself as larger than life by imbuing his portraits with qualities of history paintings. But he only rarely represented himself as a contemporary gentleman, the predominant self-portrait convention at the time.

That his self-portraits were largely internally motivated is suggested by the scarcity of documented works from his lifetime. The scanty records tell us only that Charles I of England owned one (Fig. 70) by the early 1630s but not whether he had commissioned it, that the art dealer Johannes de Renialme owned another, and that Cosimo de' Medici may have acquired one when he visited the artist's studio in 1667. A few more are mentioned in Dutch inventories from shortly after Rembrandt's death in 1669. We have, in other words, no records of specific commissions and virtually no knowledge of specific owners. Considering the vogue for self-portraits, Rembrandt's presumably found an audience. That not a single one appears in the inventory of his own collection, made in 1656 after his insolvency, perhaps suggests he sold them all. Or some may have been omitted from the public sale as personal possessions. Unfortunately, we just do not know. But whether he kept them or sold them, and however much they served to project an image, his self-portraits, like the many portraits of his family members, have the qualities of personal works, generated by internal pressures.

In this regard, Rembrandt stands in marked contrast to his contemporary Peter Paul Rubens, who painted far fewer self-portraits, sometimes reluctantly at a patron's request. Of one (Fig. 93), Rubens humbly wrote that Charles I "has asked me for my portrait with such insistence that I found it impossible to refuse him. Though to me it did not seem fitting to send my portrait to a

prince of such rank, he overcame my modesty."[1] Yet he portrayed himself in elegant garb with a glistening gold chain of honor as a gentleman-artist fully worthy of princely attention. Rubens, who had been educated and trained to serve at court, fit perfectly the role of painter to the great monarchs of Europe. Indeed, he elevated the humanistic ideal of the virtuoso artist to unprecedented heights, becoming a learned nobleman, diplomat, and knight. His self-portraits consistently project his worth through his courtly image. They reflect a man confident of his goals and secure in his attainments.

In the intensity with which he succumbed to the self-portrait impulse, Rembrandt was more like Albrecht Dürer, the great pioneer of self-portrayal over a century before. Dürer, who directly experienced the turmoil of the Reformation, was awakened to the contrast between the status of artists in Italy and in his native Nuremberg when he visited Venice, where he lamented, "here I am a gentleman, at home I am a parasite."[2] Living half in the Renaissance and half in the Middle Ages, he was torn by the conflicting appeals of Italian humanism, classicism, mathematical perspective, and ideal beauty on the one hand and of German mysticism and his Reformation beliefs on the other. His self-portraits range among these domains, showing him in his various roles as gentleman, in the 1498 Prado painting, and as pious imitator of Christ, in the Munich portrait of 1500. Dürer is a classic example of the reflective individual born to self-scrutiny, sensitive to tensions in his cultural milieu, and struggling to reconcile his artistic and spiritual allegiances.

In Rembrandt, too, what must have been an innate propensity to self-study was reinforced by his historical, social, and cultural circumstances. To put it bluntly, he was deeply affected by the rising individualism of the age in which he lived. Obviously this claim, though it has been often made before, demands explanation. Especially today the mere mention of "individualism" invites controversy. By it I mean the concept of the individual human being as autonomous and self-governing that has dominated Western civilization for much of the past five hundred years: man (as opposed to God) makes and shapes the world in which he is primary and in which association, group membership, is voluntary. The roots of this valuing of the individual, his uniqueness, and his privacy have been found variously in ancient Greece, Renaissance Italy, the Reformation, and seventeenth-century England.[3] It has been associated with rationalism, empiricism, secularization, and the rise of the bourgeoisie. And it has in this century been brought into question by communitarian ideologies, most notably Marxism, that view human beings as constituted primarily by their social relations. Today those who view individualism as a universal human drive and those who view it as a historical construct are engaged in a profound debate over human nature.[4]

Whatever may be the current state of this modern debate, the discussion itself makes clear that any notions about individuality, subjectivity, and self-consciousness are specific to their own period. Historical evidence strongly supports the idea that a fundamental shift away from a God-centered world-view and toward a man-centered one took hold in the Renaissance and gained

greater strength in the seventeenth century, and that this radical change in consciousness fostered a new concept of the person as an individuated self.

The seventeenth-century individual was characterized, philosophically, by a growing faith in reason and experience and an increasingly empirical way of thinking. Men looked to their world and even inside themselves for answers: hence Descartes's *cogito ergo sum*. Politically, this new kind of individual, holding that people should be governed only by consent, was more likely to question authority, a frame of mind that ultimately led to the American and French revolutions. Economically, individualism is tied to the rise of capitalism, with a free market economy and open competition: economic opportunity and success gave at least some people greater control over their lives. In the religious sphere the Reformation, and particularly Calvinism, recast the individual's relation to God. Not only did the Reformation call into question the authority of the Catholic Church: the concept of the priesthood of all believers denied the very efficacy of priestly intercession. Though still bound by the absolute authority of the Gospel, the individual Protestant, justified by faith and denied the spiritual comfort of good works, was left with primary responsibility for his salvation. He faced his maker and his spiritual destiny naked and alone.

The growth of individualism marked a radical reordering of society that prompted many to turn inward and closely examine their lives, values, and beliefs as they attempted to reorient and reintegrate themselves. From this intense introspection would emerge a fundamentally altered type of personality, governed more by reason than emotion, with a high degree of self-awareness, a personality endowed with inner authority. Seventeenth-century introspection assumed a variety of modes. Devotional practices, from the Catholic *Spiritual Exercises* of Ignatius Loyola to Protestant sermons, encouraged private religious self-scrutiny. During this period, the autobiography emerged as a literary form along with other types of first-person expression.[5] Here in particular we find a consciousness of the self as subject and an idea of individuality as something to be cultivated. And, of course, self-portraits proliferated. Especially in the Netherlands, there was hardly an artist who did not paint his own features.[6]

Moreover, in the Netherlands a number of factors identifiable as contributing to the formation of this new kind of autonomous individual converged. The Dutch Revolt, in which the northern Netherlands successfully rebelled against Spanish rule, however conservative its motivation, gave the Dutch political autonomy and fostered a love of freedom and strong aversion to imperial authority. In the aftermath of the Revolt, the wealthy cities of Holland, above all Amsterdam, developed almost overnight into what was arguably the first capitalist society. Free trade—the fortunes amassed in shipping and manufacturing—gave political weight to the rising urban merchant class. This and the new political organization left the Stadholder and the old nobility virtually powerless, a situation unlike any elsewhere in Europe. Religious attitudes in Holland also reflected a new valuing of the individual: though the Calvinist Reformed Church dominated, the presence of other Protestant sects and other

5

faiths provided unusual religious choice and fostered a novel climate of religious tolerance.

All these features of Rembrandt's milieu had direct bearing on his social and economic status, religious outlook, and professional identity, and so on his definition of the self. In some ways Rembrandt seems to typify the new social mobility. He came from a solid middle-class background—his father was a relatively well-to-do miller—and his education and choice of trade were designed to better his position in life. Rembrandt's move from Leiden to Amsterdam and his early rise to wealth and artistic fame were, on the face of it, not extraordinary for his times: Dutch artists were accustomed to moving from city to city, and a few of them achieved comparable, though not so meteoric, success. That we remain unsure of Rembrandt's religious affiliation, even though he was most certainly a profoundly religious man, suggests a high degree of religious individuality, but this too was not unusual.

Yet in this setting of heightened individualism Rembrandt stands out. As he presents himself in his self-portraits, the young Rembrandt exhibits extreme traits of the emerging and anxious individual, trying to make sense of, or accommodate himself to, a rapidly changing world; and the mature Rembrandt attains an uncommon degree of autonomy. That he, of all his contemporaries, so relentlessly pursued and asserted his indivduality might be attributed purely and simply to his personality. But I believe at least a partial explanation can be sought elsewhere, in his unique conception of the artistic calling. A central thesis of this study is that in Rembrandt the impact of broader social change was intensified by a divergence between his artistic ideals and the mundane reality of being a painter in Holland. Those socio-economic circumstances that gave Dutch painters greater artistic autonomy—freedom from a system of ecclesiastical and humanistically inclined princely patronage—denied to them the very values on which the Renaissance artist had predicated his unprecedented sense of worth. For Rembrandt this called for a new conception of the artist. In this quest he was not alone—the proliferation of studio scenes and allegories of painting suggests many Dutch painters were concerned with redefining their professional identity—but the acuteness with which Rembrandt felt the tensions and the solutions he formulated certainly set him apart.

The question of how Rembrandt's individuality, originality, and extraordinary genius fit into and resonated with his social and cultural milieu has been part of his eternal fascination. Consider how dramatically perceptions of his place in Dutch painting have changed in recent years. The idea that his art was unorthodox, unconventional, and anti-classical has given way to a view that roots it firmly in tradition and straightforwardly ascribes to it the values of seventeenth-century Dutch painting.[7] Interpretations of Rembrandt's art are closely tied to appreciation of his character and biography, which are also undergoing revision. Emmens has debunked the so-called "Rembrandt myth" of the rebellious, isolated genius, who after his stunning early success suffered a devastating decline.[8] Scholars following in his wake have replaced it with a picture of social conformity. For example, Rembrandt's vast collection of art

and curiosities, once regarded as evidence of his eccentricity, has become a refined *kunstkamer*, a manifestation of conventional gentlemanly ambitions.[9] In two of the most interesting recent reassessments of Rembrandt we hardly recognize the same person. Schwartz characterizes him as a failure, a would-be Rubens who repeatedly bungled his attempts to gain favor at court and with his Amsterdam patrons.[10] Alpers, in contrast and to my mind closer to the mark, bases Rembrandt's success in his independence as a Lockean *pictor economicus*, a manipulator of the market.[11] But economic individualism, I would argue, is only one aspect of a larger phenomenon, with which we must come to terms.

To bring some order out of this confusion, I take a fresh look at Rembrandt's self-portraits, the primary evidence as to who he thought he was and how he wanted to be seen by his contemporaries and by posterity. Until now Rembrandt's self-portraits have, for the most part, been treated chronologically, as a measure of his progress and decline. According to the older view, his early expressive studies reveal his rebellious nature, and his late paintings mirror artistic failure and personal tragedies.[12] More recent appraisals, which focus on the elegant images of his middle years, argue that his self-portraits reflect his social aspirations.[13] With few exceptions, recent critics have shied away from considering Rembrandt's self-portraits in the context of the ideology of individualism.[14] Underlying the current impulse to leave the self-portraits "to speak for themselves" or to deny Rembrandt self-consciousness altogether is a kind of post-Freudian timidity, an understandable reaction to the excesses of an earlier psycho-biographical approach.[15]

Today, scholarship in fields outside art history demonstrates most clearly that one need not engage in wild psychoanalytic speculation to gain historical insight into the individual.[16] Studies in the history of autobiography suggest fruitful alternative ways of conceptualizing self-portraiture. The historian of ideas Karl Weintraub, for example, argues that individuality and concepts of the self, as revealed in autobiography, are historically determined and culture-specific.[17] And literary critics, like Olney and Eakin, increasingly regard autobiography and, by extension, other kinds of self-portrayal as essentially self-creation, self-invention, and (the most relativist of these critics would say) fiction.[18] No one demonstrates better than Rembrandt that self-portraiture is more invention than reflection. This is evident not just in his imaginary, romantic, and historical guises but in every way that he chose to present himself. However, if his self-portraits are not pure reflection they are also emphatically not fiction. For whatever their element of invention (and justification, compensation, even delusion, all of which must be operative but which I, for the most part, would not presume to analyze), conviction stands behind each of Rembrandt's images. The seventeenth-century individual, however much engaged in self-fashioning and self-cultivation, was sustained by belief in the authenticity of his personality.[19]

Broadly stated, Rembrandt's self-inventions over and over again dissociate him from his everyday world. As Huizinga put it, "Rembrandt forever tried to

depict a life different from that lived in the bourgeois Dutch Republic."[20] This was nowhere truer than when he depicted himself. In the various identities he created we see that his rich imagination, his aspirations and ambitions, and his artistic ideals proved again and again to be different from those of his contemporaries and irreconcilable with the constraints of his middle-class Dutch milieu. This is no wonder, for Rembrandt was initially trained as a history painter—in the great European tradition—that is, as a specialist in noble biblical, mythological, and historical subjects. He especially admired and, for a time, emulated the internationally renowned artists Titian and Rubens and the courtly virtuoso ideal for which they stood.

Yet this elevated, cosmopolitan ideal must have seemed unattainable in the Netherlands with its relative backwater of a court and predominantly *burgerlijk* clientele who demanded primarily genre, still life, landscape, and portraiture. Ultimately it became, or perhaps was from the start, an anti-ideal that forced Rembrandt to invent a new concept of the artist. In redefining his calling as artist, he discovered that he could gain selfhood more from his talent and professional identity than from his social status. In consequence he proclaimed his individuality, his distinctive identity, by deviation from the gentlemanly role of the virtuoso artist, and by contempt for what his contemporaries called "the rules of art." Non-conformity was his strategy for autonomy. That his earliest critics, Sandrart, Baldinucci, and Houbraken, saw it this way explains in part why they found his rebelliousness so threatening.[21]

In this study I retrace Rembrandt's career in individuation through the chronology of his self-portraits. I seek to locate his unique sense of identity in seventeenth-century perceptions of the self, changing concepts of the artist, and the Christian valuing of the individual. To this end, I examine Rembrandt's self-portraits in their cultural and historical setting and in the course of his life, taking into account recently discovered documents and new interpretations of familiar ones.[22] Chapter 1, on his earliest self-portraits, examines the basis of his heightened self-consciousness in seventeenth-century ideas of melancholy and the self and, more specifically, in the circumstances of his Latin School education and his training as a history painter. Chapter 2 looks at his portraits in fanciful guises and explores this early fashioning of multiple identities as a manifestation of his protean, still unformed, concept of the self. Chapter 3 focuses on the dominant portrait type to come out of his early self-fashioning, the ideal of the virtuoso artist that culminates in the London *Self-Portrait at the Age of 34* (Pl. IV). Here we see Rembrandt sorting himself out from his models Rubens and Titian, and reformulating this traditional exemplar of the artist. In chapter 4 he presents a radically revised self-image as nothing less than a fully independent individual governed by a sense of his own uniqueness. Now separated from the past and freer from his models, he portrays himself as artist in the studio, autonomous in his professional identity. Chapter 5 looks back over Rembrandt's career and tracks his development toward greater autonomy, or inner authority, in his biblical roles. These range from the self-portrait

in the early *Raising of the Cross* (Fig. 148) to his late *Self-Portrait as the Apostle Paul* (Pl. VII).

Chapter 6, the epilogue, has two goals. First it concentrates on the portraits of Rembrandt's very last years to establish the implications of the evolution of his self-image. His accommodation to the pressures of a changing society in which outmoded values have found no suitable replacement is seen in his shift from self-portraits based on Renaissance ideals to those expressing an independence of thought and feeling that is fundamentally modern. Rembrandt now takes self-examination and artistic creation as ends in themselves, as the defining criteria of a life worth living. Finally, the epilogue also reexamines Rembrandt's reputation as handed down to us from his earliest biographers by way of the nineteenth century. The classicist critique of Rembrandt as an artist who flouted the rules of art and the Romantic conception of him as an isolated, independent genius are both found to be surprisingly consistent with the image he projected in his self-portraits. Rembrandt is revealed as the source of the Rembrandt myth. Even the most general reader should not be alarmed that I end on this historiographic note: I conclude by reappraising Rembrandt the person because in asking why he portrayed himself so many times in so many ways I am really asking who he was.

I

Discovery
of the Self

REMBRANDT'S initial foray into self-portraiture was entirely unprece-
dented. Between about 1627 and 1631 he portrayed himself at least
twenty times. Often more concerned with character and facial expression than
with likeness and public image, he scrutinized his features in the mirror, made
faces at himself, and cast his eyes in evocative shadow, paying scant attention
to the conventional formalities of portraiture. At first glance the etchings (Figs.
9–12, 14, 16–18) look crude, rough, sometimes careless, like trifles to be dis-
carded, and even some of the paintings (Pl. I, Fig. 23) seem to be sketchy studio
exercises, which perhaps accounts for the prevailing view of them as expression
studies featuring the artist as his own model. If they are considered in another
light, though, it becomes clear that a remarkable individuality distinguishes
each of these otherwise unassuming images. In their extraordinary psycholog-
ical presence we can recognize the initiation of one of the most concerted efforts
at self-representation in the history of art. Far from being peripheral to his later
self-portraits, they were the crucial first steps. Here Rembrandt discovered the
self; or, put more precisely, here he discovered the value of self-portrayal.

I invoke "discovery" here and in the title of this chapter first to emphasize,
contrary to current opinion, that Rembrandt's earliest self-portraits display
from the very outset his reflective self-consciousness. This is certainly not to
claim that self-portrayal was for him the same process of self-analysis that it
would become for some modern painters. Second, I wish to qualify the twen-
tieth-century interpretive framework that colors my approach to self-portrai-
ture. Today we would characterize Rembrandt's endeavor as invention rather
than discovery, and, indeed, this book traces his invention of a series of differ-
ent selves. But viewing Rembrandt as inventing or creating himself through his
self-portraits is ahistorical in the sense that he and his autobiographer contem-
poraries, who thought more than we do in terms of objective truths, would
have conceptualized their endeavors as self-discovery. The French author
Michel de Montaigne, whose *Essais* reflect a lifelong quest to understand the
human condition through understanding the self, expressed the age's new atti-
tude of self-discovery and conscious individuality thus: "There is no one who,
if he listens to himself, does not discover in himself a pattern all his own."[1]

Despite the period's penchant for introspection and despite the nigh-obsessive intensity with which Rembrandt studied his own face, recent scholarship has questioned the status of these early works as self-portraits and has retreated from considering the nature, or even the possibility, of subjectivity underlying them. According to this view Rembrandt, in an etching like the *Self-Portrait, Bareheaded* (Fig. 1), was "probably using himself as a model rather than producing an intentional self-portrait."[2] With his own face so readily available, he could study dramatic emotional expressions and light effects for use in his biblical and historical paintings, the primary products of his Leiden years. Those who consider these portraits mere studies, however, hardly seem to distinguish them from a studio exercise like Jacques de Gheyn's sheet of nine studies of the head of an anonymous young model (Fig. 2).

My contention is that Rembrandt's earliest self-portraits are indeed self-portraits, informed by reflective self-consciousness. Through them he conceptualized and projected his self-image and role as artist. To bring their self-referential aspects into sharper focus, and to suggest what might have motivated their creation, I offer two readings of these works. Although each interpretation focuses on a different type of self-portrait from the Leiden period—and here I make a distinction that has not been made before—they are, as will become clear, complementary. First I will examine Rembrandt's depictions of extreme facial expressions against the background of his immediate situation in his native Leiden. His education, artistic training, and early activity as a history painter were singularly conducive to a mode of portrayal stressing character and heightened emotionalism or, in the terminology of the period, the passions of the soul. To the young Rembrandt, caught up in the excitement of the new, dramatic style of history painting, rendering the passions required imagining them, for which self-study was essential. Through his early expressive self-portraits he proclaimed his proficiency in the dramatic emotional expression required of the history painter.

Second, I will explore several even earlier self-portraits that are distinguished at once by remarkably evocative shading and by a relative lack of outward emotional expression. That these images seem to penetrate the dark recesses of Rembrandt's mind suggests a depth of introspection not usually attributed to him at this early age. Placing these works in the context of early modern psychology, specifically the psycho-physiological theory of the bodily humors, provides historical access to Rembrandt's conception of the self, what he would have called his nature or temperament.

As prelude to examining Rembrandt's early experiments in self-portrayal consider briefly Constantijn Huygens, a most notable contemporary who shared Rembrandt's acute self-awareness. Huygens, a learned humanist, poet, musician, and connoisseur, was secretary to the Stadholder Frederik Hendrik at the court in The Hague, where taste tended toward Rubens, Jordaens, and the more Italianate Dutch painters. He knew Rembrandt during his Leiden years, secured court commissions for him, and lauded him in his manuscript *vita* or autobiography, written in Latin between 1629 and 1631 at precisely the

time the young artist was engaged in his first intense production of self-por-
traits.[3] Although it has often been discussed for what it tells us about the artists
of his time, Huygens' writing has rarely been analyzed as autobiography. But
his devotion to self-scrutiny and literary self-portrayal, not only here but in
many of his published works as well, provides an illuminating parallel to Rem-
brandt's self-portraits. Like Rembrandt, he was an introspective, seeking to
understand himself and his temperament, and like him he also fashioned a pub-
lic image through which to promote himself.

When Huygens set out, at age thirty-four or thirty-five, to write about his
life, he asked questions that point to his awareness of his own uniqueness and
complexity. He wondered what made him who he was. He pondered to what
extent he had been formed by his upbringing and experience and to what extent
he had been true to his inborn nature.[4] It behooves us, similarly, to explore
Rembrandt's nurturing and his nature if we hope to understand his imperative
to portray himself.

THE ARTIST AS ACTOR

Rembrandt, at this early stage in his career, fancied himself a history
painter and had not, to our knowledge, painted any formal, commissioned por-
traits. Yet it is no surprise that he turned to making self-portraits. In the sev-
enteenth-century Netherlands it was practically *de rigueur* to paint, draw, or
etch one's own likeness. Indeed, the great flowering of Dutch self-portraits con-
stituted a popular genre in itself with its own characteristic forms and conven-
tions.[5] Although his teachers Jacob van Swanenburgh and Pieter Lastman are
not known to have made self-portraits, many of his predecessors and contem-
poraries in Leiden did, including Lucas van Leyden (Fig. 3), his most renowned
fellow townsman, and Jacob van Swanenburgh's father Isaac.[6] Rembrandt may
have regarded Jan Lievens's unusual and evocative profile self-portrait (Fig. 4)
of about 1626, which appears to predate even his earliest etched ones, as a
particular challenge, for the two were engaged in constant artistic rivalry.

The proliferation of self-portraits in Leiden and the Netherlands as a
whole was one manifestation of a burgeoning interest in the artist and his pro-
fessional status. Painted self-portraits were in increasing demand, and collec-
tions of them were being formed in Italy and England.[7] At the same time, por-
traits of artists were widely disseminated in engraved series, a dignified format
that had originated as a humanist conceit and would shortly find its ultimate
expression in van Dyck's *Iconography*. The first of these in the North was Hi-
eronymus Cock's *Pictorum aliquot celebrium Germaniae Inferioris effigies*,
published in Antwerp in 1572, which, like the illustrated editions of Vasari's
Lives of the Artists, followed the model of Renaissance portrait books of fa-
mous rulers, doctors, humanists, and the like. Each of the twenty-three por-
traits of famous Netherlandish painters from Jan van Eyck to Cock himself is
accompanied by a laudatory Latin verse by Domenicus Lampsonius glorifying
the artist's achievements or praising him for the fame he brought to his father-
land (Figs. 75 and 76).

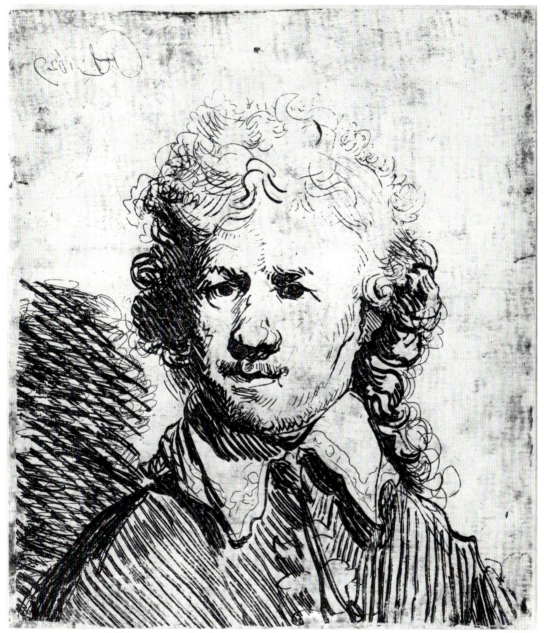

1. *Self-Portrait, Bareheaded*, 1629. Etching. Amsterdam, Rijksprentenkabinet.

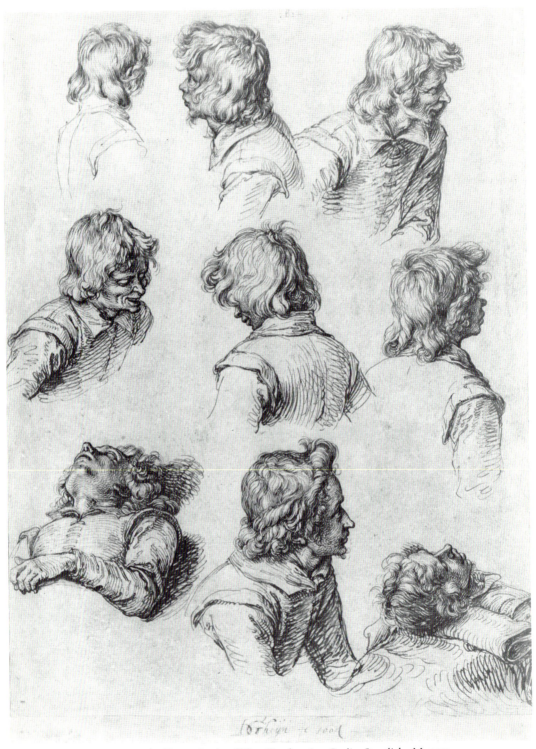

2. Jacques de Gheyn, *Study of Nine Heads*, 1604. Berlin, Staatliche Museen Preussischer Kulturbesitz, Kupferstichkabinett.

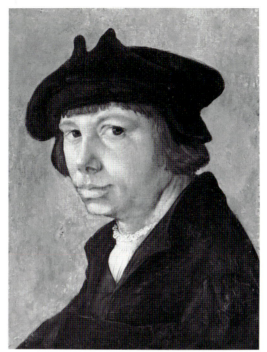

3. Lucas van Leyden, *Self-Portrait*. Braunschweig,
Herzog Anton Ulrich-Museum.

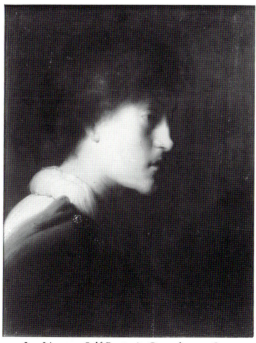

4. Jan Lievens, *Self-Portrait*. Copenhagen, Statens
Museum for Kunst.

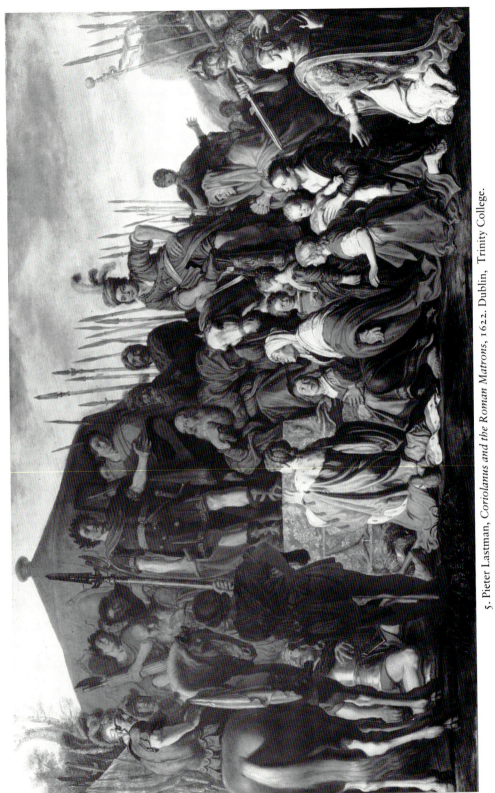

5. Pieter Lastman, *Coriolanus and the Roman Matrons*, 1622. Dublin, Trinity College.

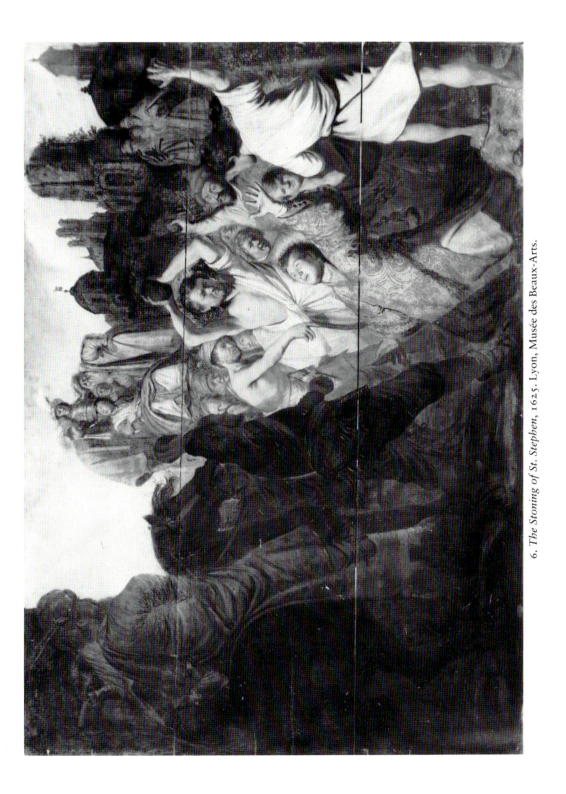

6. *The Stoning of St. Stephen*, 1625. Lyon, Musée des Beaux-Arts.

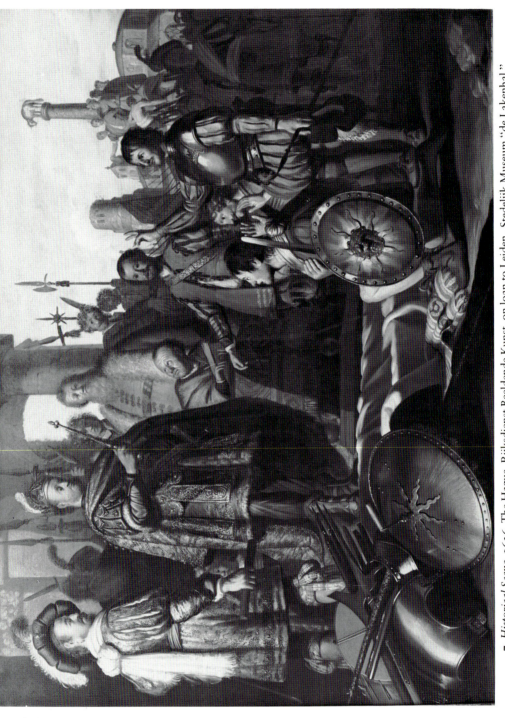

7. *Historical Scene*, 1626. The Hague, Rijksdienst Beeldende Kunst, on loan to Leiden, Stedelijk Museum "de Lakenhal."

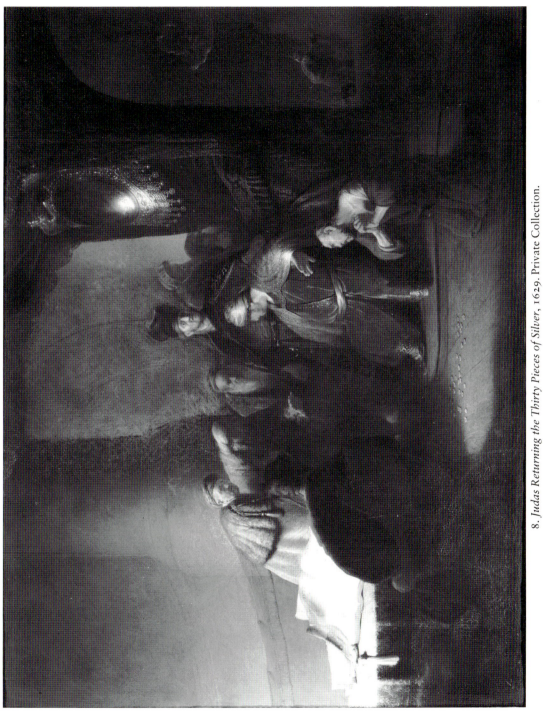

8. *Judas Returning the Thirty Pieces of Silver*, 1629. Private Collection.

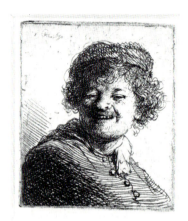

9. *Self-Portrait in a Cap, Laughing,* 1630.
Etching. Amsterdam, Rijksprentenkabinet.

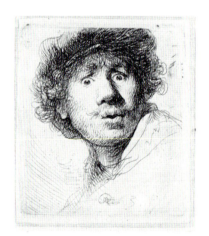

10. *Self-Portrait in a Cap, Open-Mouthed,* 1630.
Etching. Amsterdam, Rijksprentenkabinet.

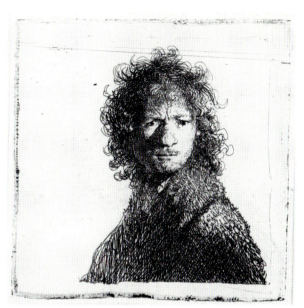

11. *Self-Portrait, Frowning*, 1630. Etching. Amsterdam,
Rijksprentenkabinet.

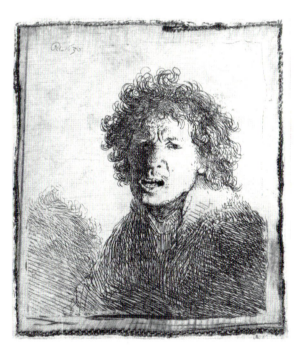

12. *Self-Portrait Open-Mouthed, as if Shouting*, 1630.
Etching. Amsterdam, Rijksprentenkabinet.

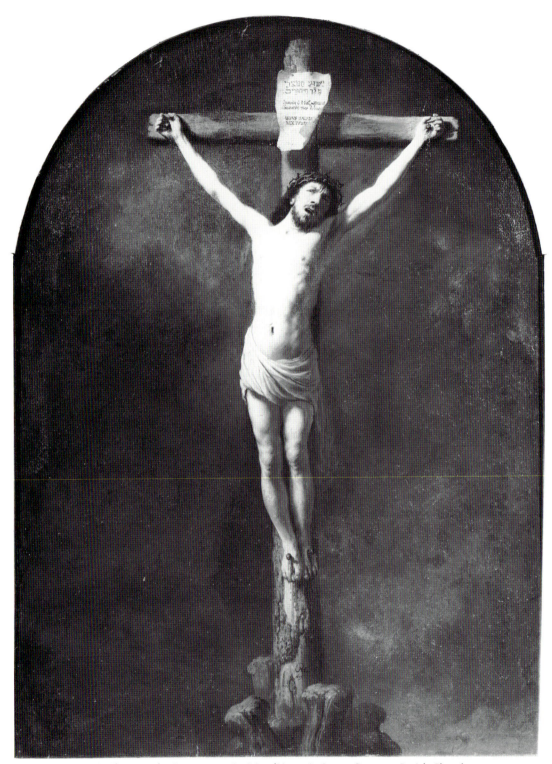

13. *Christ on the Cross*, 1631. Le Mas d'Agenais, Lot et Garonne, Parish Church.

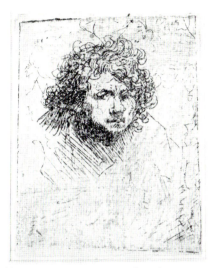

14. *Self-Portrait Leaning Forward*. Etching. Amsterdam, Rijksprentenkabinet.

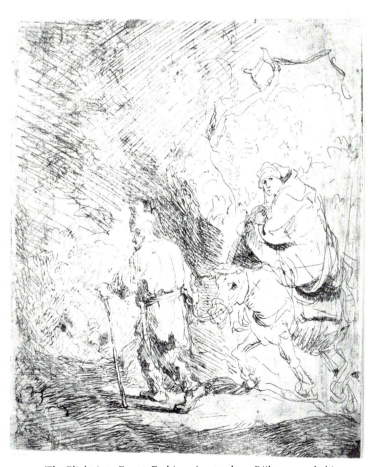

15. *The Flight into Egypt*. Etching. Amsterdam, Rijksprentenkabinet.

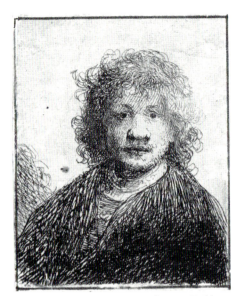

16. *Self-Portrait with a Broad Nose*. Etching.
Amsterdam, Rijksprentenkabinet.

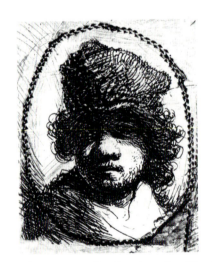

17. *Self-Portrait in a Fur Cap, in an Oval Border*.
Etching. Amsterdam, Rijksprentenkabinet.

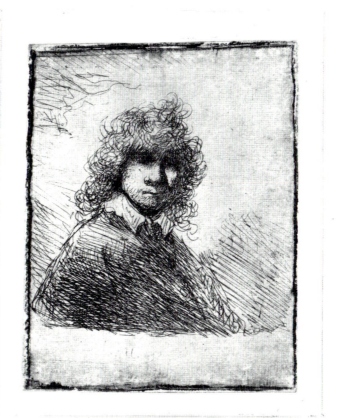

18. *Self-Portrait with High, Curly Hair*. Etching. London,
British Museum.

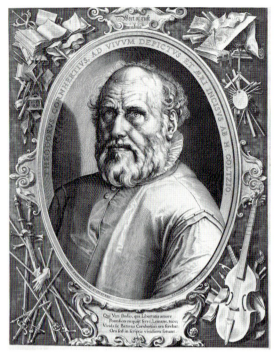

19. Hendrick Goltzius, *Dirck Volckertsz. Coornhert*. Engraving. Amsterdam, Rijksprentenkabinet.

20. Nicolaes Eliasz., *Self-Portrait*, 1627. Paris, Musée du Louvre.

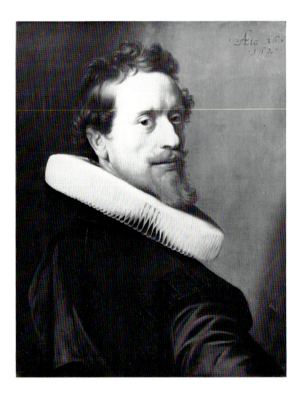

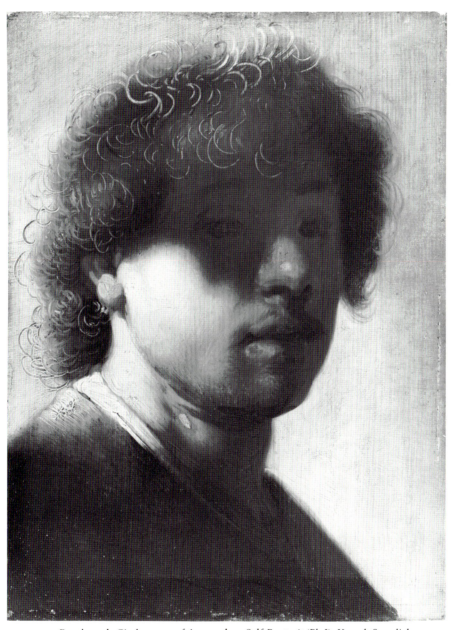

21. Rembrandt Circle, copy of Amsterdam *Self-Portrait* (Pl. I). Kassel, Staatliche Kunstsammlungen, Gemäldegalerie Alte Meister.

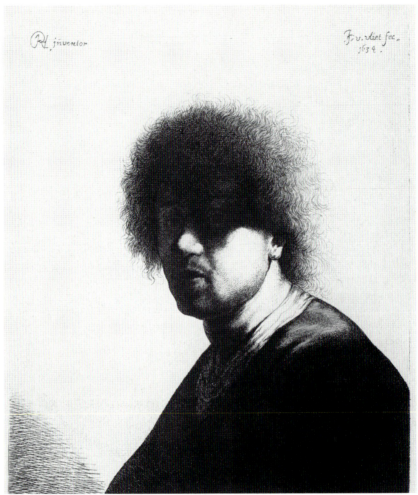

22. J. G. van Vliet, *Bust of a Young Man* (after Rembrandt's *Self-Portrait*, Pl. I), 1634. Etching. Amsterdam, Rijksprentenkabinet.

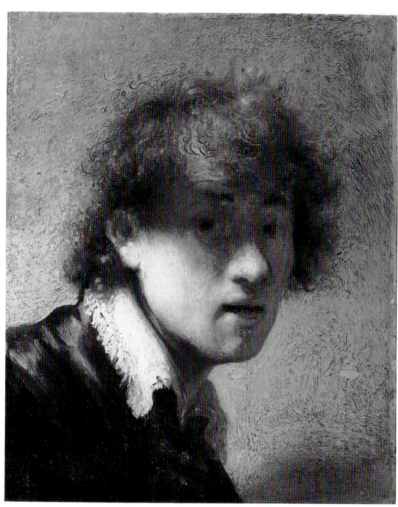

23. *Self-Portrait*, 1629. Munich, Alte Pinakothek.

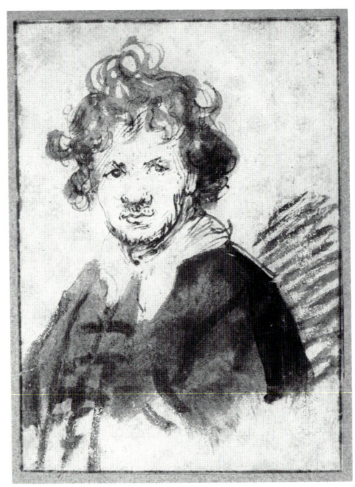

24. *Self-Portrait*. Drawing. Amsterdam, Rijksprentenkabinet.

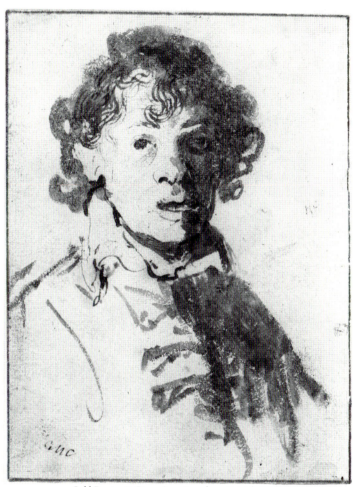

25. *Self-Portrait*. Drawing. London, British Museum.

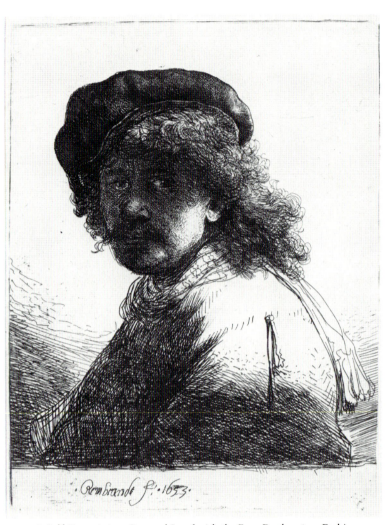

26. *Self-Portrait in a Cap and Scarf with the Face Dark*, 1633. Etching.
Amsterdam, Rijksprentenkabinet.

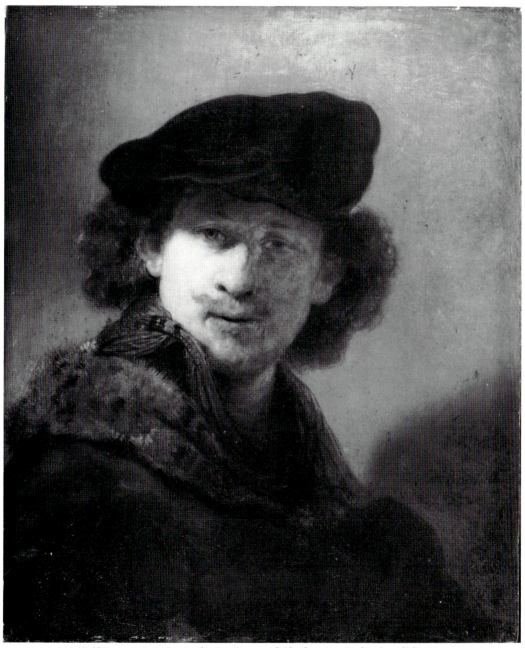

27. *Self-Portrait in a Cap and a Fur-Trimmed Cloak*, 1634. Berlin, Staatliche Museen
Preussischer Kulturbesitz.

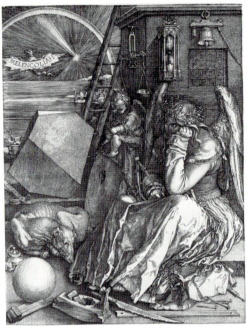

28. Albrecht Dürer, *Melancholia I*, 1514.
Engraving. Washington, National Gallery of Art.

29. Jan Davidsz. de Heem, *A Man Seated at a Table*, 1628. Oxford,
Ashmolean Museum.

30. Pieter Codde, *Young Man with a Pipe*. Lille, Musée des Beaux-Arts.

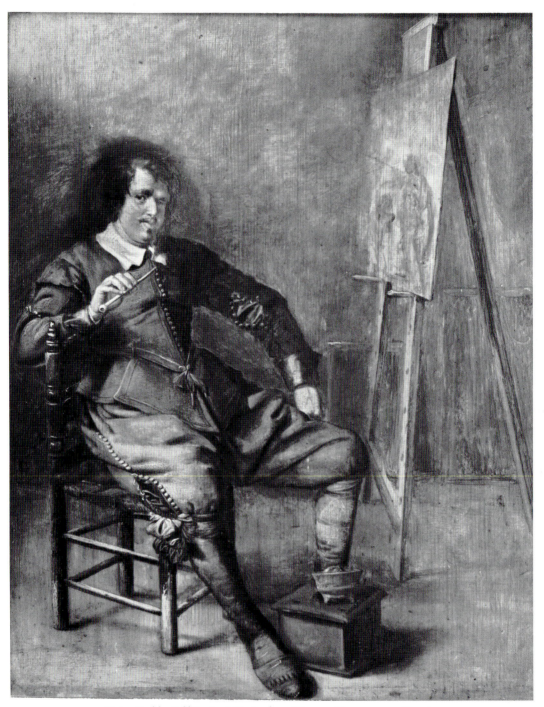

31. Pieter Codde, *Self-Portrait*. Rotterdam, Museum Boymans-van Beuningen.

32. Samuel van Hoogstraten, *Self-Portrait*, 1644. Rotterdam, Museum Boymans-van Beuningen.

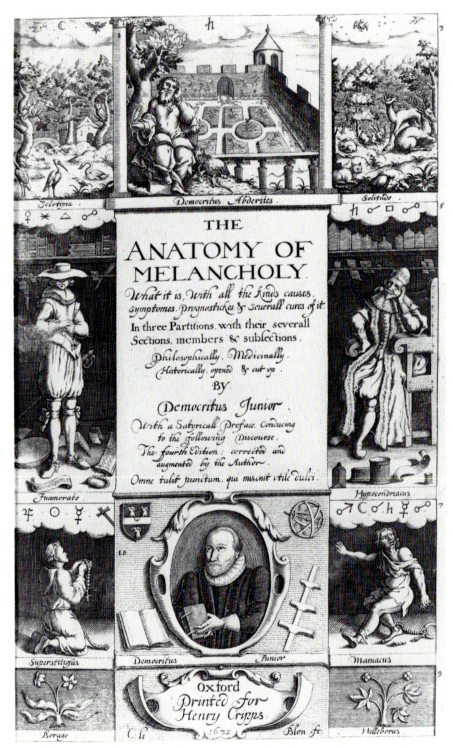

33. Title page to Robert Burton, *The Anatomy of Melancholy*. London, 1632. Bethesda, National Library of Medicine.

34. Anonymous, *John Donne*. The Marquess of Lothian.

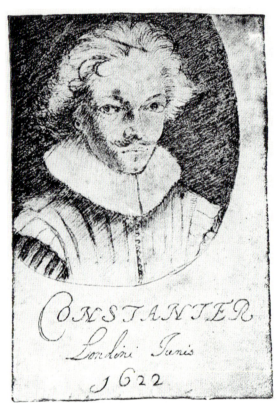

35. Constantijn Huygens, *Self-Portrait*, 1622. Current
whereabouts unknown.

36. Jan Lievens, *Constantijn Huygens*, 1628. Douai, Musée de la Chartreuse, on loan to Amsterdam, Rijksmuseum.

37. *Beggar with a Wooden Leg*. Etching.
Amsterdam, Rijksprentenkabinet.

38. *Beggar Seated on a Bank*, 1630. Etching.
Amsterdam, Rijksprentenkabinet.

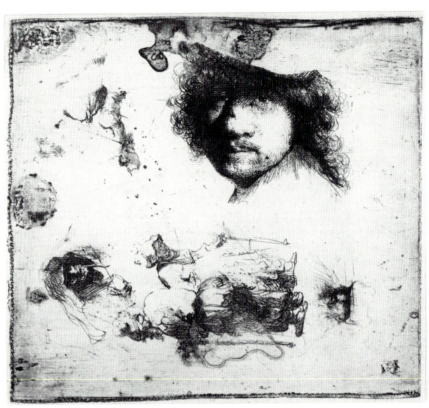

39. *Studies of the Head of Rembrandt and Beggars*. Etching. Amsterdam,
Rijksprentenkabinet.

This promotion of illustrious Netherlanders marked the beginning of Dutch artistic nationalism, stimulated both by the artists' increased professional confidence and by the heightened political consciousness that developed during the revolt against Spain. It was echoed in Karel van Mander's *Schilderboeck* of 1604, the first compilation of biographies of Northern artists. And in 1610 Hendrik Hondius's *Pictorum aliquot celebrium praecipue Germaniae Inferioris effigies* incorporated Cock's original portraits, with new verses, and expanded the series to sixty-eight artists, incidentally making available a broader repertory of portrait types on which painters could model their own images (Fig. 144).[8]

The popularity of studio scenes like Rembrandt's *Artist in His Studio* of about 1629 (Fig. 117) is further evidence of the Dutch artist's professional consciousness. Although the learned atmosphere of a university town perhaps accounts for the allegorical complexity of this subject as handled by David Bailly and Gerard Dou, its sudden flowering in Leiden in the late 1620s has not been explained. It may be that unusually disadvantageous conditions there heightened the painters' concern to elevate their professional status. Leiden was the only important Dutch town in which the painters still did not belong to their own guild of St. Luke. Guild membership afforded a number of advantages, including protection from outside competition, which after the Revolt was aggravated by an influx of artists and picture dealers from the southern Netherlands seeking more profitable markets in the north. The guildless painters' agitation for protection reflected the lack of respect accorded their craft, which, in conjunction with an especially depressed market for paintings, may have prompted their heavy output of self-promoting studio scenes. Indeed, David Bailly, a major contributor to this genre, was one of three overseers assigned to enforce new regulations on picture dealing in 1642.[9]

Hence Rembrandt's earliest self-portraits were produced in a milieu of heightened artistic consciousness, reinforced by the local artists' less than ideal socio-economic circumstances. This, combined with the popularity of self-portraits and images of artists, might in part account for his initial impetus to portray himself. It does not, however, explain the particular, highly original expressive form of his early self-portraits or the motivation behind his singular preoccupation with self-portraiture. For this a closer look at the artist himself and his unique circumstances is necessary.

Though the facts of Rembrandt's education and training are well known, their relevance to his approach to self-portraiture has not been considered. He was trained as a history painter, and the major works of his Leiden years, like the *Stoning of St. Stephen* (Fig. 6), are biblical, mythological, or historical. That this experience deeply affected his self-portraits is obvious: his face appears in several of his earliest history paintings, and some of his independent likenesses, mostly etchings, reappear in larger works. Yet the usual explanation of these images as expression studies done in preparation for, or in conjunction with, more significant subjects is an oversimplification. The complexity of the relation between his self-portrayal and his history painting has not been fully ap-

preciated. In what follows I will argue that Rembrandt, in part because of an attitude toward expression that was central to his history painting, could not have portrayed himself without self-awareness.

For a painter in Rembrandt's time, despite such lucrative specialities as portraiture, landscape, or still life, history painting was still the genre held in highest regard. It dealt with noble, human subject matter and for that reason brought the artist greatest esteem. Rembrandt's parents' high ambitions for their son very likely led to his taking this most prestigous route. As his earliest biographer, the Leiden city chronicler Jan Jansz. Orlers, relates in the *Beschrijvinge der stadt Leyden*, published in 1641,

> his parents sent him to school, so that in the course of time he would learn Latin and thereafter could enter the Leyden Academy [i.e. the University], and that eventually, upon reaching maturity, he would with his knowledge be best able to serve and prompt the [interests of the] city and the community.[10]

At the Latin School, where he probably stayed until reaching the highest class at age thirteen, Rembrandt would receive a rigorous humanistic education, an atypical start for a Dutch painter. We get some idea of what he must have been taught from the "school order" of 1625, which a few years later reorganized Latin schools throughout the Netherlands for the purpose of achieving a uniform standard of preparation for entering the university at Leiden.[11] Presumably these guidelines reflected existing practice in Leiden's own Latin School to a greater extent than in those in more distant towns. Instruction was primarily in Latin, but Rembrandt also will have learned Greek. The long school day was devoted to studying the Bible as well as Cicero, Ovid, Vergil, Caesar, Hesiod, Homer, Horace, and other classical authors. Although the books listed in the "school order" may not be exactly what Rembrandt read, they accurately reflect the rigor of his education.

On 20 May 1620, two months shy of his fourteenth birthday, he registered at the University of Leiden. But, Orlers reports,

> he had no desire or inclination whatsoever in this direction because by nature he was moved toward the art of painting and drawing. Therefore his parents were compelled to take him out of school, and according to his wish they brought and apprenticed him to a painter from whom he would learn the basic and principal rules of art.[12]

Rembrandt went to school but did not like it. Put another way, he was educated—extremely well, for a painter—and obviously gifted and intelligent, but he was not an intellectual like Rubens, interested in abstract ideas and learning for its own sake. If the Latin School had not made him a scholar, it had prepared him to be a history painter by instilling in him a proper "knowledge of the histories"[13]—the Bible and the classics—and a basically humanist attitude towards them.

Rembrandt's parents had had higher hopes than the painter's trade. But when their son displayed unusual talent they saw that he took the most ambi-

tious route and sent him to train with the best local history painter, Jacob Isaacsz. van Swanenburgh, a well-connected artist of moderate talent, with whom he apprenticed for about three years. Orlers tells us that he then went to Pieter Lastman, the most renowned history painter in Amsterdam, "for further and better instruction."

This choice of teacher was a clear indication of Rembrandt's ambition, for Lastman embodied, to the extent then possible in the Netherlands, the ideal of the classically trained history painter. One of a generation for whom it was obligatory to go to Italy, he, like van Swanenburgh, had made the requisite trip to Rome and returned home having assimilated both classical forms and humanist attitudes. His *Coriolanus and the Roman Matrons* (Fig. 5) of 1622, for example, is based on the ancient Roman formula used for scenes of emperors addressing their troops—the *adlocutio*, as found on the arches of Trajan and Constantine—and was directly influenced by an important High Renaissance work, the fresco of *The Vision of Constantine* in the Sala di Constantino of the Vatican Palace by Giulio Romano and Rafaellino dal Colle.[14]

Rembrandt's earliest known history painting, *The Stoning of St. Stephen* (Fig. 6) of 1625, is heavily indebted to Lastman's compositional and narrative style. Two works of 1626, *Balaam and the Ass* and *The Baptism of the Eunuch*,[15] rework his teacher's versions of the same subjects. The 1626 *Historical Scene* in Leiden (Fig. 7)—so called because its subject has yet to be satisfactorily identified—is directly based on Lastman's *Coriolanus* and clearly demonstrates the older artist's influence in composition, color, and archaeological accuracy. In all these works Rembrandt, with characteristic boldness, improved upon his master, pushing figures forward, intensifying actions, heightening emotions, and concentrating the narrative to isolate the dramatic moment.

In one respect Rembrandt's paintings differed from Lastman's right from the start: in *The Stoning of St. Stephen* two or possibly three of the saint's tormentors look very much like Rembrandt, and in the Leiden *Historical Scene* he included himself just to the right of the standing ruler. These visages indicate that as early as 1625, before any of his extant independent self-portraits, Rembrandt was drawing his face in the mirror. More important, they suggest that he came to self-portraiture through history painting and that his practice in that genre colored his approach to his self-portraits.

Including oneself in a larger work imitated a tradition widespread in the Renaissance and sanctioned by Antiquity. According to Plutarch, Phidias portrayed himself in the battle between Greeks and Amazons on the shield of Athena Parthenos. Vasari informs us that there are self-portraits of (to name only a few) Masaccio as one of the Apostles in the *Tribute Money*, Raphael in the *School of Athens*, and Michelangelo as the flayed skin of St. Bartholomew in the *Last Judgement*. Van Mander provides similar information about Northern painters: Jan and Hubert Van Eyck are said to be portrayed, on horseback next to the Count of Flanders, in the *Ghent Altarpiece*. Albrecht Dürer was especially noted for painting himself in many of his works, including his *Martyrdom of the Ten Thousand* and *Adoration of the Trinity*.

15

A participant self-portrait traditionally functioned in several ways. As a pictorial signature it expressed the artist's pride in his work, spread his fame, and, like any portrait, preserved his image for posterity. Besides promoting his personal glory, the participant self-portrait was a reminder that the artist's God-given gift of creation accorded him a privileged position. Furthermore, it enriched the beholder's experience of the work of art, since the artist acted as a mediator between the viewer and the divine or historical event portrayed. Often the painter, who usually stands to the side, looks out of the painting and catches the viewer's eye, thereby drawing him into the scene. The expressive effect of his presence can be compared to theatrical devices employed to intensify the audience's involvement: in Dutch drama beginning with Bredero and Coornhert, just as in Jonson and Shakespeare, characters speak directly to the audience in the form of a prologue, soliloquy, epilogue, or other commentary on the action, conveying the insight of the author.

In his history paintings of the Leiden period, Rembrandt transformed the Renaissance convention by assuming an active presence. No longer a bystander discreetly pushed to the side, he took a central position in the Leiden *Historical Scene* (Fig. 7). In *The Stoning of St. Stephen* (Fig. 6) he participated fully in the scene enacted, appearing, curiously enough, in several roles. I think we can assume that Rembrandt's face would be recognized by at least some of his contemporaries, for it is likely that these two works were commissioned as pendants by a fellow townsman, the prominent Leiden historian and Remonstrant sympathizer Petrus Scriverius.[16] Yet here especially the signature function of the participant self-portrait has diminished in favor of emotional engagement.

Examining how one of Rembrandt's contemporaries responded to the intense emotionalism of his early history paintings provides insight into his motivations for including himself. In his autobiography Constantijn Huygens reviewed the state of painting in the Netherlands, singling out two especially promising young Leideners, Rembrandt and Jan Lievens, and contrasting their talents. He praised Rembrandt as surpassing Lievens "in the natural power with which he is able to move the spirit [of the viewer]."[17] As evidence he described the *Judas Returning the Thirty Pieces of Silver* (Fig. 8) of 1629, the first truly independent work in which Rembrandt replaced Lastman's classicized naturalism with his own brand of dramatic emotional expression.[18] Huygens was particularly struck by the remorseful Judas's pathetic attempt to atone for his betrayal of Christ:

> the posture and the gestures of this one despairing Judas, leaving aside so many other breathtaking figures [brought together] in a single painting, of this one Judas I say who, out of his mind and wailing, implores forgiveness yet holds no hope of it, or has at least no trace of hope upon his countenance; that haggard face, the hair torn from the head, the rent clothing, the forearms drawn in and the hands clasped tight together, stopping the blood-flow; flung blindly to his knees on the ground in a [violent] access of emotion, the pitiable hor-

ror of that totally twisted body—*that* I set against all the refined art of the past.[19]

If Huygens' description strikes us as more impassioned than the figure of Judas itself, it is because, like others of his period, he demanded that a painting move the beholder through immediacy and emotional intensity. His praise of Judas as filled with emotion ("vivacitas affectum") and his characterization of Rembrandt as one who "gives himself wholly over to dealing with what he wants to express from within himself"[20] confirm that the empathetic, heartfelt rendering of the passions was precisely what moved him.

Rembrandt's sole utterance on his artistic aims, written in a letter to Huygens in 1639, similarly expressed his desire to capture "die meeste ende die naetuereelste beweechgelickheijt," the greatest and most natural emotion.[21] This phrase has prompted a great deal of debate because critics are divided over whether Rembrandt meant "motion" or "emotion." Probably he meant "emotion," but our confusion arises from the fact that he used a term, indeed a concept, that originally implied physical—bodily and facial—motion. The concept of the *affetti* (movements of the soul) as formulated in the Renaissance meant physical gesture. A classical concept, derived from ancient rhetoric, the *affetti* connoted the system of figural expression at the basis of Renaissance art theory. As Alberti put it, "these feelings are known from movements of the body."[22]

Early seventeenth-century artists, and Rembrandt in particular, with their intensified concern to make visible the deepest recesses of the human psyche, tried increasingly to represent the more intangible aspects of emotion and thought. In their attempts to capture great extremes of feeling and to penetrate the depths of the inner man they relied even more on the face as a primary vehicle for expression. This interest in the emotions and the corresponding tendency to individualize were evident already in van Mander's regard for the expression of the passions as the very "soul of art."[23] He devoted an entire chapter of *Den grondt der edel vry schilder-const*, the theoretical section of his *Schilder-boeck*, to the "passions of the soul," or *affecten*, recommending an intuitive, naturalistic approach to facial expression. He provided a few formulae for representing specific emotions: for instance, to depict gaiety of the heart "make the eyes half closed, the mouth somewhat open and merrily laughing,"[24] advice which Rembrandt seems to follow in his *Self-Portrait in a Cap, Laughing* (Fig. 9).[25] Mostly van Mander offered general observations on the expressive roles of different features: the eyes are the "seat of the passions, . . . mirrors of the soul, messengers of the heart"; the forehead and brows "reveal the thoughts," and in them "one can read the human mind."[26] More specifically, "wrinkles and furrows" on the brow "show that in us is concealed a sorrowful spirit, anxious and full of cares. Indeed, the forehead resembles the sky and the weather, wherein sometimes blow many gloomy clouds, just as the heart is oppressed by the weight of sadness and discord."[27] For the most part van Mander declined to describe specific emotions, maintaining that the artist can best learn from observing nature how to represent feelings and states of

mind.[28] Van Mander's naturalistic, subjective, and particularized approach to the passions signaled an important modification of the Renaissance convention of figural expression. It was, moreover, far more intuitive than the later systematization of the passions in Charles Le Brun's formulaic catalogue of generalized facial expressions, the *Conférence sur l'expression*, published in 1698.

Rembrandt's contemporary Franciscus Junius took a similar naturalistic approach to the passions in his erudite treatise *De Pictura Veterum*, published in Amsterdam in 1637, which he translated into English (as *The Painting of the Ancients*) in 1638 and into Dutch in 1641. Junius was a classical scholar and librarian to Thomas Howard, Earl of Arundel, one of the greatest English collectors of the period. Though writing in England, he had been educated at Leiden and continued to correspond with G. J. Vossius, professor first at Leiden and then at the Remonstrant Academy in Amsterdam and author of the treatise *De Graphice, sive Arte Pingendi* (1650). The importance of Junius's book as a reflection of views on painting held by learned Dutchmen, like Huygens, and ambitious artists, like Rembrandt, has been underestimated. While ostensibly writing about ancient artists and criticizing modern practices, he seems to have combed classical texts for ideas supporting the current theoretical model of the learned virtuoso painter: "Seeing also that many Artificers seeme to have drawn that same love of new-fangled conceits from *Poets*, I do not thinke it amisse to shew what affinitie there is between *Poesie* and *Picture*."[29] Regarding emotional expression Junius wrote,

> An Artificer . . . must be well acquainted with the nature of all things, but principally with the nature of man. . . . it sufficeth that he doe but learne by a daily observation [of] how severall passions and affections of the minde doe alter the countenance of man.[30]

These art theorists' appeal to observation was symptomatic of the period's increasingly empirical scientific approach to knowledge. A broader confidence in experience, especially of the self, as a means to understanding human nature is reflected in Montaigne's statement:

> Whatever fruit we may glean from experience, that which we draw from outside examples will hardly contribute much even to our elementary education, unless we profit from the experience we can have of ourselves; that is more familiar to us and certainly enough to teach us what we need.[31]

Even Descartes, whose mechanistic treatise *Les passions de l'âme* is at the root of Le Brun's formulaic expressions, claimed to reject the teachings of the ancients and to study the passions by observing himself:

> everyone feels passions in himself and so has no need to look elsewhere for observations to establish their nature. And yet the teachings of the ancients about the passions are so meagre and for the most part so implausible that I cannot hope to approach the truth except by departing from the paths they have followed. That is why I shall be

obliged to write as if I were considering a topic that no one had dealt with before me.[32]

We sense in Rembrandt's four etched self-portraits of 1630 a similar impulse to study himself and represent the emotions as if no one had done so before. In the *Self-Portrait in a Cap, Laughing* (Fig. 9), he glances over his shoulder with a toothy grin, his eyes half-closed in pleasure, following van Mander's formula for gaiety and, more important, his advice to particularize expression by observing nature. In his *Self-Portrait in a Cap, Open-Mouthed*[33] (Fig. 10) he starts in amazement, his eyes bulging and brows raised, though whether his somewhat theatrical reaction should be read as horrified shock or surprised wonderment is difficult to tell. For the *Self-Portrait, Frowning*[34] (Fig. 11) he arranged his features into a tense glare. Frowning, fully lit eyes stare out from under flattened brows, the horizontal line of which is echoed in his tightly closed mouth. Leonine hair and furry garments complete his image of fierce anger. His moving *Self-Portrait Open-Mouthed, as if Shouting*[35] (Fig. 12) is the most strongly emotive representation of momentary passion. He cries out in distress, his mouth snarling in pain, his forehead deeply creased. Sharp side-lighting intensifies his anguish.

Some of these expression studies soon show up in his biblical works. That in the *Self-Portrait Open-Mouthed, as if Shouting* reappears the following year on the face of the crucified Savior in his *Christ on the Cross* (Fig. 13), as if Rembrandt was acting out the emotion he wanted to use for Christ. His look of wonder in the *Self-Portrait in a Cap, Open-Mouthed* appears on the faces of some of the astonished witnesses to Christ's miracle in the painted *Raising of Lazarus* of 1630–31 and in the etching of the same subject from about 1632. And in the etched *Descent from the Cross* (Fig. 150) the figure standing on the ladder, helping to lower Christ's body, not only has Rembrandt's features but makes a face similar to that in the *Self-Portrait, Frowning* (Fig. 11).

The period's empirical attitude toward rendering the passions, which we have seen recommended by van Mander, practiced by Rembrandt, and admired by Huygens, led artists throughout Europe to study their own emotions. Bernini is said to have thrust his leg into the fire to observe his agonized expression when carving his St. Lawrence martyred on the grill.[36] Caravaggio seems to have used himself as a model for such works as the *Sick Bacchus* and *Boy Bitten by a Lizard*. And Domenichino reportedly went around "talking to himself, crying out in pain or gladness, and then practicing the proper *affetti*."[37]

The idea that the artist must draw on his own experience to imagine emotions and dramatic situations for the sake of convincing expression stems from ancient poetic theory. In the *Ars Poetica*, a text Rembrandt probably read at the Latin School,[38] Horace advised the tragic actor:

> Not enough is it for poems to have beauty: they must have charm, and lead the hearer's soul where they will. As men's faces smile on those who smile, so they respond to those who weep. If you would

have me weep, you must first feel grief yourself: then . . . will your misfortunes hurt me: if the words you utter are ill suited, I shall laugh or fall asleep.[39]

In Dutch art theory, as in Italian theory since Alberti,[40] Horace's idea that the poet had to imagine emotions he wanted the beholder to feel was interpreted literally and applied to the painter. According to Junius, the painter, like the poet, was "most of all advanced by the ready help of a strong and well-exercised Imagination."[41] This enabled him to empathize with his subjects and thus move the beholder. Painters, he wrote,

first of all passe over every circumstance of the matter in hand, considering it seriously, as if they were present at the doing, or saw it acted before their eyes: whereupon feeling themselves well filled with a quick and lively imagination of the whole worke, they make haste to ease their overcharged braines by a speedie pourtraying of the conceit.[42]

And, he continued, for proper invention "our minde must first of all be moved, our minde must conceive the images of things, our minde must in a manner bee transformed unto the nature of the conceived things."[43] Only an artist who is so moved himself can hope to move the spectator with his work:

A minde rightly affected and passionated is the onely fountaine whereout there doe issue forth such violent streames of passions, that the spectator, not being able to resist, is carried away against his will.[44]

Samuel van Hoogstraten, who was Rembrandt's pupil in the 1640s and in 1678 published a rather eccentric theoretical treatise, the *Inleyding tot de hooge schoole der schilderkonst* (Introduction to the Elevated School of the Art of Painting), discusses "the passions or movements of the heart" in the section of his book devoted to history painting. Here he presents his own version of the Horatian dictum, possibly reflecting what he had learned in Rembrandt's studio: "If one wants to gain honor in this most noble part of art [the passions], one must reform oneself totally into an actor."[45] He goes on to say, "the same benefit can be derived from the depiction of your own passions, at best in front of a mirror, where you are simultaneously the performer and the beholder. But here a poetic spirit [Poëtische geest] is necessary in order to imagine oneself in another's place."[46] Hoogstraten seems to distinguish between acting out a role and experiencing passions as one's own, the latter being more difficult because it requires imagination or *poëtische geest*. He recognizes, then, that the artist gains unique insight in being both performer and beholder, or represented and representer.

Rembrandt's earliest history paintings manifest the artist's heightened emotional involvement. When he appears as a participant in the Leiden *Historical Scene* and *The Stoning of St. Stephen* (Figs. 7 and 6), he claims his ability to "reform [him]self totally into an actor." Although the participant self-portrait was not new in the seventeenth century, the artist's role as mediator no

longer depended merely on the fact that his face was familiar or his glance engaging: instead, what became most important was the strength of his imagination and the authenticity of the emotions he rendered. Empathizing with historical protagonists and situations enhanced—indeed, it announced—the artist's ability to express the appropriate passions and relate the narrative.

Rembrandt's use of his own face for expressions he then used in his *Raising of Lazarus*, *Christ on the Cross*, and *Descent from the Cross* anticipated Hoogstraten's advice to depict one's passions in front of a mirror. Here we find Rembrandt even more intensely trying to imagine himself in another's place and to experience emotions for the sake of convincing expression. Through his four etched self-portraits of 1630 (Figs. 9–12) he projected an image of one who, in Huygens' words, "gives himself wholly over to dealing with what he wants to express from within himself."[47] That these etchings were monogrammed and dated and were made in a reproductive medium, presumably meant for wider distribution, suggests that Rembrandt's use of himself as a model was a decision prompted by the history painter's imperative to engage his imagination to the fullest extent possible for the sake of emotional expression. Rather than studies, they are deliberate demonstrations of his proficiency in rendering the passions.

Rembrandt's participant self-portraits and his expressive faces are two sides of the same coin. Both arise from the artist's need for emotional engagement in the historical event he depicts. And both reflect the period's new emphasis on the individual, on the particularized face rather than the generalized type as the prime vehicle for emotional expression. They also represent the beginning of Rembrandt's unprecedented self-involvement in his own work, which is manifested not only in the number of times he included his face in history paintings and prints, but also in the frequency with which he included members of his family in biblical scenes and painted them in historicized portraits, as well as in the close ties between his biblical works and his habit of drawing events in his everyday life.

But not all of his early self-portraits can be so closely connected to his history paintings. Another group of images is distinguished by their introspective mood and evocative shadows: not representations of particular emotions, they concern the artist's imagination in a different and perplexing way.

THE ARTIST'S TEMPERAMENT

A conceptual transition from historical representation to self-portrayal is encapsulated in one of Rembrandt's earliest endeavors with the etcher's needle. In 1627 or 1628, he etched the *Self-Portrait Leaning Forward* (Fig. 14), probably his first independent self-portrait, on a piece of the copper plate he had previously used for *The Flight into Egypt* (Fig. 15).[48] In the unique impression of the print the Virgin Mary's ghostlike head remains faintly visible, upside down, just above his own. He strains forward, his shoulders hunched, not so much for dramatic effect as to see himself properly in the mirror. Intent on rendering psychological depth rather than simple likeness, he pays little atten-

tion to his hastily sketched-in body. Ignoring the conventional niceties of portraiture, he shades his eyes, deeply creases his brow, and accentuates his unruly hair with heavy scratched lines, imparting a sense of solemn, intense thoughtfulness. Similarities between his expression and Mary's suggest that, mindful of the destroyed work, he was practicing her furtive glance. But of course Rembrandt was primarily characterizing not Mary but himself. In so doing, he proclaimed himself to have the strength of imagination and to be of the proper artistic temperament for historical representation. He announced, in Hoogstraten's words, his *poëtische geest*.

In two other etchings of about the same date he sat up straight and posed for himself, with different results in each. The subtly shaded full-face *Self-Portrait with a Broad Nose*[49] (Fig. 16), though more open and accessible than the *Self-Portrait Leaning Forward*, shares its solemn intensity. In contrast, the gloomy *Self-Portrait with High, Curly Hair*[50] (Fig. 18) seems inaccessible, shrouded in mystery. One of his least attractive self-portraits, it is worth examining closely, for here we find that in the very act of making his first attempt at a proper portrait, adopting a traditional format and paying more attention to his clothing, he employed a loose technique and heavy shading of the eyes atypical of portraiture. He used the same shading device, to almost sinister effect, in his somber *Self-Portrait in a Fur Cap, in an Oval Border*[51] (Fig. 17). Scrawly lines, harshly darkened face, and crudely tooled frame seem to mock the control of more conventional engraved portraits like Hendrick Goltzius's *Dirck Volckertsz. Coornhert* (Fig. 19).

His *Self-Portrait, Bareheaded*[52] (Fig. 1), signed "RHL" and dated 1629, comes still closer to true portraiture. In recognition of his bolder, more public image, Rembrandt had chosen a plate several times the size of the previous ones and etched it with unconventional bravado, experimentally using a double-pointed tool, possibly a quill pen, to achieve dark, bold lines. He also portrayed himself with new confidence, adopting a formal demeanor, donning respectable clothing, and abandoning extreme shading in favor of deepening his eye sockets with concentrated shadows. The workings of the mind are still suggested by his furrowed brow and intense gaze. Although his hair is coiffed with a fashionable "lovelock" or *liefdelok*, it nonetheless seems wild and unkempt. A subject of theological debate in the Netherlands, long hair was the mark of a stylish courtier or gentleman.[53] Whether Rembrandt really wore his hair this way is questionable, since its length varies even among portraits of the same year. More likely, hairstyle is another aspect of the costumes and guises that he puts on and takes off at will.

Rembrandt's small bust-length self-portrait in the Rijksmuseum (Pl. I), probably his first in paint, is just as unconventional as these etchings.[54] From his stubbly beard, shaggy hair, and nondescript clothing we gather that conveying a refined public image was far from his mind. He reduced the portrait to bare essentials. Abbreviating his body and summarily defining his small white collar, he suppressed any interest in his clothing, which would ordinarily convey social status. His face is unmistakable, yet the picture does not primarily

record likeness. Those features crucial to recognition that we most want to see—his eyes and mouth—are inaccessible, cast in deep shadow. Bright light falls from the left, hitting his ear, the side of his face, and a few strands of his bushy hair. This unusual lighting scheme with its dramatic, mysterious shadow is what strikes us most and would have struck his contemporaries even more. In contrast to the polished formality, evenness of lighting, air of permanence, and corresponding lack of emotion in contemporary self-portraits by Rubens and Nicolaes Eliasz. (Figs. 93 and 20), Rembrandt's evokes astonishing psychological depth.

His seemingly spontaneous painting technique enhances mood and personality at the expense of descriptive detail. Sketchy, free brushwork creates an overall unifying effect of atmosphere and light. Though paint is applied thickly in the lightest areas, in areas of dark it is quite thin, allowing the warm ground to radiate through. By limiting his palette to a monochrome range of gray, brown, and yellow, relieved only by touches of pink, Rembrandt focuses all attention on the play of light and shadow. He masterfully enhances the three-dimensionality by incising lines in the paint surface with a sharp instrument, probably the butt end of a brush. Seemingly effortless shortcuts, these brilliantly conceived scratches expose the yellow-brown ground, creating glittery highlights in the frizzy hair on his brow.[55] In contrast, along the left profile of his neckline, incised lines expose dark brown underpainting instead of ground, creating the effect of hairs silhouetted against the gray wall.

Contemporary copies of the Amsterdam panel indicate that what initially may have been a private work must have acquired a wider audience. Rembrandt's daring handling of paint distinguishes it from another, less confident version in Kassel (Fig. 21), long thought to be the original but now recognized as a workshop copy.[56] Subtle highlights have become crude blobs of paint on the neck, the shoulder, and the tip of the nose. Details of the collar and hair have been simplified, and the incising technique has been clumsily imitated with limited three-dimensional effect. Moreover, the copyist, a poor judge of proportions, awkwardly enlarged Rembrandt's features and compressed the top of his head. This and other painted copies may have been studio exercises to teach particular techniques and expressive effects—students customarily learned by copying drawings, plaster casts, and, in Rembrandt's studio especially, paintings by their master. Or they may have been produced in his shop for sale, suggesting a demand for such copies.

Anticipated demand for the image, probably as a portrait but perhaps as an expressive character type or *tronie*, must have prompted the etched copy, dated 1634, by J. G. van Vliet (Fig. 22), a printmaker with whom Rembrandt was associated for a brief time.[57] Van Vliet fully captures, even exaggerates, the startling contrast of light and dark in the painting, impressing upon us just how novel Rembrandt's mysteriously shaded eyes must have seemed at the time.

A smaller self-portrait in Munich (Fig. 23), monogrammed "RHL" and dated 1629, is similar to the Amsterdam panel (Pl. I) in its dramatic lighting and abbreviated bust-length format, but more intense and spontaneous in its

emotional expression.[58] Rembrandt thrusts his head forward, his lips slightly parted, eyes shaded but wide open and brows raised. Sharp side-lighting, now casting a shadow on the wall, reinforces his vitality. His hair, more unruly than in the Amsterdam portrait, magnifies his excitement, as does his larger, nervously painted white collar. More confident, freer handling of paint—visible in the loose brushwork of the face and background—further heightens the immediacy.

Two self-portrait drawings of about 1629 exhibit analogous differences. The pen and wash drawing in the Rijksprentenkabinet (Fig. 24), like the Amsterdam panel (Pl. I), achieves a restrained psychological presence without such dramatic lighting.[59] More than either of the paintings it has qualities of a traditional portrait—even lighting, psychological composure, and formal clothing. Nevertheless, it too is a study in character rather than a simple likeness. In contrast, the drawing in the British Museum (Fig. 25), like the Munich panel (Fig. 23), emphasizes momentary expression.[60] With half of his gaunt face lost in shadow, Rembrandt raises his brows and opens his mouth as if speaking. Heightening the immediacy, his collar is open and the rest of his body is only summarily indicated. It has been suggested that the drawings were made in conjunction with the painted portraits or, more likely, with the etched *Self-Portrait, Bareheaded* of 1629 (Fig. 1), but they are too independent to be true preparatory sketches.

Rembrandt's intense, rough, sometimes gloomy countenance in many of these portraits from the late 1620s contradicts our image of him as a confident, ambitious young painter. After all, by 1628, at age twenty-one or twenty-two, he was an established independent master with his first paying pupil, Gerard Dou, and he probably counted among his patrons one of the most prominent intellectuals in Leiden, Petrus Scriverius. Furthermore, he had achieved sufficient renown to attract the attention of Constantijn Huygens and of Hendrick Uylenburgh, the art dealer from Amsterdam with whom he would soon go into business.

The difficulty of reconciling Rembrandt's position and promise with these coarse, shockingly informal images may explain in part why recent scholars have resorted to thinking of them in formalistic terms, as studies in light and expression. Yet precisely their relative lack of emotionalism separates them from the likenesses he included in history paintings and from his expressive etchings of 1630, as well as from more traditional portraits of the time. Moreover, consistent features—shaded eyes, expressive brows, unruly hair, and (when shown) careless garments, combined with extraordinarily free and loose handling—suggest that these are not purely naturalistic studies but portraits governed by certain conventions designed to convey a particular image.

Again and again, from these earliest etched and painted self-portraits to the *Self-Portrait in a Cap and Scarf with the Face Dark* of 1633 and the painting in Berlin dated 1634 (Figs. 26 and 27), Rembrandt evoked his vital psychological presence, nature, or character primarily through the relatively simple

device of shading his eyes.[61] This feature is so stunning visually and so original, yet so widely misunderstood, that it deserves our close consideration. The usual formalist explanation—that Rembrandt was practicing chiaroscuro effects—trivializes these images. He could study lighting techniques much more easily using other models, yet no such studies exist from this period. More to the point, he shades his eyes specifically, and the eyes, as van Mander knew, are "the mirrors of the soul."[62] I suggest a different interpretation of this device that pertains to the art of portraiture: that Rembrandt, responding to the reiterated challenge to paint the inner man or the soul, portrayed himself as a man of melancholic temperament.

At the time, portraiture was faulted for being slavishly tied to nature and capable of representing only external appearances. In the hierarchy of genres implicit in Dutch art theory, portraits were accorded lowly status because they were thought to rely exclusively on the imitation of a model, leaving no room for the painter's imagination. As late as 1707 Gerard de Lairesse wrote, "As far as [portraiture] is concerned it has often seemed strange to me that someone can abandon his freedom to make himself a slave."[63] A century before, van Mander had called it a "calamity" that so many Dutch painters,

> lured by profit or simply in order to make a living, start and continue
> on that side road of the arts (that is, portraiture from life) without
> having the time or the desire to look and search for the road of his-
> torical or figure painting which leads to the highest perfection.[64]

Seventeenth-century Dutch poets criticized portraits for representing only man's physical exterior, not his soul.[65] And so they entered into a philosophical debate over the relation between mind and body and over the nature of representation that goes back at least to Socrates' question to the painter Parrhasius: "Do you not imitate the character of the soul?" To which he replied: "But how could such a thing be imitated, O Socrates, which has neither proportions, nor color, nor any of the things which you mentioned just now, and which, in fact, is not even visible?"[66]

In reality the provocative mental vitality, emotional vivacity, and "speaking likeness" in portraits by Rembrandt, Frans Hals and others seemed to plumb greater, more varied depths of feeling than ever before, thereby defying the Aristotelian disbelief in the possibility of representing the invisible. In contrast to the stoical ideal of *tranquillitas* expressed in emotionless, even-tempered portraits by artists of the previous generation such as van Miereveld, van Ravesteyn, de Keyser, and Eliasz., beginning in the late 1620s portraits seemed to project a less idealized, more individualized notion of character.[67] As Hoogstraten would later put it, the face was "the mirror of the heart . . . wherein can be seen and read favor and envy, love and hate, joy and sorrow, and as many emotions as stir the heart."[68] Constantijn Huygens called the portrait "a summary of the whole man, of his body as well as his spirit."[69] His defense of his portrait by Jan Lievens (Fig. 36) as accurately capturing his troubled mental state signaled a new idea of what a portrait could appropriately reveal:

There are those who claim that the pensive expression on the face belies my geniality. [In the painter's defense] I must point out that, as I freely admit, this is entirely my own fault, since I was weighed down at the time by serious family matters, and although I tried to keep my worries to myself, I apparently displayed them for all to see in my features and eyes, as one always does.[70]

The period's fascination with investigating the nature of the soul and the relation between body and soul, which we have seen in the emphasis on expression in history painting, is also reflected in the several hundred books that were published on physiognomy, memory, the emotions, theories of cognition and perception, and questions of free will and the immortality of the soul. Indeed, the term "psychology," from the Greek *psyche* (soul), was coined in the sixteenth century to denote the scientific study of the human mind or soul.[71] Although many authors still based their ideas on Aristotle, whose *De Anima* (On the Soul) was reprinted with some forty-six new commentaries in the sixteenth century alone, others transformed ancient and medieval ways of thinking about the inner man into attitudes that were fundamentally new.[72] In his *De Anima et Vita* of 1538 the Spanish humanist Juan Luis Vives, called by some the father of empirical psychology, covers all aspects of man's psychological makeup, treating, with heavy reliance on Aristotle, the nature of the soul and the senses and, with greater originality, memory, understanding, will, and the emotions.[73] Symptomatic of the new emphasis on the individual is Juan Huarte's *The Examination of Men's Wits, in Which, by Discovering the Varieties of Natures, is Showed for What Profession Each One is Apt, and How Far He Shall Profit Therein*, first published in 1575 and widely read throughout Europe. Huarte's study of men's "wits," or intelligence, focuses (as its title indicates), on different types of intellectual abilities suitable for different professions. Huarte is concerned with how identity is formed, and his suggestions as to how different types of intellect should be educated thus tend toward a conscious cultivation of individualized talent.[74]

Just how vastly early modern psychology differed from that of today is made clear by the currency of humoral theory. According to this psycho-physiological system, which had originated in Antiquity, the four elemental fluids of the body determined, by their relative proportions, each person's physical and mental constitution. The four bodily humors—blood, yellow bile, phlegm, and black bile—were conceived of as having the same essences as the four elements of fire, water, air, and earth. They were held responsible, by their balance or lack thereof, for all of man's physical and emotional conditions and diseases. And they were thought to govern which of the four personality types or temperaments—the sanguine, choleric, phlegmatic, and melancholic—would dominate in each person.

The melancholic temperament in particular caught the attention of this age of heightened self-awareness.[75] For it was associated with depression, self-absorbed introspection, and artistic creativity. As conveyed in Dürer's complex

humanistic allegory *Melancholia I* of 1514 (Fig. 28), *melancholia imaginativa*, a particular aspect of the temperament dominated by the imagination, was regarded as a mandatory condition for creative genius.[76] It distinguished the artist as divinely inspired by *furor melancholicus*, alienated him from society, and made him acutely vulnerable to his passions. Jacques de Gheyn's somewhat later allegory of Melancholy simplified Dürer's and transformed his female personification into a Saturnine old man brooding, in the darkness of night, atop a terrestrial globe, symbol of melancholy's earthy essence. De Gheyn repeated the pensive pose of *Melancholia I* and encapsulated his elaborate emblematic accouterments in a compass and orb, which symbolize the creative powers of the true artistic genius who, like God, the architect of the universe, "ordered everything by measure and number and weight."[77] The print's caption, by Hugo Grotius, conveys the most important aspect of the seventeenth century's less abstruse concept of melancholy: "Melancholy, the most calamitous affliction of soul and mind, often oppresses men of talent and genius."[78]

Since Antiquity, melancholy had been regarded both as the source of creative and contemplative intelligence and as a dread disease, the source of madness. Aristotle had summed up its importance in his question, "Why is it that all those who have become eminent in philosophy or politics or poetry or the arts are clearly melancholics, and some of them to such an extent as to be affected by diseases caused by black bile?"[79] The idea of heroic melancholy as the natural condition of genius was formulated by the Florentine Neoplatonists, most notably Marsilio Ficino, who conflated Aristotle's notion that all great men are melancholic with the Neoplatonic idea of Saturn, the highest of the planets, which bestowed the noblest faculties of the soul, reason and speculation. According to Ficino, "Saturn seldom denotes ordinary characters and destinies, but rather men who are set apart from the others, divine or animal, joyous or bowed down by the deepest grief."[80]

The many late sixteenth- and early seventeenth-century medical treatises devoted to melancholy and, above all, to melancholic diseases are evidence that the popularization of the temperament also represented a dilution of the complex humanistic concept as Dürer and the Florentine Neoplatonists knew it. Still believed to be seated in the imagination, melancholy was simultaneously feared as the cause of madness and of countless physical diseases and romanticized as the source of genius or "inventive wit." Laurentius recognized three sorts of melancholy. One "altogether grosse and earthie, cold and drie" made people "grosse and slacke in all their actions both of bodie and minde, fearful, sluggish and without understanding." The "hot and burnt" sort caused men "to be outrageous and unfit to be imployed in any charge." Only that which is mixed with blood made men "wittie and causeth them to excell others":

> when this humour groweth hot, by the vapours of the blood, it causeth as it were, a kinde of divine ravishment, commonly called *Enthousiasma*, which stirrith men up to plaie the Philosophers, Poets

and also to prophesie: in such manner, as it may seeme to containe some divine parts.[81]

Unfortunately, the fluid boundaries between these types of melancholy meant that the witty melancholic was especially prone to "accidents" that might thrust madness upon him at any time. Despite this risk, "the melancholike are accounted as most fit to undertaking matters of weightie charge and high attempt."[82] They are most likely to be solitary, introspective thinkers, for, as Huarte put it, "wits full of invention . . . will not follow any beaten path, nor go in companie."[83]

Scholars, humanists, professors, philosophers, poets—anyone engaged in solitary intellectual pursuits—either suffered from or affected "the disease of the age." Not unexpectedly, Leiden, home of a famous university and medical school, produced numerous dissertations on melancholy and a wealth of imagery associated with its scholarly aspects.[84] The Leidener Jan Davidsz. de Heem's *Man Seated at a Table* (Fig. 29), painted in 1628, is a genre-fied version of Dürer's *Melancholia I*: a young scholar, seated in the traditional pensive pose of personifications of melancholy, turns away from the books on his desk. In a similar work by the Amsterdammer Pieter Codde (Fig. 30) the brooding scholar's face is cast in shadow. Rembrandt's *Old Man Asleep by the Fire* of 1629, called "a philosopher" in the eighteenth century, is probably an allegory of melancholy—perhaps stressing *acedia*, idleness or sloth, one of its principal causes—as are some of the other Rembrandtesque representations of scholars in darkened rooms.[85] In the early 1640s, Rembrandt fully captured the dark, gloomy mood of idle melancholy produced by "overmuch study"[86] in his richly tonal etching *A Student at a Table by Candlelight*.[87] And some years later, as Julius Held has convincingly argued, he characterized Aristotle as a somber melancholic deep in thought.[88]

Artists, especially, were thought to be born under Saturn and dominated by melancholy. In the Renaissance a melancholic temperament had come to be regarded as a divine gift necessary for true artistic genius. The theorist Romano Alberti offered this explanation in his treatise of 1585:

> painters become melancholic because, wanting to imitate, they must retain visions fixed in their minds so that later they may reproduce them as they have seen them in reality. And this not only once but continuously, such being their task in life. In this way they keep their minds so abstracted and detached from reality, that in consequence they become melancholic which, Aristotle says, signifies cleverness and talent because, as he maintains, almost all gifted and sagacious persons have been melancholic.[89]

As early as 1519, Raphael was described as "inclining to Melancholy, like all men of such exceptional gifts."[90] Other Renaissance artists, most notably Michelangelo, cultivated—and Vasari exaggerated—the idea of the artistic personality driven by poetic fury, prone to alternating periods of solitary, obsessive work with spells of "creative idleness," and distinguished by extreme

introspection, heightened emotionalism, strange behavior, and eccentric dress. Many seventeenth-century artists—among them Annibale Carracci, Domenichino, Adam Elsheimer, Carlo Dolci, and Borromini—exhibited traits of or were considered to be melancholics.[91]

The Dutch in this period represented artists as melancholics in several ways. In 1629 Cornelis Saftleven portrayed himself according to a variation of de Heem and Codde's pensive young scholars. Shortly thereafter Codde (Fig. 31) also presented himself as a painter sitting idly before his easel in a shabby, sparsely furnished studio, smoking instead of working. Smoking, "dry drunkenness," was believed to cloud the brain and color the body brown, in an artificially induced state of melancholy "fatal to genius."[92] Codde pointedly refers to melancholy by cleverly adapting the scholar's traditional thinking pose to the artist's raised arm holding the clay pipe. In the late 1630s and 1640s Jacob Backer and Ferdinand Bol portrayed themselves in the traditional pose of the melancholy thinker or *pensieroso*, a formula found in the portrait of Michelangelo from Raphael's *School of Athens* and in a self-portrait by Parmigianino, among others.[93] And in Samuel van Hoogstraten's self-portrait of 1644 (Fig. 32) the artist's pensive mood, his shaded face, and the vanitas objects of his contemplation—books, an hourglass, a snuffed-out candle, and a skull—mark him as a melancholic meditating on death.[94]

For insight into these works it is useful to turn to England, just as the Dutch frequently did in the seventeenth century, for it was there that melancholy reached its apogee. Its spirit permeates English poetry and drama of the period. Shakespeare's Hamlet was the archetypal melancholic tragic hero. By the time of Robert Burton's wildly popular *Anatomy of Melancholy*, published in 1621 and continuously revised until 1640, this "epidemical disease" had become the privilege of the fashionable, sensitive, yet malcontent gentleman.[95] Burton's treatise, the culmination of a long tradition, draws on both medical books and the romanticized literary version of the "English malady." Its title page (Fig. 33) is a virtual encyclopedia of the visual conventions for representing the melancholy temperament. Juxtaposed with the pensive philosopher Democritus, seeking solace "under a tree," and the melancholic hypochondriac, we find *Inamorato*, the sad unrequited lover, an emotional, self-absorbed, and alienated young gentleman-poet, with his arms crossed over his body and his hat shading his eyes:

> Down hangs his head, terse and polite,
> Some ditty sure he doth indite.
> His lute and books about him lie,
> As symptoms of his vanity.
> If this do not enough disclose,
> To paint him, take thyself by th' nose.

Thus Burton comments, not without irony, on fashionable melancholy and the vogue for having one's portrait painted as a sensitive melancholic "musing all alone."[96] Some years earlier Isaac Oliver had painted several miniature por-

traits of young noblemen, their fashionable clothing carelessly neglected or their arms crossed, seeking solace in the shade of isolated wooded settings.[97]

An anonymous portrait of John Donne (Fig. 34), the supreme melancholic poet, captures the psychology of melancholy that the allegorical, emblematic miniatures lack. Donne's likeness is a love-portrait, and its Latin inscription, *Illumina tenebras nostras domina*, implores that the darkness dominating him be lighted. He has the accouterments of the melancholic—black garments, collar carelessly open at the neck, and the *Inamorato*'s folded arms and wide-brimmed hat—but he also projects a profound seriousness that elevates love-sickness to poetic genius. Particularly unusual is the way Donne's face is subtly shaded to convey his melancholy.[98]

Rembrandt, I suggest, drew on his period's rich, varied, and widely known vocabulary of melancholy to convey his own artistic temperament. Characteristically he opted not for the most stereotypical imagery, the thinking pose with the head resting on the hand, which his other works indicate he associated primarily with scholarly types. Instead he fashioned himself as an introspective, preoccupied with his inner imagination. In the *Self-Portrait with High, Curly Hair*, the panel in Munich, and the drawing in London (Figs. 18, 23, and 25) his collar is open and his hair is fashionably long and unkempt, marks of a man too distracted for worldly concerns. In others, the *Self-Portrait in a Fur Cap, in an Oval Border* and the somewhat later paintings in Berlin and Glasgow (Figs. 17 and 27; Pl. III) for example, his hat shades his eyes. The most striking and most consistent feature of these images is, indeed, Rembrandt's shadowy countenance. Whether gloomy and brooding or emotional and excitable it suggests his overcast mind. Heightened emotionalism, it should be noted here, was regarded as a melancholic trait of particular importance to artists. In keeping with the current view of melancholy, Franciscus Junius described the painter as "possessed with the love of [Art] . . . by a blind fit of a most violent and irresistible fury," which caused him to "expresse in his workes the inward motions of his most forward minde," and "delight in a violent driving of [his] passions."[99] This glorification of the painter's vulnerability to his emotions, which we saw earlier in Huygens' assessment of Rembrandt, goes hand in hand with the esteem for expression in his early history paintings.

Rembrandt's shaded eyes, like those of Hoogstraten and Pieter Codde's melancholic scholar, seem concealed, unreadable, impenetrable, turned inward, suggesting the "spirit" or soul they mirror. The significance of the shaded brow as a meaningful pictorial device has gone virtually unnoticed. Yet surely Rembrandt's contemporaries would have read it as revealing a spirit oppressed by sadness, discord, or melancholy, which van Mander had likened to a dark, cloudy sky.[100] According to Junius,

> of all parts of the countenance the eyes are most powerfull, being as the soules window; for in them, even when they moove not, either our cheerefulnesse shineth forth, or a cloud of sadnesse overshadoweth them.[101]

As the medical doctor Laurentius explained, melancholics "love darkness" and are

> enemies of the Sunne, and shunne the light, because their spirits and humours are together contrary to the light. The Sunne is bright and warme, the melancholike humour is blacke and colde. They desire solitarieness, because they using to bee busie and earnestly following their imagination, doe feare to bee drawne away by others. . . .[102]

In art, a shaded face had long been a clear indication of a troubled or melancholic mind. Both children of Saturn and melancholics were traditionally swarthy; but in the Renaissance this physiognomic feature had been transformed into a cast shadow, as in the portrait of Michelangelo from Raphael's *School of Athens* and Michelangelo's effigy of Lorenzo de' Medici from the Medici Tomb, both of whom are posed as the *pensieroso*.[103] The shadowy face of Dürer's *Melancholia I* (Fig. 28) expresses a tragic state perpetually caught between light and darkness, between near-godly ecstatic experience and earthly wretchedness, or between a glimpse of true understanding and the knowledge that it is humanly unattainable.[104] Dürer's allegory still served in Rembrandt's time as a metaphor for the artistic imagination, which, despite intellectual power, exists in a twilight, "for [in Dürer's words] there is falsehood in our knowledge, and darkness is so firmly planted in us that even our groping fails."[105]

By shading his face and eyes Rembrandt extracted the essence of the melancholy artist, his imagination or *poëtische geest*. Whether he would have been as captivated as Dürer was by the highly theoretical aspects of the melancholic temperament seems doubtful. Rather, he redefined the ideal of the poetic *pensieroso*, reducing it to its essential element, the introspective mind. His spontaneous, seemingly careless style reinforces this image of inspired mental activity. As crude and unsophisticated as this device may appear in these early self-portraits, it is the same one with which Rembrandt would later achieve similar, though perfected, psychological effects in his paintings of Aristotle and the merchant-poet Jan Six,[106] and in his self-portrait in the Frick Collection (Pl. V). The penetrating inwardness usually associated with Rembrandt's late portraits in fact had surfaced at the very beginning of his career.

Not only was the intellectual climate of Leiden especially conducive to melancholic imagery, but Rembrandt was also in contact with the most notable Dutch melancholic of his time, Constantijn Huygens. In his autobiography Huygens described his temperament as dominated by black bile, and he pondered its causes.[107] In his long autobiographical marriage poem *Daghwerk* (A Day's Work), written around 1630, he complained that his spleen, commonly thought to be the source of black bile, "makes me so often vexed without cause."[108] Huygens also revealed his melancholy in his early pessimistic religious poems with their overriding concern with vanity and the sinfulness of man. Indeed, this may partly account for his powerful fascination with Rem-

31

brandt's *Judas Returning the Thirty Pieces of Silver*, for Judas was thought a tragic melancholic because of his avarice.

Huygens' melancholic tendencies had most likely been stimulated during several visits to England early in his adulthood. In 1618 he had traveled on a kind of "grand tour" in the company of Dudley Carleton and Jacques de Gheyn II to England, where he met John Donne, whom he held in highest regard and whose poems he would later translate. From there he wrote home to his parents of his "melancholie."[109] On his third visit, between 1621 and 1623, he suffered a spiritual crisis, a depression that may have coincided with an unlucky love affair, and again wrote of his tendency toward melancholy.[110] During this same stay, in June 1622, he drew a remarkable self-portrait (Fig. 35) in which he characterizes himself as an intense, thoughtful young man with wild, unkempt hair and deep-set eyes, and which he cast in a mysterious sidelong shadow. His image of himself as melancholic is also projected in the pensive portrait Jan Lievens painted of him in the winter of 1628 (Fig. 36).

It is tempting to speculate that Huygens imparted to Rembrandt some of the ideas and imagery that so impressed him. After all, his unusual interest in the young artist coincided with Rembrandt's first serious venture into self-portraiture. On the other hand, even without direct contact we can consider the two as parallel products of the same cultural climate, the same historical psychology. Like Rembrandt, Huygens devoted his life to self-portrayal, not only in his manuscript *vita* but in his many other strongly autobiographical works as well. Though melancholy was fashionable and often affected, Rembrandt and Huygens seem to have been genuine introspectives. Their enhanced self-awareness and preoccupation with self-portrayal suggests that both fit the age's definition of melancholic.

Such self-interest was regarded with suspicion, an attitude reflected centuries later in Jacob Burckhardt's surprising question: "One may wonder whether this constant examination of his own features with a mirror was good for [Rembrandt]. . . ."[111] And, to be sure, melancholy had its dangers. The witty melancholic was by definition a self-doubter, a solitary thinker or malcontent, and an outsider, subject to extreme shifts from exaltation to despair. His biggest worry was that by some accident or affliction he could slip from genius to madman, from creator to idler, or that he could become totally isolated, outcast, reduced to a beggar. Burton lamented that scholars are so far from being properly rewarded or honored that

> they shall in the end be rejected, contemned, and, which is their greatest misery, driven to their shifts, exposed to want, poverty, and beggary.[112]

Especially the crippled beggar, like Rembrandt's shadowy-faced *Beggar with a Wooden Leg* (Fig. 37) of about 1630, was governed by Saturn and melancholy.[113] But any beggar could be a "Childe of Idleness" or, in Huygens' "Moral Prints," a series of character studies in verse, "an earthly Planet, a Tortoise with no shell; though his house be by him, a homeless snail."[114]

Rembrandt portrayed himself as a beggar, the ultimate outcast, in an etching of 1630 (Fig. 38).[115] He sits, stooped, on a bank beside a road, hirsute and ragged, his garments torn and tattered, his toes poking through his shoes. He extends his hand, begging yet snarling at us, overwhelmed by the miseries of the outcast. A year or two later, he juxtaposed on a single plate a shadowy partial self-portrait with studies of several old beggars (Fig. 39). There is obvious misbiting, and it is generally assumed that the ruined plate was arbitrarily used for unrelated studies.[116] But what better way to admit defeat and confess the fear of failure than to picture oneself among the end results of carelessness and idleness?[117]

With his very earliest self-portraits Rembrandt had appeared on the scene, boldly flying in the face of convention and shocking the public—assuming there was one for these works—to announce his *poëtische geest*, his imagination, as something to be reckoned with. By inventing a vital new imagery of self-absorbed, creative melancholy he claimed for himself the temperament proper to his profession. The almost morbid self-scrutiny that produced these portraits would last throughout his life. As few but Emmens[118] have noted, he would later develop other melancholic traits, reflected in his supposed miserliness and documented financial irresponsibility, his social isolation and unconventionality, his increasing independence, and, above all, his continued preoccupation with self-portraiture. More immediately, as we shall see in the next chapter, he demonstrated his acute self-awareness by fashioning different roles for himself, roles that distanced him from his everyday life.

2

The Self Fashioned

\lessgtr

AROUND 1629 Rembrandt turned from playing parts in his history paintings to fashioning different identities in independent self-portraits. In this crucial year he painted the ambitious *Judas Returning the Thirty Pieces of Silver* and portrayed himself more times than in any comparable period of his career. Appearing in an astonishing variety of guises, he modeled himself as a painter in the *Artist in His Studio* (Fig. 117), as a melancholic in the Amsterdam and Munich panels (Pl. I and Fig. 23), and as a gentleman in the technically experimental *Self-Portrait, Bareheaded* (Fig. 1). Two more formal, even elegant, painted portraits of 1629 depart radically from the rough, unadorned images examined in the previous chapter: in the *Self-Portrait as a Young Man* (Fig. 41) he appeared as a distinguished military officer, and in the self-portrait in Boston (Pl. II) he donned luxurious, old-fashioned costume. Though both have qualities of conventional portraits and project an image through the traditional means of clothing and attributes, they are imaginary self-portraits, not naturalistic records of likeness and social status of the sort he would soon paint on commission.

With these Rembrandt began a practice he would continue throughout his career: as we shall see, he repeatedly romanticized his self-portraits with fanciful costumes and shaped his image by fashioning an extraordinary variety of identities, appearing as beggar, oriental ruler, and Renaissance gentleman, and, later, assuming the guise of St. Paul and the ancient painter Zeuxis. He only rarely portrayed himself as a contemporary gentleman, the self-portrait convention most prevalent at the time.

Eccentricity has served to explain, and explain away, Rembrandt's imaginary self-portraits. And to many of his contemporaries his costumes and guises must have seemed quite out of the ordinary. Filippo Baldinucci found it strange that Rembrandt

> often went to public sales by auction; and here he acquired clothes that were old-fashioned and disused as long as they struck him as bizarre and picturesque, and those . . . he hung on the walls of his studio along with the beautiful curiosities.[1]

But buying old clothes, hats, and armor was not in itself unusual. Judging by Dutch paintings of studio interiors, artists commonly used curiosities as studio

props or collected them, in the fashion of encyclopedic *kunstkamers*, for their intellectual or artistic value. The 1656 inventory of Rembrandt's possessions, made as a consequence of his near bankrupty, confirms that he owned many articles of exotic apparel and armor.[2] Some of his earliest paintings, for example *Christ Driving the Moneychangers from the Temple, David Playing the Harp to Saul*, and the *Musical Allegory*,[3] suggest that in the 1620s he was already using old-fashioned garments, gorgets, plumed caps, chains, and turban-like silk scarves as legitimate studio props.

Rembrandt's use of imaginary costume reflects a widespread interest during the first half of the seventeenth century in the exotic and picturesque, or *schilderachtig*.[4] We tend to think of Dutch painting at this time as descriptive and true to life, as indeed much of it is. However, a simultaneous allegorical and historical current, neglected until recently, was fueled by an attitude that regarded the biblical world and Antiquity as relevant to the present. Particularly in biblical painting, the desire for historical accuracy led to exoticism and fascination with foreign lands and costumes. The past was also romanticized in popular *portraits historiés*, portraits in the guise of biblical, mythological, or historical figures, like Rembrandt's *Self-Portrait as the Apostle Paul* (Pl. VII), and in historicized *tronies*, portrait-like character studies in old-fashioned dress, like his *Bust of a Man in Gorget and Cap* (Fig. 43).[5]

Rembrandt's practice and ambitions as a history painter must have predisposed him to these more embellished, more elevated portraits. However, his early imaginary self-portraits do not fit neatly into the tradition of the *portrait historié*. Nor, for that matter, can the idiosyncratic nature of his role-playing be explained solely by a taste for the archaic and exotic. Rather, it is symptomatic of what has been called "the flexibility of the self" that characterized the transitional personality of the late Renaissance and early Baroque. Stephen Greenblatt refers to "an increased self-consciousness about the fashioning of human identity as a manipulable, artful process."[6] Especially in this climate of rapidly changing social and moral values, power to shape one's identity could produce several selves according to different, possibly conflicting, models. The individual's difficulty in integrating and consolidating his identities, and thus his personality, further heightened introspection and concern with defining the self. One manifestation of this enhanced self-awareness was, of course, an increased incidence of melancholy.

Constantijn Huygens fits this protean personality, playing out his diverse personas: melancholic poet, staunch Calvinist moralist, classically educated humanist, elegant courtier, and diplomat.[7] In his autobiography he fashioned himself a gentleman and a nobleman, exaggerating his noble birth and masking social insecurity. His father, in fact, had not been born to the old nobility of the sword but was of *les gens de robe*, a man of *burgerlijk* birth who rose to rank and power through his service as secretary first to Prince William of Orange and then to the Raad van State. Huygens was educated according to the aristocratic ideal set forth by Castiglione for the courtly gentleman-amateur, but he had to earn his living. It was a great worry when in 1620, his education complete, he still had no job. Only in 1625, at age twenty-eight, with his ap-

pointment as secretary to Frederik Hendrik, did he gain a secure position and become financially independent of his father.[8]

Huygens' embellished self-portrayal parallels Rembrandt's in that he fashioned for himself—in his written work—several images according to several ideals governing his life. However, we should be wary of drawing too close a parallel, for while Huygens lived out his various personas in real life, Rembrandt played out many of his in his imagination. Still, at the root of his self-creation lie profound social, professional, and religious vacillation and mobility.

THE ARTIST-PATRIOT

In 1628 or 1629 Rembrandt began to portray himself wearing armor, usually a gorget, a practice that would continue well into the 1630s. This varied group of self-portraits includes two from Leiden: the *Self-Portrait with a Gorget* (Fig. 40) and the quite formal *Self-Portrait as a Young Man* (Fig. 41). After his move to Amsterdam in 1631, some of the portraits of this kind, such as the *Self-Portrait with Gorget and Helmet* (Fig. 51) and the *Self-Portrait as an Officer* (Fig. 53), become increasingly fanciful; others, like the etched *Self-Portrait with Plumed Cap and Lowered Saber* (Fig. 54) and the *Standard-Bearer* (Fig. 57), stretch the conventional limits of portraiture to the point where even likeness is ambiguous.

Since Rembrandt had no connection with any military organization prior to his commission for *The Nightwatch* of 1642, the armor in his self-portraits amounts to an ideal guise. Armor in portraits traditionally pointed to martial prowess, moral fiber, and triumph over death. In the Netherlands after the revolt against Spain armor acquired patriotic associations and served to declare the sitter's allegiance to the fatherland. Moreover, a wealth of martial imagery in art of the period suggests that fortitude and patriotism became tied to the Dutch artist's concept of his profession. The idea that the Art of Painting must battle its adversaries was already part of established allegorical tradition: as reinterpreted by the Dutch, the painter's role as protector of his craft became fused with his defense of the fatherland. The painter thus declared his professional allegiance to the values of the new republic, independence, freedom, and prosperity.

Historians have been at odds as to whether the Dutch Republic developed a national identity between its *de facto* founding with the Twelve Year Truce of 1609 and the official recognition of its independence at the Treaty of Münster in 1648. Some have maintained that religious division, provincial separatism, and competition between the stadholders and the urban oligarchies, particularly that of Amsterdam, undermined any sense of national patriotism. Simon Schama, however, has recently put these doubts to rest with his compelling reading of the cultural identity that the Dutch devised for themselves following the revolt. To legitimize first their rebellion against Spain and then their very existence as an independent state, the Dutch manufactured a heritage. Hugo Grotius and other historians of the time glorified the Dutch as a freedom-

loving people by likening their rebellion to the exodus of the Israelites (another chosen people) from Egypt and by finding their roots in the Batavians, the ancient inhabitants of Holland who had rebelled against the Romans. These myths of Holland's greatness and heroic ancestry were embodied in paintings and printed allegories. Political prints, medals, and civic decoration also document the invention of a vernacular pictorial language appropriate for allegorizing the mentality of the new state: images of sailors, farmers, sleeping soldiers, the Dutch cow, the Netherlands Maid and Lion, and the *hollandse tuin* (garden of Holland) all proclaim the prosperity, freedom, and nationhood of the Dutch. Abundant martial imagery celebrated the remarkable courage of this extraordinary nation that was still fighting to secure its independence.[9]

Without turning Rembrandt into more of a *homo politicus* than is warranted, we can isolate several instances in which he contributed to Dutch political iconography. His hefty, Rubensian *Bellona* of 1633 (Fig. 52) presumably had political significance in the war-torn Netherlands: she calls to mind the *Nederlands maagd* (Netherlands Maid), the personification of Dutch liberty. The monochrome *De Eendracht van het land* (The Concord of the State)[10] draws on allegorical political prints and may itself have been a study for a print advocating allegiance to the Republic. For the *Nightwatch* Rembrandt transformed a portrait tradition and invented an imagery to evoke the militia company's heroic role in Amsterdam's glorious history. Later he would be commissioned to do a scene from Batavian history, the *Oath of Claudius Civilis*, for Amsterdam's new town hall.[11]

Swelling political and artistic nationalism sheds light on Rembrandt's "failure" to go to Italy as a young man, the only thing for which Huygens criticized him and Lievens. Their excuse—that they had no time, and that "nowadays the best [Italian] paintings are to be found outside Italy . . . in well-chosen collections"[12]—seems lame but was possibly calculated to appeal to Huygens. While artists of the previous generation had routinely completed their training in Italy, painters of Rembrandt's circle were more likely to stay home, for reasons both practical and doctrinal. The decline of the Italian sojourn might be explained by a growing artistic nationalism that diminished the importance of classical models—when used, Philips Angel advised, such borrowings should not be obvious[13]—and emphasized the native Dutch tradition with its aptitude for naturalistic description. Rembrandt's interest in Lucas van Leyden and other northern printmakers reflects precisely this leaning toward his indigenous heritage.

At about the time Huygens was decrying his refusal to go to Italy, Rembrandt painted what was probably his first self-portrait in martial guise, the *Self-Portrait with a Gorget* (Fig. 40) now in Japan, which is monogrammed and can be dated to 1628 or 1629.[14] Along with his steel gorget he wears a silk scarf and beret of the sort that frequently appears in his self-portraits of this period. In its composition and dramatic side-lighting, and the subject's evocatively shaded eyes, the portrait resembles those in Amsterdam and Munich (Pl. I and Fig. 23). Rembrandt's technique is also similar, with its rough brushwork

and use of the butt end of the brush to highlight his curls. As in the Munich panel, he opens his mouth to speak. He assumed this lively stance, appropriate to the military ideal, in three other self-portraits with armor: the lost *Self-Portrait with Gorget, Laughing*, believed to date from about 1630 and known only through an eighteenth-century engraving (Fig. 42), the *Self-Portrait with Gorget and Helmet* (Fig. 51), and the *Self-Portrait as an Officer* (Fig. 53).

The *Self-Portrait with a Gorget* (Fig. 40) is related conceptually to Rembrandt's earliest known painting of a single figure, the *Bust of a Man in Gorget and Cap* (Fig. 43) of 1626 or 1627.[15] Not a portrait *per se*, this *tronie* or head, though often called Rembrandt's brother, is probably an anonymous soldier. Right around 1630 Rembrandt and his circle produced a number of *tronies* of young or old men in historicizing military garb like the so-called portraits of Rembrandt's father by Rembrandt, in the Getty Museum, and by Gerard Dou, in Kassel. Numerous inventoried *tronies* suggest considerable demand for these interesting character types. This category of non-portrait can be compared to the literary portraits then in vogue in England and represented in the Netherlands by Constantijn Huygens' "Moral Prints" of 1622–23, a series of poems sketching different sorts of psychological and professional characters.[16]

We might also think of these romanticized officers as lifelike bust-length translations from print to paint of the tradition of Hendrick Goltzius's *Standard-Bearer* (Fig. 44). That this powerful engraving, which dates from the 1580s, during the revolt, had patriotic overtones is evident from the inscription to Goltzius's *Pike-Bearer* from another series:

> The country's welfare must be defended by the faithful
> Who on every side prove that they are true to the fatherland.[17]

Like the military *tronies*, other martial imagery from the first half of the seventeenth century must have been intended to focus attention on the Dutch struggle for independence. In Gerard Dou's *Allegory of War* from about 1630 (Fig. 45), for example, a soldier stands beside a huge pile of armor and weapons that allude to victory in war and the laying down of arms in peacetime. He, like the bust-length figures, is distinguishable from the real, often foreign, mercenary soldiers shown in guardroom paintings by Jacob Duck and Willem Duyster by his historicized costume and allegorical military attributes. This allegorical imagery suggests that the *tronies* are generalized patriotic exemplars, and that in the *Self-Portrait with a Gorget* Rembrandt cast himself in a similar positive moral role.

His *Self-Portrait as a Young Man* (Fig. 41) of about 1629 is markedly more formal than the panel in Japan (Fig. 40).[18] Though so far as we know it was not commissioned, the painting is a posed and purposeful portrait, not a study as is sometimes claimed.[19] Rembrandt holds his head high, challenging the viewer with his commanding gaze. His dark mantle and shining steel gorget enhance his authority and dignity. Although his hair is seemingly unkempt and uneven, it is actually coifed in a courtly lovelock. In contrast to the self-portraits in Amsterdam, Munich, and Japan (Pl. I; Figs. 23 and 40), the dramatic

lighting and atmospheric darkness have been tempered. Furthermore, the re-
fined, controlled brushwork is unique among Rembrandt's works of this pe-
riod. Layers of paint meticulously built up with delicate, exacting brushstrokes
produce an unusually translucent, firmly modeled finish, which adds to the im-
pression of formality.[20] The portrait can be compared in costume and de-
meanor to a similar one that Jan Lievens painted of Rembrandt in perhaps the
same year (Fig. 46). Bearing out Huygens' assessment of the differences be-
tween the two, Lievens' style is more polished and his figure more physically
imposing, while Rembrandt's self-portrait has greater psychological bravura.[21]

As portrait-like as they seem, the paintings by Rembrandt and Lievens dif-
fer from conventional portraits of real military figures. Since the Renaissance,
armor had been reserved for portraits that commemorated great military
men—rulers, generals, admirals, and the like—as models of heroic virtue.[22]
These portraits, in Vasari's words, awakened love "alla virtu ed alla gloria"[23]
and inspired virtuous behavior in others. In an age when martial proficiency
was essential, the image of the valiant prince, nobleman, or even urban oligarch
was necessarily bound up with fortitude. As personified in Cesare Ripa's *Ico-
nologia* and other emblem literature, Fortitude customarily wears armor.[24] In
the body of courtesy books directed to instilling proper conduct and ethical
values in the nobility, of which Castiglione's *Courtier* is the best known, a great
deal of attention was devoted to fortitude, especially as it is expressed in the
ideal of the Christian Knight and the related concept that life is a battle on
earth—*Militia est vita hominis super terram*.[25] Fortitude, then, was not just
bravery in battle but was spiritual and moral strength and, above all, a com-
mendable attitude toward adversity and death.[26]

In the newly independent Dutch Republic patriotism, a corollary of forti-
tude, had acquired added importance as a virtue in its own right. With govern-
ment in the hands of the urban patriciate and the power of the nobility severely
curtailed, it is no surprise to find that civic virtue and patriotism had replaced
individual valor as the crucial component of fortitude. Though Ripa's 1603
Iconologia had not included a personification of Patriotism, the Dutch edition,
published in 1644 by Dirck Pers, devoted five pages to *Liefde tot het Vaderland*,
Love of the Fatherland, personified by an armored youth.[27]

Countless portraits presented Dutch officers, admirals, and civic guard
companies as exemplars of patriotic fortitude and commemorated their roles
in the liberation of the Netherlands and the defense of her cities. Frans Hals's
paintings of Haarlem officers and Rembrandt's *Nightwatch* glorified the by
then largely ceremonial militia companies for their past valor and continuing
importance as symbols of civic pride and independence.[28] Rembrandt's impres-
sive three-quarter-length portrait of Joris de Caullery (Fig. 47), a lieutenant in
the civic guard in The Hague, is a single-figure counterpart to these group por-
traits.[29] De Caullery stands in a traditional authoritative pose with one hand
on his hip, wearing a leather buffcoat, gorget, scarf, and tooled bandolier; a
large cavalry sword hangs at his side, and he holds a caliver or *roer*, a small
musket. Similarly, Thomas de Keyser's portrait of Loef Vredericx in the Maur-

itshuis commemorated the subject's becoming an ensign of Amsterdam in 1626. Holding the standard of the city, he wears a ceremonial gorget, broad-brimmed hat, ruff, and close-fitting jerkin—the height of fashion in the 1620s. Both works exemplify how armored portrait formulae, developed by Titian and Antonis Mor to glorify rulers of the great absolute states, were adapted to promote the values of the urban oligarchs of the Netherlands.

At this time, another more elite convention of military portraiture was ensconced at the court in The Hague and associated primarily with the painters Jan Anthonisz. van Ravesteyn and Michiel Jansz. van Miereveld. One series of twenty-five portraits of officers from the Eighty Years War by van Ravesteyn and his school, in the Mauritshuis, was probably painted at the order of Prince Maurits.[30] In these grand three-quarter-length images the sitter stands with his helmet on a table beside him, following a format employed for portraits of rulers and generals since the Renaissance and, more recently, in van Dyck's portrait of Frederik Hendrik (Fig. 48). Rembrandt's curious full-length *The Artist in Oriental Costume, with a Poodle at His Feet* (Fig. 50) of 1631 is an imaginary variation on this same commanding portrait convention.[31]

His elegant, and relatively subdued, *Self-Portrait as a Young Man* (Fig. 41) is closer in form and conception to another series of *kleine borststucken*, more modest bust-length portraits, of military leaders from Honselaarsdijk Castle (Fig. 49).[32] The sheer quantity of these pictures indicates that they were in great demand and that a number of artists were employed producing them. Some date from the late 1620s, just when Rembrandt was painting several works for the Stadholder. It is reasonable to speculate that the young artist, perhaps briefly hoping for more permanent employment with Frederik Hendrik, was drawn to this convention by his own social and artistic ambitions.

While the allure of the court may account for the aura and dignity of the *Self-Portrait as a Young Man* (Fig. 41), it does not suffice to explain Rembrandt's adopting the martial guise. Even though he was never in the military, I suggest he shared values with those who were. His imaginary self-portraits in gorgets of the Leiden period, like the popular officer *tronies*, are analogies or allegorical counterparts to grander "real" portraits in armor. As such they gave him a way to affirm his allegiance to the *vaderland*.

In 1631 Rembrandt left Leiden for Amsterdam, where he immediately established himself as a leading portraitist. There, as he began to concentrate on relatively conventional commissioned portraits, his self-portraits became increasingly divorced from reality. During the 1630s, even more than previously, flamboyant costumes and old-fashioned armor take him out of his everyday world. In the frontal, direct *Self-Portrait with Gorget and Helmet* (Fig. 51) of about 1634 he is subsumed in his imaginary role.[33] The ornate plumed helmet, which is similar to the one he used for *Bellona* in 1633 (Fig. 52), enhances his military posture and at the same time further distinguishes this portrait from more conventional ones. Rembrandt's antiquated armor anticipates his use of outmoded costumes in the *Nightwatch*, where historical figures strategically

placed among company members in contemporary garb symbolically allude to the history of the company and its defense of Holland.[34]

A few years later, in about 1636, Rembrandt again presented himself in martial array in the *Self-Portrait as an Officer* (Fig. 53).[35] In addition to the steel gorget and scarf he wears a bandolier and a slashed, plumed beret of the type worn by soldiers and standard-bearers in sixteenth-century prints and in his own history paintings.[36] His momentary active pose—literally it seems he has just turned his head, acknowledging the viewer—reinforces the flamboyance of his costume. As in the self-portraits in Japan and Kassel (Figs. 40 and 51), his parted lips—possibly responding to the challenge, voiced in poems of the day, to paint a "speaking likeness"[37]—create an extroverted presence appropriate to his military bearing. This stunning vitality is characteristic of Rembrandt's work in the mid 1630s, when he related pendant portraits through gesture and unified double-portraits with action. However, here his seemingly spontaneous turn of the head is rooted in an established self-portrait formula, found, for example, in Nicolaes Eliasz.'s self-portrait of 1627 (Fig. 20). Though looking over the shoulder was a practical way for the painter to accommodate both his mirror and his easel, the pose, which is often exaggerated in self-portraits, had also acquired emblematic significance: as an expression of the opposition of mind or spirit and body it symbolized poetic inspiration in Cesare Ripa's personification of *Furor Poeticus*.[38] Consistent with Rembrandt's attitude towards tradition, he transformed an existing type, almost to the point of obscuring it.

Two related works from the mid 1630s, the etched *Self-Portrait with Plumed Cap and Lowered Saber* dated 1634 (Fig. 54) and the painted *Standard-Bearer* (Fig. 57), further strained at the conventional limits of portraiture. Rembrandt etched the *Self-Portrait with Plumed Cap and Lowered Saber* in two states.[39] The first (Fig. 54) shows him in three-quarter length, standing with his right hand on his hip and his left resting on the pommel of a large sword. For the second (Fig. 55) he cut the plate to a bust-length oval format, reworked areas of costume, shaded the background, and added his signature, "Rembrandt f. 1634." In the first state his elegant garb, gorget, neckerchief, and long hair are not unlike his costume in the paintings just described. But his fur-trimmed cape, diagonal chain, and close-fitting fur cap with its upright brush and jeweled brooch, as well as his huge saber, impart an imposing martial exoticism. Far from improving his appearance, Rembrandt added a wart to his nose, shadowed his eyes, and broadened his features and girth, creating an unusual and disquieting barbaric grandeur.

Like some of his other self-portraits, this can be seen as a highly idiosyncratic recasting of a traditional portrait format. The three-quarter or full-length armored portrait, in which the subject stands with one hand on his hip, has a long history. But paintings like Titian's *Charles V* seem far removed from Rembrandt's print. A closer prototype is found in Michael Vosmerus's *Principes Hollandiae et Zelandiae*, a book of full-length pictures of Netherlandish rulers from the medieval counts of Holland to Philip II of Spain, engraved by Philips

Galle and published in Antwerp in 1578.⁴⁰ From the upright jeweled brush on his cap to his downward-pointed sword, Rembrandt's portrait is strikingly similar to the first in Vosmerus's book (Fig. 56), that of Theodoricus Aquitaniae, or Dirk I. Whether he intended to identify with Dirk I is doubtful. More likely his coarse features and brutish appearance call up, in a general way, the fearsome leaders of Holland's past. Since Antiquity the Dutch had been considered strong and rustic. Legend had peopled Batavia, ancient Holland, with giants, and classical authors had described the Dutch as fierce, rustic boors with unsightly faces. Erasmus was the first to transform the ancient Netherlanders' brutishness into a flattering national identity typified by martial prowess and straightforward simplicity:

> Martial . . . says that *Batavam aurem* means an ear which is rustic, untutored, boorish. . . . As a people [the Batavi] were strong fighters, with much experience in the Germanic wars, but also powerful through their wealth. . . . As to that accusation of boorishness which Martial levels against her, and Lucan's charge of savagery, I think that either they have nothing to do with us at all, or both can be turned into praise. For which people has not been uncultured at one time? And when was the Roman people more praiseworthy than when they knew no arts except farming and fighting? If anyone argues that the criticisms levelled at the Batavians long ago, still hold good today, what better tribute could be paid to my dear Holland, than to have it said that she recoils from Martial's pleasantries, which he himself calls vile. . . . If you call that rusticity, we freely admit the impeachment, in company with the virtuous Spartans, the primitive Sabines, the noble Catos. . . . It is a straightforward nature, without treachery or deceit.⁴¹

Not surprisingly, after the revolt, when the Dutch found in the Batavian *natie* the prototype for their own, a spate of scholarly tracts like Grotius's *Liber de Antiquitate Republicae Batavicorum* and dramas like P. C. Hooft's *Bato* glorified the Batavians' valor, love of freedom, and refusal to submit to any absolutist authority.

In the *Standard-Bearer* (Fig. 57), too, Rembrandt modified his appearance, seemingly also in keeping with this legendary Dutch national character, by thickening his features and exaggerating his long moustache. As in the etched *Self-Portrait with Plumed Cap and Lowered Saber* (Fig. 54), his pose, with his right hand on his hip and his left supporting the huge standard, conveys arresting dignity and self-confidence. His stance and his costume—consisting of a gorget, a short full-sleeved jerkin with elaborate closures, a fancy slashed plumed beret, and a short dagger—come from sixteenth-century *landsknecht* imagery. To contemporary Dutchmen this costume signified not merely soldiers, but the ancient Batavians, as evidenced by Otto van Veen's series of twelve paintings illustrating the Batavian revolt, which were purchased by the States General in 1613 (they now hang in the Rijksmuseum).

Rembrandt's *Self-Portrait with Plumed Cap and Lowered Saber* and *Standard-Bearer* suggest that our conception of his self-portraits be redefined to include these genre-like images in which he adopted his guise completely. However much they go beyond the limits of conventional portraiture, they are certainly consistent with his other self-portraits of the 1630s, most of which allude to the past and decidedly separate him from his everyday world. During this decade of striving for grandeur and dramatized splendor in all aspects of his work, Rembrandt felt least bound to convention when portraying himself and members of his family. He painted himself, with Saskia, as the Prodigal Son in the tavern (Fig. 155). His etchings include the regal *Self-Portrait with Raised Saber* of 1634 (Fig. 58) and the *Self-Portrait in a Velvet Cap and Plume* of 1638 (Fig. 59), in which his elaborate clothing is based on sixteenth-century costume. His profile portrait of Saskia in Kassel, begun in 1633 or 1634, exemplifies his revival and transformation of a Renaissance portrait type, the profile view, rarely seen in the seventeenth-century Netherlands. In commissioned portraits he stayed closer to convention but still took liberties with established ways by imparting striking vitality to his sitters.

The image of the artist in martial guise that originated in Rembrandt's studio immediately inspired numerous imitations. Several paintings of Rembrandt in gorgets in Berlin (Fig. 60), Florence (Fig. 61), and (formerly) Vaduz, previously called self-portraits but no longer accepted as autograph, come from his circle.[42] Rembrandt's assistants and pupils, including Isaac Jouderville, Ferdinand Bol, Samuel van Hoogstraten, Carel Fabritius (Fig. 62), and Aert de Gelder, also painted themselves wearing armor.[43] And Jacob Backer presented himself (Fig. 63) looking back over his shoulder in a pose similar to that of Rembrandt's *Self-Portrait as an Officer* (Fig. 53). This proliferation of self-portraits suggests that martial representation held particular significance for Dutch artists.

There exist a few distant precedents for self-portraits in armor, but they seem to have little to do with Rembrandt's. Giorgione's much earlier depiction of himself as the melancholic Old Testament hero David with the head of Goliath (Fig. 64) was a reference to the artist's virtue and fortitude, since David symbolized the invincibility of the spirit.[44] Rembrandt's *Self-Portrait with a Gorget* (Fig. 40) bears some formal resemblance to Giorgione's in pose and gaze; but even if he had this work in mind—perhaps through a copy or Vasari's description—its essential element, the identification with David, appears to have held little meaning for him.

More relevant to our understanding of Rembrandt's martiality are the contemporaneous allegorical studio scenes in which armor, shields, and weapons litter the floor. Gerard Dou painted several of these around 1630,[45] and in Rembrandt's slightly later etching *An Artist Drawing from a Model* (Fig. 121) a shield hangs on the wall. Usually the painter's military attributes are associated with the arms of Minerva, goddess of wisdom and war, who had been adopted as the protector of painters in late sixteenth-century allegories, replacing in popularity their more traditional patron, St. Luke.[46] The identification

of the *schilder* (painter) with Minerva, who was never without her *schild* (shield), even seemed predestined by a pun. More seriously, Minerva embodied the conception of the learned painter.[47] She also stood for his moral fortitude when she defended the Art of Painting from its enemies, Ignorance and Envy, an idea that arose from the allegory of Calumny painted by Apelles. Van Mander alluded to this allegorical tradition when he poetically described a wise woman bearing arms—Minerva—who nourished the painter and assisted his ascent of the Mountain of Virtue to the Temple of Eternal Fame, and when he admonished the painter not to be disturbed by the judgment of the ignorant.[48] Goltzius's *Minerva* (Fig. 65), part of a triptych allegory of painting dated 1611 and 1613, represents the learned, theoretical basis of painting, which she protects from Ignorance, personified by King Midas.

However, I do not think this aspect of Minerva fully explains the abundance of martial imagery in the art of the period, even that of Gerard Dou, who was particularly enamored of abstruse allegories. Rather, the prevalence of images juxtaposing art and war without reference to elevated humanistic concepts suggests that the themes of power and adversity had more immediate significance for the seventeenth-century Dutch artist. Considering the importance of maintaining peace in the war-torn Netherlands, it was to the painters' advantage to assert the brush as mightier than the sword. So they contrasted the peacetime productivity of painting with the destruction of war, or championed their art as celebrating Dutch victory and independence.

Before the truce van Mander, in his brief survey of living Netherlandish painters at the end of the *Schilder-boeck*, complained that "art-destroying, reckless Mars terrifies our country with thundering batteries that make even Time's grey hair stand on end."[49] And he expressed surprise that so many fine artists could continue to paint in such terrible conditions, for art requires peace and prosperity. Several political prints from early in the century convey the idea that the arts will thrive under and strengthen the new Dutch state. Jan Saenredam's *Allegory of the Flourishing State of the United Netherlands Under Prince Maurits* of 1602 includes personifications of the Liberal Arts in its celebration of the fruits of peace and freedom. In a similar allegory engraved by Hendrik Hondius I, and issued in 1603 and 1608 (Fig. 67), a sketching artist sits among other representatives of the arts and sciences.[50]

Later paintings that contrast art and war do not provide the easy access of these text-laden prints and thus require more speculative interpretation. Armor pushed to the side of painters' studios in works by Dou and Bailly, while it evokes the artist's traditional association with Minerva, may also celebrate peace in the aftermath of the revolt. A decorated painter's box from the first half of the century in the Rijksmuseum (Fig. 66) has painted on its lid a pastoral landscape in which the presence of a flute-playing shepherd alludes to poetic inspiration.[51] Two scenes of cavalry skirmishes on its front—in stark contrast to the peaceful, idyllic setting conducive to painting—may have another inspiration, that of history. Given that war in general and the Dutch Revolt in

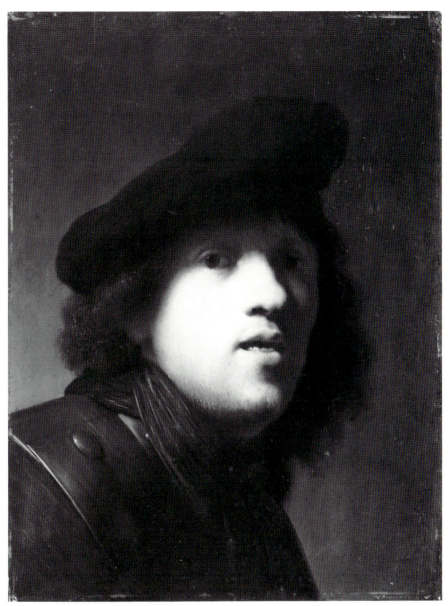

40. *Self-Portrait with a Gorget*. Atami, Japan, MOA Museum of Art.

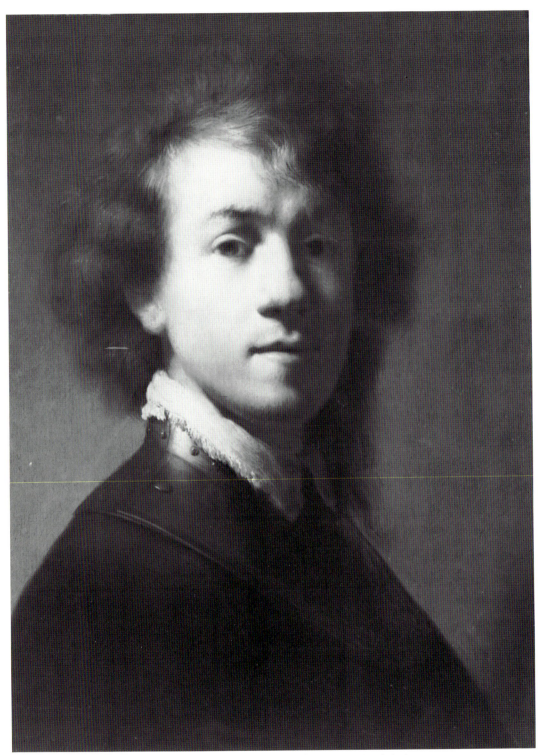

41. *Self-Portrait as a Young Man*. The Hague, Mauritshuis.

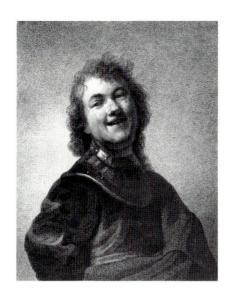

42. Lambertus Antonius Claessens, after Rembrandt, *Self-Portrait with a Gorget, Laughing*. Engraving. Amsterdam, Rijksprentenkabinet.

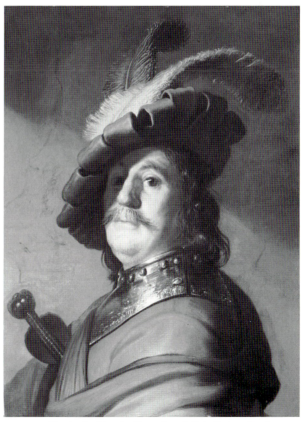

43. *Bust of a Man in Gorget and Cap*. Switzerland, Private Collection.

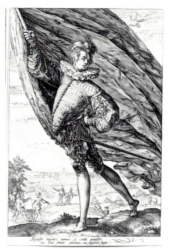

44. Hendrick Goltzius, *The Standard-Bearer*, 1587. Engraving.
Amsterdam, Rijksprentenkabinet.

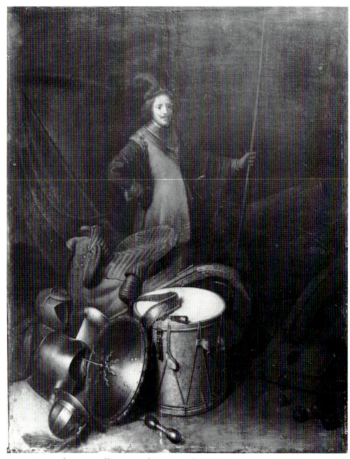

45. Gerard Dou, *Allegory of War*. Budapest, Szépművészeti Múzeum.

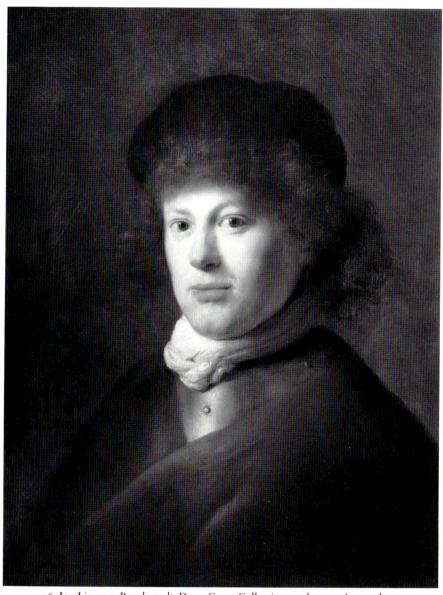

46. Jan Lievens, *Rembrandt*. Daan Cevat Collection, on loan to Amsterdam, Rijksmuseum.

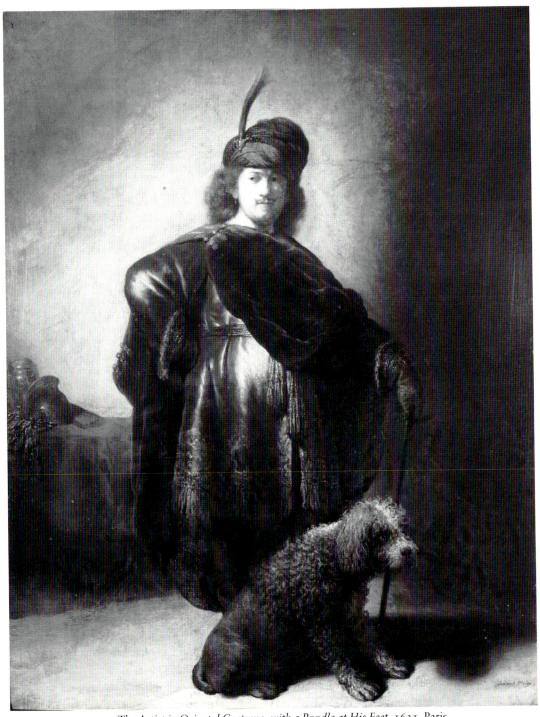

50. *The Artist in Oriental Costume, with a Poodle at His Feet,* 1631. Paris, Ville de Paris, Musée du Petit Palais.

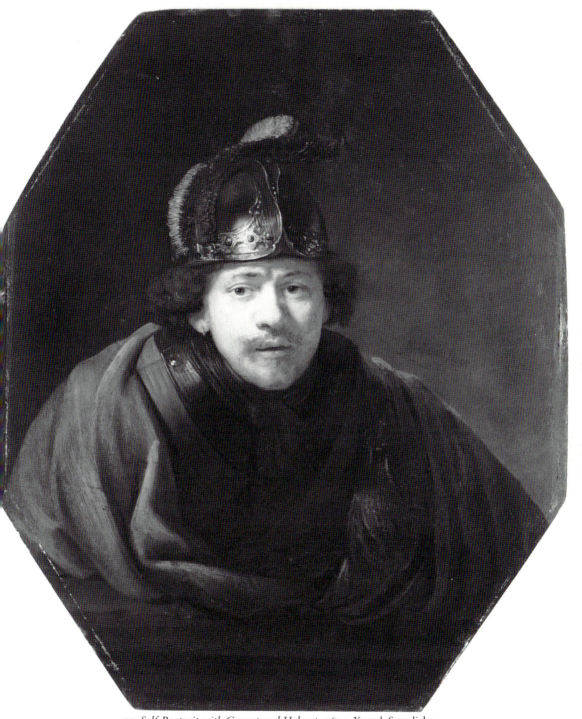

51. *Self-Portrait with Gorget and Helmet*, 1634. Kassel, Staatliche
Kunstsammlungen, Gemäldegalerie Alte Meister.

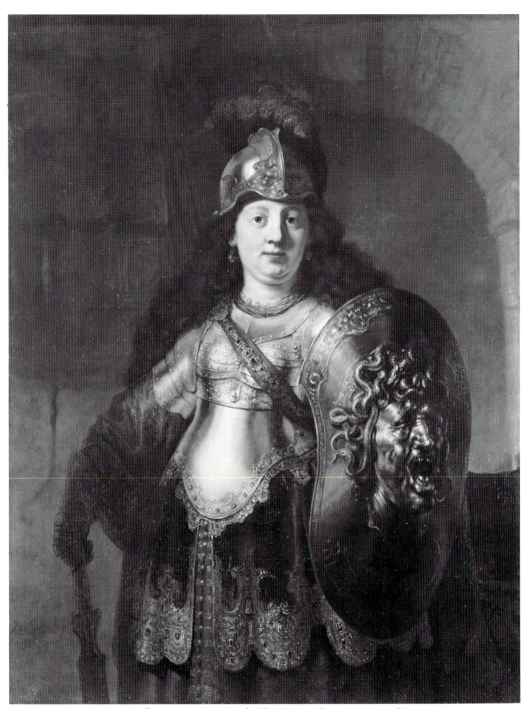

52. *Bellona*, 1633. New York, The Metropolitan Museum of Art.

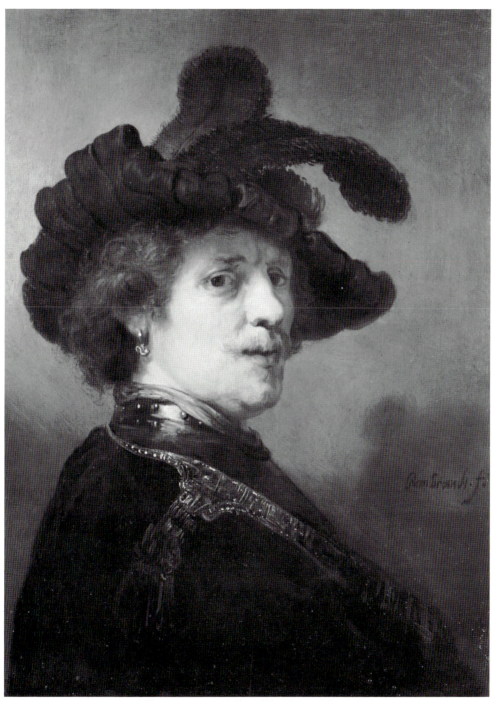

53. *Self-Portrait as an Officer*. The Hague, Mauritshuis.

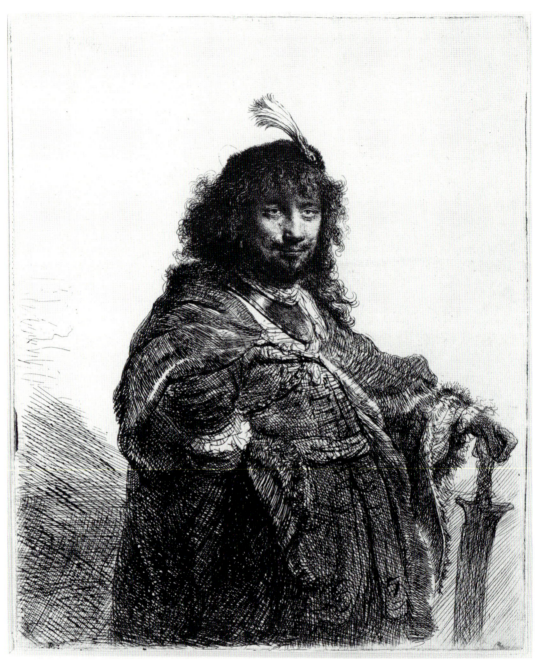

54. *Self-Portrait with Plumed Cap and Lowered Saber*, 1634. Etching, first state.
Amsterdam, Rijksprentenkabinet.

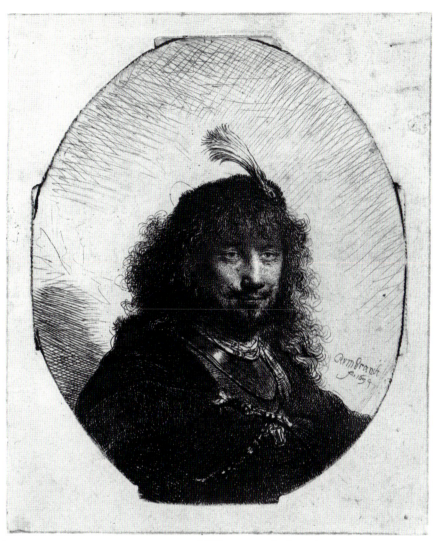

55. *Self-Portrait with Plumed Cap and Lowered Saber*, 1634. Etching, second state. Amsterdam, Rijksprentenkabinet.

56. Philips Galle, *Theodoricus Aquitaniae*. Engraving from Michael Vosmerus, *Principes Hollandiae et Zelandiae*, Antwerp, 1578. The Hague, Koninklijke Bibliotheek.

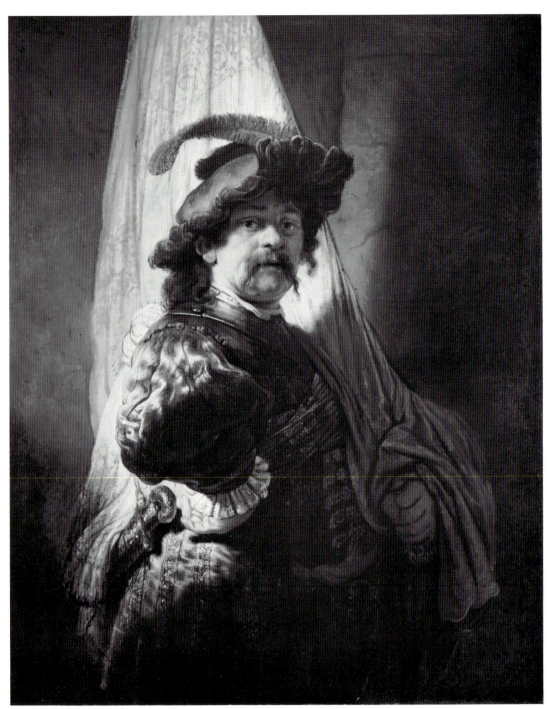

57. *The Standard-Bearer*. Private Collection.

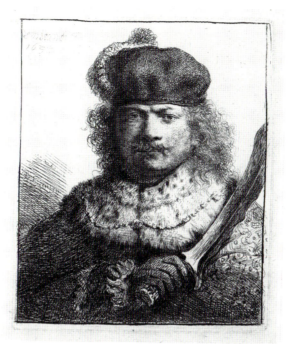

58. *Self-Portrait with Raised Saber*, 1634. Etching.
Amsterdam, Rijksprentenkabinet.

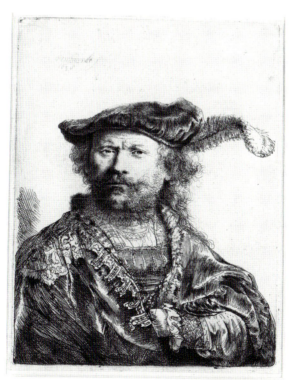

59. *Self-Portrait in a Velvet Cap and Plume*, 1638.
Etching. Amsterdam, Rijksprentenkabinet.

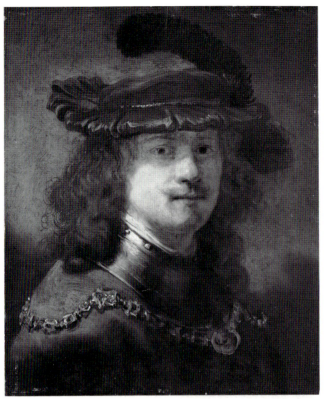

60. Rembrandt Circle, *Rembrandt*.
Berlin, Staatliche Museen Preussischer
Kulturbesitz, Gemäldegalerie.

61. Rembrandt Circle, *Rembrandt*.
Florence, Galleria degli Uffizi.

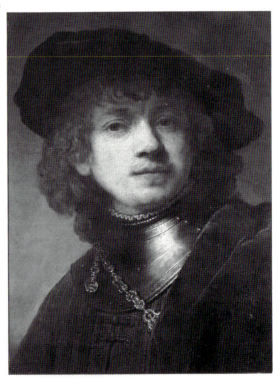

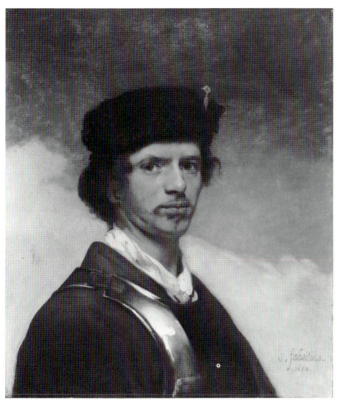

62. Carel Fabritius, *Self-Portrait in Armor*, 1654. London, National Gallery.

63. Jacob Backer, *Self-Portrait in Armor*. Munich, Alte Pinakothek.

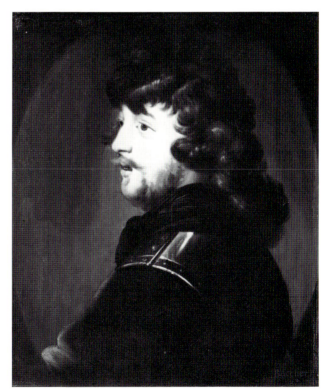

64. Giorgione, *Self-Portrait as David*.
Braunschweig, Herzog Anton Ulrich-Museum.

65. Hendrick Goltzius, *Minerva*. The Hague,
Mauritshuis, on loan to Haarlem, Frans
Halsmuseum.

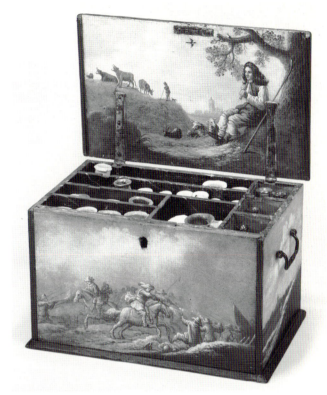

66. Painter's box. Amsterdam,
Rijksmuseum.

67. Hendrik Hondius I, after Hans
Joerdaens, *Nutu Dei, Allegory of the
Fortunate State of the Netherlands*, 1603.
Engraving. Amsterdam,
Rijksprentenkabinet.

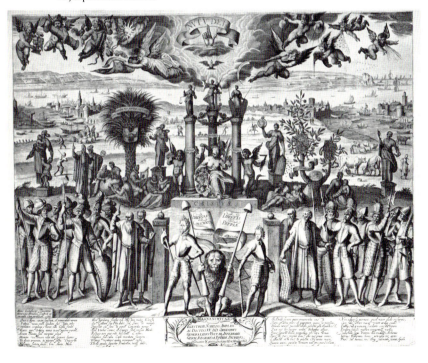

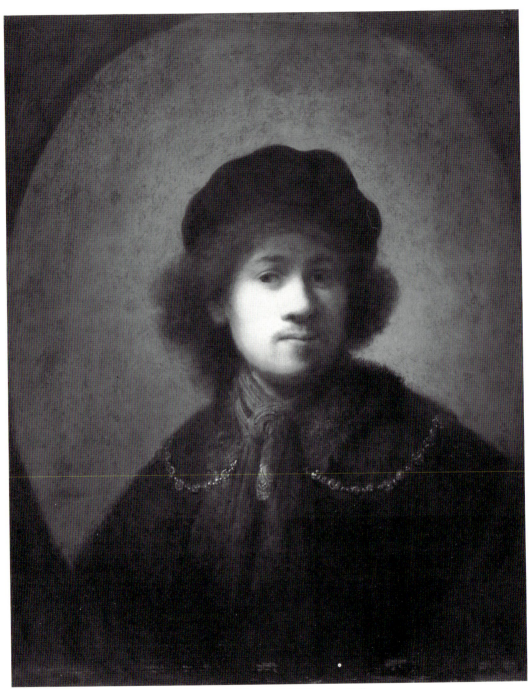

70. *Self-Portrait*. Liverpool, Walker Art Gallery.

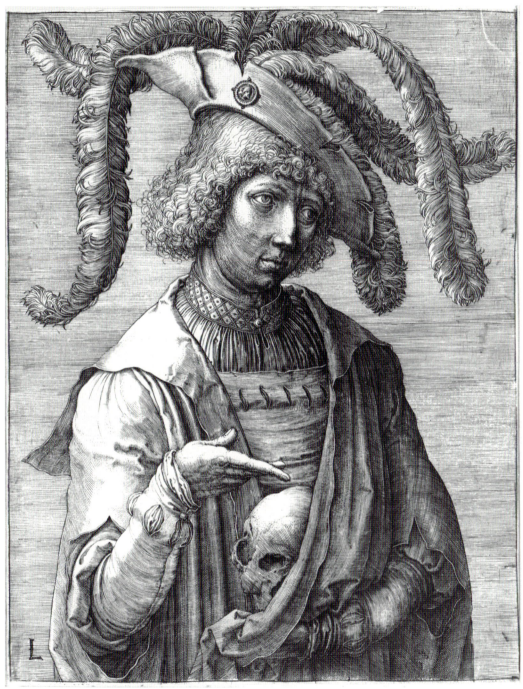

71. Lucas van Leyden, *Young Man with a Skull*, 1519. Engraving. Amsterdam, Rijksprentenkabinet.

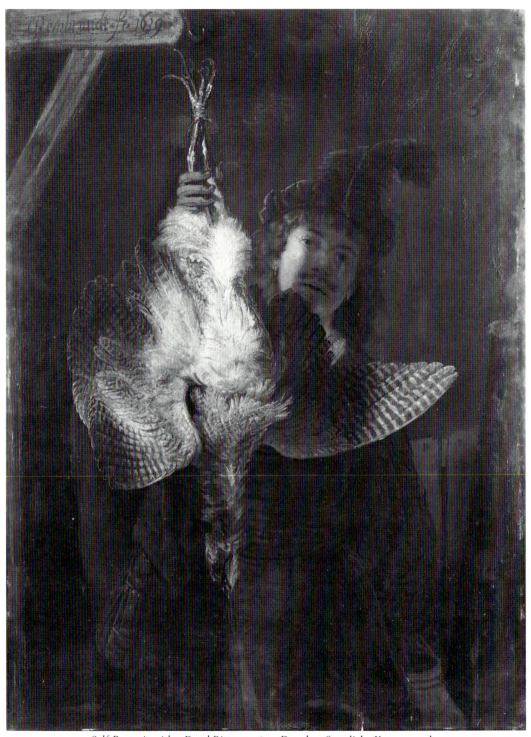

72. *Self-Portrait with a Dead Bittern*, 1639. Dresden, Staatliche Kunstsammlungen, Gemäldegalerie.

73. *Sheet with Two Studies: A Tree and the Upper Part of a Head of the Artist Wearing a Velvet Cap.* Etching. Amsterdam, Rijksprentenkabinet.

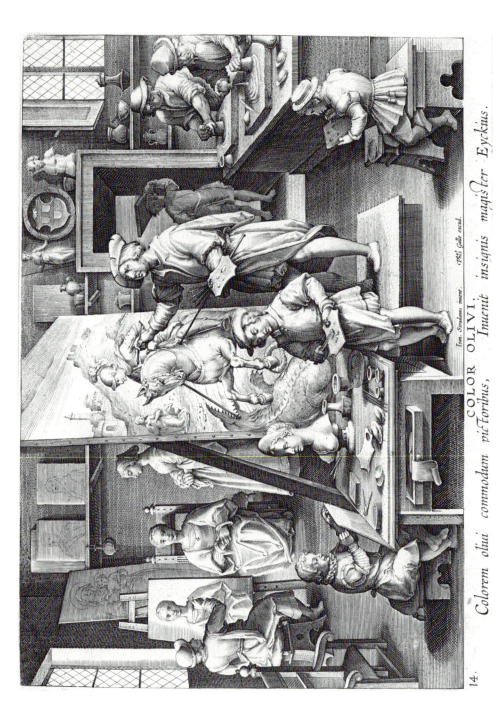

14.

Colorem oluij commodum pictoribus, COLOR OLIVI. *Inuenit insignis magister Eyckius.*

Ioan. Stradanus inuent. *Phls Galle excud.*

74. Theodore Galle, after Stradanus, *Color Olivi.* Engraving from the *Nova Reperta.* Amsterdam, Rijksprentenkabinet.

THEODORO HARLEMIO, PICTORI.

Huc & ades, Theodore, tuam quoque Belgica semper
Laude nihil ficta tollet ad astra manum,
Ipsa tuis rerum genitrice expressa figuris
Te Natura sibi dum timet arte parem.

5

LUCAE LEIDANO PICTORI.

Tu quoque Durero non par, sed proxime, Luca,
Seu tabulas pingis, seu formas sculpis ahenas,
Ectypa reddentes tenui miranda papyro,
Haud minimam in partem (si qua est ea gloria) nostrae
Accede, & tecum natalis Leidae, Camenae.

B iiij

10

75. Bernard van Orley. Engraving from Hieronymus Cock,
Pictorum aliquot celebrium Germaniae Inferioris effigies,
Antwerp, 1572. Amsterdam, Rijksprentenkabinet.

76. Lucas van Leyden. Engraving from Hieronymus Cock,
Pictorum aliquot celebrium Germaniae Inferioris effigies,
Antwerp, 1572. Amsterdam, Rijksprentenkabinet.

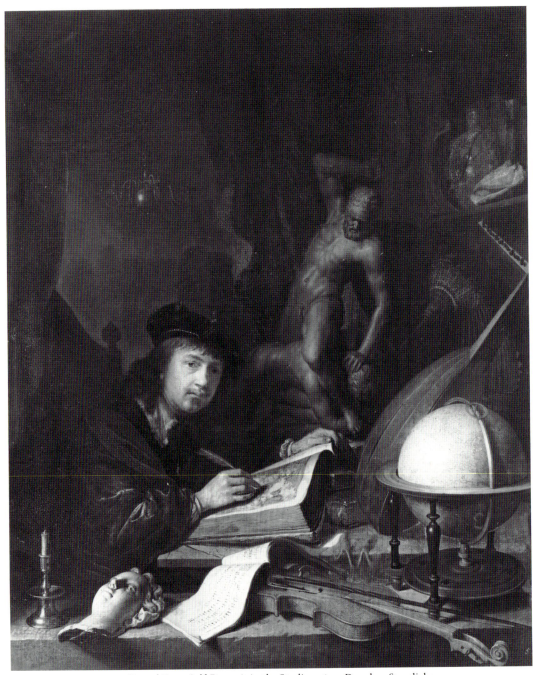

77. Gerard Dou, *Self-Portrait in the Studio*, 1647. Dresden, Staatliche
Kunstsammlungen, Gemäldegalerie.

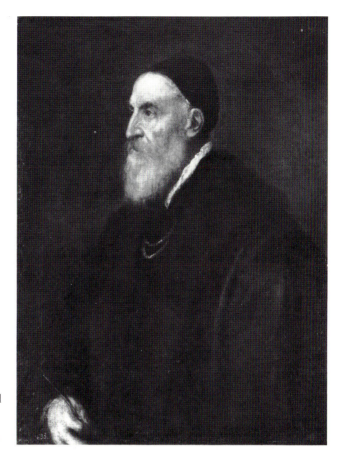

78. Titian, *Self-Portrait*. Madrid, Museo del Prado.

79. Anthony van Dyck, *Self-Portrait with a Sunflower*. The Duke of Westminster.

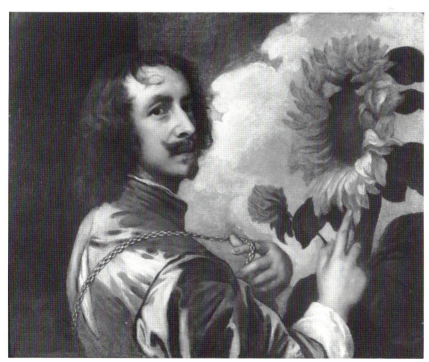

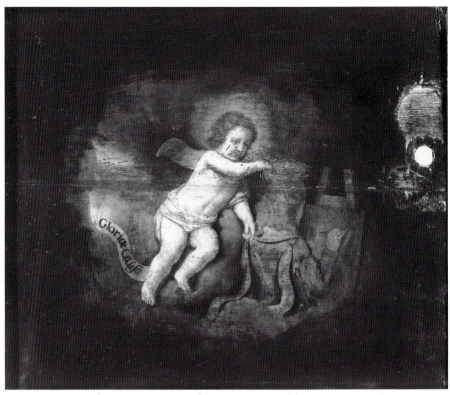

80. Samuel van Hoogstraten, *Gloriae Causa*. Detail from a perspective box.
London, National Gallery.

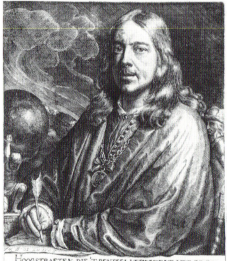

HOOGSTRAETEN, DIE 'T PENSEEL VERWISSELT MET DE PEN,
WIL DAT ZYN VADERLAND HEM DUS NAER 'T LEEVEN KEN,
MIN IN ZYN BEELD, DAN KONST OP LOUTRE REEDENS GRONDEN,
GEROEMT IN CESARS-HOF TE ROOME, EN BINNEN LONDEN.
J. Oudaan.

81. Samuel van Hoogstraten, *Self-Portrait*.
Engraving from his *Inleyding tot de hooge
schoole der schilderkonst*, Rotterdam, 1678. The
Hague, Koninklijke Bibliotheek.

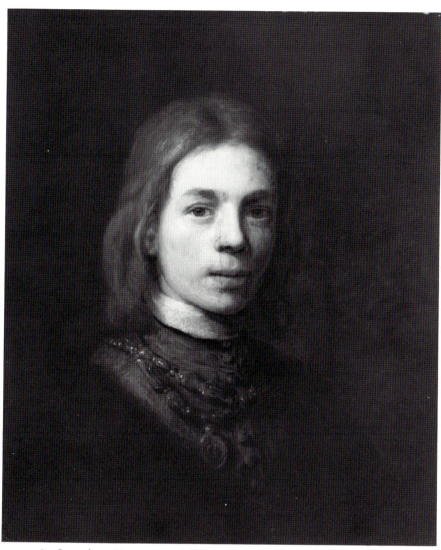

82. Samuel van Hoogstraten, *Self-Portrait with a Chain*, 1645. Vaduz Castle,
Collections of the Prince of Liechtenstein.

83. Ferdinand Bol, *Self-Portrait*, 1646. Dordrecht, Dordrechts Museum.

particular both provided the painter with his subject matter and hindered the practice of his profession, ambiguity is not surprising.

However, the founding of a new republic, whose freedom and prosperity were extolled by artists in everything from history paintings and allegorical prints to militia company portraits and landscapes, had awakened a sense of patriotic purpose in the Dutch artistic consciousness. This would shine forth in the self-portraits included in Rembrandt's *Nightwatch* and some of the other group-portraits for the *Kloveniersdoelen*, through which painters honor themselves for commemorating Amsterdam's civic guard. It was also evident in the Dutch artists' growing appreciation for their indigenous artistic heritage, specifically their tradition of naturalism. And it is reflected in the nationalistic series of artists' portraits published by Cock and Hondius, in van Mander's lives of the Netherlandish painters, and in Philips Angel's *Lof der schilder-konst*, a somewhat chauvinistic praise of Dutch, especially Leiden, painting, given as a St. Luke's Day speech in 1641 and published the following year. Angel's title page (Fig. 68) updates Minerva's traditional association with painting. Pictura, wearing a plumed helmet and Roman armor and supporting an architectural *schilderij* in lieu of her shield, has become Minerva. She is surrounded by a wattle fence, the *hollandse tuin*, or Garden of Holland, which had come to stand for the liberated Netherlands. This unique conflation of allegorical artistic personification and popular national symbol bestows contemporary patriotic significance on Minerva's defense of painting: the armed personification of Painting is identified with the freed Netherlands.[52] In a variety of ways the Dutch painter's competence and freedom to practice his art were likened to the power, prosperity, and independence of the fatherland.

The new and, it seems, indigenous armored persona that Rembrandt created in Leiden (Figs. 40 and 41) may not have alluded explicitly to his profession; yet his invention satisfied the need for, and evolved into, a self-portrait idiom that forged a connection between the proud Dutch painters and their *patria*. Its success is evident in the enthusiasm with which his colleagues adopted it in their self-portraits and transformed it, as Hoogstraten would on the title page to his *Inleyding* (Fig. 69), into the epitome of the ideal painter.

At the same time as he was developing this nativistic image, Rembrandt was exploring other ways of asserting his artistic identity. He envisaged himself according to a much more cosmopolitan ideal of the artist in the self-portraits we examine next.

"REMBRANDTS CONTREFEIJTSEL ANTIJCKS"

The item "Rembrandts contrefeijtsel antijcks" in the 1657 inventory of the collection of the Amsterdam merchant and art dealer Johannes de Renialme is one of only two extant records of self-portraits by Rembrandt from his lifetime.[53] Of moderate value relative to other pictures by him in the estate,[54] it could describe any of the medium-sized self-portraits in which he wears archaic costumes and alludes to portraits of a kind that his contemporaries would have recognized as old-fashioned or *antijcks*. A likely candidate might be one of sev-

eral portraits in which Rembrandt wears a beret and a chain, a group that includes the early portraits in Boston and Liverpool and culminates in the *Self-Portrait at the Age of 34* of 1640 (Pls. II and IV; Fig. 70).

In the first of these elegant, romantic images (Pl. II), almost certainly dated 1629, Rembrandt asserts his sense of his importance.[55] His fancy dress consists of a sumptuous silvery-blue beret adorned with a large ostrich plume and jeweled band, a silk scarf, a mustard-yellow mantle, and a chain of ornate links with a heavy medallion, all rendered with careful attention to detail and texture. Evocative handling of light and shadow is one of the painting's most distinctive features: sharp light strikes Rembrandt's hat, his shoulders, and the right side of his face, leaving his eyes and much of his face in darkness. As in the *Self-Portrait as a Young Man* of about the same date (Fig. 41), Rembrandt's costume, his dignified pose, and his placement on the relatively large panel distinguish this work from the plainer, unadorned portraits in Amsterdam and Munich (Pl. I and Fig. 23), betraying his intent to create a formal portrait.

The other reference to a self-portrait by Rembrandt from his lifetime, in Abraham van der Doort's 1639 catalogue of the collection of Charles I of England, reads as follows:

> Item above my Lo[rd]: Ankroms doore the picture done by Rembrant. being his owne picture & done by himself in a Black capp and furrd habbitt with a litle goulden chaine uppon both his Shouldrs In an Ovall and a square black frame.[56]

This valuable document provides the earliest evidence on the whereabouts of one of Rembrandt's self-portraits. Although the inventory dates from 1639, the inscription on the back of a painting of an old woman by Rembrandt, a gift from Lord Ancram, suggests that the portrait in question was in Charles's collection by 1633.[57] At this time Rembrandt was about twenty-seven and had been in Amsterdam for less than two years. The presence, as early as the 1630s, of at least two of his paintings in one of the most illustrious collections of the age attests to his youthful fame.

Van der Doort saw fit to mention the portrait's most notable features. His description of Rembrandt "in a Black capp and furrd habbitt with a litle goulden chaine uppon both his Shouldrs" leaves little doubt that the bust-length self-portrait now in Liverpool (Fig. 70) is that once owned by Charles I, although its provenance cannot be traced before the early twentieth century.[58] Its measurements correspond to those in van der Doort's catalogue, and the painted oval within a rectangular panel explains the seemingly contradictory "In an Ovall and a square black frame."[59] Furthermore, his description of Rembrandt's clothing fits the Liverpool portrait closely. He wears a "furrd habbitt" or fur-trimmed cloak; the term "capp" aptly describes his soft black beret, whereas Rubens is described as wearing a broad-brimmed "hatt" in the self-portrait Charles commissioned in 1623 (Fig. 93).[60] Also, Rembrandt's "goulden chaine," instead of hanging suspended at the front, is draped literally "uppon both his Shouldrs."

The Liverpool portrait is not signed or dated.[61] It is tempting to surmise that the work was acquired by Lord Ancram when he traveled to the Netherlands in 1629.[62] However, on stylistic grounds the painting is datable to the end of Rembrandt's Leiden years, 1630 or 1631. Perhaps, then, it was commissioned for the king by Lord Ancram when he was in Holland, completed by Rembrandt within the next year or two, and then delivered to Ancram. Conceivably it was a gift from the Stadholder.

However it came into the king's possession, it was a most suitable subject. Charles owned at least twelve self-portraits, a number of which were in adjoining rooms in the palace at Whitehall. Rembrandt's hung in the long gallery along with those by Bronzino, Pordenone, and Giulio Romano, and in the next room were self-portraits by Rubens, van Dyck, and Daniel Mytens.[63] Charles's collection itself reflects a general interest in the artist that began in the sixteenth century with the appearance of artists' biographies and collections of artists' portraits, such as that of Vasari.[64]

Rubens' rather more conventional self-portrait brings out the idiosyncratic character of Rembrandt's Boston and Liverpool paintings, which, because of their romantic, imaginary mode, have sometimes been mistaken for *tronies* or "heads." Such a characterization does not really apply to these rather elegant, albeit unconventional, likenesses. Their dignified poses and formats betray Rembrandt's intent to create formal portraits of himself.[65] Indeed, I would go so far as to propose that here he invented—by, as we shall see, transforming tradition—a new type of embellished self-portrait designed to enhance his professional identity.

The unusual costume, atmospheric handling of paint, and distinctive contrast of light and shadow in these pictures set them apart from more conventional Dutch portraits. Rembrandt does not wear the fashionable *burgerlijk* white ruff and dark jerkin that we find in Joachim Wttewael's self-portrait (Fig. 141) and in most others painted in the Netherlands prior to his time, or in his own self-portrait of 1632 in Glasgow (Pl. III).[66] To the seventeenth-century viewer Rembrandt's cloaks, ornamented berets, and silk scarves would be conspicuous deviations from the norm.

Most extraordinary, however, are the chains around his neck. These were often worn in self-portraits, but most, like that in the portrait Rubens painted for Charles I, were real chains, given to the painter by a noble patron. Rembrandt, however, had not been granted one, nor would he be. His historicized costume and chain, in particular, reflect not his actual circumstances but an appearance that depends heavily on artistic convention. By reinterpreting this self-portrait convention he formulated an ideal of the painter that distinguished him from the typical Dutch artist and removed him from his everyday reality.

The unusual romanticism of the portraits in question seems to have been inspired by a melancholic image of Rembrandt's most illustrious fellow townsman, Lucas van Leyden (Fig. 71). Whether or not it was really a self-portrait, Lucas's engraved *Young Man with a Skull* of about 1519 was considered as such by van Mander and was copied for the series of artists' portraits published

by Hieronymus Cock. It is obviously a moralizing vanitas image: the baleful man points to a skull, a *memento mori* or reminder of death, in jarring contrast to his own youth and worldly, foppish appearance.

Rembrandt's Boston portrait (Pl. II) comes closest to this prototype in its elegant garb, plumed beret, and longer format; even his frizzy hair and somewhat distant expression resemble Lucas's. Whether Rembrandt's portrait retains the print's vanitas content without the skull is questionable.[67] Generally his works evince little interest in the explicit moralizing imagery so popular among his contemporaries.[68] An obvious exception is the poignant *Self-Portrait with a Dead Bittern* (Fig. 72) of 1639. Whatever its reference to the elite sport of hunting, which I suspect was motivated by irony rather than social ambitions, Rembrandt's presentation of the lifeless bird suggests transience and inevitable mortality.[69] And he himself has a shadowy *tristesse* in keeping with melancholic contemplation of death. In the case of the Boston portrait, it might be argued that feathers had vanitas associations, and, indeed, the plumed cap was a common symbol of worldliness.[70] Yet a plumed cap could also signify the painter's imagination or poetic *ingenium*, surely more appropriate in a self-portrait.[71]

My suspicion is that Lucas's print appealed to Rembrandt not for its by then old-fashioned vanitas content, but because it was a self-portrait by a famous Leidener. That it characterized the artist not as a craftsman, as did many self-portraits, but as a sensitive, melancholic personality, elegantly attired in a cap that, to Rembrandt, probably signified his capacity for imagination, strengthened its appeal.

The slightly later Liverpool self-portrait (Fig. 70) seems to confirm that vanitas content was irrelevant to his self-conception. He further reduced any suggestion of worldliness by making his beret smaller and plainer. The resulting image bears little resemblance to vanitas portraits but has a great deal in common with other self-portraits, for both the beret and the chain were by then firmly associated with the archetypal artist.

Throughout his life Rembrandt would continue to don a beret, usually an unadorned black one, for his self-portraits, as in those of 1640 in London (Pl. IV), of 1652 in Vienna (Fig. 123), and of 1658 in the Frick Collection (Pl. V), to name just a few.[72] He also used it to distinguish himself when he included his own portrait in larger history paintings like *The Raising of the Cross* (Fig. 148). Just how central it was to his personality is shown by its being the only article of dress depicted in a drawing from the late 1630s in the National Gallery, Washington. Later, on an etched plate of studies from around 1642 (Fig. 73), he could draw just one eye and his characteristic furrowed brow, leaving his familiar beret as the main clue to his identity. This same partial face appears in *The Nightwatch* to the right of the standard-bearer and just below the keystone of the arch, confirming that Rembrandt, like some of the other artists who painted group portraits for the same militia company headquarters, the *Kloveniersdoelen*, saw fit to include himself.[73] Unlike them, he pointedly as-

48

serted his recognizability by reducing the individuality of his face to a minimum.

Although Rembrandt's self-portraits fixed the image of the beret-sporting painter for posterity, this type of hat had been associated with the artist for some time. Numerous sixteenth-century representations of artists' workshops confirm that the beret was then part of the painter's working attire. For example, Jan van Eyck wears one in the print illustrating his legendary invention of oil paint (Fig. 74) from the series *Nova Reperta* (New Discoveries) by Johannes Stradanus, engraved by Theodore Galle in the 1580s.[74] Painters wear similar, often more elaborate berets in sixteenth-century portraits. By the time the artist had achieved sufficient status to consider himself a worthy subject for an independent portrait, he began to wear the fashionable garb of his courtier and humanist clients.[75] His gentlemanly demeanor and attire reflected a conscious effort to elevate painting to a liberal art by dissociating it from the mechanical crafts.[76]

This ideal is reflected in the portraits of Netherlandish artists, many based on self-portraits, in the *Pictorum aliquot celebrium Germaniae Inferioris effigies*. Cock's series presented artists as learned gentlemen by modeling their portraits after a humanist format, by praising their achievements in Latin verses by Lampsonius, and by clothing them in the fashionable attire of their educated, often noble, patrons. Bernard van Orley (Fig. 75) with his refined glove, Lucas van Leyden (Fig. 76), Joos van Cleve, Peter Bruegel, and the brothers Matthys and Hieronymus Cock all wear berets. Presumably the beret was at first worn simply because it was fashionable, but to some of the later artists portrayed it may have been specifically associated with their profession. Two of Cock's later beret-sporting painters, William Key and Lucas Gassel, hold their brushes, palettes, and mahlsticks. This combination of elegant attire and artist's attributes served to elevate the fine painters above their more mechanical fellow guildsmen—house and sign painters and the like.[77] Rembrandt, as we shall see, kept the image of the painter with his tools or in his studio separate from his formal self-portraits until the late 1640s. Before then, his concept of his profession predisposed him to the virtuoso gentleman-artist type of portrait favored by Rubens and van Dyck.

By Rembrandt's time the beret was no longer in fashion—we do not find it in portraits of people in contemporary dress—and so it carried somewhat different connotations. It remained the painter's characteristic headgear not because it was stylish, but because of its traditional association with his art. That Rembrandt considered the beret appropriate artist's attire is indicated by his several depictions of painters in their workshops, including his *Artist in His Studio* (Fig. 117) of about 1629 and the drawing from the early 1630s of a *Painter at the Easel* (Fig. 119). In his etching *An Artist Drawing from a Model* (Fig. 121) of about 1639, the seated artist wears a more practical white painter's turban, while his plumed beret hangs, perhaps as a prominent emblem of his imagination, from a hook on the wall.[78] Among other artists, Gerard Dou, Rembrandt's first pupil, wears a beret in his allegorical self-portrait as the

learned artist (Fig. 77). In Vermeer's *Art of Painting* (Fig. 142) the painter's elegant black beret and Burgundian garb would have had historical resonance for the seventeenth-century viewer.[79] His model is Clio, muse of history, suggesting that his costume alludes both to the illustrious tradition of painting in the Netherlands and to the histories that were the painter's proper subjects.

Rembrandt's beret not only distinguished him as a painter but also, because of its intellectual connotations, enhanced his virtuoso image. Professors at Leiden University and students, scholars, philosophers, and scholarly saints in works by Rembrandt and his circle from around 1630 wore berets that derived from fifteenth-century "academical bonnets."[80] Through its long association with scholars the beret had come to symbolize genius.[81] It conveyed the learnedness and *pöetische geest* that set the history painter apart from his ordinary counterparts. Worn as part of a historicizing costume the beret expressed what Rembrandt saw to be his vocation as an artist, that of the learned painter who lived and practiced his profession in the light of great masters of the past.

The gold chain he wears around his neck completed this image.[82] During the sixteenth century, the chain became the supreme sign of the artist's, and thus his art's, new elevated status. In a revival of ancient custom—or at least so it was thought[83]—painters were rewarded with gold chains in the manner of humanists, scholars, and poets. Increasingly they displayed these coveted tokens of esteem in self-portraits. In 1533 Titian, court painter to Charles V, was knighted and given a chain, which he proudly wears in his self-portrait in Madrid (Fig. 78).[84] Vasari, who wears in his Uffizi self-portrait the chain he received when knighted by Pius V,[85] scrupulously recorded which artists had received chains. Van Mander, too, informs us of their Northern counterparts, among them Antonis Mor, Hendrick Goltzius, and Bartholomeus Spranger, whose self-portrait engraved by Aegidius Sadeler shows the chain he received when knighted and appointed court painter by Rudolph II.[86]

Throughout the seventeenth century artists continued to receive chains, mostly from noble patrons. Rubens was so honored by Albert and Isabella in 1609 when he accepted their appointment as court painter, by Christian IV of Denmark in about 1620, and by Charles I of England in 1639. He wears a chain in the self-portrait he painted for Charles (Fig. 93), which was engraved by Paulus Pontius in 1630 (Fig. 94), and in an earlier self-portrait in the Uffizi.[87]

To the artist who received or coveted it the chain was an object of considerable consequence. It signified status at court and a mutually beneficial relation between artist and ruler. In return for the sovereign's interest and favor, the court artist was expected to glorify him and his office through his art and by personal devotion. Van Dyck as flatterer to Charles I is embodied in his *Self-Portrait with a Sunflower* (Fig. 79), where his ostentatiously displayed gold chain, given him with his appointment as King's Painter in 1632, together with the flower that always turns to face the sun, expresses his devotion.[88] Although contemporary emblems occasionally used the chain as a metaphor for the courtier's enslavement to a ruler,[89] the evidence overwhelmingly suggests that to

most painters it signified a position of great privilege, the advantages of which far outweighed the disadvantages. Not only did the court artist get substantial financial rewards, but royal service often meant exemption from guild regulations and, hence, freedom from a system that not only closely governed a painter's work but also defined it as a trade rather than an art. Rubens, however, was something of an exception. He demanded unprecedented autonomy as court painter. Writing, in 1609, that he had "little desire to become a courtier again,"[90] he accepted his appointment as painter to Albert and Isabella only on condition that he be allowed to live in Antwerp, not at court in Brussels, and practice his art free from guild regulation. For his late self-portrait in Vienna he abandoned his chain to declare himself a true nobleman.[91]

But the chain did not only signify a painter's rank and achievement. It also had important implications for the status of his profession and a unique theoretical relevance to the art of painting. Since chains were traditionally bestowed for intellectual pursuits, they signaled that painters had risen above craftsmen, that painting had entered the liberal arts. As van Mander makes abundantly clear, what honor or luster a chain brought to the individual it also brought to his art, thereby helping to establish painting as a noble pursuit.[92] As the titles of numerous theoretical treatises—Michelangelo Biondo's *Della nobilissima pittura* (1549), Romano Alberti's *Trattato della nobilità della pittura* (1585), van Mander's *Den grondt der edel vry schilder-const* (1604)—suggest, to establish painting's nobility was no small matter.

These gold chains carried, in addition, a wealth of emblematic associations of singular relevance to the painter. That emblem books and art treatises are indispensable sources for bringing these associations to light does not mean that they existed only on an esoteric, literary level. Not only were emblem books popular and widely read in the seventeenth century, but much of their content merely codified preexisting symbolic values. Nevertheless, these erudite allusions would constitute the most sophisticated readings of these self-portraits. While not accessible to every viewer, such symbolic concepts would be appreciated by the educated connoisseur or artist.

Pictura, the personification of the Art of Painting, wore a chain. Ripa described her as a "Beautiful woman . . . with a chain of gold around her neck, from which hangs a mask, having written on the front 'imitation.' "[93] Because its reflective properties are so difficult to represent, the ability to depict gold in paint was widely regarded as the supreme test of a painter's skill, which perhaps explains the glowing aura surrounding the few visible links of the chain in Rubens' Windsor self-portrait (Fig. 93). As an image of universal concatenation and continuity stemming from the "golden chain of Homer" *Pictura*'s chain also signified, according to Ripa, the tradition inherited by the painter from his master, an idea that assumes particular relevance in self-portraiture.[94]

The chain was also an attribute of honor.[95] Conferred as a mark of distinction, it connoted the recipient's noble character, exalted position, and good reputation—in sum, his honor. During this period much was written about the ideal of honor and the standards of social conduct and ethical values it implied.

Initially it was a courtly concern, as we know from the many courtesy books that guided aristocratic behavior. By the mid-sixteenth century the concept of honor had been incorporated into the literature on art. In Dutch art theory honor was considered the highest goal toward which a painter strives. As such it concerned both the painter's conduct and the definition of the purpose of his art.

To van Mander the gold chain was not only a sign of recognition but a symbol of honor, or *eer*, which he defined in his life of Antonis Mor as the artist's greatest incentive:

> Usually a man is moved to learn and practice art for two reasons, namely honor and profit. Whenever a courageous youth feels himself endowed by nature with talent, and sees the example of an excellent artist who has attained high honors and is held in high esteem by great people, he is spurred on by a burning desire to imitate such an example and to equal such an excellent man.[96]

Seen in this light, Hendrick Goltzius's motto *Eer boven golt* (Honor Above Gold) becomes, rather than just a clever play on the artist's name, a witty personalization of an oft-repeated slogan about the goals of art.[97]

Virtue was an essential ingredient of honor. Van Mander wrote that the true painter wins the favor of God and man by being virtuous and honorable.[98] In the first chapter of *Den grondt der edel vry schilder-const* he devotes considerable attention to the moral development of the young student, reflecting his humanist background and concern with the status of the art of painting. He uses the image of the Mountain of Virtue, surmounted by the Temple of Fame, as a metaphor for the artist's striving after perfection: the path to the Temple of Fame, like the Temple of Honor accessible only by way of Virtue, symbolizes the painter's lifelong struggle. Van Mander thus argues against the notion that the greatest artists are the greatest rogues, saying that those who lead unruly lives are not worthy of the name of artist. He admonishes the student to avoid vice and the life of the senses, warning that Cupid, by courting lust, aims only to hinder the painter's rise to virtue. The painter's life is ideally a quest for honor, the reward of virtue and the key to immortality.

Philips Angel also enlisted honor and virtue to promote the painter's professional identity. Almost half of his *Lof der schilder-konst* is concerned with the painter's personal behavior and artistic attitudes. Drawing on van Mander, Angel enumerates the "virtues" needed to gain the eternal *eere-kroon* (crown of honor).[99] Some of these criteria, such as good judgment, a steady drawing hand, and the mind to make unforced compositions, are inborn talents. Others are acquired skills, like the abilities to render light and shadow and represent textures. Still others, such as an understanding of mathematics, perspective, and anatomy, and a knowledge of the histories, derive from a good education. This knowledge of science and, especially, of history separates the history painter, who is worthy of honor, from the portraitist, who is rewarded with wealth. Angel devotes the last few pages of his text to the moral virtues neces-

sary in an ideal painter, which he discusses in learned terms and attributes to renowned painters of Antiquity and the Renaissance. Finally, he counsels the painter, if you wish to be honored and triumph over death, be virtuous by nature and avoid the pleasures of the senses.[100]

Later, Samuel van Hoogstraten codified these earlier authors' ideas about the painter's goals in book nine, "Urania," of his *Inleyding tot de hooge schoole der schilderkonst*. The "fruits an artist can expect to gain from his work" are, first, love of art, which is the source of the second, profit and wealth, and the third and most important, honor and glory.[101] Each of the artist's incentives— *Amoris Causa*, *Lucri Causa*, and *Gloriae Causa*—is personified by a putto in the title print to the ninth book and more fully illustrated on the exterior panels of his perspective box in the National Gallery, London. There *Amoris Causa*, love of art, shows an artist drawing a picture of Urania, muse of astronomy. *Lucri Causa*, profit, the least noble incentive, is symbolized by an artist painting a portrait and a putto emptying a bag of coins.[102]

Gloriae Causa (Fig. 80), honor, is represented by an artist at an easel, who is being crowned with a laurel wreath and decorated with a gold chain by a putto. This use of the chain as an attribute of the honored painter is probably the clearest pictorial expression of its symbolic meaning. Of the two rewards of the painter's love of art, profit and honor, Hoogstraten regards the latter as the more worthy because it concerns the painter's moral and spiritual well-being and it "verquickt den geest" (stirs the imagination). As we see from the self-portrait in his book (Fig. 81), he took great pride in his own chain, received from Ferdinand III, which he called, "To be sure, a generosity that gives more incentive than satisfaction."[103] Hoogstraten, like van Mander, regarded the honors bestowed upon the painter as evidence of the nobility of the art of painting and of the virtue of its practitioners. Moreover, it was honor that incited the painter to greatness.

But what are we to make of the fact that, although Rembrandt never received a chain, he often wears one in his self-portraits? Surely this fiction was motivated by his understanding of how the chain operated in earlier portraits of artists. Even when still in Leiden he must have been familiar with this tradition through either firsthand or indirect knowledge of artists' biographies and portrait prints. What was a coveted token of esteem for other artists had become for Rembrandt a symbolic object. It represented an abstract ideal. Precisely because the chain was firmly established in the language of self-portraiture, he could portray himself wearing it, thereby likening himself to his illustrious predecessors. Presumably his pupils Samuel van Hoogstraten and Ferdinand Bol understood the significance of his invention, for they soon imitated his practice of donning fictitious chains (Figs. 82 and 83).[104]

Unfortunately, we cannot be certain that Rembrandt painted the Liverpool self-portrait (Fig. 70) knowing it was destined for Charles I. But if he had, deliciously ironic is the idea of Rembrandt granting himself a fictitious chain and presenting himself as "the true painter . . . esteemed by rulers and scholars." It would have been both fitting and brazen to model his image after that

of the courtier-artist best exemplified by Rubens' portrait in Charles's collection (Fig. 93). For at the same time that Rembrandt seemed to embrace the courtly ideal he boldly defied it by claiming its honors, with scant attention to— or, more likely, willful disregard for—the court artist's subservience to his patron.

To regard the Liverpool self-portrait and others solely as attempts to bestow upon himself the prizes other painters had actually received is to credit Rembrandt with a more clumsy quest for worldly status than is warranted. Court life must have been quite alien to the young Leidener, despite the attention of Huygens and the aspirations it may have stirred in him. Rembrandt's chain, like a drawing of an elephant by someone who has never seen one, is curiously not quite right, too ostentatiously draped, more like the ornate *schutsketen* granted annually to the "kings" of Dutch militia companies than the chains of plain links customarily given to painters.[105]

This is not to suggest that Rembrandt's self-portraits mock the courtly ideal. On the contrary, they transform the old ideal of social status and privilege into a professional ideal of artistic honor. By conflating and reinterpreting two pictorial traditions, the beret-sporting artist and the courtly self-portrait with chain, Rembrandt created a new image of the honored but independent virtuoso artist.

We have already seen how Rembrandt, after leaving Leiden in 1631, recast the traditional portrait in armor and transcended its noble origins to fashion a guise that connoted his own artistic prowess and freedom. How his virtuoso persona evolved in Amsterdam remains to be seen. But first we must consider the implications of his moving to Amsterdam. That decision had immeasurable consequences for his professional identity and was in itself a crucial aspect of his self-creation.

3

The Virtuoso
Ideal Transformed

D URING Rembrandt's first decade in Amsterdam, between 1631 and 1640, a dominant portrait style emerged from the self-fashioning of the Leiden years. To be sure, he continued to portray himself in a staggering array of increasingly imaginary roles and guises, as in his self-portrait as the Prodigal Son (Fig. 155) and the martial images considered in the previous chapter. Yet his formal self-portraits most consistently concern the ideal of the virtuoso artist. First, as if to commemorate his newfound success as a portraitist and to project his *burgerlijk* social status, he twice portrayed himself as a gentleman, much as he did his paying clients (Fig. 88 and Pl. III). But he soon discarded this naturalistic mode for an imaginary one that was better suited to conveying his professional identity. He did not use this mode for portraits of others. In the self-portraits of this type, which originated in that owned by Charles I (Fig. 70) and would culminate in the *Self-Portrait at the Age of 34* (Pl. IV) of 1640, Rembrandt conceptualized his professional identity by alluding to theoretical ideas of the learned virtuoso painter and emulating artists who embodied that ideal. In contrast to the Leiden period, when he drew on self-portraits by his fellow townsmen Lucas van Leyden and Jan Lievens, in Amsterdam his horizons extended and he found the greatest challenge in artistic models from farther afield: Rubens, Raphael, and Titian.

Moving to Amsterdam must have stimulated Rembrandt to define and establish his professional identity, a process that we can observe throughout his self-portraits but which assumes particular intensity in the 1630s. Weintraub has argued that autobiography is richest in periods of historical and personal crisis and change, which force upon the individual "the task of doubting and reinvestigating the very foundations upon which his self-conception had traditionally rested."[1] Amsterdam represented a tremendous change for the young Rembrandt, calling into question some fundamental assumptions underlying his training in Leiden and drawing attention to the discrepancy between the ideals of a history painter schooled in the humanist tradition and the reality of portrait painting in the *burgerlijk* Netherlands. Furthermore, even Amsterdam, despite its artistic vitality and promise of great opportunity, still could not provide clear avenues for an ambitious painter seeking to claim his place in artistic

tradition. For that he had to look beyond his immediate milieu to a grander, nobler ideal. How Rembrandt positioned himself in relation to, and in the process transformed, the virtuoso ideal is the subject of what follows.

A *BURGERLIJK* AMSTERDAMMER

Bustling international Amsterdam, with a rapidly growing population of nearly 100,000 and well on its way to becoming, briefly, the economic capital of Europe, presented quite a contrast to the smaller, quieter university town of Leiden.[2] For the young Rembrandt it must have been a heady experience. Virtually immediately, it afforded him the opportunity to do portraits of some of the city's most prominent citizens, notably the physician Nicolaes Tulp and his colleagues. It also offered something more difficult to quantify, the tremendous visual and intellectual stimulation of a large, exciting city. In his drawings especially, Rembrandt captured the range of urban humanity, from beggars to visiting orientals with their strange ways and exotic costumes. He recorded all entertainments from theater performers to a curious elephant and fierce lions. Surely part of Amsterdam's appeal lay in the wealth of visual material—paintings and other art objects from all over Europe, readily accessible in large private collections, with important dealers, or at auctions—for the artist to study or even buy.

Rembrandt had left Leiden probably in late 1631, at the age of twenty-five, presumably in search of more lucrative commissions and a more stimulating environment, for which he had perhaps developed a taste when studying with Lastman. According to his biographer Jan Orlers,

> because his art and work had greatly pleased and impressed the burghers and residents of Amsterdam, and because he received frequent portrait commissions, as well as requests for other pictures, he decided to move from Leiden to Amsterdam.[3]

He arrived with a reputation and work awaiting him in the picture business of the painter and art dealer Hendrick Uylenburgh, his success virtually guaranteed.

We do not know the exact details of the relation between Rembrandt and Uylenburgh, who had immigrated from Poland in the mid 1620s. The two probably met in March 1628, when Uylenburgh visited Leiden.[4] Rembrandt's initial sales in Amsterdam may have come about through this encounter. The first recorded purchase of one of his paintings, "een tronitgen van Rembrant," was made on 15 June 1628 by the Amsterdam regent Joan Huydecoper, who lived across the street from Uylenburgh.[5] If (as Orlers reports) Rembrandt had received portrait commissions from Amsterdam before leaving Leiden, no such works have been positively identified. But they probably were arranged through Uylenburgh, who can be connected, on the basis of shared membership in the small but influential Mennonite community, to two of Rembrandt's first Amsterdam patrons, the merchants Nicolaes Ruts, whose portrait of 1631 is in the Frick Collection (Fig. 84), and Marten Looten, whose portrait, dated 17 January 1632, is in the Los Angeles County Museum of Art.[6]

In June 1631 Rembrandt, still a "resident of Leiden," had lent Uylenburgh 1,000 guilders,[7] and by July of the following year he was lodging in Uylenburgh's house on the Breestraat,[8] suggesting that the two had entered into some sort of mutually advantageous business arrangement. Why Rembrandt, already an independent master in Leiden, joined Uylenburgh's workshop rather than immediately setting up on his own, is perhaps explained in part by the protectionist regulations of the Guild of St. Luke. Because the records of the Amsterdam guild are gone, we can only speculate about working conditions there on the basis of practices in other towns. Most likely the guild ordinances prohibited artists from outside the city from joining the guild and establishing themselves as independent masters until becoming citizens. They would not, however, prevent foreigners from being employed by local masters as studio assistants, completing their training by painting works—which they were not permitted to sign—in the manner of the master. Nor, it seems, would the ordinances prevent arrangements such as that which probably existed between Rembrandt and Uylenburgh, in which a master from another town went to work for a guild member, producing works in his own style and under his own name but still to be sold by his employer. Indeed, a period of contractual obligation may have been required before a foreigner could become a master, as was the case in The Hague. That Rembrandt did join the Amsterdam guild in 1634, after two years in Uylenburgh's shop, lends support to the idea that his employment there was a necessary step to becoming an independent master.[9]

Presumably his stay with Uylenburgh had other advantages. In the few years after 1632, what Baldinucci called "la famosa Accademia de Eeulemborg"[10] grew into an art enterprise on a scale unequaled in Amsterdam. Uylenburgh continued to import and deal in old paintings, but now he also sold new ones by Rembrandt and his assistants as well as copies the assistants made after paintings in his collection. In addition he published etchings, including Rembrandt's *Descent from the Cross* (Fig. 150). Rembrandt not only was the leading painter in the business, producing numerous commissioned portraits, but probably also trained apprentices in the traditional fashion.[11]

In 1634, he married Uylenburgh's young cousin Saskia, and the couple continued to live on in his house until the next year when, perhaps because Saskia was expecting their first child, they rented a home of their own on the Nieuwe Doelenstraat. It is commonly thought that Rembrandt married above his social status. But his artistic success and privileged position in Saskia's cousin's business suggest instead that it was she who married not only appropriately but well. It is true that she came from an important family in Friesland and that her father, Rombertus Uylenburgh, had been burgomaster of Leeuwarden. Both her parents, however, had died by 1624, leaving her an orphan with an inheritance the value of which has been exaggerated. Since then she had been dependent on her several married sisters and other relatives, becoming in 1628 the legal ward of her brother-in-law Gerrit van Loo in Het Bildt, and being sent in 1633, the year of her engagement to Rembrandt, to Frankener to nurse her sister Antje and then keep house for Antje's widower Johannes

Maccovius, professor of theology and rector of the university.[12] Given these circumstances, to the orphan from provincial Friesland marriage to the most successful portrait painter in Amsterdam must have seemed highly promising. For his part, while Rembrandt may have hoped for a more substantial dowry he must have known that Saskia had to share her inheritance with seven sisters. Most likely he married her primarily out of genuine love and affection. His first portrait of Saskia, wearing a romantically pastoral broad-brimmed straw hat and holding a flower (Fig. 85), is, like subsequent ones, an intimate act of devotion. It was drawn, in the precious medium of silverpoint on vellum, to record their engagement: "This is drawn after my wife, when she was twenty-one years old, the third day after we were betrothed—8 June 1633."

Rembrandt found immediate success and, presumably, happiness in Amsterdam. However, in two important respects his practice there contradicts, or at least was not at all anticipated by, his education and previous experience. In Leiden he had attended the Latin School and had specialized primarily in the most noble art of history painting. In Uylenburgh's "academy" he made his name as a portraitist, a genre widely disparaged as a profitable but inferior "side road of art," too firmly grounded in reality and leaving no room for the painter's imagination.[13] Moreover, the Rembrandt who just prior to his move had been praised by Huygens and patronized by Frederik Hendrik, and whose self-portrait (Fig. 70) was perhaps already in the collection of Charles I, might have seemed destined for a career at court, like Rubens, van Dyck, Honthorst, or (briefly) Lievens. Yet there he was in Amsterdam, employed in a business that, though superficially resembling Rubens' studio in Antwerp, was in fact more like the economic enterprises of the wealthy merchants who sat to him for their portraits.

It was probably ambition, not lack of prospects elsewhere, that brought Rembrandt to Amsterdam late in 1631.[14] By then he had already done several works for the Stadholder, including a *Presentation in the Temple*, a *Minerva*, and the *Abduction of Proserpina*, and within the next few years he would be commissioned to do part of a major series of Passion paintings.[15] Moreover, in 1632 he seems to have spent time in The Hague, painting portraits of the Stadholder's wife, Amalia von Solms, of the militia officer Joris de Caullery (Fig. 47) and his son, and of the friends Maurits Huygens and Jacques de Gheyn (Fig. 86).[16] In contrast to Leiden and The Hague, Amsterdam, with entrée through Uylenburgh, must have seemed an exciting, though possibly risky, challenge. It offered potentially greater opportunity in the form of wealthier, more varied, and more numerous clients from the expanding merchant class in whose hands Dutch economic and political power rested. Amsterdam also promised, eventually, greater independence and the prospect of building his own career free of courtly obligations. So he moved there prepared, at least temporarily, to relinquish his training as a history painter and turn out portraits. It seems he had little time for much else during the next few years.

As if to create the right aura for a sought-after portraitist, Rembrandt depicted himself just as he might wealthy Amsterdam merchants and regents on

commission. After the imaginative, romanticized portraits of the Leiden days, his etched *Self-Portrait in a Soft Hat and Embroidered Cloak* of 1631 (Figs. 87–90) and the oval *Self-Portrait as a Burgher* of 1632 (Pl. III) come as a surprise. Indeed, they stand out from the entire corpus of his self-portraits as the only ones in which he wears contemporary formal dress and (in the case of Pl. III) adopts a popular, conventional portrait format.

Yet the *burgerlijk* appearance of these innovative images is somewhat deceptive, for in designing them Rembrandt appropriated cosmopolitan portrait formulae from Rubens and van Dyck. As a result these portraits allied him as much with the esteemed Flemish masters as with his Amsterdam sitters, if not more. At the same time as they celebrated his newfound success as a portraitist, they expressed his lofty artistic ideals.

The *Self-Portrait in a Soft Hat and Embroidered Cloak* was Rembrandt's most ambitious portrait etching to date.[17] Its importance is reflected not only in its grandeur but also in the extraordinary energy devoted to working up the plate in eleven states, sometimes with only minor changes in areas of shadow. Rembrandt must have conceived of it as a major portrait from the start, for he chose a plate larger than he had used for earlier portraits, except for his relatively formal *Self-Portrait, Bareheaded* of 1629 (Fig. 1). He began, in the first state (Fig. 87), by drawing only his head in the upper right quadrant of the plate, and the next three states he devoted to subtly adjusting the contrast of light and dark on his face and hat. As in many of his Leiden self-portraits, Rembrandt's face is half brightly lit and half lost in a deep shadow, which is only partly convincing as that cast by the brim of his hat. His broad-brimmed felt hat, a *respondet*, not seen before, is like those worn by several of his more elegant clients, beginning in 1632 with Marten Looten, and it seems to identify him with these men.

But the hat also reveals that Rembrandt drew on a most fitting prototype from outside his *burgerlijk* milieu, the self-portrait Rubens painted for Charles I, which he knew through Paulus Pontius's engraving of 1630 (Figs. 93 and 94). Specifically, he appropriated the turn of Rubens' head and his hat with its curled brim and angled placement high on the head, which was far too jaunty for the reserved Dutch, as comparison with commissioned works shows. Perhaps Rubens' self-portrait held special significance for Rembrandt by virtue of being in the same princely collection as his own self-portrait. In any case, it must have appealed to him for the elevated image of the artist it conveyed and for the venerable self-portrait tradition to which it alluded: as remarked in the previous chapter, Rubens wears a chain of honor and elegant courtly attire that identify him with the ideal of the virtuoso artist.

In the fifth state (Fig. 88), taking his cue from Rubens' image, Rembrandt added his body in almost three-quarter length, creating in one daring move a remarkably flamboyant portrait and transforming austere Dutch sobriety into swaggering, cosmopolitan elegance. He stands in a confident, authoritative pose, one hand on his hip, his extended elbow covered by his cloak, and the other in front of his body, resting on an almost completely concealed balus-

trade. While his white pleated collar and cuff conform to the contemporary Dutch attire in which he would paint others, he borrowed from Rubens the elegant cloak that sweeps across his body in a dynamic, if admittedly awkward, flourish. As if satisfied with his effort he added his monogram "RHL" and the date 1631.

Yet he continued to work on the plate. In the sixth and seventh states he accentuated the shadow on his face and strengthened the contrast between his white collar and black garments. He also darkened the fur on his cloak and added a brocade pattern to his sleeves, heightening their lavishness, and he lengthened his already fashionably long hair. To clarify his pose he added the line of the balustrade at right. In states eight (Fig. 89) and nine he increasingly shaded the background with sketchy, irregular hatching, reducing the stark contrast of dark figure against white paper and creating an enveloping darkness in keeping with his shaded face.

In the tenth state (Fig. 90) he added distinct folds and a lace pattern to his collar, diminishing the contrast between collar and cloak, and focusing more attention on his face. Since the original monogram and date had been obscured, he signed the plate again, "Rembrandt f." Changing his conventional, unassuming monogram to the first-name signature he would use for the rest of his life was an assertive gesture in imitation of famous artists—Raphael, Michelangelo, Titian, even Lucas—who were known this way. Perhaps this was the very first time he signed a work "Rembrandt." After all, the image projected in this bold signature was certainly consistent with the uniquely cosmopolitan, even pretentious, *Self-Portrait in a Soft Hat and Embroidered Cloak*. That this signature is not found in Rembrandt's other works until 1632–33 suggests that he continued to work on the plate for at least a year after 1631.[18]

Though rooted in Rubens' self-portrait, the overall conception of Rembrandt's etching is also van Dyckian. At precisely this time, in the winter of 1631–32, van Dyck was in The Hague painting the portrait of Constantijn Huygens that is now known only through Pontius's engraving in the *Iconography* (Fig. 95). Several crucial qualities of Rembrandt's etching are evident in the portrait of Huygens, specifically the three-quarter-length format that imparts greater movement to the figure, the sense of spatial orientation created by suggesting an atmospheric background, and, above all, the subject's intensified psychological presence. These elements are not found to the same degree in Pontius's engraving after Rubens' self-portrait; and they are certainly not characteristic of the work of Nicolaes Eliasz. or Thomas de Keyser, the foremost Amsterdam portraitists of the previous generation. They suggest that van Dyck's brief stay in Holland had a significant impact on Rembrandt's portraits of the early 1630s.

Given Rembrandt's interest in Rubens and his connection with Huygens, who favored the Flemish masters, it was perhaps inevitable that he be drawn to portraits by van Dyck, arguably the most lively and innovative of the day. It is true, however, that his debt to Flemish portraiture in this period, like his debt to Venetian portraiture in the 1640s and 1650s, is difficult to isolate. Only rarely are specific prototypes identifiable. When we can point to a particular

84. *Nicolaes Ruts*, 1631. New York, The Frick Collection.

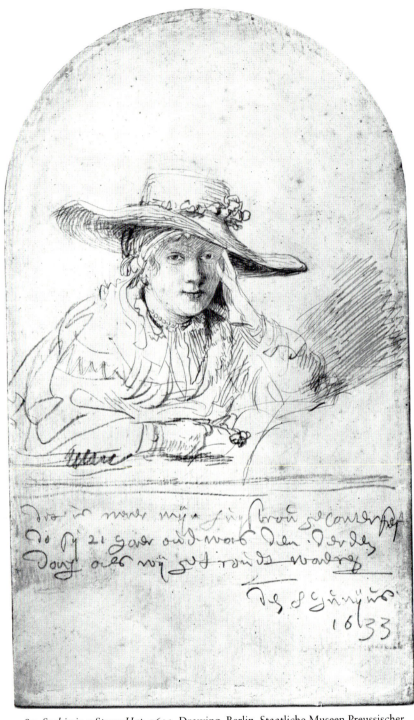

85. *Saskia in a Straw Hat*, 1633. Drawing. Berlin, Staatliche Museen Preussischer Kulturbesitz, Kupferstichkabinett.

86. *Jacques de Gheyn*, 1632. London, Dulwich Picture Gallery.

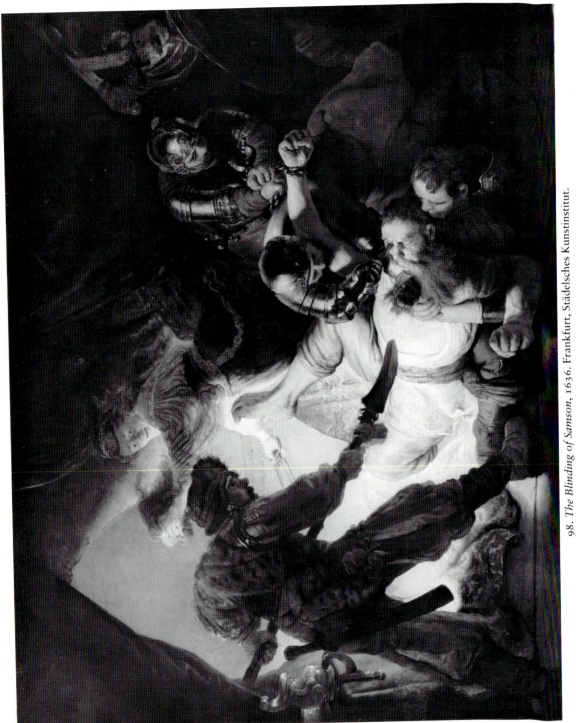

98. *The Blinding of Samson*, 1636. Frankfurt, Städelsches Kunstinstitut.

99. *Last Supper*, after Leonardo da Vinci. Drawing. New York, The Metropolitan Museum of Art.

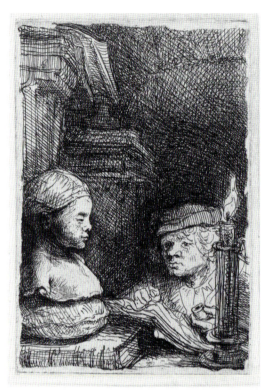

100. *A Youth Drawing from a Cast by Candlelight*,
1641. Etching. Amsterdam, Rijksprentenkabinet.

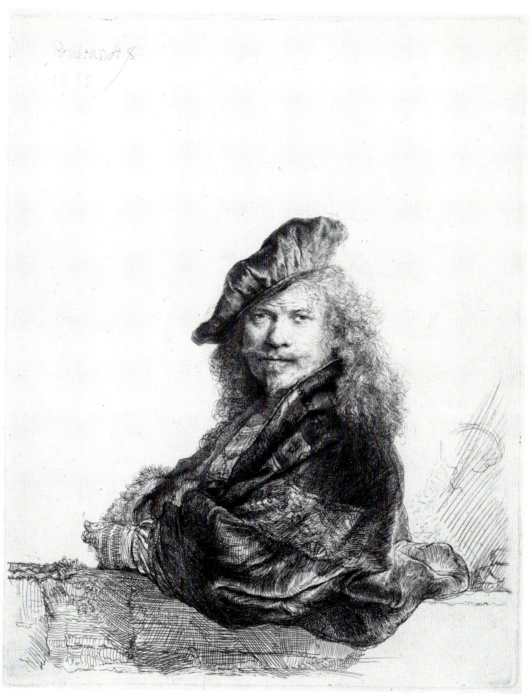

101. *Self-Portrait Leaning on a Stone Sill*, 1639. Etching. Amsterdam, Rijksprentenkabinet.

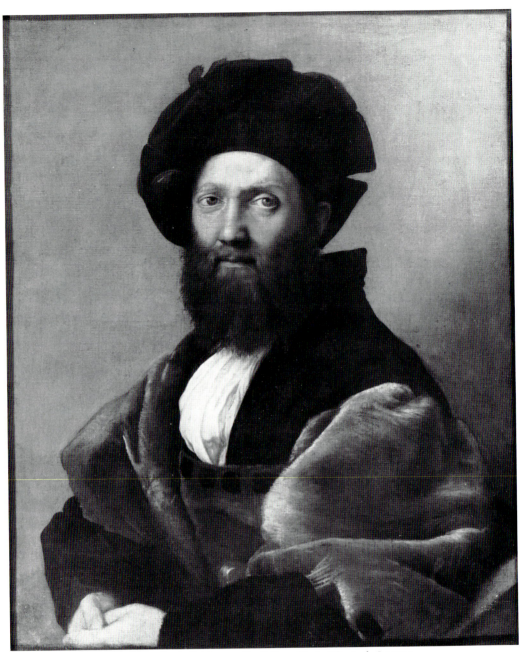

102. Raphael, *Baldassare Castiglione*. Paris, Musée du Louvre.

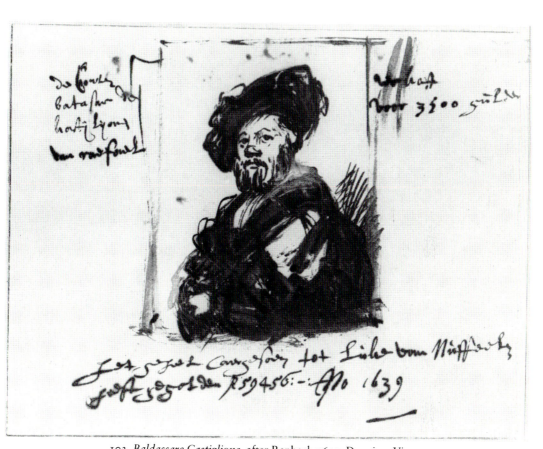

103. *Baldassare Castiglione*, after Raphael, 1639. Drawing. Vienna,
Graphische Sammlung Albertina.

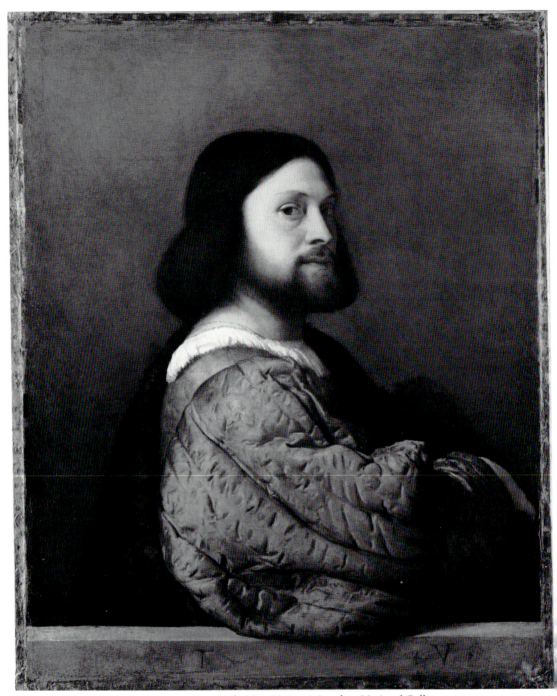

104. Titian, *Portrait of a Man* (*Ariosto*). London, National Gallery.

Qui vedi il Balthasaro Castiglione,
Che l'arte di corte refe si fino;
ch' al mondo visse senza paragone;
pero quel grand Raphaele d'Vrbino

Ritratto fe del suo Paesano,
Per l'haver fatto dopo la morte;
Lo spirito, da lui nell corteggiano;
La viata al vivo, di questa altra forte.

Raphael Vrbinas
Sculptor fecit

ILLVSTRISSIMO DÑO ALPHONSO DE LOPEZ REGI CHRISTIANISSIMO A CONSILYS, EQVITI
ORDINIS SANCTI MICHAELIS, AC REGII PALATII MAGISTRO L.M.Q.D.D. Ioachimus Sandrart.
Ioachimus Sandrart del. et exc. Amstard. RAPHAEL VRBINAS Pinx. in ædibus Alph. Lopez.

105. Renier van Persijn, after Raphael,
Baldassare Castiglione. Engraving.
Amsterdam, Rijksprentenkabinet.

106. Renier van Persijn, after Titian,
Ariosto. Engraving. Amsterdam,
Rijksprentenkabinet.

TITIANVS. U.

107. *Young Man in a Velvet Cap*, 1637. Etching. Amsterdam,
Rijksprentenkabinet.

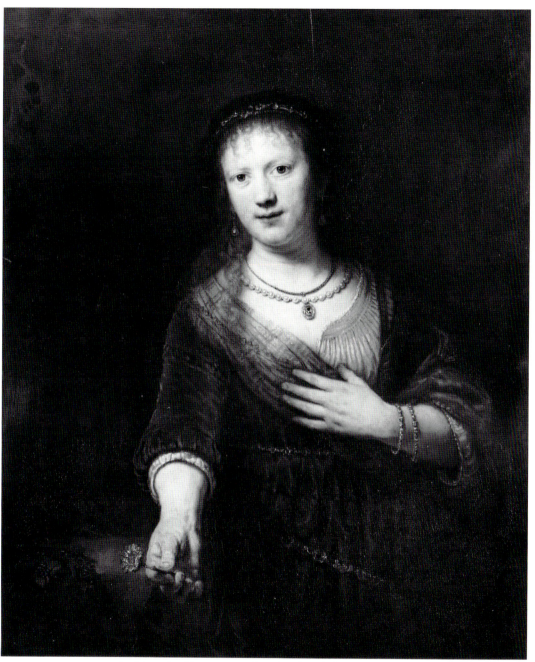

108. *Saskia with a Flower*, 1641. Dresden, Staatliche Kunstsammlungen, Gemäldegalerie.

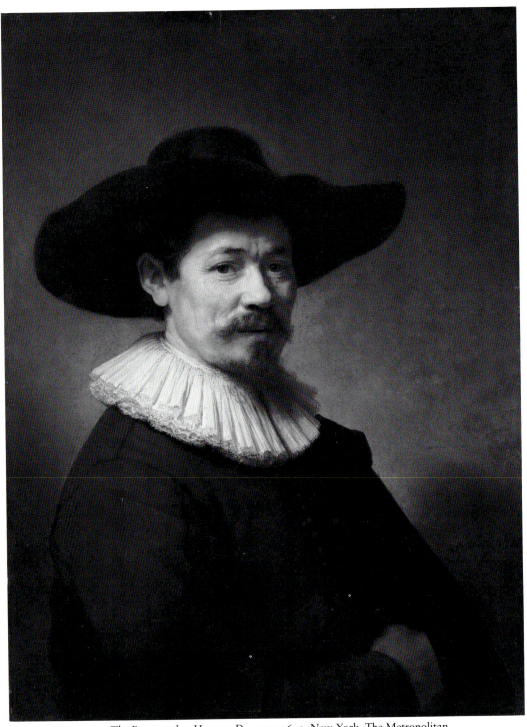

109. *The Framemaker Herman Doomer*, 1640. New York, The Metropolitan
Museum of Art.

source, like Rubens' self-portrait, it is almost invariably because allusion to the earlier work imparts significant meaning to Rembrandt's. The broader impact of style is another matter. Without drawing on obvious prototypes, Rembrandt appropriated the innovative stylistic features and the psychological and physical vitality of van Dyck's portraits as a point of departure for his own highly individual transformation of the Dutch portrait tradition.[19]

Two impressions of the *Self-Portrait in a Soft Hat and Embroidered Cloak* completed in black chalk pose a complex, and possibly insoluble, problem as to their place in the sequence of etched states and their relation to Rubens' self-portrait. On the impression of the second state in the British Museum (Fig. 91) Rembrandt drew his body in bust-length and added an illusionistic arched frame like that in Pontius's engraving (Fig. 94). In much the same manner, he added a somewhat more abbreviated body, turned in three-quarter view, to an impression of the fourth state in the Bibliothèque Nationale (Fig. 92). He signed and dated both "Rembrandt 1631" and inscribed them with his age, "AET 27," which he then changed to "24," his correct age in 1631.

Though these two impressions with drawn additions bear little resemblance to the three-quarter-length format of the finished etching, they are usually interpreted as preparatory sketches made before he added his body in the fifth state.[20] B.P.J. Broos has proposed instead that he drew them after completing the etching, in 1633, when he really was twenty-seven years old, and that he predated the drawings and corrected his age to accord with the year in which he had etched the face.[21] Several things argue that these are afterthoughts and not preparatory sketches, drawn on proofs kept in the studio. For one thing, they have the look of signed, finished drawings. More concretely, Rembrandt's first-name signature, which, as has been mentioned, he did not use until 1632–33, is in the form it takes in the tenth state of the etching. His apparent confusion over his age is best explained by his having worked on the portrait over several years. Furthermore, the London impression is trimmed so that his head is lower, closer to the vertical axis, and larger in proportion to the overall space. Yet the initial placement of the head on the plate clearly anticipated the final etched composition, suggesting that he fully worked it out beforehand. Finally, in the London drawing (Fig. 91) the relation between his body and head is awkward and disjointed, in part because the shaded side of the face and hat brim are too heavy for the body below, whereas in the finished etching they are balanced by his jutting elbow. These two versions, then, seem independent of the sequence of enlarged etched states, and the drawn additions may even postdate the fifth state, in which Rembrandt added his body. We might think of them as his reconsideration of the print's relation to its Rubensian prototype. Or perhaps he did them in connection with his *Self-Portrait as a Burgher* (Pl. III), which they resemble more closely.

The Glasgow panel was the first, and only, self-portrait Rembrandt painted in a mode he frequently used for commissioned portraits.[22] Signed "RHL van Rijn" and dated 1632, it may have been done before the late states of the etched *Self-Portrait in a Soft Hat and Embroidered Cloak*. Conceivably the chalk versions of the second and fourth states were preparatory sketches

for the painting; but more likely they were done afterwards, either as finished drawings in their own right or perhaps as models for a projected reproductive print. Disseminating his painted likeness through a reproductive print, just as he would his *Descent from the Cross* in 1633 (Figs. 149 and 150), would have been entirely consistent with Rembrandt's emulation of Rubens at this time.

Compared to his Leiden portraits and even to the similar but more flamboyant etching, the *Self-Portrait as a Burgher* seems at first glance surprisingly conventional. The traditional bust-length format was extremely popular for the moderately priced portrait for which Rembrandt was then receiving orders. Moreover, he wears the same formal attire as many of his sitters: a black felt hat with a broad brim, a white pleated collar tied with a red ribbon, a black doublet adorned only with tiny gold buttons, and a black cloak.

Yet this, his most assertive self-portrait to date, is far from ordinary. It stands apart from his commissioned portraits in its evocative shadows and self-assured frontal pose. It offers a more vital and imposing image than his Leiden portraits. His head is positioned almost full-face, occupying more of the picture space, and his eyes engage the viewer more directly. Reminiscent of his earlier works, his hat shades half his face, imparting a melancholic psychological impact to the work. His palette, though limited, is remarkably sophisticated. A sparing use of red in his lips and cheeks and at the closure of his collar brings the stark contrast of his black and white garments to life. The painting's simpler format and elegant design of curves and counter-curves may have seemed an improvement over the confusing flourish of drapery in the etched *Self-Portrait in a Soft Hat and Embroidered Cloak*. This was not the only time Rembrandt would use a bold and, one might say, experimental etched self-portrait as the point of departure for a more formal, seemingly more conventional, yet still highly original painting.

Perhaps the most striking difference between etching and painting is the painting's greater independence from Rubens' portrait. Rembrandt's hat, the lit side of his face, and perhaps his gold buttons, derived from Rubens' subtle chain, indicate that Rubens was still at the back of his mind. However, in the Glasgow panel Rembrandt has broken free of, and virtually obscured, his model, updating Rubens' image of a courtier-artist to fit his own time and place. He cast himself as a *burgerlijk*, rather than courtly, gentleman.

This was the last time he would fashion himself as the contemporary burgher. For one thing this portrait type allowed little, if any, reference to his profession. Ironically, in so effectively transforming his model he removed any allusion to the self-portrait tradition to which it belonged. In the portraits to follow Rembrandt would return to that tradition as a way of defining his professional identity.

RUBENS AS MODEL

In two self-portraits (Figs. 96 and 97) from the following year, 1633, Rembrandt abandoned his fashionable *burgerlijk* mode for one that aligned him more closely with the virtuoso ideal embodied in Rubens' self-portrait (Fig. 93).

Like the Glasgow painting, both of the 1633 portraits are bust-length on oval panels, but here the resemblance ends. With the *Self-Portrait in a Cap*[23] (Fig. 96) Rembrandt reverted to the imaginary mode of the Liverpool painting (Fig. 70), in which his black beret and gold chain identified him as a painter.

To complete the image of an ideal artist, Rembrandt donned a heavy black cloak, and added a gray-gloved hand with which he draws attention to his chain. Gloves, traditionally the attribute of a gentleman, acquired special significance in sixteenth-century portraits of artists, where they indicate that painting is an intellectual pursuit, not a manual craft (Fig. 75).[24] And, indeed, Rembrandt has taken pains to evince the workings of his mind. His subtly shaded face looks more thoughtful than his smooth, naive countenance in the Glasgow painting. The deep crease between his brows suggests greater maturity and serious mental activity: though certainly true to Rembrandt's features, the furrowed brow, which according to van Mander revealed man's thoughts, was also a portrait convention.[25] In its heightened animation and visual complexity as well, this portrait departs from that in Glasgow. Overall, light is more broken and simplified contours have given way to more complex lines. The single sweeping line of Rembrandt's white collar in the earlier painting has been replaced by the elegant double curve of his gold chain, which is echoed in the lively contour of his beret. In keeping with his new and more refined virtuoso image he gave this portrait his new first-name signature, "Rembrandt f.1633."

The similarly signed and dated *Self-Portrait, Bareheaded* (Fig. 97), also dated 1633, is simpler and less polished and is probably slightly earlier than the painting just considered.[26] Its extraordinary loose execution and visible areas of warm yellowish ground suggest it is a preliminary version of its more finished counterpart. Rembrandt's vigorous technique is one of several features that give it greater force. Reducing his costume to its essentials, he wears a similar mantle and an ornate gold chain, but he has added a barely visible gorget and omitted his cap and gloved hand. As a result, we focus on his face almost exclusively. Only his chain, partly in shadow, competes for attention. Moreover, his face itself seems more interesting and his eyes more piercing. Above all, without the hat Rembrandt concentrates expression in his tensely wrinkled, deeply creased brow. It may not be an exaggeration to call this one of the most expressive foreheads in the history of art, and it is nearly matched by his self-portraits in Karlsruhe and Amsterdam (Fig. 110 and Pl. VII). Rembrandt's face characterized him as a thinking artist, a *pictor doctus*, so effectively and naturalistically as to render the symbolic gloved hand superfluous.

It comes as no surprise that Rembrandt would model his self-portraits of the early 1630s after the ideal embodied by Rubens, for that was precisely the period of his most concentrated study of the Flemish master.[27] An ambitious artist like Rembrandt could not have failed to attend to Rubens, the greatest and most famous of living painters. But the challenge Rubens' work presented was probably reinforced by Rembrandt's contact with The Hague. Frederik Hendrik had several paintings by Rubens in his collection, and Constantijn Huygens, in discussing artists in the Netherlands, wrote that

they are all great artists and my friends, but the leader of them all and the Apelles of our time, Petrus Paulus Rubens, I hold as one of the wonders of the world.[28]

Many of Rembrandt's earliest etchings and paintings draw on compositions by Rubens that were widely circulated through prints produced by engravers in his shop. For the painting *David with the Head of Goliath Before Saul* of 1627 he borrowed the motif of Saul and his trainbearers from Rubens' *Adoration of the Magi* of about 1617 or 1618, which he knew through an engraved copy of the authorized reproductive print by Lucas Vorsterman, published in 1621.[29] By 1631, the year he used Pontius's engraving after Rubens' self-portrait as a starting point for his *Self-Portrait in a Soft Hat and Embroidered Cloak* (Figs. 94 and 88), Rembrandt's fascination with Rubens had grown. He derived his full-length self-portrait in oriental costume (Fig. 50) from the figure of the black king in the same print of the *Adoration*.[30] For his *Christ on the Cross* (Fig. 13) he appropriated an entire composition by Rubens, which had been published that same year in an engraving by Pontius.[31] The *Christ on the Cross* is in the same format as the Passion series that Rembrandt would soon paint for Frederik Hendrik, yet it is not part of that cycle. This and the fact that Jan Lievens also painted a similar *Christ on the Cross* in 1631 suggest that Constantijn Huygens may have held a competition for the commission, a *combattimento* in the Renaissance tradition, in which his two favorite Leiden painters produced their own versions of Rubens' composition.[32] Rembrandt more successfully captured the emotional drama that Huygens must have admired in the prototype. Shortly thereafter he began his first Passion painting, the *Descent from the Cross* (Fig. 149), drawing on, but deepening the pathos of, the central panel of Rubens' Antwerp altarpiece, which he knew through the engraving by Vorsterman (Fig. 151).

His other single most Rubensian work—the *Blinding of Samson* (Fig. 98), which he painted in 1636 and which he tried twice, without success, to give to Huygens—was also associated with The Hague.[33] Here he not only generated a dramatic emotionalism of the sort Huygens had earlier praised in *Judas Returning the Thirty Pieces of Silver* (Fig. 8), but he based the figure of Samson on Rubens' *Prometheus*, which had been in The Hague between 1618 and 1625 and thereafter entered the collection of Sir Dudley Carleton, where Huygens admired it.[34] Other works from the 1630s draw on Rubens in various ways. Several etchings of lion hunts, for example, were inspired by prints after paintings of similar subjects.[35] Presumably some of the prints by and after Rubens that Rembrandt collected during this period were still in his possession at the time of the 1656 inventory, which includes:

228. A book filled with portraits, of [or by] van Dyck, Rubens and various other old masters,
245. One ditto with trial proofs by Rubens and Jacob Jordaens.[36]

We know, moreover, that Rembrandt purchased a painting of *Hero and Leander* by Rubens in 1637.[37] His works of the first half of the 1630s suggest he

already had studied at first hand Rubens' painting technique as well as his com-
positions.

Rembrandt's response to Rubens should be considered in the context of
seventeenth-century artistic emulation. Emulation, like many art-theoretical
concepts, came, via the Renaissance, from Antiquity. According to classical
poetic theory, the art of poetry was learned in three stages. The student began
with *translatio*, translating the classical authors. Next he advanced to *imitatio*,
imitating the style of a particular model. In the final stage of training, *aemula-
tio*, the advanced student, with a developed sense of judgment, emulated an
esteemed author while writing in his own style. *Aemulatio* differed from *imi-
tatio* in that it implied both a desire to surpass the model and a greater degree
of freedom from it. Moreover, it was thought to stimulate the writer and en-
courage him to fulfill his potentiality.[38]

The tripartite process *translatio–imitatio–aemulatio*, explicit in literary
theory, was not applied so programmatically in the theory of art. Nonetheless
a parallel course of study was advocated for painters. Direct copying from a
model, the equivalent of *translatio*, was regarded as the necessary first step in
the education of a painter, as well as a practice to be continued throughout his
career. Rembrandt's etching of a youth drawing from a cast by candlelight (Fig.
100) from about 1641 depicts this first stage of copying from a model. His own
early drawings after Pieter Lastman and his copy of Mantegna's drawings of
the *Calumny of Apelles* (London, British Museum) are examples of *translatio*.
A visual counterpart to the next step, *imitatio*, might be Rembrandt's drawings
after Leonardo's *Last Supper* (Fig. 99), where the composition of the original
retains its overriding importance but the model is not copied directly. *Aemu-
latio*, the highest stage, is exemplified by Rembrandt's self-portraits purpose-
fully alluding to portraits by other masters. However, the exact nature of his
emulative rivalry with Rubens, and later with Titian and Raphael, merits fur-
ther consideration.

Aemulatio implied that an existing admired work be surpassed. To the
Renaissance mind the models most worthy of emulation came from classical
Antiquity. One of the highest forms of praise was to say that a painter had
surpassed Apelles, no matter that none of his paintings could be seen. Antonis
Mor, for instance, referred to himself as one "who surpassed Apelles, the an-
cients, as well as the moderns" in the inscription on his self-portrait of 1558
(Fig. 140). In the seventeenth century van Mander, Philips Angel, and Samuel
van Hoogstraten continued to hold up ancient as well as Renaissance masters—
above all Raphael, Michelangelo, and Titian—as models. Hoogstraten as-
serted:

> It is impossible for us to excel at anything, says Chrysostom, unless
> we strive with those who are most supremely excellent. And moreover
> it cannot be harmful for two racers to compete against each other.
> This noble rivalry shall lead worthy spirits to the summit. Thus did
> Raphael strive with Michelangelo, and Michelangelo with Raphael,
> and Pordenone with the great Titian.[39]

Later in his book he counseled the painting student:

> Allow ambition to trouble your sleep, for such, too, is the nature of
> virtue that she prods the mind to rivalry to surpass the foremost,[40]

adding, in English, "It is no Herezy to outlymn Apelles."

Constantijn Huygens not only, it seems, encouraged rivalry between Rembrandt and Lievens but also couched his praise of them in the conventional form of emulation:

> If I said they alone were equal to those prodigies I have pointed out
> among so many great mortals, I would judge even this something less
> than what these two deserved. If I said they will shortly surpass them
> I would leave nothing more to hope for than what certain sage observers have anticipated from their astonishing beginnings.

He expressed high regard for classic Italian art, but also confidence that the young prodigies could outdo it:

> Oh, if only they were acquainted with Raphael and Michelangelo.
> They would eagerly visually devour so many monuments of these
> great souls. How quickly they would surpass them all and, as men
> born for the consummation of art (did they only realize it), they
> would summon Italians to their own homeland.[41]

In Huygens' eyes emulation is a most positive endeavor, a kind of constructive, respectful rivalry through which the painter, by way of paying tribute to the master, lays claim to his status, fame, and place in tradition. His classicist version of emulation is exemplified by the reverence for Antiquity and the classical ideal displayed in Rubens' *Descent from the Cross* (Fig. 151). By quoting from the Hellenistic sculpture of the *Laocoön* for the figure of Christ, Rubens conveyed his erudition, claimed his place in the classical tradition, and dignified his own work by using the appropriate ancient model of heroic martyrdom as a prototype for Christ's suffering. He surpassed his exemplar by Christianizing it and by painting life into the stone original. Rubens himself summed up reverent classicist emulation:

> I conclude, however, that in order to attain the highest perfection in
> painting it is necessary to understand the antiques, nay, to be so thoroughly possessed of this knowledge that it may diffuse itself everywhere. Yet it must be judiciously applied, and so that it may not in
> the least smell like stone.[42]

In contrast, for the nonconformist Rembrandt the pull between the model and the mandate to surpass it must have been a constant battle, in which the desire to create something new and all his own often won, effacing the model. More than many of his contemporaries he appears to have recognized the inherent conflict that unqualified reverence for the past presents to the artist seeking to create an independent work of art. From his initial attempts to "outlymn" his teacher Pieter Lastman (in *Balaam and the Ass*, for instance), and his early refusal to go to Italy to his lifelong lack of real affinity for Antiquity,

Rembrandt displayed irreverence toward the past. For him emulation, if we can still call it that, served to emphasize his differences from his model. In his *Descent from the Cross*, for which he drew on Vorsterman's engraving (Figs. 149 and 151), he remodeled Rubens' composition with less respect and greater antagonism than Rubens had had for his classical source. Rembrandt's *Descent* transgressed the classical ideal at the very heart of Rubens' art. By dispensing with the quotation from Antiquity he in effect washed away the classical tradition. Quoting from Rubens was no substitute, for in rejecting his ideal heroic Christ in favor of naturalistic, excruciatingly pathetic suffering he placed himself in opposition to the very principle underlying the prototype.[43]

Rubens' tremendous but equivocal pull on Rembrandt extended to his artistic identity, which he "emulated" in the Louvre self-portraits (Figs. 96 and 97) of 1633, the year he completed the *Descent from the Cross*. Seventeenth-century Dutch painters were taught to emulate not only the works of admired artists but their behavior, moral qualities, and even dress—in short, their professional identity. Philips Angel, near the close of the *Lof der schilder-konst*, advised the painter to acquire the courtly demeanor of Apelles, the discipline and virtue of Michelangelo, and the diligence of Ghirlandaio.[44] Rubens, who combined all these qualities, embodied the ideal of the artist of *virtu*, dignity, and *ingenium*. It is fitting that in his Windsor self-portrait (Fig. 93) he wears the chain of honor, for honor, in the thinking of the time, is the primary goal toward which the artist should strive.[45]

Rembrandt's Louvre self-portraits allude, primarily through their chains, to the ideal of the honored, gentlemanly virtuoso artist embodied by Rubens. But although Rembrandt assumed Rubens' role he could not have lived up to it. Rubens was a court painter, scholar, knight, and diplomat, and his identity as an artist, like his chain, was linked to these diverse positions. Rembrandt, in contrast, had received no chain and could not claim noble rank. Indeed, he had settled in *burgerlijk* Amsterdam, and his relations with the court were perhaps already becoming rather strained. He could not appropriate Rubens' professional identity without transforming or transgressing it.

Rembrandt's bold donning of fictitious chains, his whole virtuoso bearing, and even his independent approach to artistic tradition are brought into sharper focus when considered in the context of a particular transformation of the courtly ideal. In the literature of art, a variation on the theme of the noble artist is the commoner artist who is ranked by his royal patron above nobility. Van Mander, Angel, and Hoogstraten all related the legend of the Emperor Maximilian's ordering a courtier to let Albrecht Dürer stand on his back to draw on a high wall. The nobleman objected that it debased him to serve as a footstool to a painter,

> whereupon the Emperor replied that Albrecht was already a nobleman because of the excellence of his art; and he declared further that he could easily make a nobleman out of a peasant, but that he could not make an artist out of a nobleman.[46]

Hoogstraten amplified the significance of this anecdote with the pointed statement that the artist gains noble esteem by his own merit, without having inherited or borrowed anything from anybody.[47] Franciscus Junius expressed a similar attitude when he wrote that "the way of Honour lieth open to every one, and that glory likewise doth not so much follow from the condition of our birth, as the vertues of our life."[48] The honor bestowed upon the artist was, then, evidence that his superiority derives not only from the excellence of his works but also from his *virtu*, his moral, intellectual, and spiritual worth.

Constantijn Huygens, who himself had risen from *burgerlijk* beginnings to attain his position at court, glorified Rembrandt and Lievens in similar terms:

> When I consider the parentage of each, I think no stronger argument can be given against nobility being a matter of blood. . . . Trajan Boccalinus . . . tells the story of an anatomical examination on a corpse of a noble. When the veins were carefully examined by the doctors present, all denied that nobility resides in the blood, for clearly this corpse was no different from a commoner or peasant. The father of one of these young men [Lievens] is an embroiderer and a commoner; the other's is a miller and surely not of the same grain. Who could help but marvel that two prodigies of talent and creativity could emerge from these farmers.[49]

This attitude toward artists is symptomatic of the unprecedented social mobility in seventeenth-century Holland. Especially in Amsterdam, the newly wealthy, educated merchant families constituted a social and cultural elite that was undergoing a process of aristocratization. To distinguish themselves, members of this powerful regent class increasingly aspired to the privileges and trappings of nobility, buying titled seigniories in the countryside and acquiring noble titles at foreign courts.[50] This urban elite, like Constantijn Huygens and other self-consciously aristocratic members of the Stadholder's court, adopted standards of courtly behavior codified in French and Italian courtesy books. It has been suggested that Stefano Guazzo's *Van den hevschen burgerlycken ommegangh* of 1603, one of the few such treatises translated into Dutch, may have appealed to Holland's elite, who could not claim hereditary nobility, because of its attitude that "the Gentleman by virtue is more excellent than the Gentleman by birth."[51]

Rembrandt's emulation of Rubens might be seen as a parallel to this aristocratization, though it differs in that it concerns his professional identity rather than his social standing. This is not to deny his social aspirations, for there is sufficient evidence to suggest that he too longed for a grander way of life. However, his self-portraits in elegant garb and gold chains reflect his ambition to attain not the social or material status of his Amsterdam patrons but the honor that was the virtuoso painter's professional goal. In the absence of figures embodying this ideal in his immediate milieu, he turned to Rubens in fashioning his self-image.

The ubiquitousness of honor as the painter's goal in the literature on art

suggests that Rembrandt was familiar with these ideas and that he deliberately evoked them in his self-portraits. This seems to be confirmed by his 1634 inscription in the *album amicorum* of the German merchant Burchard Grossman:

> A righteous soul
> Values honor above wealth.[52]

Although not written specifically with reference to art, this expresses succinctly the prevailing view of honor as not just a mark of esteem or social approval but a reflection of one's moral and spiritual worth.

To distinguish his ideal virtuoso guise from those of real court painters, Rembrandt donned historicizing costume and an old-fashioned beret. His chain—now a purely notional one—stands for abstractions, the Art of Painting and the Honor that is the painter's aim. In comparison to Rubens, Rembrandt fashioned himself not as an honored gentleman but as an artist of Honor, claiming nobility solely on the basis of his personal artistic excellence. In short, Rubens stood for the most elevated theory of the artist current at the time. And he lived a life consistent with the virtuoso ideal displayed in his self-portraits. Rembrandt, drawn as he was to this ideal, did not live it—could not do so in the seventeenth-century Netherlands. He changed social into professional standing.

IN RENAISSANCE GUISE

In two magnificent portraits from the end of his first Amsterdam decade, Rembrandt as virtuoso became even more fantastic. Each is notable not only for the statement Rembrandt makes about himself and his art but also for the clarity of the formal means by which that message is delivered. First in the arresting etched *Self-Portrait Leaning on a Stone Sill* (Fig. 101) of 1639 and then in the ambitious painting of the following year, the *Self-Portrait at the Age of 34* (Pl. IV), Rembrandt put on romantic sixteenth-century garb, similar to that worn in the Amsterdam theater. The painting, among the grandest of Rembrandt's historicized portraits, was possibly that inventoried in the collection of Johannes de Renialme as "Rembrandts contrefeijtsel antijcks."[53] Portraits *à l'antique* were just coming into vogue, and, like *portraits historiés*, they appealed to the elite. This is one reason why it has been assumed that these two particularly elegant portraits project primarily Rembrandt's social rank. They have been read, at one extreme, as evidence of his crass social climbing and, at the other, as manifestations of his profound intellectual commitment to the Renaissance gentlemanly ideal.[54]

I would argue, however, that their greatest concern is with his artistic aspirations. For they differ fundamentally from the fashionable historicized portrait modes: as has long been recognized, they are distinguished by deliberate reference to earlier portraits of and by famous men, Raphael's *Baldassare Castiglione* (Fig. 102) and Titian's *Portrait of a Man*, thought to represent the poet Ludovico Ariosto (Fig. 104): two important sixteenth-century Italian paintings that Rembrandt saw in Amsterdam.[55] By appropriating a Renaissance portrait

type and by suggesting specific works by two of the most highly esteemed Renaissance masters, Rembrandt further divorced himself from his artistic milieu. In alluding so pointedly to the past these powerful yet entirely imaginary portraits show nostalgia for a lost ideal of the artist and claim mastery of that ideal. Through them Rembrandt boldly asserted his standing in the grand lineage of European painting.

Now an independent master and enjoying new heights of success, Rembrandt was in a position to exhibit extraordinary self-assurance. His artistic activity of the second half of the 1630s stands in sharp contrast to that of the first. After leaving Uylenburgh's house and business, he set up his own studio, took on his own assistants and apprentices, and quickly became the most sought-after teacher in Amsterdam. With increased access to foreign paintings in the growing Amsterdam collections, he turned his attention to Italy and the more distant art of the early sixteenth century. As his frenetic portrait production ended, his output dropped off considerably, and he turned primarily to biblical subjects, painting *The Blinding of Samson* (Fig. 98) in 1636, *The Angel Leaving Tobias and his Family* in 1637, and *Samson's Wedding Feast* and *The Risen Christ Appearing to Mary Magdalen* in 1638.[56] In January 1639 he completed the last two of the Passion paintings for Frederik Hendrik, *The Entombment* and *The Resurrection*, which he had inexplicably left unfinished for three years. His letters to Huygens indicate he had trouble extracting payment from the Stadholder and finally had to lower the price. They also reveal that he tried to give Huygens a gift, presumably *The Blinding of Samson*, which was refused for reasons unexplained.[57] Clearly his relations with Huygens had soured, and whether his flurry of activity in 1639 was a last-ditch effort to gain favor with the Stadholder or, more likely, an attempt to accumulate cash to buy a house, it meant his near-final break with the court.

With the Passion series out of the way, he again turned to portraying well-to-do Amsterdammers, producing the elegant full-length painting of the powerful regent Andries de Graeff and the etched historicized portrait of Joannes Uytenbogaert, the tax collector for the States General, perhaps in gratitude for helping him secure payment from Huygens. In 1640 he received the commission for *The Nightwatch*, testimony to his esteem among Amsterdam's elite.[58] By this time his fame had also spread beyond the Netherlands. When, that same year, the English traveler Peter Mundy visited Holland and commented on the excellent painters there, Rembrandt was the only one he mentioned by name.[59]

By all indications Rembrandt and Saskia lived quite well during this period. In 1638 he sued Saskia's relatives for libel, claiming that he and his wife "were quite well off and were favored with a superabundance of earthly possessions (for which they can never express sufficient gratitude to the good Lord)," but protesting as slander and "entirely contrary to the truth" the defendants' claim that Saskia "had squandered her parents' legacy by ostentatious display, vanity and braggadocio."[60] Perhaps, though, these accusations had some truth. In January 1639 he purchased, with a loan of 13,000 guilders that he would never pay off, a grand house on the Jodenbreestraat, now the Rem-

brandthuis.[61] The year 1640 also brought unhappiness in the deaths of his mother and his third-born child, who, like those born in 1635 and 1638, lived only a few weeks.[62]

As if to celebrate his great success, Rembrandt reformulated his portrait identity, casting himself in the new shape of the Renaissance gentleman-artist. First, in 1639, he created his imposing *Self-Portrait Leaning on a Stone Sill* (Fig. 101), an image of unprecedented self-confidence.[63] With his arm resting on a stone balustrade and his body in profile turned to the left, he regards the viewer full-faced, with an intense, commanding, almost haughty gaze. His rakishly angled beret is reminiscent still of Rubens' Windsor self-portrait (Fig. 93). His long hair, his sophisticated moustache and beard, his ostentatious, old-fashioned brocade- and fur-trimmed garments, and his gloved hand and chain together create an image of cultivated, though somewhat theatrical, refinement. Rembrandt's controlled yet daring handling of the etcher's needle and his unusual placement of the figure on the plate, with a vast expanse of space above his head, enhance the portrait's powerful bearing.

The 1639 etching anticipated the composition and conception, but not the dignified calm, of the painting from the following year.[64] The *Self-Portrait at the Age of 34* (Pl. IV) conveys the sense that Rembrandt either set himself a higher goal or achieved a definitive solution to a problem with which he had previously been occupied. Again he strikes the distinctive half-length pose, with his arm on the balustrade, and again he wears lavish Renaissance garb. But the painting considerably tones down features of the etching, resulting in a more accessible, less harsh image. Rembrandt's beret is now placed squarely on his head, his hair is shorter, and his pose has been relaxed by lessening the opposition between his head and body. The etching's *hauteur* has been replaced with a more natural grace.

This sequence of etched followed by painted version reverses the standard procedure of making a print after a painting. However, it was not uncommon in Rembrandt's practice. We have twice before seen him develop a bold self-portrait conceit in etching before translating it, in somewhat tamer form, into paint. His earliest painted self-portraits in Amsterdam and Munich were anticipated by several shadowy-faced etchings (Pl. I; Figs. 23, 17 and 18) and in the flamboyant *Self-Portrait in a Soft Hat and Embroidered Cloak* he explored the gentlemanly appearance that he subsequently modified in the Glasgow performance (Fig. 88 and Pl. III). This suggests that for Rembrandt etching was a more experimental and more personal technique, rather like drawing, to be employed with greater freedom and daring. Painting, by way of comparison, was the more formal medium, to be treated somewhat more conservatively—though not much more when it came to self-portraits.

One thing that lost none of its impact in the translation from print to painting was Rembrandt's resplendent costume. In both he distinguished himself as an artist by wearing a particularly lavish version of his by now characteristic beret. And in both he is dressed *à l'antique* in clothing that was fashionable in the first part of the sixteenth century. He wears in the painting, for

example, a white chemise-like shirt with an embroidered neckband, a style virtually obsolete by 1530 when collars came into fashion. His fitted doublet, or *paltroc*, is datable to the first quarter of the sixteenth century by its low horizontal neckline and lack of front closure. Likewise, his *onderwambuis*, the garment with the standing brocade collar worn between chemise and doublet, and his *wambuis*, the fur-trimmed outer garment, are consistently early in date.[65]

For such accurate costume, which is in marked contrast to his vaguely historicized dress in earlier self-portraits,[66] Rembrandt could not have relied solely on the hodge-podge collection of outdated garments that Baldinucci implies he owned. Rather, his sophisticated knowledge of costume, evident also in a number of other works from the mid 1630s on, seems to be drawn from a variety of visual sources. He had seen this sort of costume in the Amsterdam *Shouwburg*, the new town theater, notably at the first production of Vondel's medieval tragedy *Gysbrecht van Aemstel*, where he made drawings of the actors and actresses.[67] But while theater costume may have inspired Rembrandt's *antijck* garb, it was not his only source. Like stage dress designers, he too must have turned to costume books and other kinds of prints. He would have seen similar clothing in sixteenth-century portrait prints like that of Lucas van Leyden from Cock's *Pictorum aliquot celebrium Germaniae Inferioris effigies* (Fig. 76).[68]

Thus Rembrandt created a consistent sixteenth-century image of himself. His costume in these self-portraits, though chronologically in keeping with their Italian prototypes, is by no means identifiable as specifically Italian. To the contrary, from its warm fur trim and similarity to costume worn by Lucas and in Vondel's *Gysbrecht van Aemstel* one might conclude that it has taken on a distinctly Netherlandish cast. Nonetheless, Rembrandt's educated contemporaries surely would have recognized the unprecedented fidelity of the two self-portraits to their Italian prototypes as intentional allusions, for both Raphael's *Castiglione* and Titian's *Ariosto* were in important Amsterdam collections (Figs. 102 and 104).[69] Rembrandt must have seen Raphael's painting when, or shortly after, it was auctioned in Amsterdam on 9 April 1639, as part of the estate of the wealthy merchant Lucas van Uffelen. It was acquired, for the considerable sum of 3,500 guilders,[70] by Alphonso Lopez, an agent of Cardinal Richelieu stationed in Amsterdam from 1636 to 1641 buying arms, ships, and munitions for the French crown and, on the side, collecting and dealing in art.[71] Joachim Sandrart was the underbidder for the painting at 3,400 guilders.[72]

It is generally assumed that Rembrandt was present at the sale, for he made a rough pen and ink sketch of the painting (Fig. 103), alongside which he noted

The Count Baldassare Castiglione by Raphael sold for 3,500 guilders.
The entire estate of Luke van Nuffeelen fetched fl 59,456. Anno 1639.[73]

Yet his free copy deviates conspicuously from the original. Sketching it after the fact might account for this discrepancy. However, there is a better expla-

nation for the variations than that he drew from memory. What is often over-looked is that this is the only known instance in which he recorded in a drawing the sale of a painting by another artist, although documents certainly confirm he was actively attending auctions and buying works of art at this time. Presumably he found Raphael's painting particularly striking. But he did not just record its appearance. He reinterpreted it in a purposeful, consistent manner. Mindful perhaps of his own earlier transformation of Rubens' self-portrait in his *Self-Portrait in a Soft Hat and Embroidered Cloak* (Fig. 88), he gave Castiglione's hat a jaunty tilt. Still more telling variations are in the features: Rembrandt broadened Castiglione's nose, thickened his face, and raised his brow, making them more like his own. In short, he copied the *Castiglione* not only to record its sale but also because he saw in it an idea for a self-portrait. Indeed, it seems he was already inspired to use it as such.

The appeal of Raphael's portrait lay in style, composition, artist, and sitter. Prints from earlier in the 1630s, the *Self-Portrait in a Soft Hat and Embroidered Cloak* and the *Young Man in a Velvet Cap* (Fig. 107)[74] for example, show Rembrandt already working in a similar half-length format. Raphael's painting, because of its very lack of strangeness, probably stimulated him to continue seeking a solution to a problem that had occupied him for some years. That the portrait was by Raphael of course provided further incentive, for he was one of the masters held in highest esteem by Rembrandt's contemporaries. To van Mander, Raphael, "leading painter of his time,"[75] "who resembled a Prince more than a Painter,"[76] was the most admired Renaissance artist, the true counterpart of Apelles. He exemplified the perfect gentleman-painter, the universal virtuoso artist, who attained excellence not only through his skill and learnedness but also through his exemplary character, courtesy, and courtly grace. As he had for Vasari, Raphael also embodied the ideal of *disegno*, perfect drawing, composition, and invention.[77] Huygens too cited him, along with Michelangelo, as an artist whose work Rembrandt and Lievens should study and surpass.[78] Rembrandt was well acquainted with Raphael's compositions, primarily through reproductive engravings. He had drawn on these for several of his earliest history paintings including the *Presentation in the Temple* and the *Raising of Lazarus*,[79] suggesting he had already acquired some of the four albums of prints after Raphael that would be listed in the 1656 inventory. By then he also owned a *tronie* and a Madonna by Raphael.[80]

That the portrait was of Baldassare Castiglione must have increased its appeal. Castiglione's *Book of the Courtier*, first published in 1528, is emblematic of Renaissance self-fashioning, the attitude that viewed the formation of the self as an artful, conscious process. The most sophisticated of the Renaissance courtesy books, it was dedicated to the cultivation of a particular kind of individual, the gentleman-virtuoso. As such it served as a guide to the intellectual life, ethical conduct, and civilized behavior proper for a courtier. The verses on Renier van Persijn's engraving of Raphael's portrait (Fig. 105), made when it was in the Lopez collection, attest to Castiglione's renown in the seventeenth-century Netherlands. There too he was regarded as the embodiment

of the perfect gentleman. Although his *Book of the Courtier* was not yet translated into Dutch, it was presumably read by the educated elite, if not in the original Italian then in French, to which they sometimes seemed more accustomed than their own tongue. Castiglione's book presumably appealed to the most refined and humanistically inclined members of the aristocratized Amsterdam elite, men like Jan Six, to whom the 1662 Dutch translation was dedicated.[81]

But that some of Rembrandt's patrons subscribed to and modeled themselves after a gentlemanly ideal derived from Castiglione's does not necessarily mean that he did too. Indeed, it is hard to imagine just what he would have made of such a book. After all, he had neither the social rank nor the strong scholarly leanings of Jan Six. Still, Castiglione's image as gentleman-virtuoso may well have appealed to him, inasmuch as it corresponded to the Rubensian identity he had already created in the two self-portraits of 1633 in the Louvre (Figs. 96 and 97). Perhaps, then, it is not going too far to suggest that in his quick sketch of the Renaissance portrait Rembrandt both emulated Raphael and likened himself to Castiglione, the perfect gentleman.

That same year, he modeled his etched *Self-Portrait Leaning on a Stone Sill* (Fig. 101) on another work that he may have found even more striking and more challenging, Titian's *Portrait of a Man* (Fig. 104), which was also in the Lopez collection for a few years around 1640. Sandrart copied it in a drawing sometime between 1637, when he arrived in Amsterdam, and 1641, when the painting was sold at auction in Paris.[82] This too was engraved by Renier van Persijn, as a portrait of the poet Ariosto (Fig. 106).

The following year, 1640, Rembrandt painted the self-portrait now in London (Pl. IV), again drawing on Titian's composition and learning from Titian's painting style as well. In 1641 he found inspiration for a portrait of Saskia, the last he painted of her before her death, in Titian's *Flora*, also in the Lopez collection. The *Saskia with a Flower* in Dresden (Fig. 108) is close in size to his *Self-Portrait at the Age of 34*, which itself was originally rectangular.[83] Though not pendants in the conventional sense, the two paintings in Titianesque guise form a complementary pair and perhaps were conceived as such. Rembrandt presumably had access to the originals in Lopez's collection, which included several of his own paintings, for he drew on other works there and, more important, studied Titian's painting technique at first hand.[84]

A profound interest in the Venetian master had by this time replaced Rembrandt's earlier fascination with Rubens.[85] Titian's portrait must have struck Rembrandt on a number of levels. As court painter to Charles V, Titian too personified the virtuoso ideal. His works embodied Venetian *colore*, the rich coloring, tonal unity, and golden luminosity that appealed so strongly to the Dutch. Traditionally, Northerners like Dürer and Antonis Mor had assimilated Venetian styles more easily than those of central Italy. Van Mander's biography of Titian reflects this preference. For his lives of Italian painters he usually relied completely on—"plagiarized" might be more accurate—Vasari's *Lives*. But when it came to the Venetians he went his own way, chastising Vasari for his

pro-Tuscan bias.[86] Significantly, he departed from Vasari's estimation of Titian as lacking *disegno* to praise him as an innovator who "began to paint from life, without drawing; thus painting will be united with drawing."[87] To van Mander Titian exemplified the "rough" style of painting, the more difficult of the two manners open to the young painter. He praised Titian's painterly style, his *rouwicheyt* or roughness, as the product of maturity, good judgment, skill, and grace, for "done with great effort, it seemed to be effortless."[88] Moreover, like Vasari he regarded Titian's mature style as unique and inimitable:

> at the end he painted with bold, rough brushstrokes, so that when viewed from nearby his works had no perfection, but when viewed from afar they had good harmony. And this has been the reason why many who have wanted to imitate this, wishing to demonstrate their accomplished manner, have made things that are clumsy and unskill-ful to look at.[89]

Hoogstraten, too, praised Titian's early works as painted in a "flowing manner . . . with a loaded brush"; his late work, done with "broad brushstrokes . . . standing in relief," he regarded as more powerful, even though he attributed the style change to failing vision.[90]

Titian, in effect, legitimized the "rough" style of painting with a "loaded brush" toward which Rembrandt increasingly moved as many of his colleagues—most notably his former pupil the *fijnschilder* Gerard Dou—opted for the finer, more polished "smooth" style. His highly individual approximation of Titian's Venetian coloring, visible brushwork, rich texture, and heavy impasto would be most apparent in such works of the 1650s and 1660s as the Frick self-portrait (Pl. V), but already around 1640 he was studying Titian's notoriously difficult *rouwicheyt* at first hand and translating it into his own distinctive idiom.

Rembrandt's 1639 etching (Fig. 101) was his first response to Titian's portrait (Fig. 104). From it he appropriated the ledge and overlapping sleeve that seem to invade our space, imparting greater immediacy to the portrait.[91] Not only his pose but also his long hair and such details of his costume as the full sleeve and mantle derive directly from Titian's painting. Furthermore, Rembrandt seems to have been particularly attracted to the tightly structured pyramidal composition of his prototype, for he accentuated its triangular format by sharply tilting his beret. Yet, although it is difficult to be certain, I believe Rembrandt had seen and sketched Raphael's *Castiglione* (Fig. 102) before he etched this portrait. Certainly references to Titian's painting dominate, but Rembrandt's frontally posed head, beret, and clothing suggest he knew Raphael's as well.[92]

As we would expect, in the etching Rembrandt thoroughly transformed Titian's portrait, creating a kind of pictorial criticism of it. He reworked Ariosto's pose, rejecting his haughty sidelong glance in favor of a more assertive direct gaze. Instead of hiding his hand he brings it forward, resting it on the sill. His reinterpretation of Titian's *Ariosto* harks back partly to the *Castiglione* and

even more to his own earlier works. He had already portrayed himself in full-face in three etchings from the 1630s, the *Self-Portrait with Raised Saber* (Fig. 58) of 1634, the *Self-Portrait with Saskia* (Fig. 115) of 1636, and the *Self-Portrait in a Velvet Cap and Plume* (Fig. 59) of 1638. But now Rembrandt's soft, refined etching technique captures the virtuoso's effortless grace, or *sprezzatura*, for which Titian was renowned. In modeling his own portrait after the *Ariosto* Rembrandt achieved a kind of double emulation, imitating Titian's composition and painterly, atmospheric style—to a remarkable extent, given the difference in media—and likening himself to the famous poet.

Ariosto probably had even greater appeal than Castiglione to seventeenth-century Netherlanders, who regarded him as the greatest poet of the Italian Renaissance. His lengthy *Orlando Furioso*, a mock epic of chivalrous love and adventure in the time of Charlemagne, translated into Dutch in 1615, had a significant impact on Dutch literature. Van Mander had quoted from it numerous times and noted the friendship between Ariosto and Titian. Moreover, several Dutch painters depicted scenes and characters from *Orlando Furioso*. When Rembrandt portrayed himself as Titian had portrayed Ariosto, he likened himself to the famous poet and his art of painting to poetry. Since the Renaissance, writers on art had twisted Horace's famous dictum *ut pictura poesis* and likened painting to poetry in order to elevate its intellectual status. Hoogstraten summed up earlier Dutch opinions when he wrote:

> A like natural spirit [*geest*] rules over all the liberal arts, the same spirit that inspires the poets to [write] poems prompts painters to represent visible things, things that poets can express merely in words.[93]

What art theorists had been writing about for over a century—*poëtische geest* or *ingenium*—Rembrandt brilliantly claimed in one work.

However, I am not sure that he actually cared as much about this particular theoretical stance as did some of his more theoretically minded colleagues such as Dou and Hoogstraten. For in his next self-portrait, that of 1640 in London (Pl. IV), he assimilated both Titian's painting and Raphael's *Castiglione*, effectively undermining the allusion to Ariosto.

To be sure, the *Self-Portrait at the Age of 34* still makes clear and deliberate reference to Titian's portrait. Rembrandt's dignified pose, leaning on a ledge, is obviously derived from Ariosto's and has a similar effect of solidly anchoring the figure while thrusting him forward. At the same time, Rembrandt's style approximates the effects of Titian's fluid, painterly technique: by painting with a small but loaded brush on canvas—up to now most of his self-portraits had been on panel—Rembrandt achieved a comparable textural unity and soft, atmospheric tonalism. He also approximated Titian's extraordinary illumination, creating a warmer, almost glowing luminosity overall. As critic of Titian, he animated his own portrait, breaking up light, enlivening the patterns and folds of his garments, and setting his figure forward from the light background.

Yet Rembrandt also took greater notice of Raphael's composition and

modified his primary model in the direction of the *Castiglione*, drawing on its costume, pose, format, and coloristic harmony. Indeed, his slashed beret, white chemise, and standing collar have more in common with Castiglione's garments than with Ariosto's. Furthermore, Rembrandt's pose in the painting deviates farther than it did in the etching from Ariosto's, bringing it closer to Castiglione's. In the etching he faced the viewer with his body, like Ariosto's, in almost full profile. But in the painting Rembrandt diluted the most striking aspect of the *Ariosto*, its profile view, by turning his body toward the viewer and drawing his hand closer to his body. Rembrandt's portrait of the framemaker Herman Doomer (Fig. 109), also from 1640, provides an instructive comparison that illustrates the extent to which the London self-portrait departs from Titian's *Ariosto*. While it appears to have little in common with Titian's painting, it is very similar to Raphael's *Castiglione*, especially when compared to the reversed Persijn engraving. Herman Doomer's pose is almost identical to Rembrandt's in the London self-portrait, a similarity that becomes particularly striking when the sill in the self-portrait is covered up.

In the etching Rembrandt had already rejected Ariosto's sidelong glance in favor of more direct confrontation. In the painted *Self-Portrait at the Age of 34* he entirely abandoned Ariosto's haughty remove for a more accessible stance. Certainly the portrait is still dignified and formal, but now Rembrandt's pose seems less contrived. Without Ariosto's haughty bearing he provides more subtle insight into his character and creates more direct psychological contact with the viewer. Consequently the painted portrait has a relaxed ease and grace more like that of Raphael's Castiglione.

Possibly Rembrandt intended to liken himself both to Ariosto the poet and to Castiglione the courtier. If we read the allusions in the *Self-Portrait at the Age of 34* as concretely as this, then we understand Rembrandt to be, all at once, emulating Titian and Raphael, likening painting to poetry through Ariosto, and alluding to the courtly ideal through Castiglione. However, this intricate, contrived program, in which no single idea comes to the fore and Rembrandt's identity becomes virtually subsumed, seems more like an iconographer's dream than the artist's conception.

Rather, I suggest that when he set out to paint this, his most ambitious self-portrait to date, Rembrandt forgot about Castiglione and Ariosto to the extent that they became virtually interchangeable as ideal, learned Renaissance gentlemen. True artist that he was, he centered on the makers of his prototypes rather than their sitters. Thus he focused his attention instead on Raphael and Titian. By emulating these two great Italian masters and by unifying their two, usually opposed, manners, central Italian drawing and Venetian painterly coloring, he claimed mastery of his profession and his place in artistic tradition.[94]

Compared to his earlier formulations of the virtuoso image, Rembrandt's costume is more obviously historical and his allusion to portraits of another, more distant, era is more explicit. This shift of focus from Rubens to the Renaissance might be explained by Rembrandt's increased access to Italian paintings in the growing Amsterdam collections and art market, or by a sense that

he had exhausted his interest in Rubens. Or it might be viewed as a stylistic progression, a maturing of Rembrandt's artistic sensibilities. But considered in a different light this shift can be interpreted as another step in Rembrandt's creation of his self-image. He no longer emulates or surpasses a contemporary. Raphael and Titian were artists of near-mythic proportions, giants from a bygone era. Rembrandt puts himself in their league. Yet the obviously imaginary, romantic, even theatrical nature of his Renaissance guise reveals the fiction of his virtuoso image, casting doubt on the very validity of this ideal of the artist. It is a thing of the past and of the imagination. It remains to discover what image Rembrandt created in its stead.

4

The Artist
in the Studio

IN THE DECADE following his ambitious *Self-Portrait at the Age of 34* (Pl. IV) of 1640 Rembrandt produced fewer self-portraits than at any other time. He appears to have lost interest in the ideal of the virtuoso artist that had occupied him in the 1630s. His few painted likenesses from the early 1640s, like the oval self-portrait in Karlsruhe (Fig. 110), are weaker restatements of this imaginary role. When he returned to self-portrayal in 1648 with the powerful etched *Self-Portrait Drawing at a Window* (Figs. 112–114) he projected a radically revised image of himself, as a working artist in studio attire. Henceforth Rembrandt would turn his attention to the ideal of the artist as maker, portraying himself as draftsman, etcher, and, finally, painter. Concern with his craft and with the artistic process, which he had previously explored only in images of the artist in the studio, would now become the basis of his self-portraits.

Several explanations have been advanced for Rembrandt's hiatus in self-portrayal during the 1640s. Personally, this was a decade of increasing difficulty. Saskia died in 1642, probably after a difficult pregnancy or long illness to judge from the many drawings of her in bed, and Rembrandt was left alone with their year-old child, Titus. Living in the grand house on the Breestraat purchased in 1639, he was financially well off. In 1647 he estimated their joint estate at the time of Saskia's death at a minimum of 40,750 guilders. The estimate was made at the insistence of her relatives, who perhaps felt they needed to protect Titus's inheritance from Rembrandt's poor management or from the new woman in his life.[1] She was Geertge Dircx, Titus's nursemaid, with whom Rembrandt became intimately involved in an affair that would result in a disastrous series of ugly lawsuits, beginning in 1649, and finally in her committal to a reform institution.[2] His relation with Geertge must have ended by 1648, for by then a new companion, Hendrickje Stoffels, had entered his household. Hendrickje's presence may have given him renewed confidence and vigor.

Artistically, the 1640s signaled a change of direction for Rembrandt. We must discount much of the myth of poverty and decline after *The Nightwatch*, which, as a controversial *tour de force* unlike any other group portrait, met with mixed reactions yet assured his fame.[3] It is true, though, that Rembrandt was no longer the most fashionable painter in Amsterdam, and his output had

fallen off. In 1642 a client, Andries de Graeff, refused to pay for a portrait for reasons unknown. Moreover, we know of few commissioned works from this decade with the exception of the *Birth of Christ* and *Circumcision* he painted for Frederik Hendrik in 1646. In the following year he was passed over in favor of more classicizing painters when Constantijn Huygens selected artists to decorate the new palace in The Hague, Huis ten Bosch.[4]

Presumably many of his paintings now were made for the open market, and used subjects of his own choosing. These tended, in contrast to the dramatic Old Testament narratives of the 1630s, to be simpler, more intimate New Testament subjects like the birth of Christ and the Holy Family. Moreover, as he painted less his production increased in the more private media of etching and drawing.

Two themes in the graphic works of the 1640s show him turning inward and give a clue to how his conception of himself was changing. His representations of male models posing, a subject he transferred from the usual medium of drawing to etching, reflect his deepened concern with life in the studio and with the practice of his art (Fig. 120).[5] His many landscape drawings and prints record his walks in the countryside around Amsterdam. Rembrandt's exploration of the outdoors lasted from about 1640 to 1653, and his two periods of greatest landscape activity—from 1640 to 1645, culminating in his most naturalistic painted landscape, the *Winter Scene* of 1646, and from 1650 to 1653—coincided with his suspension of self-portrayal. This suggests that the solitude of nature served as an alternative form of self-examination, for rural retreat traditionally signified a renunciation of worldly values for the *vita contemplativa*. In the seventeenth century, retirement to nature was widely acclaimed as promoting the harmony and purity of the soul. Medical books advised the troubled melancholic to seek the solitude of nature. Dutch pastoral art and poetry, especially that of Heinsius and Huygens, celebrated the poet or distraught lover who turns from society to contemplate the soul in nature. Perhaps the closest parallel to Rembrandt's landscape interlude can be found in the *hofdichten* or country house poems, like Huygens' *Hofwyck* of 1653, that describe country estates as places of refuge from the city, sanctuaries made for contemplation.[6] We should be wary of drawing too close a parallel between Rembrandt's interest in landscape and these loftier pastoral literary modes. Yet if freedom from society was the aim of rural retreat Rembrandt's landscape drawings and etchings may well have fostered the direct communion with self and nature that the poets celebrated.

For Rembrandt the 1640s was a decade of increased independence, of breaking away—from Rubens, the court, and fashionable Amsterdam, and even from his home and studio for the outdoors. To be sure, he had been an independent from the outset, but beginning with his daring transformation of the group portrait in his largest public commission, *The Nightwatch*, he seems to have announced his mastery and pursued his independence with greater confidence. His unconventional living arrangements after Saskia's death, his refusal to go along with changing aesthetic taste, and his concentration on more

personal media and subjects all suggest increasing nonconformity and self-suf-
ficiency. When we find him again receiving more commissions, in the late 1640s
and 1650s, his patrons are no longer fashionable Amsterdammers but a nar-
rower group of intellectuals, writers, and artists, who sought him out for his
unique talent.[7]

As Rembrandt became assured of his own originality and individuality,
the persona projected in the 1640 self-portrait (Pl. IV) must have seemed un-
satisfactory, for it depended on modeling himself after other artists and con-
forming to an established and, it must be admitted, rather old-fashioned ideal.
Yet he had invested a decade of effort and thought in transforming that image
into an appropriate expression of his own ideals. Other artists from his circle,
notably Ferdinand Bol and Govert Flinck, recognizing the brilliance of his in-
vention, had been quick to imitate it (Fig. 111).[8] Though this courtly Renais-
sance self-portrait type did not sit well with his emerging independence, it must
have been hard to relinquish. It took Rembrandt eight years to reformulate his
self.

A NEW SELF

In 1648 he returned to self-portraiture with a dramatically different con-
tent. In the etched *Self-Portrait Drawing at a Window*[9] (Figs. 112–114) Rem-
brandt's real professional role appears for the first time to be sufficient basis
for a self-portrait. Compared to his previous etched likeness, the grandiose *Self-
Portrait Leaning on a Stone Sill* of 1639 (Fig. 101), this one is down-to-earth,
direct, and authentic. No longer elegantly costumed, he wears mundane studio
attire; no longer play-acting, he sits at a table drawing. For the first time we
sense that he has looked in the mirror and is portraying himself, without em-
bellishment, as a working artist. The man he sees has now entered middle age,
gained weight and thickness in his face, and lost many of his pretensions. From
his modest moustache to his simple artist's smock and collarless white shirt, he
is a man who works with his hands.

Departing from his Renaissance dream, he presents himself as a confident,
contemporary craftsman. Instead of an elegant beret he wears a prosaic, mid-
dle-class small-brimmed hat, which brings to mind the "freedom hat" widely
used as a symbol of Dutch liberty in political allegories on the independence of
the Netherlands.[10] His revised self coincided with a wider climate of optimism.
In 1648 the Treaty of Münster finally ended the war with Spain and brought
official recognition of Dutch independence. That same year construction began
on the grand new Amsterdam town hall, a timely and impressive monument to
the city's glory. At the height of her wealth and power, Amsterdam stood to
benefit further from the cessation of fighting: her future seemed, if only for the
moment, especially bright.

In keeping with his everyday attire, Rembrandt presents himself with an
unprecedented dignity, commanding yet austere. Placed relatively high in the
picture space, he faces the viewer directly, his assured, masterful presence en-
hanced by the solid triangular composition. To achieve this imposing directness

and clarity of form he seems to have drawn on an earlier portrait type. The half-length portrait with the sitter placed in an interior next to a window, exemplified by Dirk Bouts's *Portrait of a Man* of 1462 in London and Dürer's self-portrait in the Prado, was a fifteenth-century Northern invention that quickly spread to Italy.[11] Rembrandt's portrait bears a close resemblance to an Italian example, the powerful, volumetric *Portrait of Perugino* of 1503 by Lorenzo di Credi.[12] Although we do not know what examples were available in Amsterdam, clearly some were. In short, when Rembrandt renounced his elegant Titianesque posture he found inspiration in an earlier, simpler portrait idiom.

The most essential change from his own earlier likenesses is that he now presents himself as a working artist. That he is drawing accentuates the immediacy of a study made from life. Rembrandt had not previously portrayed himself working with his tools, with one exception. In the etched *Self-Portrait with Saskia* (Fig. 115) of 1636 he draws on paper, probably with a *porte-crayon*, a two-ended chalk holder.[13] There identifying himself as a draftsman significantly enhanced his image: in contemporary Italian art theory, which had its greatest impact on his thinking during the 1630s and 1640s, *disegno* or drawing, the most elevated of the arts, was regarded as the father of all the arts and the most direct expression of the imagination.[14]

Although the *Self-Portrait with Saskia* shows Rembrandt at work, as in his other imaginary portraits of the 1630s both he and his wife wear old-fashioned clothing. Furthermore, Rembrandt has transformed the traditional domestic tranquility common in a double or marriage portrait. The figures are disconcertingly out of scale, and their relation is ambiguous: that of Saskia has the quality of an afterthought, being obviously smaller and not as deeply bitten. In fact, she may have been etched first and then stopped out when Rembrandt added himself, as indicated by lines of her garments that continue under his. He dominates and, with his fanciful, plumed beret shading his eyes, his open collar and scholarly fur-trimmed cloak, commands our attention as the artist consumed by his work, his wife—whether she is his muse or his model—relegated to the background.

In the 1648 *Self-Portrait Drawing at a Window* (Figs. 112–114) Rembrandt abandoned his fanciful Renaissance image and the romanticized melancholic mystery of his shaded eyes for an attitude of serious, rational study. Rather than drawing per se, he is probably working with an etcher's needle directly on the plate—indeed, making the very portrait we see printed before us—an activity that would not carry quite the same lofty theoretical weight.[15] Justifiably, he takes pride in his mastery of printmaking and in his technical advances during the 1640s, the decade that culminated in the *Hundred Guilder Print*.

He worked up this portrait in three, or possibly four, states, using etching and drypoint from the outset. The print is remarkable as a study in rich, dark shades, heightened by contrast with the white of the window. In the unsigned and probably unfinished first state (Fig. 112) Rembrandt set the composition

and tonal values. The rich, velvety drypoint burr in early impressions clearly conveys the direct involvement of his hand. In the second state (Fig. 113) he added his signature and the date in the window, and he firmed up the modeling over much of the print, deepening tonality but losing spontaneity. In the third state Rembrandt added parallel shading to his right hand, left side, and forehead. The fourth (Fig. 114) is somewhat problematic. The heavy-handed reworking of the face, especially, has raised doubts as to whether this state is by Rembrandt.[16] Yet the addition of a sketchy, but seemingly autograph, view out the open window into a landscape accords with Rembrandt's other main interests in the 1640s. If this state is by him, it is the one time he juxtaposes himself with the outdoors. Rembrandt's frank self-portrait reminds us that the mode of contemplation afforded by his landscape interlude has now given way to an alternative mode of self-study, one that is more subjective, more introspective, and literally darker.

The portrait's deep tonality and imposing clarity are in keeping with the quieter mood and monumental simplicity of Rembrandt's biblical subjects from the same year, for example the *Supper at Emmaus* in the Louvre and his etching *The Pharisees in the Temple*. This change in his formal means and artistic goals coincided with a more direct approach to the purpose of the portrait. His *Self-Portrait Drawing at a Window*, an occupational portrait with nothing to distract from the artist at work, is one of several etched portraits from this period in which Rembrandt established his sitters' professional or intellectual roles more fully than he had in the past. In the illusionistic posthumous portrait of 1646, Jan Cornelis Sylvius is shown as the eloquent preacher he was. Jan Six, in the unusual genre-like full-length portrait of 1647, is characterized as a sensitive gentleman-poet who took great pride in his humanistic interests, poetry and plays. He reads by a window in a dark room in a state of melancholic absorption, his eyes downcast, his collar carelessly undone.[17] At about the same time Rembrandt portrayed the landscape painter Jan Asselyn as a well-dressed artist beside a table covered with his tools and books and in front of a large painting on an easel (Fig. 116). In the second state the easel was burnished out, suggesting that the sitter preferred a more gentlemanly, learned presence.

But Rembrandt had now rejected this gentlemanly role for himself, choosing instead to appear as a professional who derives his pride and dignity from his craft. Of course, he was not the first to do so. Many artists portrayed themselves with their tools, but most also asserted their gentlemanly status by wearing fashionable, formal attire. Rembrandt's working attire appreciably altered this tradition.

Owing to the unique reflexivity of self-portraiture, the portrait as artist is one of the few occupational studies with a distinct tradition. Early Netherlandish painters like Rogier van der Weyden and Dirk Bouts had shown themselves in the mask of their patron St. Luke painting the Virgin.[18] During the sixteenth century, painters portrayed themselves as famous ancient artists to substantiate their association with Antiquity and the classical ideal.[19] Antonis Mor's self-

portrait of 1558 (Fig. 140), showing the formally attired craftsman at his easel, reflects the most popular type at this time. Yet, in keeping with the humanist ideal of painting as a liberal art, the portrait of the artist as craftsman was soon eclipsed by that of the virtuoso painter, embodied in self-portraits by Rubens and van Dyck (Figs. 93 and 79), which tended to suppress the manual aspect of his art. As we have seen, Rembrandt favored this kind of self-portrait from the early 1630s to around 1640.

Prior to his *Self-Portrait Drawing at a Window* he had explored the practical side of his profession in several representations of the artist's studio. These works, mostly on paper, provide evidence of what he considered to be the primary aspect of his work and are the closest he comes to making any kind of conceptual statement about his art. They suggest that his ideas about art are tied more closely to practice and technique than to abstruse allegorical concepts.

Some twenty years earlier, while still in Leiden, Rembrandt had first treated the subject of the painter in his *schilderkamer* in the *Artist in His Studio* (Fig. 117), his only known painting of this extremely popular subject.[20] The setting is a bare, shabby room with cracked plaster walls, sparsely furnished with studio essentials: a table with several flasks, a color-grinding stone, and a palette hanging on the wall. Bright raking light strikes the painter and illuminates the front of his panel, which rests on the easel facing away from the viewer. The painter, whom Rembrandt endowed with his own features, stands far back from, and is dwarfed by, the huge easel looming in the foreground. He holds a palette, mahlstick, and several brushes and is clad in a floppy beret and a fanciful historicized painter's robe rather than the fashionable jerkin and breeches that painters often wear in studio scenes.[21] His large hat and long robe, combined with the scale of his easel, suggest that he is quite young and may allude to the notion, expressed by van Mander, that talent appears early in the gifted.[22]

Ernst van de Wetering has interpreted the painter's exaggerated distance from his easel as a display of the preferred practice of composing or inventing a work before beginning to execute it.[23] Seventeenth-century Dutch writers on art advised the painter to start a picture by first forming a *denkbeeld* or mental image of it. Van Mander wrote metaphorically that the art of painting is first begotten by the spirit or mind (*gheest*) and borne by inward imagination (*inwendinghe inbeeldinghen*), before it can be reared by the hand.[24] He devoted a chapter of *Den grondt der edel vry schilder-const* to the mental processes of artistic creation, namely *ordinanty* (roughly translated as composition) and *inventy* or invention.[25]

Hoogstraten, following Franciscus Junius, illustrated the need to form a mental image of one's work by retelling the story of a famous competition among three landscape painters.[26] The first contestant, Knibbergen, immediately put his face up close to his large panel and began to paint individual details. The second, Jan van Goyen, smeared his whole panel with color so that it resembled marbled paper and then from this "chaos" selected the natural forms

from which he derived his composition. The third painter, Jan Porcellis, was judged the winner because he worked from *idea*. But at the start of the competition the onlookers had little hope for him, for

> It seemed at first that he mischievously wasted time or did not know how to begin: this was because he first formed in his imagination the whole shape of his work, and made a painting in his mind, before he put color on his brush.[27]

The young painter in Rembrandt's *Artist in His Studio* appears to approach his work in this preferred manner, by first making a painting in his mind. Holding his brush tensely, he seems anxious to translate his thinking into paint. The warm light streaming into the room and illuminating the panel may well be a metaphor for artistic invention and imagination.[28] After all, the imagination was a central concern of Rembrandt's self-portraits from this period. Support for the argument that he had this model of invention in mind is also found in his near-contemporary drawing *A Painter at the Easel* (Fig. 119).[29] Here the painter, who could well be Jan Lievens to judge from his profile self-portrait (Fig. 4), bends forward to scrutinize a small section of his panel. He presumably works by chance like van Goyen, picking forms out of the colors smeared on the support, a technique for which Lievens was known.[30] Possibly Rembrandt's images of himself and Lievens were motivated by this contest, for if it actually took place it would have been between 1626 and 1632, the year of Porcellis's death, and very likely in Leiden, the home of van Goyen and Porcellis.

Rembrandt continued to emphasize artistic practice when he returned to the subject of the artist around 1640. His unfinished etching *An Artist Drawing from a Model*[31] (Fig. 121), for which there is a preparatory sketch in the British Museum,[32] glorifies *Teycken-const* or the art of drawing as "Den vader van 't schilderen," the basis of both painting and etching.[33] Here Rembrandt demonstrated the theoretical importance of drawing through his technique as well as by evoking an ideal usually associated with classical art, namely that of beauty as embodied in the female nude.

A draftsman, probably Rembrandt himself, identified as a painter by the easel behind him, sits drawing from a model posed on a low platform. He wears a white painter's turban, though his plumed beret, signifying his imaginative capacity, hangs on the wall. Holding his sketchbook on his knees, he is more clearly defined as a draftsman in the etching than in the preparatory sketch. He sits between his model and his stretched canvas as if to indicate (as Slatkes has suggested) that drawing is the necessary connection between the two.[34] Drawing is also identified as the foundation of the etcher's art by the print's unfinished state. Only the shadowy dark background and the sculpted bust on the chimneypiece are finished, while the rest is roughly sketched in. By leaving—presumably deliberately—part of the print in the form of a rough compositional sketch, Rembrandt exposed the process by which it was made and emphasized that drawing is also the starting point for etching.[35]

85

But the *Artist Drawing from a Model* has another, still more interesting, level of meaning, for it draws upon the classical legend of Pygmalion, the sculptor who fell in love with his own sculpture and brought it to life. Specifically, Rembrandt's source was an etching by Pieter Feddes van Harlingen (Fig. 122).[36] He transported the scene to a darkened studio and presented it from a lower viewpoint, so that the model in the foreground towers over the seated artist. And, of course, he transformed the love-struck sculptor, gazing longingly at his sculpture, into a painter with a ravishing live model.[37] But that Rembrandt's print was known in the eighteenth century as "the statue of Pygmalion" was probably only partly due to its similarity to the pictorial tradition.[38]

In the Netherlands Pygmalion embodied a narcissistic type of artist motivated by self-love rather than by the more noble love of art.[39] Van Mander calls those artists

> Pygmalions who blindly fall in love with their own works, and who unwittingly are lesser artists than they imagine and are ridiculed by those who understand art . . .[40]

The inscription on Feddes van Harlingen's etching begins "Volght niet Pygmalion" (Do not follow Pygmalion), making it clear that Pygmalion, whose self-love impedes self-knowledge, is a negative exemplar. Many of Rembrandt's early biographers, strongly biased toward a classical ethos, accused him of just such self-interest because he refused to abide by the rules of art. In relying on the Pygmalion etching Rembrandt himself may have been responding to the admonition in its caption. His draftsman is a sort of anti-Pygmalion, motivated by his love of art for its own sake. In contrast to the self-satisfied artist who finds perfection in his own work, he displays his love of the art of drawing by glorifying it as the foundation of his art. To underscore his difference from the ancient sculptor who fell in love with his own work, Rembrandt left his etching unfinished, indicating that neither is it perfect nor is he satisfied with it.[41]

Whether or not the allegorical *Artist Drawing from a Model* (Fig. 121) represents a lifelike studio situation, it reflects the academic ideal of instruction from the nude model, which had fairly recently spread from Italy to the Netherlands and which we know was part of Rembrandt's teaching practice. Especially in the years after 1640, Rembrandt and his pupils must have spent a good deal of time drawing from the nude. A somewhat later drawing in Darmstadt (Fig. 118) by an unidentified follower of Rembrandt provides a more literal picture of artists drawing from a nude model in his studio.[42] Rembrandt's etching *Het Rolwagentje* (Fig. 120) juxtaposes male models with the image of a child learning to walk in a walker (*rolwagen*) to convey the idea that practice, in the form of life-drawing, is the necessary foundation of painting.[43]

His 1648 *Self-Portrait Drawing at a Window* (Figs. 112–114), then, came at a time when Rembrandt was especially concerned with his artistic practice. Close to the same time several other Dutch artists, notably Gerard Dou and Gerard van Honthorst, portrayed themselves as draftsmen, but in the *pictor doctus* mode (Figs. 77 and 131). Compared to these gentlemanly self-portraits,

Rembrandt's image is reduced to its essentials; he has eliminated the trappings of learnedness and any hint of fashionable attire, to concentrate exclusively on his craft. The first of many likenesses in which he explored his professionalism, the *Self-Portrait Drawing at a Window* marked the beginning of a more independent approach to self-portraiture.

As he had several times before, Rembrandt first formulated his new self in etching before realizing it in paint. From this image as working artist two types of painted self-portrait would emerge in the early 1650s, that in studio attire and that showing him in the act of drawing. The large, powerful three-quarter-length portrait dated 1652 in Vienna (Fig. 123) was Rembrandt's most ambitious painted self-portrait since 1640.[44] In contrast to his romanticized Renaissance man in the *Self-Portrait at the Age of 34* (Pl. IV) he now puts forward an equally impressive person wearing only studio attire. As in the 1648 etching, he wears a brown painter's smock, belted with a sash, over a black jerkin and a collarless white shirt. Instead of the brimmed hat he has the more customary black artist's beret. His drab brown garb, his muted hands, and the overall dark tonality of the painting focus our attention on his face and his direct, authoritative gaze.

The aggressive informality of this portrait must have seemed shocking at the time. With a disarming sense of real presence, Rembrandt stands frontally, his arms akimbo, his thumbs tucked under his belt. His proud, confrontational worker's stance conveys a self-assurance matched only in a few of the late paintings. In short, Rembrandt presents himself with unprecedented inner authority. His commanding pose and the dignified three-quarter-length format manifest a confidence new in Dutch portraiture of the 1650s. We see this quality already in his portrait of the printseller Clement de Jonghe (Fig. 138) of 1651 and will find it in his painting of *Jan Six* of 1654, as well as in works such as Frans Hals's *Portrait of a Man* of about 1650 in New York. This new monumentality probably reflects Rembrandt's acquaintance with a sixteenth-century Venetian three-quarter-length portrait type represented by Titian's *Young Englishman* in Florence. But whatever its dependence on Venice, Rembrandt's self-portrait in Vienna is remarkably fresh and original.

We do not know what prompted Rembrandt to draw a full-length version of it in the late 1650s (Fig. 124).[45] He stands in the same position, directly confronting the viewer, and he wears the same painter's smock, though a molded felt hat like that in the 1648 etching now replaces his beret. An attached inscription in a seventeenth-century hand identifies the work as "Drawn by Rembrandt van Rhijn after himself the way he was dressed in his painting studio."[46] Whoever wrote it had noticed something unusual, for few if any painters had portrayed themselves so informally in their everyday working attire, and few would be influenced by this image. One exception is the impressive self-portrait of about 1648–50 by Carel Fabritius (Fig. 126), who had probably been an assistant in Rembrandt's shop in the early 1640s.[47]

Rembrandt continued to present himself as working artist in a bust-length portrait of 1655 in Vienna[48] and in a monumental half-length painting dated

1660 (Fig. 125). Both show him in his prosaic studio smock. X-rays and auto-radiographs of the New York painting reveal that Rembrandt tried out several hats, from a simple white painter's turban to a huge black velvet beret that was even larger than the oversized hat in the finished portrait.[49]

A second type of image stemming from the *Self-Portrait Drawing at a Window* shows the artist drawing, but not in such mundane attire. Rembrandt painted his *Self-Portrait Drawing in a Sketchbook* probably in 1653. Although the original is lost, it is preserved in several copies, the best being that in San Francisco (Fig. 127).[50] Now Rembrandt has retreated somewhat from being a simple working man. He still wears a beret, but instead of the brown smock he wears more elegant, though understated, clothes: a black jacket with gold buttons, open at the neck to reveal bright red and white, and over this a mantle with fur trim. His more formal clothing may reflect his elevated notion of drawing.

Rembrandt's last etched self-portrait (Fig. 128), dated 1658, is known in only two impressions. Again, he presented himself drawing, most certainly on a small copper plate he holds in his hands. This likeness has not been universally accepted as by Rembrandt, yet it accords stylistically with his other prints of the same year, virtually the last in which he produced any etchings.[51] Technically it is similar to other late etchings, the portraits of the writing-master Coppenol and the *Woman Bathing by a Brook* in particular, in which Rembrandt lost his customary sketchy, loose touch. Instead we see many straight, often short, parallel strokes, made with a labored stiffness, as if he were now handling the tiny etcher's needle the way he had come to use his palette knife to daub on short strokes of paint.

Although the figure occupies virtually all of the picture space, this portrait is similar in pose and conception to his *Self-Portrait Drawing at a Window*. Rembrandt sits at a table wearing studio garb and painter's turban. Again he looks directly at the viewer, or, one supposes, into the mirror as he draws his reflection. But now he concentrates on his face almost exclusively. In a way that is reminiscent of the early *Self-Portrait Leaning Forward* (Fig. 14), he barely sketches in his body and hands. His face is fully lit and only summarily defined, accentuating his black, remarkably penetrating eyes. Only these extraordinarily alive and powerful eyes give us any indication that in the same year he produced one of the greatest self-portraits of his career.

THE SOVEREIGN SELF

These forthright images of the 1650s in no way prepare us for Rembrandt's monumental painting of 1658 in the Frick Collection (Pl. V), which is larger and grander than any of his other self-portraits.[52] Seemingly claiming the proverbial title "Prince of Painters," he occupies his armchair as if it were a throne, and his eyes engage the viewer in a direct, masterful way. His elegant, fanciful costume and unusual frontal seated pose mark a return to the imaginary mode of his *Self-Portrait at the Age of 34* (Pl. IV). Again he draws on older portrait traditions, but in contrast to his earlier emulative virtuoso per-

formance the painting of 1658 relies on no clearly identifiable prototype. In-stead, Rembrandt now demonstrates a deeper understanding and more thor-ough assimilation of Venetian painting and, at the same time, a greater independence from that tradition. Responding to the past with greater origi-nality, he projects unsurpassed dignity and importance.

Rembrandt did this portrait near the end of a decade of considerable hard-ship. In 1650 his relation with Geertge Dircx had deteriorated to such an extent that he put into action a scheme to have his former mistress committed to the *Spinhuis* at Gouda, an institution for the reform of morally delinquent women. Over the next few years her relatives harassed him to get her released.[53] Liti-gation ended only in 1656 with Geertge's death. Meanwhile, in 1654 his new companion, Hendrickje Stoffels, having been summoned three times, went be-fore the Amsterdam council of the Reformed church where, it is recorded, she "confesses to fornication with Rembrandt, is gravely punished for it, admon-ished to penitence, and excluded from the Lord's Supper."[54] How much these events, which resulted in a number of legal proceedings between 1650 and 1656, affected Rembrandt personally and professionally remains a question. They may well have compounded his main difficulty, financial collapse.

His financial troubles began coming to a head in 1653, when creditors to whom he was heavily indebted started to demand payment. He still owed 7,000 guilders on the large house on the Breestraat that he had purchased in 1639 on the condition that its price of 13,000 guilders be paid off in "five or six years."[55] In December 1655 and January 1656 he arranged to sell a number of his pos-sessions at seven public auctions, presumably to raise money to pay his debts.[56] By July 1656, the financial strain had become so great that to stave off outright bankruptcy he applied for a *cessio bonorum*, a voluntary ceding of his goods to the state to be sold for the benefit of his creditors. The application had to be accompanied by an inventory prepared under the supervision of the *Desolate Boedelskamer* (Chamber of Insolvent Estates), the source of a remarkable list of his possessions and extensive art collection. The *cessio bonorum* was granted in August 1656.[57] Almost immediately a guardian was appointed for Titus, in accordance with official regulations.[58] Over the course of the next two years, until December 1658, Rembrandt's things were sold at a series of public auc-tions. The loss of his vast collection of paintings, prints, and other art objects must surely have been devastating to an artist for whom these constituted a visual library essential to the practice of his profession.[59]

In February 1658, his attempt to assign it to Titus having failed, Rem-brandt's house was sold, and within the year he had moved into a smaller rented house on the Rozengracht in the working-class section of Amsterdam called the Jordaan.[60] It is impossible to know just how he responded to these events. But the sheer number of pertinent documents suggests that the series of sales and the move must have been disruptive of his work and probably dam-aging to his self-esteem.

Despite these setbacks, this decade was intensely creative. Although he had been passed over for major commissions in Amsterdam, his work was interna-

tionally sought after and he enjoyed the patronage of a select group of connoisseurs. During the 1650s he produced some of his finest portraits: the paintings of Nicolaes Bruyningh and Jan Six, the *Anatomy Lesson of Doctor Joan Deyman*, and a number of etched portraits, some of which were surely commissioned. In 1655 he was asked to etch four illustrations for Rabbi Menasseh ben Israel's *Piedra Gloriosa*.[61] Some of the most important commissions of his later life, the *Syndics of the Drapers' Guild* and the *Oath of Claudius Civilis* for the Amsterdam town hall, would not come until the early 1660s, but they nonetheless attest to his continued fame. Still, the order for the entire series of paintings for the town hall had initially gone to Govert Flinck, and only after his death was Rembrandt asked to do one of them. When he painted the Frick self-portrait (Pl. V) in 1658, he was not receiving the attention he had in 1640.

Unless we can read Rembrandt's cares in his lined face, stoically clamped mouth, and piercing eyes, this monumental portrait reveals nothing of his difficulties. It is as if he created his most extraordinarily imposing and original appreciation of himself to compensate for these hardships, or to celebrate his freedom from obligations.

Contemporary portraits underscore the striking uniqueness of Rembrandt's frontal pose and lavish imaginary costume. Dutch portraiture of the 1650s and 1660s is characterized by monumentality and a broadened awareness of new sources and foreign traditions. The three-quarter-length seated format, though rarely fully frontal, was commonly used for portraits of persons who commanded respect—scholars, preachers, elderly men and women. Yet nowhere among the sober *burgerlijk* portraits by Hals, Bol, van der Helst, or others do we find any formal precedent for Rembrandt's 1658 self-portrait. Even Rembrandt's most monumental mature works, the painting of Jan Six for example, are no match for this portrait's unprecedented grandeur. Current trends simply do not account for its patriarchal quality. A slightly later work, Ferdinand Bol's *Portrait of a Gentleman* (Fig. 129) of 1663, which draws on the Frick painting's frontal pose and its colorful gold and red garb, merely brings out the contrast between fashionable elegance and Rembrandt's hieratic splendor.[62]

Nor does any precedent exist for Rembrandt's picture among contemporary self-portraits and portraits of artists. It conforms neither to the convention of showing the artist working at his profession nor to that of emphasizing his gentlemanly social status. Though he is seated, the work is independent of the type showing the painter at his easel holding his palette, brushes, and mahlstick, like Rembrandt's later self-portrait in the Louvre (Fig. 139) and Bartholomeus van der Helst's portrait of Paulus Potter of 1654 (Fig. 130).[63] Another portrait type presents the artist as a *pictor doctus* or learned painter, whose knowledge is the foundation of the art of painting and the basis for its claim to be one of the liberal arts. Gerard Dou's self-portrait of 1647 (Fig. 77) and Gerard Honthorst's of 1655 (Fig. 131) are conceptual statements in which the gentleman-artist sits, like a scholar, at a desk, surrounded by objects referring to his mastery of *disegno*, scientific learning, and classical art. On the other

hand, van der Helst's imposing self-portrait of 1662 (Fig. 132) and that by Jan Lievens of about 1637–40 (Fig. 133) convey the sitters' high social status without providing any indication of their craft. Inasmuch as Lievens is seated at neither a table nor an easel, but relaxes wearing elegant golden garb, his portrait is perhaps the closest Dutch precedent for the Frick painting. Yet Lievens's fashionable dressing gown or *kamerjas* and his air of casual nonchalance run quite contrary to the gravitas of Rembrandt's painting.

Rembrandt's magnificent clothing is the most striking feature of the picture. The nature and origin of this outfit have perplexed generations of scholars, who have tended to see it as oriental or princely. More recently it has been inaccurately called studio attire.[64] Certainly not the mundane working clothes of a contemporary painter, of the sort he wears in the Vienna self-portrait (Fig. 123), it is most definitely a fanciful, old-fashioned costume. Though it has elements in common with that in the *Self-Portrait at the Age of 34* (Pl. IV), it was not conceived with the same attention to historical accuracy. Instead it is a product of Rembrandt's fancy. He seems to have fashioned a guise for himself that combined garments he used in his history paintings with those he associated with his being an artist. Quite possibly this costume represents his somewhat imaginative conception of historical artist's attire. As such it would connote what he saw to be his particular role as artist, that of the history painter who continues in the tradition of the great painters of the past.

Rembrandt's large, black slashed beret had by this time become the hallmark of the painter not only in his own self-portraits but in those of many other artists as well. The fur-trimmed robe or tabard draped over his shoulders had originated in the sixteenth century and by the seventeenth had acquired venerable associations as the garment of elderly men, ministers, scholars, and others engaged in sedentary, learned pursuits. Though still worn by some in the 1650s, it was by then largely out of style. Rembrandt's splendid golden tunic, with its square neckline, brocade lapels, and red sash, has more distant historical associations, being an imaginative reinterpretation of Renaissance garb. These garments closely resemble those in which he and his contemporaries attired mythological gods and biblical and historical heroes. A similar long tunic with brocade lapels is worn by the god Jupiter in the *Jupiter and Mercury Visiting Philemon and Baucis* (Fig. 135), which also dates from 1658, by the high priest in the etched *Presentation in the Temple in the Dark Manner* of about 1654, and by the Batavian leader in the *Oath of Claudius Civilis* painted for the town hall in 1661. Brightly colored sashes adorned with gold ornaments lend an exotic air to costumes in paintings such as *Samson's Wedding Feast* and *The Reconciliation of David and Absalom*.

The silver-knobbed stick Rembrandt holds in his left hand brings to mind both a scepter and a mahlstick, the painter's tool that often appears in self-portraits.[65] Though it is not clearly identifiable as a mahlstick, which would be smooth with a round knob at the end, it cannot be dismissed as such either. Perhaps it conflates a mahlstick and a walking stick or cane. During the seventeenth-century canes, far from being mere aids to walking, were fashionable

accessories carried by members of the aristocracy. Charles I of England considered the cane to be a symbol of his authority,[66] but it reached its height as a symbol of distinction in France when Louis XIV, who always carried one, decreed that no one else could do so in his presence. In the Netherlands, walking sticks came into vogue, along with French fashions and styles of portraiture, in the last third of the century. Rembrandt used canes primarily in his history subjects and historicized portraits. A biblical nobleman carries a cane in the *Descent from the Cross* (Fig. 149), and the elderly Jacob Trip holds one in the masterful late portrait in London. The only other self-portrait in which Rembrandt holds such a prop is the early one in oriental garb (Fig. 50) which, as we have seen, derived from a portrait convention appropriate to a ruler.[67]

In keeping with his fanciful costume, the style and composition of the Frick painting reflect Rembrandt's profound assimilation of earlier artistic traditions, especially that of Venice. During the 1650s and 1660s he drew increasingly on Venetian painting techniques, accentuating two stylistic features in particular: roughness of handling and rich, warm coloring. For van Mander and Hoogstraten, Titian epitomized the painter who had evolved stylistically from the easier "smooth" manner to the more difficult "rough" one, in which forms are loosely defined and paint is applied in broad strokes leaving heavy impasto. Rembrandt's distinctive textural, painterly technique in the Frick self-portrait has many affinities with that of Titian's late works, although the differences between their late styles are considerable. Like Titian he painted with a loaded brush without mixing the colors on the canvas. From the very beginning of his career, he had opted for this more difficult route and must have been conscious of its bold aesthetic effect, which was best seen from afar. When he had tried to give a painting, presumably the *Blinding of Samson*, to Constantijn Huygens he had written that it should be hung "in a bright light and so that one can stand at a distance from it; then it will sparkle at its best."[68] In the Frick painting Rembrandt made a virtuoso display of his own difficult and inimitable rough style, the style that comes with good judgment and mature understanding.

Titian also epitomized North Italian *colore* to the Dutch, who had greater respect for color than did Vasari. The Frick portrait's brilliant coloristic unity and warm golden tonality, created with a limited palette in which yellow and red dominate, bring to mind the luminosity of Venetian paintings, a good number of which were in several large Amsterdam collections.[69] Rembrandt's colors closely approximate not only the specific pigments Titian used to achieve his unified color scheme but also the four-color system supposedly employed by Apelles. According to Pliny and, later, van Mander, Apelles used only black, white, ochre, and red.[70] Although a number of Rembrandt's late paintings, from the *Jan Six* to the *Return of the Prodigal Son*, evidence a limited range of colors, his Frick self-portrait, with its black beret, red sash, and splendid ochre robe, seems intentionally to imitate Apelles', and Titian's, limited color scheme.

Rembrandt further proclaimed his artistic authority and mastery of tradition through his dignified pose. During this period, he was avidly assimilating

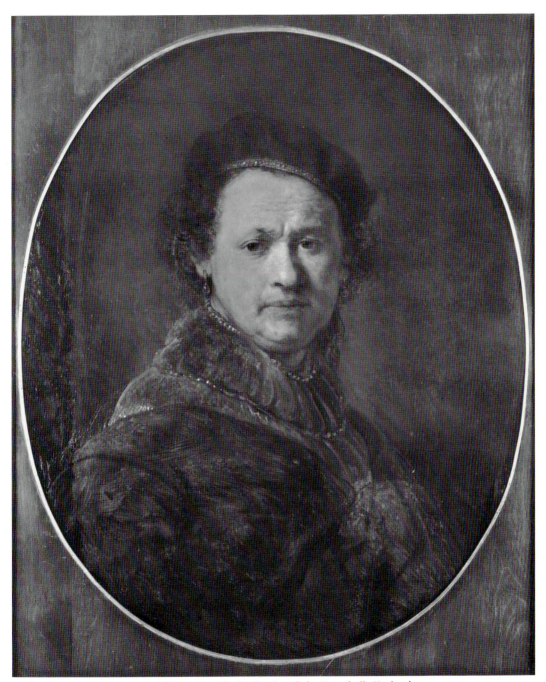

110. *Self-Portrait*. Karlsruhe, Staatliche Kunsthalle Karlsruhe.

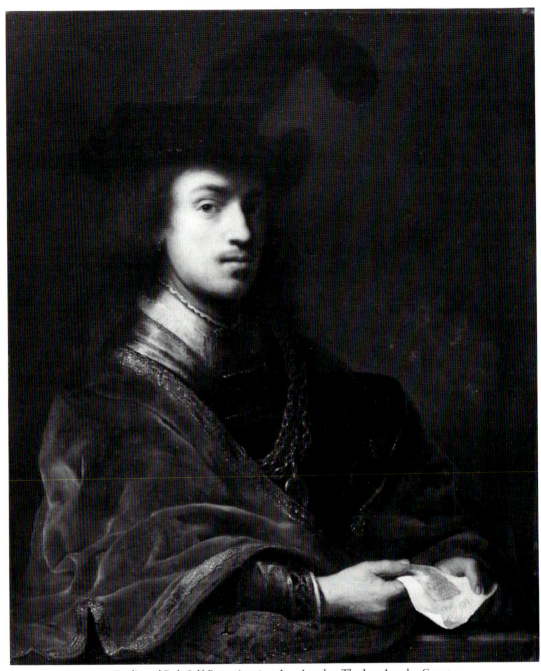

111. Ferdinand Bol, *Self-Portrait*, 1643. Los Angeles, The Los Angeles County Museum of Art.

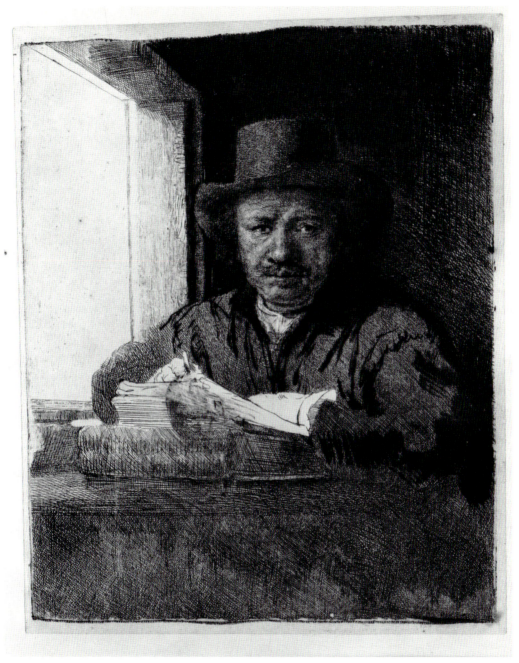

112. *Self-Portrait Drawing at a Window*, 1648. Etching, first state.
London, British Museum.

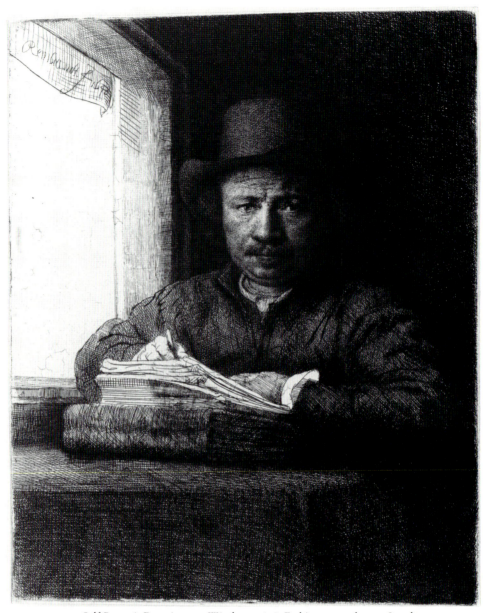

113. *Self-Portrait Drawing at a Window*, 1648. Etching, second state. London,
British Museum.

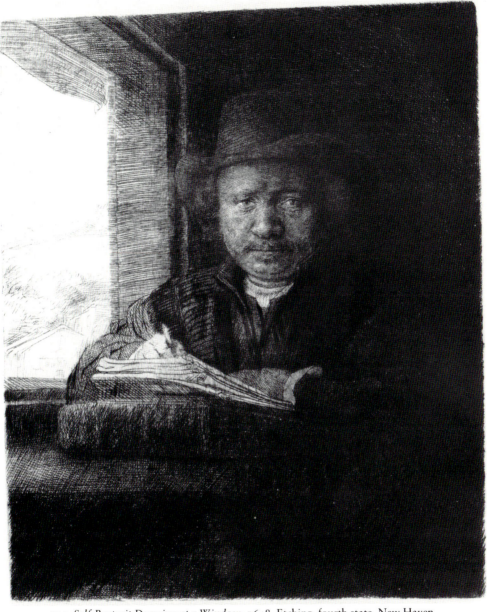

114. *Self-Portrait Drawing at a Window*, 1648. Etching, fourth state. New Haven, Yale University Art Gallery.

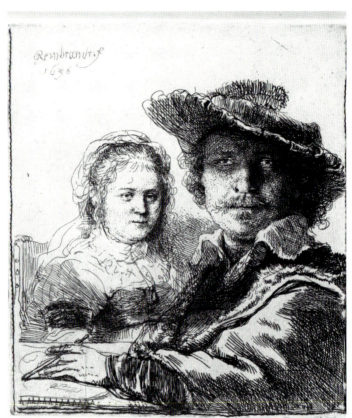

115. *Self-Portrait with Saskia*, 1636. Etching. Amsterdam,
Rijksprentenkabinet.

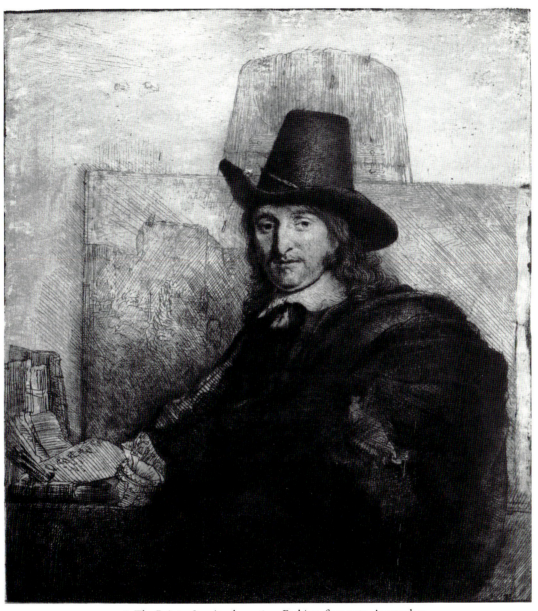

116. *The Painter Jan Asselyn*, 1647. Etching, first state. Amsterdam, Rijksprentenkabinet.

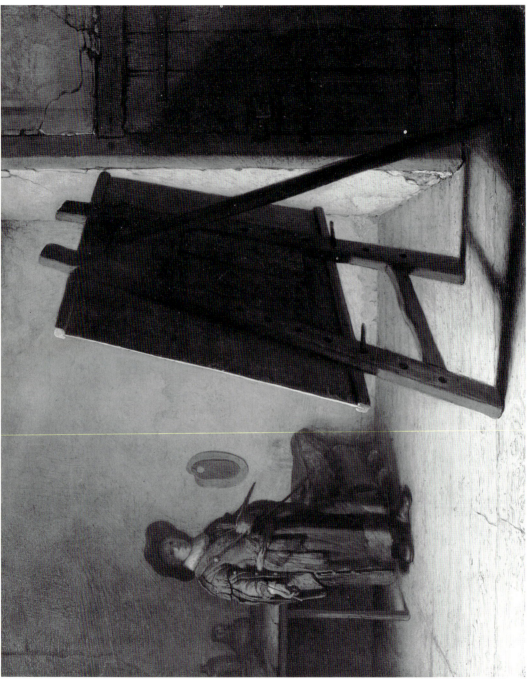

117. *The Artist in His Studio.* Boston, Museum of Fine Arts.

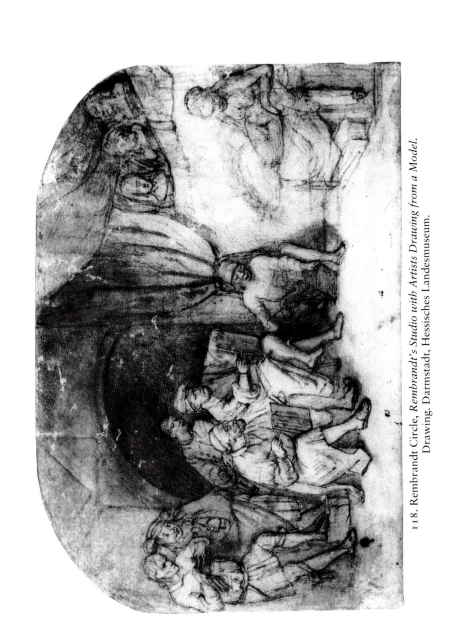

118. Rembrandt Circle, *Rembrandt's Studio with Artists Drawing from a Model.*
Drawing. Darmstadt, Hessisches Landesmuseum.

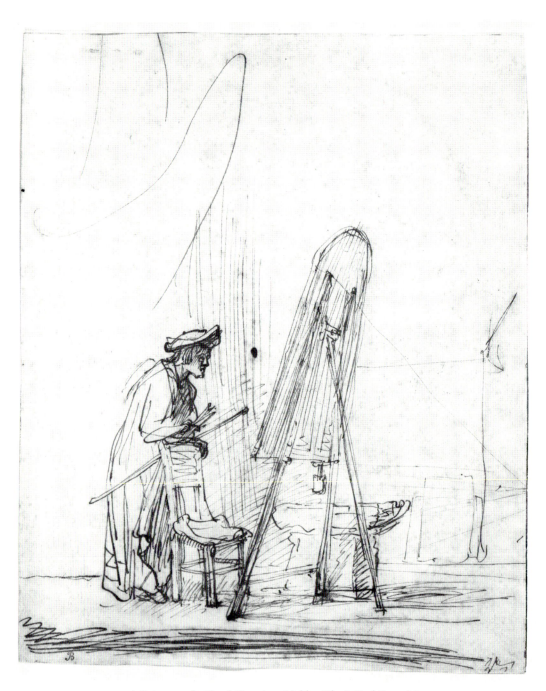

119. *A Painter at the Easel*. Drawing. Malibu, The J. Paul Getty Museum.

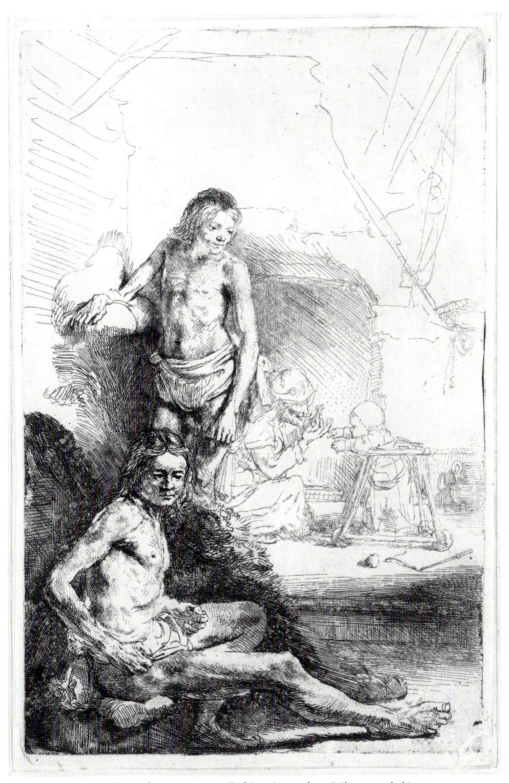

120. *Het Rolwagentje*, 1646. Etching. Amsterdam, Rijksprentenkabinet.

121. *An Artist Drawing from a Model*. Etching. Amsterdam, Rijksprentenkabinet.

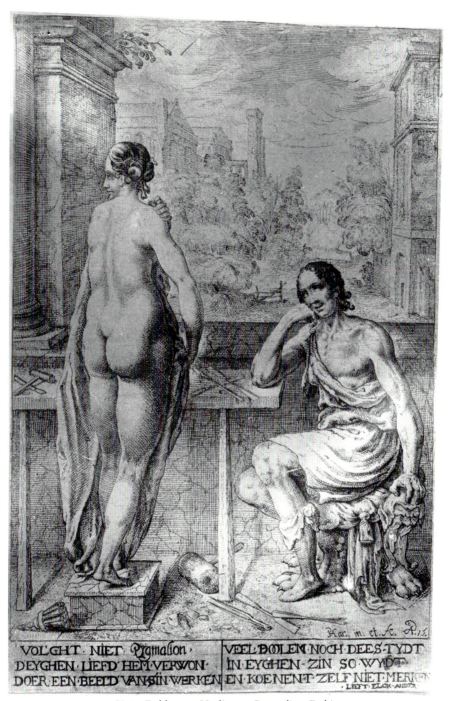

VOLGHT · NIET · Pygmalion ·
D'EYGHEN · LIEFD' HEM · VERWON ·
DOER · EEN · BEELD · VAN·SIN·WERKEN

VEEL · DOOLEN · NOCH · DEES·TYDT
IN · EYGHEN · ZIN · SO · WYDT
EN · KOE·NENT · ZELF · NIET·MERKEN ·
· LIEFT · ELCK · ANDER ·

122. Pieter Feddes van Harlingen, *Pygmalion*. Etching.

123. *Self-Portrait*, 1652. Vienna, Kunsthistorisches Museum.

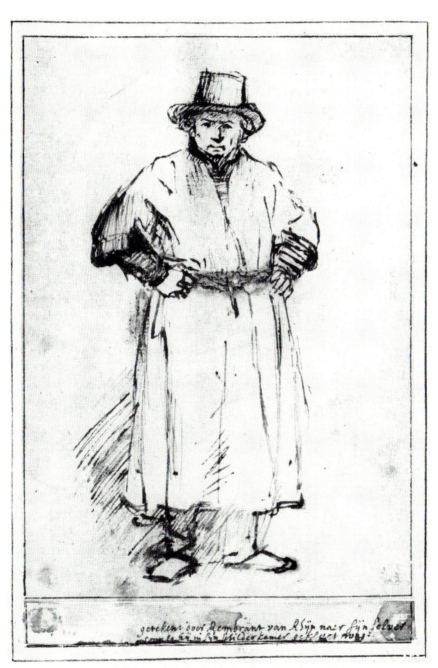

124. *Self-Portrait in Studio Attire*. Drawing. Amsterdam,
Collection Het Rembrandthuis.

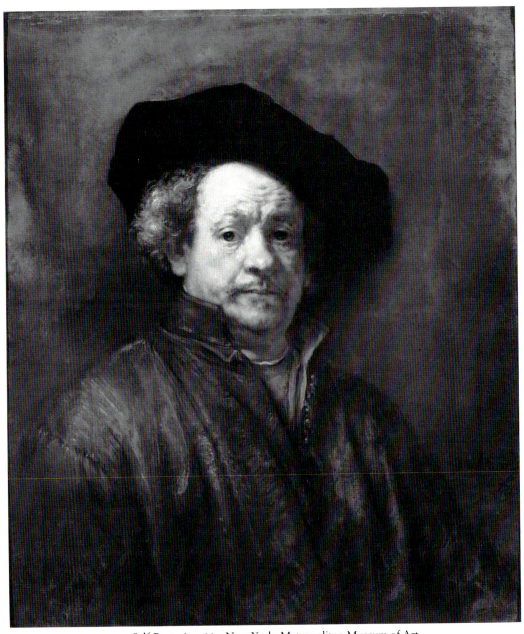

125. *Self-Portrait*, 1660. New York, Metropolitan Museum of Art.

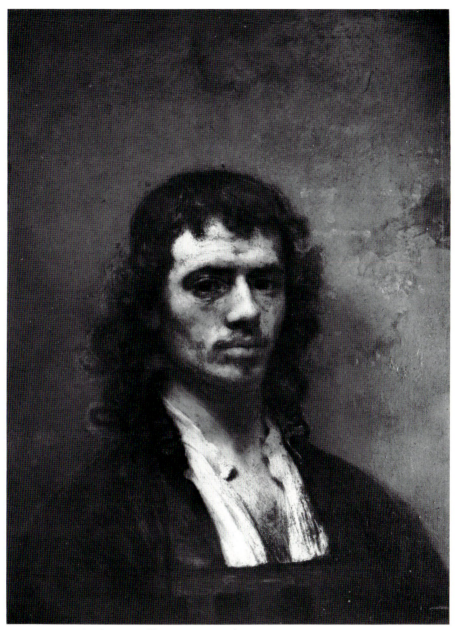

126. Carel Fabritius, *Self-Portrait*. Rotterdam, Museum Boymans-van Beuningen.

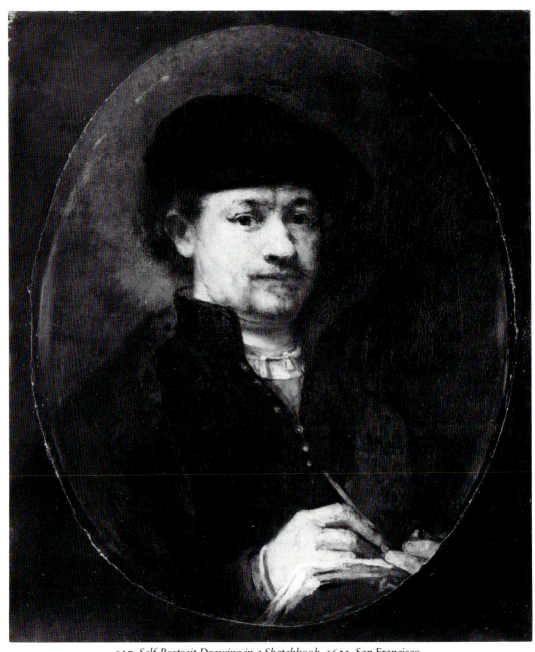

127. *Self-Portrait Drawing in a Sketchbook*, 1653. San Francisco,
M. H. de Young Memorial Museum.

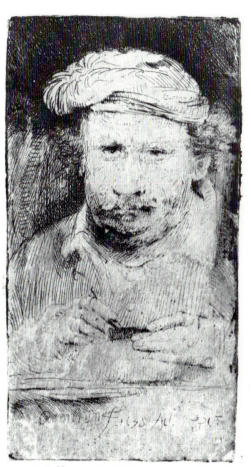

128. *Self-Portrait, Etching,* 1658. Etching.
Vienna, Graphische Sammlung Albertina.

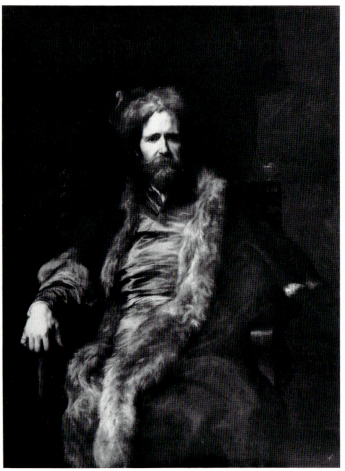

136. Anthony van Dyck, *The Landscape Painter Martin Ryckaert*. Madrid, Museo del Prado.

137. Jacob Neefs, after van Dyck, *Martin Ryckaert*. Engraving from van Dyck's *Iconography*. Ottawa, National Gallery of Canada.

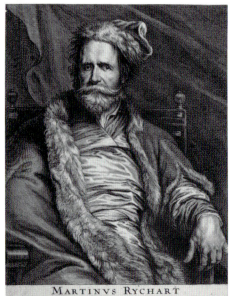

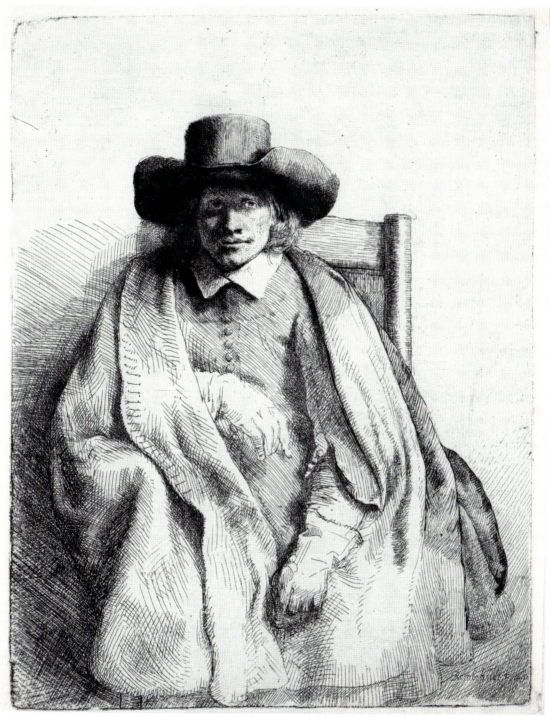

138. *The Printseller Clement de Jonghe*, 1651. Etching.
Amsterdam, Rijksprentenkabinet.

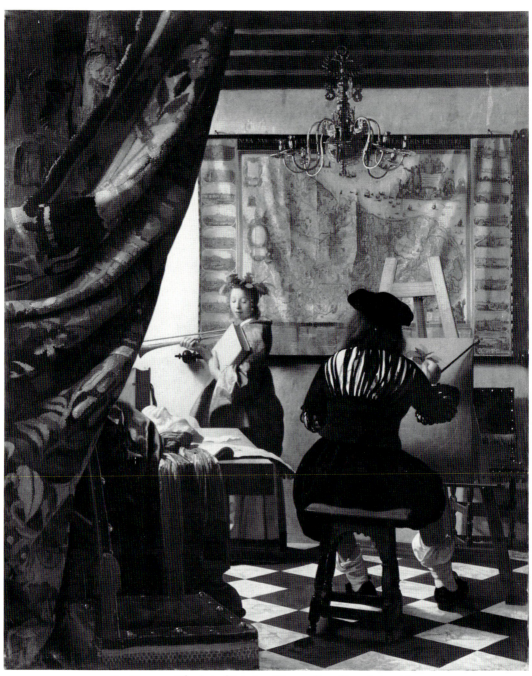

142. Jan Vermeer, *The Art of Painting*. Vienna, Kunsthistorisches Museum.

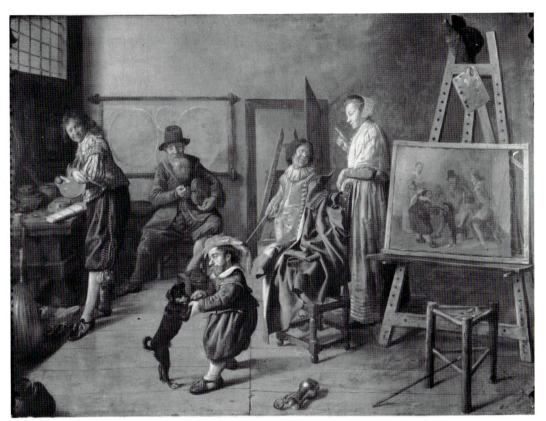

143. Jan Miense Molenaer, *Studio of the Painter*, 1631. Berlin, Staatliche Museen, Gemäldegalerie.

144. *Hendrick Goltzius*. Engraving from Hendrik Hondius, *Pictorum aliquot celebrium praecipue Germaniae Inferioris effigies*, The Hague, 1610.

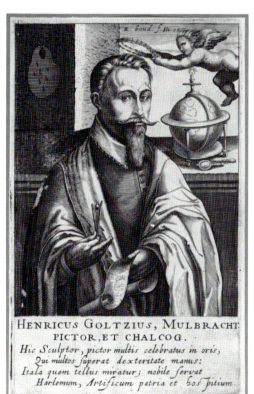

R. boud. f. H. ex.

HENRICUS GOLTZIUS, MULBRACHT.
PICTOR, ET CHALCOG.
*Hic Sculptor, pictor multis celebratus in oris,
Qui multos superat dexteritate manus:
Itala quem tellus miratur; nobile servat
Harlemum, Artificum patria et hospitium.*

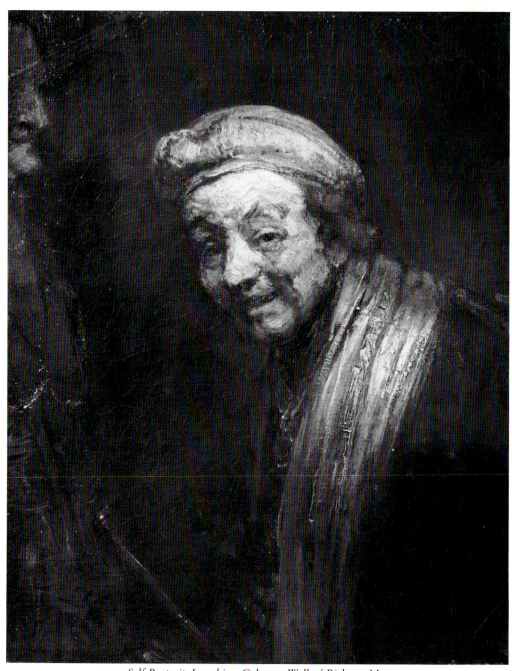

145. *Self-Portrait, Laughing*. Cologne, Wallraf-Richartz Museum.

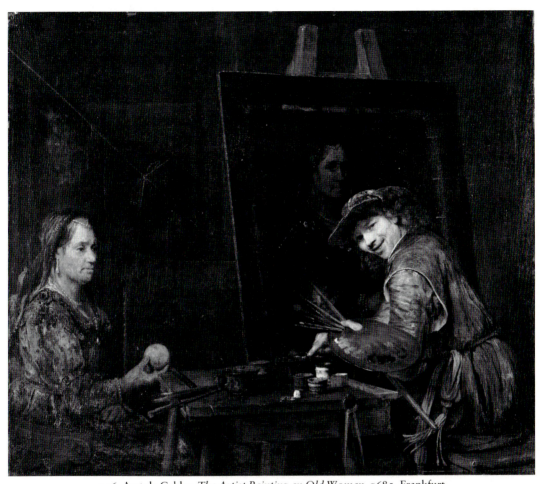

146. Aert de Gelder, *The Artist Painting an Old Woman*, 1685. Frankfurt,
Städelsches Kunstinstitut.

147. Ferdinand Bol, *Venus and the Sleeping Mars*. Braunschweig, Herzog Anton
Ulrich-Museum.

and reinterpreting Venetian portrait conventions. *Aristotle Contemplating the Bust of Homer* of 1653 bears a striking resemblance to an early sixteenth-century Venetian portrait variously attributed to Palma Vecchio and Titian.[71] *Alexander the Great* of around 1660 derives from a lost painting by Paris Bordone that had been in the Vendramin and Reynst collections in Amsterdam. *Hendrickje at a Half-Open Door* draws on a portrait by Palma Vecchio that Rembrandt presumably also saw in the collection of the Reynst brothers. For *Hendrickje as Flora* he again looked to Titian's *Flora* in the Lopez collection, on which he had earlier based his *Saskia with a Flower* (Fig. 108). Several other portraits evoke Venetian types even if specific sources cannot be identified: the portrait of Nicolaes Bruyningh is reminiscent of works by Veronese,[72] and that of Jacob Trip reflects the format of Titian's portraits of Paul III.

The convention of portraying individuals seated and in three-quarter length, a pose associated initially with spiritual or temporal authority, had strong ties to Venice. Following the prototype of Raphael's portrait of Julius II, Titian popularized the seated pose, which he used in portraits of such distinguished persons as Paul III, Archbishop Filippo Archinto, Johann Friedrich of Saxony, Philip II, and, in full length, Charles V. Although Titian used the seated pose almost exclusively for portraits of popes, cardinals, and rulers, Veronese, Tintoretto, and others employed the formula for those of lesser rank as well. What began as a papal and state portrait convention was soon appropriated by the aristocracy at large. Tintoretto's full-face *Procurator of St. Mark's* (Fig. 134) comes close to the Frick portrait, yet, as in most Venetian seated portraits, the subject's body and chair are turned diagonally to the picture plane.

The three-quarter-length seated portrait was quickly introduced into northern Europe, where it continued to exemplify dignity and spiritual authority. In the sixteenth century, Quentin Metsys, Jan Vermeyen, Frans Floris, and Antonis Mor translated the aristocratic Italian formula into a forceful Flemish idiom.[73] With Rubens and van Dyck, who both drew directly on Italian portraits as well as on the more direct Flemish mode, the seated portrait had become fully internationalized. Van Dyck in particular employed the formula widely to enhance the prestige and dignity of his Italian patrons, as in his portrait of Cardinal Bentivoglio. But to portray the Antwerp landscape painter Martin Ryckaert (Fig. 136) he abandoned his graceful, aristocratic Italian mode, opting instead for a Flemish type that harks back, appropriately, to Jan Vermeyen and Frans Floris. This work is distinguished from van Dyck's other seated portraits by its strict frontality. Ryckaert, who had only one arm, is seated *en face* with the slouched bearing of a tired, elderly man.

Rembrandt could have known van Dyck's portrait of Martin Ryckaert through the engraving by Jacob Neefs commissioned by Gillis Hendricx for the 1646 posthumous edition of the *Iconography* (Fig. 137). Included among Rembrandt's extensive collection of prints and drawings, inventoried in 1656, we find "A book filled with portraits of [or by] van Dyck, Rubens, and various other old masters."[74] His etched portrait of the printseller Clement de Jonghe (Fig. 138) may reflect the composition of the engraved *Martin Ryckaert*. In

each case the subject is placed slightly to the left of center, exposing the chair-back at right. De Jonghe's slouched posture closely resembles that of Ryckaert, and Rembrandt has retained the direction and basic lines of the cloak falling diagonally across the sitter's lap.

However, in contrast to van Dyck's *Martin Ryckaert*, his own *Clement de Jonghe* and the many sober Dutch seated portraits, Rembrandt's Frick self-portrait (Pl. V) draws on his thorough awareness of the sixteenth-century Vene-tian tradition from which such portraits ultimately derive. Furthermore, it accentuates the two stylistic features most strongly associated with Titian's painting: color and roughness of handling.

Yet to point to Titian and Venetian portraits as the source for the Frick self-portrait is to oversimplify the painting's relation to pictorial tradition and underestimate Rembrandt's originality. To be sure, both frontality and the three-quarter-length seated pose are strongly associated with Venice. But nei-ther form is exclusively Italian, and the appearance of the two together is quite rare. Indeed, the hieratic frontal pose has been used throughout the history of art to impart authority to figures of elevated spiritual or temporal rank. It was traditionally employed, for example, in images of rulers, Christ, and the Virgin Mary, and personifications of the virtues.[75] Albrecht Dürer's Christ-like self-portrait of 1500 in Munich relies on Venetian portraits, yet its *Imitatio Christi* associations derive from its similarity to Northern devotional images of the *Salvator Mundi*. Though by no means a source for Rembrandt's, Dürer's por-trait is conceptually analogous in that it expands a portrait convention to al-lude to the more universal significance of frontality.[76]

Just as he used the Renaissance connotations of the profile view in his historicized portrait of Saskia in Kassel and *Hendrickje as Flora* in New York, so had he elsewhere used the frontal pose to enhance the authority of his clients. In the etched *Self-Portrait with Raised Saber* of 1634 (Fig. 58), Rembrandt portrayed himself in full face wearing a courtly ermine collar and gold chain to evoke regality and power. In the Frick self-portrait, too, Rembrandt used fron-tality to idealize his image. By adopting a dignified upright bearing and placing both hands on the arms of his chair he informed the seated pose with its tradi-tional connotations of authority and supremacy.

Rembrandt boldly asserted his importance, dignity, and domination of his craft, perhaps even demanding recognition as the "Prince of Painters." This title, first given to Apelles, was applied to contemporary artists as a mark of highest distinction, and not only in rhetorically mindful treatises.[77] Rubens, for example, responding to flattery from Sir Dudley Carleton, protested, "I am not a prince, *sed qui manducat laborem manuum suarum* (but one who lives by the work of his hands)"—somewhat disingenuously, one might add, since he pre-ferred not to portray himself with his tools. Carleton's rejoinder was a deft acknowledgment both of the literary convention and of Rubens' diverse roles as diplomat, knight, and court painter: "You say you are not a prince, [but] I regard you as the prince of painters and of gentlemen."[78]

Unlike Rubens, Rembrandt could not claim noble rank and, indeed, had

probably intentionally opted for a life in Amsterdam quite different from that of court painter. For him the notion of "Prince of Painters" must have held a metaphorical significance. Not tied to his social status, it concerned his artistic achievement exclusively. Rather than reflecting reality, his Frick self-portrait designates an ideal of the artist, giving visual expression to, and thoroughly reinterpreting, a well-known literary topos. As he had in his earlier *Self-Portrait at the Age of 34* (Pl. IV), Rembrandt looked beyond his immediate milieu for a standard against which to measure himself. Two years after his financial collapse, when his possessions and collection were still being sold, Rembrandt, by his own craft, set himself apart from his more ordinary fellow painters and majestically affirmed his artistic eminence.

AT THE EASEL

Not until the 1660s, when he was in the prime of life, did Rembrandt paint his own portrait as a painter. In three self-portraits in the Louvre, Kenwood House, and Cologne (Fig. 139, Pl. VI, and Fig. 145) he presents a new self, standing or sitting before his easel, holding the tools of his craft. We have seen him gradually building up to this. His etched *Self-Portrait Drawing at a Window* (Fig. 112) of 1648 first signaled his rejection of the decorous virtuoso epitomized by his 1640 *Self-Portrait at the Age of 34* (Pl. IV). Only after twelve years did he translate that etched working artist into paint, in the *Self-Portrait at the Easel* of 1660 (Fig. 139).[79] Here Rembrandt's straightforward portrayal of himself seated at his easel, with his brushes, palette, and mahlstick, departs radically from his earlier paintings, suggesting a significant change in his conception of his professional identity. By displaying props alluding to the manual practice of painting he finally accepts, and even glorifies, the craft-like aspect of his work.

The *Self-Portrait at the Easel* lacks the monumental grandeur and self-confidence of the Frick painting (Pl. V). We sense that Rembrandt has let his defenses down, allowing us greater insight into his character. He sits in an armchair turned toward his easel at the right. The painting is now quite dark, making it difficult to discern Rembrandt's clothes and setting. Strong selective light focuses our attention on his sensitive face and direct gaze. Light also draws attention to his tools and working attire. It accentuates his white turban, falls on his palette and paints, and glances off the edge of the painting on his easel, bringing to mind a similar effect in the early *Artist in His Studio* (Fig. 117). X-ray photographs indicate that originally he wore his customary black beret.[80] This he replaced with the mundane white painter's cap that we saw in his last etched self-portrait (Fig. 128) and in the drawing *Rembrandt's Studio with Artists Drawing from a Model* (Fig. 118).

The *Self-Portrait at the Easel* revived a self-portrait formula that had been popular in the Netherlands from the second half of the sixteenth century until it was overtaken by the Rubensian courtly, virtuoso type in the early seventeenth century. Antonis Mor (Fig. 140), Cornelis Cornelisz. van Haarlem, Joachim Wttewael (Fig. 141), and Isaac van Swanenburgh, the father of Rem-

brandt's first teacher, had all portrayed themselves with their tools, often at their easels. Many of the engraved portraits in Hondius's print series were also in this vein. Even Rubens may have portrayed himself as a painter quite early in his career, if we are to believe a nineteenth-century engraving after a lost painting dated 1599.[81]

Bartholomeus van der Helst's portrait of Paulus Potter dated 1654 (Fig. 130) is one of few near-contemporary examples of this type. Potter sits before a blank panel, a *tabula rasa*, on his easel and looks back over his shoulder toward the viewer in a pose symbolic of the imagination. Potter, like Mor and virtually all the others, is portrayed with sophisticated flair as an elegant gentleman-artist in contemporary fashionable attire. This portrait type consistently showed the painter in refined dress in order to assert the intellectual dignity of his art. Leonardo, in claiming the supremacy of painting over sculpture, had long before emphasized the social and intellectual importance of the painter's fashionable clothing and gentlemanly demeanor:

> The painter sits in great comfort before his work, well dressed, and wields his brush loaded with lovely colors. He can be dressed as well as he pleases . . . He often works to the accompaniment of music, or listening to the reading of many fine works.[82]

By donning informal working clothes and cap Rembrandt defied an essential feature of the portrait type and so transformed the tradition. He abandoned the humanist ideal of the gentleman-painter, replacing it with an original and independent image of the artist as craftsman. Just as his late painterly manner set him apart from the trend toward a more refined, classicizing "French" style, so his painter's guise distinguished him from his more academically inclined predecessors and colleagues.

In contrast to the learned virtuoso painter, or *pictor doctus*, conveyed in self-portraits by Rubens, Dou, and Honthorst and, in a highly individual way, in his own earlier self-portraits, Rembrandt may have been asserting himself as the *pictor vulgaris*. Certainly he was the anti-ideal of the vulgar painter in the minds of his later biographers, who criticized him for lowering the dignity and intellectual status of his profession. To them his lack of decorum, sloppy appearance, working man's image, and association with common people were outward signs of his artistic failings, particularly his disdain for the antique and contempt for the rules of art.[83] According to Sandrart,

> he did not know in the least how to keep his station and always associated with the lower orders, whereby he also was hampered in his work.[84]

Baldinucci saw his coarse, careless appearance as evidence of a—highly suspect—total absorption in his work and disregard for proper social behavior:

> The ugly and plebeian face by which he was ill-favored was accompanied by untidy and dirty clothes, since it was his custom when working to wipe his brushes on himself, and to do other things of a

similar nature. When he worked he would not have granted an audi-
ence to the first monarch in the world, who would have had to return
and return again until he had found him no longer engaged upon that
work.[85]

Only Houbraken viewed Rembrandt's nonconformity a bit more sympatheti-
cally:

> In the autumn of his life he kept company mostly with common peo-
> ple and such as practiced art. Perhaps he knew the laws of the art of
> living as set out by Gratian, who says, "It is a good thing to frequent
> distinguished persons in order to become one yourself; but once that
> is achieved you should mix with ordinary people." And he gave this
> reason for it: "If I want to give my mind diversion, then it is not honor
> I seek, but freedom."[86]

While many of the biographers' anecdotes are surely apocryphal, the idea
of Rembrandt as *pictor vulgaris* is not a pure fabrication on their part. As his
self-portraits bear out, from the late 1640s on he cultivated the image of an
independent artist who valued his freedom and disdained his colleagues' quest
for the kind of honor associated with worldly prestige. Moreover, Rembrandt
would have been aware of the two kinds of artist that derived from the Hora-
tian polarity between the *poeta doctus* and the *poeta vulgaris*: the latter being
gifted with natural talent, *ingenium*, but lacking *studium* and *ars*, or theory.
Whether he would have regarded himself as a vulgar painter per se is open to
question. Images of artists drinking and carousing, like the self-portraits by
Adriaen Brouwer and Joost Cornelisz. Droochsloot or Rembrandt's own self-
portrait with Saskia in Dresden (Fig. 155), more readily bring to mind the vul-
gar painter known for his drunkeness and indolence.[87]

Rembrandt's personality as displayed in the *Self-Portrait at the Easel* has
little, if anything, to do with the proverbial love of drink and rowdy behavior
that van Mander and Philips Angel lamented were rampant among painters.[88]
If the idea of the vulgar painter is relevant here, it is recast in a positive light
and applied narrowly to his professional identity. Rembrandt displays, through
his workshop attire and unpretentious appearance, the respect for his craft ex-
pressed in the early *Artist in His Studio* (Fig. 117). As he had done in some of
his earliest self-portraits, he asserts his natural inborn talent, his *ingenium*, and
his *poëtische geest*.

When Rembrandt again portrayed himself as the working painter in the
self-portrait of the mid 1660s at Kenwood House (Pl. VI), he asserted himself
with such power and dignity as to defy the concept of the vulgar painter.[89] Here
as never before he demonstrated that his eminence rests solely on his own artis-
tic mastery and his distinctive, individual style. More self-assured than the *Self-
Portrait at the Easel* in its extraordinary monumentality and broad, painterly
handling, the Kenwood painting invites comparison with the imposing,
princely image in the Frick Collection (Pl. V). It has been the subject of several
iconographic interpretations, all of which hit upon the enigmatic circles in the

background as the "key" to its meaning and ignore its visual effect as a whole. My aim is to propose an alternative reading of the portrait and show that its visual appeal—its technique, style, composition—is essential to the conception of the artist it defines and defends.

The Kenwood portrait's impact derives not from the circles but from its monumental scale, the broad, painterly treatment, and Rembrandt's imposing figure. His frontal, three-quarter-length pose creates an overwhelming, immediate presence. He stands, confronting the viewer, his arms positioned to broaden his already massive body. The assertive handling of the face, built up with thick impasto and incised with the butt end of the brush, focuses our attention on his direct gaze. Through formal means Rembrandt dignified his working clothes. Broad strokes of white paint give unusual prominence to his painter's turban. Instead of his drab painter's smock he wears more embellished, perhaps slightly imaginary, studio garb, a smock in deep Venetian red over which he wears a fur-trimmed tabard. Though areas of his clothing are extremely roughly painted, giving the impression of being unfinished, the powerful horizontal and vertical lines of his garments contribute to the painting's firm compositional structure.

The portrait is most sketchy and least finished in the area of Rembrandt's left hand, in which he holds his tools. In fact, his hand is so completely obliterated that his tools seem to take its place. Indeed, the intangibility of both his hands stands in marked contrast to his massive strong hands in the Frick portrait. His tools—his mahlstick, bundle of brushes, and unusual rectangular palette—are also only roughly and thinly blocked in, leaving the colors of his garments to show through. X-rays and pentimenti visible to the naked eye reveal that Rembrandt repainted his hands. Originally his left hand held a brush up to the thin wedge of his canvas on the easel, while his right held his brushes and mahlstick. Then, rejecting the idea of showing himself in mirror image in the act of painting, he brought his left hand down and transferred his tools to it. The effect is to include the instruments of his craft while keeping our attention on his face.

Rembrandt's concern with artistic practice, which we have seen in the Boston *Artist in His Studio* (Fig. 117) and the etching *An Artist Drawing from a Model* (Fig. 121), extends beyond his garb and tools to his peremptory manner of execution in the Kenwood portrait. Thick impasto, visible brushwork, quickly incised lines, and seeming lack of finish, especially in the area of his hands, all call attention to the painting process. Van Mander and others had recognized the "rough" manner as the more difficult of the two stylistic paths open to the painter. Though it was appreciated by some, Rembrandt's late painterly manner was out of step with the current taste for smooth, polished surfaces. Indeed, one patron, the Italian Ruffo, returned an unfinished painting of Homer all the way from Messina to be completed.[90] Yet the extreme painterliness of the Kenwood self-portrait suggests a consciousness of, and pride in, his own style. The portrait epitomizes the crucial shift in Rembrandt's self-conception toward an identity based on acceptance of the dignity of his profes-

sion and the supremacy of his style. In this spectacular display of his artistic virtuosity Rembrandt presents himself, purely and simply, as a painter.

Rembrandt's setting reinforces this interpretation. It is often overlooked that he is at his easel, which is visible only as a thin wedge of ochre and brown paint along the upper right margin of the picture. As in the *Self-Portrait at the Easel* (Fig. 139) and the Boston *Artist in His Studio* (Fig. 117), light glances off the edge of his canvas, leaving its verso in shadow. The painting Rembrandt works on, reduced to its barest minimum, gives his portrait a definite location, the studio, which in turn suggests an explanation for the two large semicircular forms.

Although the circles are compositionally important, bringing attention to Rembrandt's head and anchoring his figure, it would be out of keeping with Dutch painting in general, and Rembrandt's in particular, to read them as purely abstract forms. Surely they are meant to represent something, though exactly what has been the subject of much debate. J. G. van Gelder put forward the theory that they are seventeenth-century cabalistic symbols representing the perfection of God.[91] More recently others have sought the answer in contemporary art literature and representations of artists. Emmens read them emblematically, interpreting the portrait as expressing the ideal of painting as a combination of inborn talent, theory, and practice—*ingenium, ars*, and *usus* or *exercitatio*. The painter stands for *ingenium*, which takes precedence in Rembrandt's conception of his art. On the basis of personifications in Ripa's *Iconologia*, Emmens interpreted the circles as symbols of *ars* (on the left), whose attribute is a compass, and *exercitatio* (on the right), whose attributes are a compass and a ruler.[92] But the ruler or ruled line which supposedly intersects the right-hand circle is actually the edge of the picture on Rembrandt's easel. More to the point, such abstract emblematic imagery hardly seems consistent with Rembrandt's iconographic style.

A more plausible explanation for the circles is Broos's suggestion that they allude to a well-known topos of artistic virtuosity, the perfect circle drawn freehand.[93] Its best-known instance is the legend, related by Vasari and van Mander, of Giotto, who, when asked to submit a demonstration of his work to the pope, drew nothing but a circle. Like the legendary line of Apelles, the circle, itself a symbol of perfection, was proof "that Giotto surpassed all the other painters of his time in excellence."[94] But it would be going too far to suggest that Rembrandt painted himself as a Giotto or that he was enacting this well-known legend. For one thing, the tale is told of numerous artists and not only of Giotto; for another, there are two partial circles behind him and not the single perfect circle crucial to the anecdote. Moreover, the image of a steady drawing hand seems hardly the message of this work's extreme painterliness. Not that the paradigm of the perfect circle is irrelevant here—certainly its significance as a display of virtuosity might have come to the mind of artist and viewer well versed in the lives of earlier painters—but it is not the primary meaning of the circles.

For, as Bauch, van de Waal and others have suggested, they represent a

double-hemisphere map, a real object frequently found hanging on the walls of artists' studios and other Dutch interiors.[95] Maps appear, for example, in Frans van Mieris's *Connoisseur in the Studio* of about 1655 in Dresden, Berckheyde's 1659 *Painter in the Workshop with Visitors* in Leningrad, and Vermeer's *Art of Painting* (Fig. 142) from the mid 1660s. Not only are the circles in the right scale for a great world map, but the heavy, probably varnished, paper on which the map is printed sags slightly from its hanger, as indicated by the two faint diagonal lines beside the top of the right circle. The primary objection to identifying the two circles as a wall map is their lack of definition. However, Rembrandt's earlier *Portrait of a Fashionable Couple* in Boston and studio scenes by other artists indicate that such maps might be only summarily defined. Possibly the map is unfinished; more likely Rembrandt regarded the outlines of the two hemispheres as sufficient to delineate it. Evidence supporting this is found within the painting itself: his treatment of the map is analogous to his extremely abbreviated treatment of the work on his easel. Both are merely suggested, and reading them depends on the viewer's knowledge of the pictorial tradition of the artist's studio. As in such late history paintings as the *Jewish Bride*, the setting has been reduced to a minimum, but not eliminated, to focus our attention on the sitter. By reducing his workshop to its barest essentials Rembrandt magnifies himself. Still, his identity depends on that setting, for it is now tied to his practice of his profession.

Considering the frequency with which maps and globes appear in Dutch atelier scenes and portraits of artists, the map in the Kenwood portrait most likely has significance beyond just defining the studio setting. Generally speaking maps and globes symbolize the world and thus, depending on the context, can have either positive or negative connotations. On the one hand the map signifies worldliness in moralizing studio scenes. Such is the case in Jan Miense Molenaer's 1631 *Studio of the Painter* (Fig. 143), where the painter's work has been interrupted by worldly activity, and in Joos van Craesbeeck's image of a painter painting a genre scene of the five senses.[96] Similarly, globes in vanitas still-life paintings with painters' tools suggest worldliness and transience.

On the other hand, maps and globes signify the painter's fame. The portrait of Hendrick Goltzius from Hondius's engraved series includes a globe with a candle atop it, which is explained quite simply in the caption "pictor multis celebratus in or[b]is" (Fig. 144). In Vermeer's allegory *The Art of Painting* (Fig. 142) a huge wall map is meaningfully juxtaposed with the artist's model, who is Clio, muse of history: her laurel crown symbolizes Fame, and her volume of Thucydides symbolizes History. Clio is the source of the painter's inspiration and fame. The map, which shows the original seventeen provinces of the Netherlands and, around the edges, views of the Dutch towns, alludes to the fame and glory that the Dutch painter brings to his fatherland and its cities.[97]

Clio is also found in conjunction with a globe in the title print of Samuel van Hoogstraten's *Inleyding tot de hooge schoole der schilderkonst* (Fig. 69) as one of the nine muses who guide the *schilderleerling* or student of painting.

As the verse appended to the title print explains, "Clio shows him the most beautiful of the visible world." *De zichtbaere werelt* (The Visible World) is the subtitle of Hoogstraten's treatise. He explains in the introduction, "The reason I also call it the 'Visible World' is that the art of painting concerns everything that is visible."[98] In this he certainly means to include the world of mythology and biblical history, more than we might consider mere visual reality. Hoogstraten's concept of the *zichtbaere werelt* affirms the widely held notion that the perfect painter should be *universael*, learned, adept at all kinds of subjects and excellent in all aspects of his art—composition, drawing, and invention. Van Mander had applied the term to some of the painters he held in highest esteem, such as Raphael; Lucas van Leyden, whom he called "gemeensaem oft universael," explaining that he paints with both oil and water colors and excels at histories, portraits and landscapes; and Maerten van Heemskerck, who "in sum was universal and accomplished in all things."[99]

The world map in the Kenwood self-portrait (Pl. VI) stands for Rembrandt's universality—as a painter of the visible world, accomplished in all techniques. It reinforces the impression, conveyed by his working artist's guise and by his powerful handling of the brush, that his fame derives from his craft. Like his earlier representations of the artist's studio, the Kenwood self-portrait is concerned with practice. Not only does Rembrandt present himself in working attire in his studio, but his broad, insistent, rough technique calls attention to the painting process. The portrait reaffirms his identity as anchored in the mastery of his art.

In sharp contrast to the commanding, assertive Kenwood portrait, Rembrandt's *Self-Portrait, Laughing* in Cologne (Fig. 145), his last in the role of painter, is poignant and ironic.[100] Grinning, his mouth open, brows raised quizically, he turns with a knowing gaze toward the viewer. Presenting himself as the classical painter Zeuxis, he comes face to face with, and laughs in the face of, his own mortality.

Intensely engaging for its emotional expression and its vigorous handling, broad strokes, and thick impasto, this portrait seems particularly difficult to grasp because of its darkness, layers of dirty yellow varnish, and poor condition. There can be no doubt that Rembrandt here portrays himself as a painter. He wears a medal on a red cord around his neck and a painter's turban like that in the *Self-Portrait at the Easel* (Fig. 139). He also has a mahlstick, clearly defined by highlights on its stick and rounded knob.

The picture was described, in 1761, as "Rembrandt painting an old woman . . . by himself."[101] Presumably the figure beside him, at the left edge of the canvas, represents the portrait of a woman on which he works. I say "presumably" because this is the most problematic feature of the painting. We see the sharp, clumsy profile of a face with a hook nose and long chin, and we can make out the looping chains of a necklace. Unfortunately, the upper part of the head is entirely repainted, and the canvas may have been cut down slightly along the left side. Although the area of background between Rembrandt and

the figure's chains is almost completely black, it is possible to discern in raking light a vertical line that may define the edge of the portrait.

As Rembrandt first composed the work, he portrayed himself in the act of painting. X-ray photographs and pentimenti visible in raking light indicate that originally he held the mahlstick in his left hand in a different position, and that with his raised right hand he touched a brush to the face in front of him. Then he rubbed these areas out, probably with turpentine in a manner analogous to his burnishing and reworking the copper plates in his late etchings. In the second state of the painting Rembrandt removed his hand and eliminated the actual act of painting, while leaving himself clearly defined as a painter in front of his work. As in his reworking of the Kenwood self-portrait, he withdrew his hand and brush from the painting on his easel.

Rembrandt's laughing expression, reminiscent of one of his early etchings of 1630 (Fig. 9), has puzzled critics and prompted several ingenious interpretations. Jan Białostocki suggested that he faces and paints the herm Terminus, god of death, whose motto is *Concedo nulli* (I Yield to No One).[102] Although this interpretation appeals for its reference to death, it accounts neither for Rembrandt's identity as a painter nor for his laughing expression. Wolfgang Stechow, taking his cue from Schmidt-Degener, proposed that Rembrandt had represented himself as the laughing philosopher Democritus painting an image of his weeping counterpart Heraclitus.[103] The appeal of Stechow's interpretation lies in the fact that Democritus was widely considered to be a melancholic—indeed, Robert Burton had assumed the role "Democritus Junior" to address the readers of his *Anatomy of Melancholy*—and Rembrandt, as we have seen, had earlier fashioned himself as, and continued to exhibit traits of, the melancholic. Moreover, images of Democritus and Heraclitus, who laugh and weep respectively at man's folly, were popular at the time: according to van Mander, Cornelis Ketel is supposed to have painted a portrait of himself as Democritus—done with his toes, no less.[104] Yet there is no reason to describe the figure Rembrandt paints as weeping or mournful. More to the point, identifying with the philosopher who laughed at men's folly and satirized their inability to recognize it does not seem to accord with Rembrandt's profound sympathy for human weakness. Such biblical paintings of the 1660s as *The Denial of Peter* suggest a serious and consuming interest in man's sinful nature, an interest more like that of Heraclitus.[105]

Albert Blankert's identification of the laughing Rembrandt with Zeuxis is the only explanation that takes into account his role as painter and his distinctive expression.[106] Moreover, there are compelling reasons why Rembrandt might want to identify with Zeuxis, himself a highly individual virtuoso. Next to Apelles, Zeuxis was the painter of Antiquity most famous and most esteemed in seventeenth-century Holland. He was known, through van Mander's *Schilder-boeck*, for his ability to paint the emotions and for having surpassed his teachers to the extent that it was said he "robbed his masters of their art and carried it off with him."[107] He took pride in the fact that his work could not be copied. He gave away his works, saying that no price was adequate to

their value, which is perhaps akin to the allegation that Rembrandt bought back his own works to jack up the prices. Zeuxis' life was the source of two oft-repeated topoi. The first concerned his fidelity to nature: he painted bunches of grapes so real-looking that birds were tricked into trying to eat them, but then he was bettered by Parrhasius who painted an illusionistic curtain so convincingly that Zeuxis reached out to draw it aside. Gerard Dou's self-portrait with the *trompe l'oeil* curtain in the Rijksmuseum alludes to this paradigm of illusionism. The second concerned his perfection of nature: to paint Helen of Troy he brought together the five most beautiful women of the town and took from each the most beautiful parts, which he assembled to paint a perfect beauty. Neither anecdote is particularly relevant to Rembrandt. Both illusionistic naturalism and the classical canon of beauty were of greater concern to his pupils and contemporaries than to him.

A lesser-known legend related by van Mander and Hoogstraten is, however, directly applicable: "Zeuxis is said to have departed this life while laughing immoderately, choking while painting a wrinkled, funny old woman." Van Mander added, "Are you laughing too hard? Do you want to go the way of the painter who died from laughing?"[108] Rembrandt's most devoted pupil, Aert de Gelder, seems to have understood his intention, for some twenty years later he too portrayed himself as the laughing Zeuxis, painting an old woman (Fig. 146). De Gelder's composition fills out Rembrandt's, providing the setting and details necessary for identification that his master often left out.

But why did Rembrandt portray himself in the guise of the painter who died from laughing? Zeuxis' darker side as a painter of reality and ugliness may have appealed to him for its contrast with his better-known accomplishment as the creator of ideal beauty. The young Rembrandt had been esteemed for his picturesque naturalism, but by the 1660s, despite his fame at home and abroad, his style was out of step with the more popular "modern" classicism of, for example, Ferdinand Bol's *Venus and the Sleeping Mars* (Fig. 147). Almost immediately after his death the classicist critique of Rembrandt began to appear in print. Jan de Bisschop's disdain of his ugly nudes with their garter marks, published in 1671, quickly escalated into an all-out assault on his failure to conform to the rules of art and the classical ideal.[109] Even though this criticism did not appear during his lifetime, it must have been obvious from the 1650s, if not before, that Rembrandt was moving increasingly away from prevailing taste. In 1647, the year after Frederik Hendrik had ordered the *Adoration* and *Circumcision* from Rembrandt, his name was omitted from a list, drawn up by Constantijn Huygens and the architect Jacob van Campen, of painters to decorate the Stadholder's new palace, the Huis ten Bosch. The list included primarily Italianate or Flemish-influenced Dutch painters—Pieter de Grebber, Salomon de Bray, Caesar van Everdingen, Gerard van Honthorst, Jacob Backer, and Jacob van Loo—and several Flemings, with one of the most important works going to Jacob Jordaens.[110] By the 1650s his pupils Ferdinand Bol and Govert Flinck had abandoned their master's teaching for the bright palette, clear light, and ideal beauty of the new classical manner. The selection of Flinck

to provide the entire series of grand allegorical compositions for the new Amsterdam town hall signaled official sanction of a style quite unlike Rembrandt's. Still, it did not mean outright rejection of Rembrandt. After Flinck's death he was commissioned to provide a single night scene for the town hall, *The Oath of Claudius Civilis*, which was removed within a year for reasons that may have had as much to do with politics as with taste.[111]

We tend to forget that we really have no idea how Rembrandt felt about the new style in vogue in Amsterdam or how he reacted to the decoration of the town hall. All too often it is assumed that he would have disapproved of his pupils' classicism and that he was bitter about the town hall commissions; but this is pure speculation. For all we know he may have admired Bol's beautiful nudes and taken pride in the fact that the major commission in Amsterdam went to his former pupil, and he may not have really wanted to participate in the decoration of the town hall. After all, he had spent much of his life distancing himself from the mainstream of Dutch painting. So we are on shaky ground if we insist on seeing his identification with Zeuxis as an angry condemnation of his classicist critics or even as a less bitter vindication of his own naturalism. Such readings are entirely possible; but conceivably he painted it without giving a thought to the opposing classicist camp.

Before concluding in despair that this very late self-portrait (Fig. 145) is so personal and individual that it defies interpretation, let us consider the possibility that it is self-referential in a different way. Perhaps in his old age, possibly even the last year of his life, he recognized a more formidable opponent, death. As a young man Rembrandt had paid little attention to the vanitas themes so prevalent in the art of his contemporaries. Now, at about age sixty, the prospect of his own mortality gave death new meaning. Looking into the mirror and seeing the face he had painted so often having become worn and ugly may have been enough to remind him of the story of Zeuxis painting an old woman. The face he laughs at, like the mortality he accepts, is his own. That may explain why he removed his hand holding the brush and practically eliminated any reference to the woman: he cannot touch his brush to the picture on his easel, for the portrait he really paints is his own. Looking in the mirror, he laughs at himself and, perhaps, at the irony of his lifelong self-portrayal, which, meaningless in the face of death, can assure him only earthly immortality.

5

Rembrandt's Biblical Roles

ξ

WHAT I HAVE described in the preceding chapters as Rembrandt's emerging individuality, his development from inner anarchy to inner authority and greater autonomy, can also be traced in the biblical personas he assumed. This chapter deals with three images that span the greater part of his career: his self-portrait as one of the henchmen helping to hoist the cross in the early *Raising of the Cross* from the Passion series owned by Frederik Hendrik (Fig. 148); the large painting in Dresden of about 1636 in which Rembrandt appears, with his wife Saskia, as the Prodigal Son in the tavern (Fig. 155); and the late *Self-Portrait as the Apostle Paul* of 1661 (Pl. VII).

Rembrandt's knowledge of the Bible was vast and his understanding of it profound. Old and New Testament subjects formed the bulk of his production in all media at most times in his life. It is no exaggeration to say that his involvement with the Bible is unique in seventeenth-century Dutch art both in the sheer quantity of works and in the depth of religious sentiment conveyed therein. Critics increasingly recognize that his biblical works not only are deeply moving but also reflect fundamental values of Dutch Protestantism. These three biblical self-portraits, when examined in the context of his life and work and the religious climate in Holland, confirm that he was deeply affected by the dominant religious mood of his time. That the roles in which he cast himself were formulated in the framework of seventeenth-century Protestant thought, especially the encouragement of self-scrutiny, suggests that his approach to the Bible was perhaps not as idiosyncratic as was once believed. Nevertheless, the image of the artist expressed in these works is profoundly personal and increasingly independent.

Unfortunately we know little of Rembrandt's religious affiliation. Baldinucci, the only one of his early biographers to discuss his religion, wrote in 1686:

> The artist professed in those days the religion of the Menisti which, though false too, is yet opposed to that of Calvin, in as much as they do not practice the rite of baptism before the age of thirty. They do not elect educated preachers, but employ for such posts men of humble condition as long as they are esteemed by them as honorable and just people, and for the rest they live following their caprice.[1]

No documentary evidence supports Baldinucci's claim that Rembrandt belonged to the radical, fundamentalist Mennonite sect, though his information presumably came from Bernhardt Keil, who had been Rembrandt's pupil in the mid 1640s. Baldinucci's assertion is suspect because it is so conveniently consistent with the generally disapproving picture he paints of Rembrandt as an artist who flouted the rules of painting, was "different in his mental make-up from other people as regards self-control," and "was a most temperamental man and despised everyone."[2] However, Baldinucci should not be discounted entirely. Rembrandt did have connections with a number of Mennonites, the most important being Hendrick Uylenburgh, whose business he joined upon arriving in Amsterdam. Probably, then, it was because of Uylenburgh that two of Rembrandt's first portrait commissions came from members of this sect, Nicolaes Ruts (Fig. 84) and Martin Looten. He continued to portray Mennonites, including the minister Cornelis Claesz. Anslo in 1641. Moreover, Govert Flinck, who worked as Rembrandt's assistant in the mid 1630s and took over his position as teacher in Uylenburgh's "academy," was also a Mennonite.[3]

However, the range of faiths represented by Rembrandt's colleagues, patrons, and sitters suggests it would be a mistake to consider their beliefs as evidence of his attachment to any particular sect. If anything, it indicates that the climate of relative tolerance in the Netherlands may have fostered in him an open-minded attitude toward religion. His teachers Jacob van Swanenburgh and Pieter Lastman were both Catholic. His hometown Leiden was a center of activity for the Remonstrants, a dissenting offshoot of the Calvinist church whose members had been banned from public office and persecuted in the 1620s. One of his most important early patrons, Petrus Scriverius, who probably commissioned the *Stoning of St. Stephen* and the Leiden *Historical Scene* (Figs. 6 and 7), was a Remonstrant leader.[4] But during his Leiden years Rembrandt was also patronized by the Stadholder Frederik Hendrik, a staunch upholder of the Calvinist Reformed Church.

In Amsterdam, though his first clients were Mennonites, Rembrandt soon drew others, a number of them distinguished clergymen, from various faiths. In 1633 he painted, and in 1655 etched, portraits of Johannes Uytenbogaert, the leader of the Remonstrants and preacher at their church in The Hague.[5] His Catholic patrons, all from the 1630s, included Jan Rijksen and Griet Jans, who sat for *The Shipbuilder and His Wife*, as well as the poet Jan Hermansz. Krul.[6] In 1633 and again in 1646 he etched portraits of Jan Cornelisz. Sylvius, preacher at the Reformed Oude Kerk in Amsterdam, who was Saskia's guardian and cousin by marriage, and who had baptized their children.[7] Other Calvinists included Johannes Elison, minister in the Dutch Reformed Church in Norwich, England, and his wife, and the prominent Amsterdammers Maerten Soolmans and his wife, Oopjen Coppit.[8] In 1636 Rembrandt etched the portrait of Menasseh ben Israel, his neighbor and the rabbi at the synagogue near his house on the Breestraat.[9] These portraits were made, for the most part, when Rembrandt was at the height of his popularity as a portraitist. Given the fairly high degree of religious freedom in seventeenth-century Amsterdam, it is not sur-

prising to find that the person who commissioned a portrait cared less about the artist's religious affiliation than about his talent and fame.[10]

Perhaps more telling are extant documents indicating that Rembrandt had a continuing, though somewhat tenuous and not particularly active, affiliation with the Dutch Reformed Church. His parents had been married in the Reformed Pieterskerk in Leiden. In 1634, Rembrandt and Saskia were married in the Reformed church in Sint Annaparochie, in the northern province of Friesland.[11] Their first three children were baptized in Reformed churches. When Saskia died in 1642 she was buried in the Reformed Oude Kerk in a grave purchased by Rembrandt.[12] His companion in his later years, Hendrickje Stoffels, also belonged to the Reformed Church, as indicated by her reprimand from the local church council in 1654. Hendrickje was probably summoned because she was pregnant: that Rembrandt himself was not included in the reprimand reveals little about his relation to the church.[13] Their daughter, Cornelia, was baptized in the Oude Kerk. In 1669 Rembrandt was the godfather—such witnesses had to profess the truth of the church's teaching—at the baptism of his granddaughter. That same year he, like Hendrickje, was buried in the Reformed Westerkerk.[14]

That Rembrandt's strongest connections to the Reformed Church were through his family, rather than direct, suggests he may have switched his religious affiliation over the course of his life or may have been a "libertine," as the freethinking non-church-goers of his day were called. Indeed, it was not at all uncommon to choose or change one's religion in seventeenth-century Holland.[15] Many Dutchmen, including Vermeer and Vondel, converted from one denomination to another. Rembrandt's parents reflect in microcosm the period's extraordinarily fluid approach to church affiliation. Rembrandt's father was the only Calvinist member of a Catholic family, and his mother, though originally Catholic herself, may have converted to Calvinism with her marriage and appears to have turned to the Remonstrant faith upon the death of her husband in 1630.[16] These religious vicissitudes in Rembrandt's own family may have reinforced in him the prevailing attitude of tolerance. Religious freedom of choice may also have strengthened his already reflective nature. Just as the social and economic disruption of his move to Amsterdam forced him to redefine his place in society and aspirations as an artist, so his religious mobility may have fostered examination of his self, the state of his soul, and his relation to God.

Critics have attempted with little success to deduce Rembrandt's religious beliefs from an investigation of his biblical narratives. Rotermund unconvincingly argued that his choice of themes was specifically Mennonite.[17] Visser 't Hooft, who saw Rembrandt's subject matter as universally Protestant and reflective of no particular sect, worked from the assumption that Rembrandt was an independent interpreter of the Bible who relied exclusively and directly on his own reading of the gospel when composing religious works.[18] Recently a more fruitful line of investigation has revised our understanding of Rembrandt's subject matter, showing it to be consistent with the beliefs of main-

stream Dutch Protestantism. Tümpel, arguing that "an age's spiritual and reli-
gious climate . . . is a more powerful formative influence than a particular
person's denomination,"[19] has demonstrated that Rembrandt relied heavily on
pictorial tradition and that many of the themes he treated had been handled by
earlier artists. In particular, he drew on sixteenth-century biblical illustrations
and series of religious prints by such artists as Lucas van Leyden and Maerten
van Heemskerck. Some subjects that had appeared exclusively in prints, as
parts of series, he treated in paint as independent themes for the first time.[20]

Rembrandt's elevation of obscure biblical motifs from the graphic media
to panel painting was part of the general change in biblical interpretation after
the Reformation. The Protestant concern with the literal historical meaning of
the Bible had a profound and far-reaching effect on religious art, as did the
elimination of devotional painting from the Calvinist Church. Old and New
Testament narratives, such as the Sacrifice of Isaac, the Raising of Lazarus and
the parable of the Prodigal Son, were depicted not typologically but literally as
historical exemplars of Christian faith. Certain types of subjects were favored,
in particular moments of recognition or realization. It is possible to identify a
Protestant iconography, in a rather general sense, in this new literal and moral
approach to the Bible.[21]

Rembrandt's approach to the Bible evolved from that of his predecessors,
especially Pieter Lastman; like them, he isolates part of the story and drives at
its literal meaning. His particular contribution is his emphasis on the human
element of the narrative. In his biblical works the moralizing approach of the
sixteenth century is transformed into a penetrating concern with the moral im-
plications of a given situation and with the characters' mental and emotional
responses. Rembrandt examines situations that have a direct bearing on how
he and his contemporaries live their lives, and above all on how they relate to
God. Specifically, a significant number of his subjects are concerned with grace,
a central element of Protestant dogma, and with its corollary, man's innate
sinfulness. In many of his works, the *Supper at Emmaus* in the Louvre for ex-
ample, he tries to make as comprehensible as possible how man reacts when he
comes in contact with the divine. Other subjects, like *Joseph and Potiphar's
Wife* or the *Denial of Peter*, seem to be attempts to grasp the nature of human
failing.[22]

RAISING THE CROSS

As if to demonstrate his faith, Rembrandt included himself in a number of
his early biblical paintings, but nowhere so assertively as in the *Raising of the
Cross* (Fig. 148).[23] Prominently placed in the center of the picture and spot-
lighted to compete with the figure of Christ, he appears, shockingly, as one of
Christ's executioners. Compared to his less exact likenesses—sometimes more
than one in a single painting—in the *Stoning of St. Stephen* (Fig. 6), the Leiden
Historical Scene (Fig. 7), the *Descent from the Cross* (Fig. 149), and, possibly,
Christ in the Storm on the Sea of Galilee, his participant self-portrait in the
Raising of the Cross is unambiguous. The henchman hoisting the heavy cross

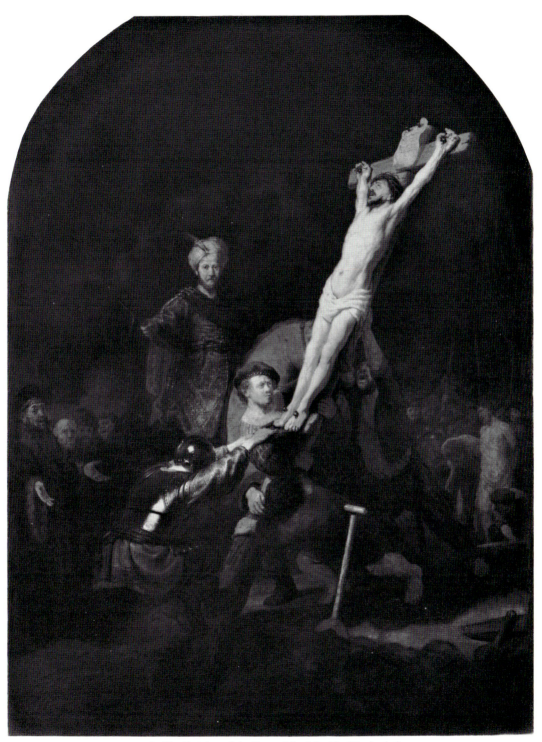

148. *The Raising of the Cross*. Munich, Alte Pinakothek.

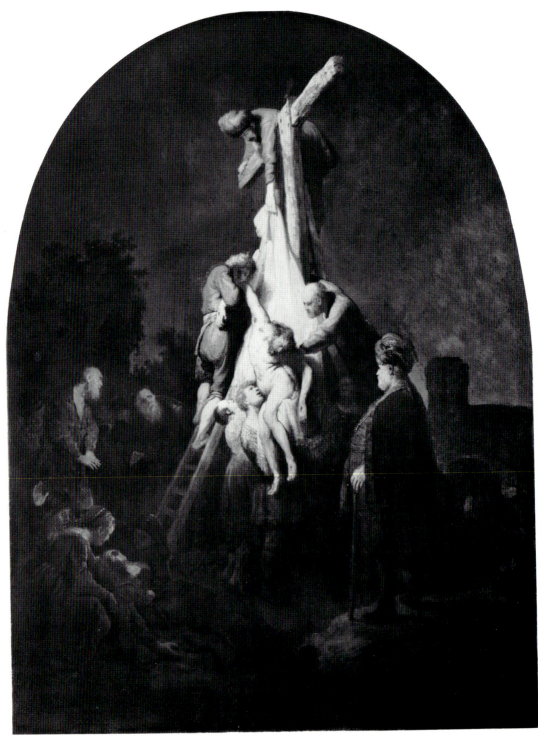

149. *The Descent from the Cross*. Munich, Alte Pinakothek.

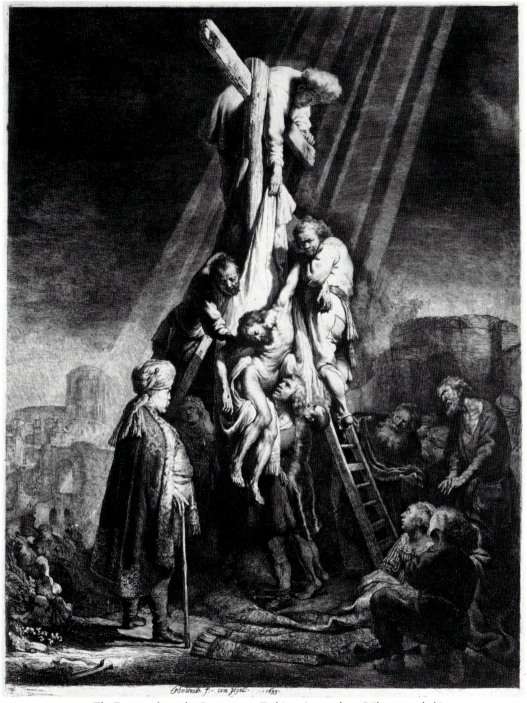

150. *The Descent from the Cross*, 1633. Etching. Amsterdam, Rijksprentenkabinet.

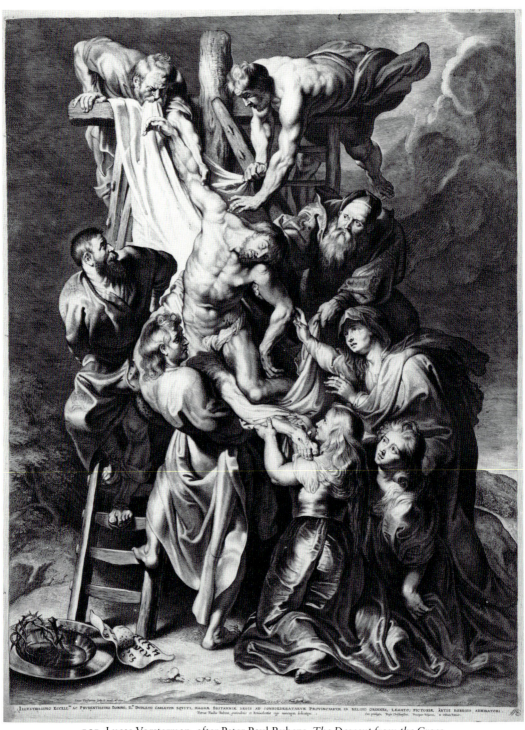

ILLVSTRISSIMO ECCELL.ᵐᵒ AC PRVDENTISSIMO DOMINO. D.ⁿᵒ DVDLEYO CARLETON EQVITI. MAGNÆ. BRITANNIÆ. REGIS AD CONFOEDERATARVM PROVINCIARVM. IN BELGIO ORDINES, LEGATO; PICTORIÆ. ARTIS EGREGIO ADMIRATORI.
Petrus Paulus Rubens, piæteulitæ et benuolentiæ ergo nuncupaui dedicatque.

151. Lucas Vorsterman, after Peter Paul Rubens, *The Descent from the Cross*.
Engraving. London, British Museum.

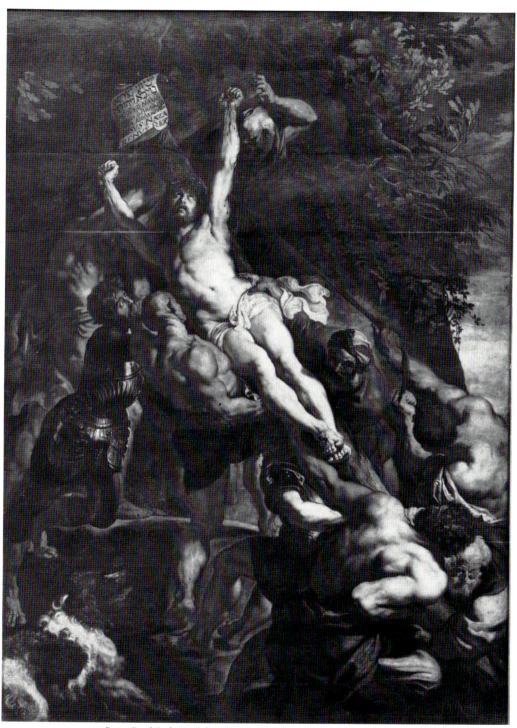

152. Peter Paul Rubens, *The Elevation of the Cross* (triptych, central panel),
1610–11. Antwerp, Cathedral.

Passio domini nostri Jesu.ex hieronp=

mo Paduano.Dominico Mancino.Sedulio.et Bapti=
sta Mantuano.per fratrem Chelidonium colle=
cta.cum figuris Alberti Dureri
Norici Pictoris.

C Has ego crudeles homo pro te perfero plagas

Atq; meo morbos sanguine curo tuos.

Vulneribusq; meis tua vulnera,morteq; mortem

Tollo deus:pro te plasmate factus homo.

Tuq; ingrate mihi:pungis mea stigmata culpis

Sæpe tuis.noxa vapulo sæpe tua.

Sat fuerit.me tanta olim tormenta sub hoste

Iudæo passum:nunc sit amice quies.

153. Title page to Albrecht Dürer, *The Large Passion*. Woodcut. Washington, National Gallery of Art.

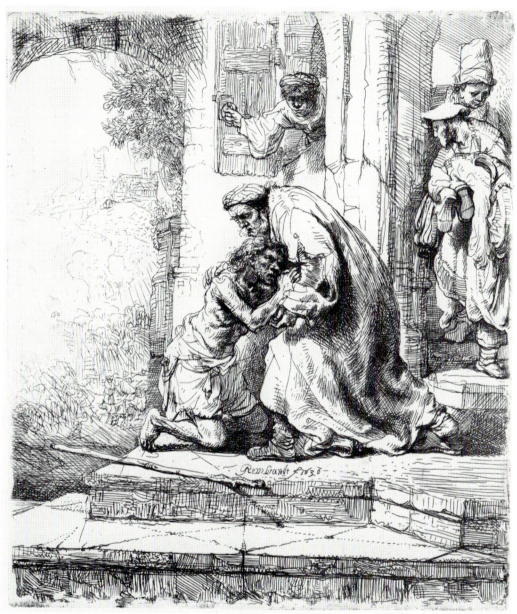

154. *The Return of the Prodigal Son*, 1636. Etching. Amsterdam,
Rijksprentenkabinet.

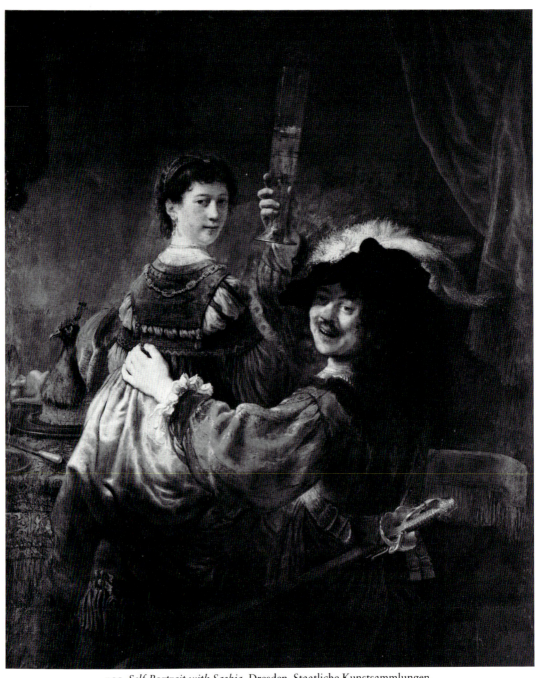

155. *Self-Portrait with Saskia*. Dresden, Staatliche Kunstsammlungen,
Gemäldegalerie.

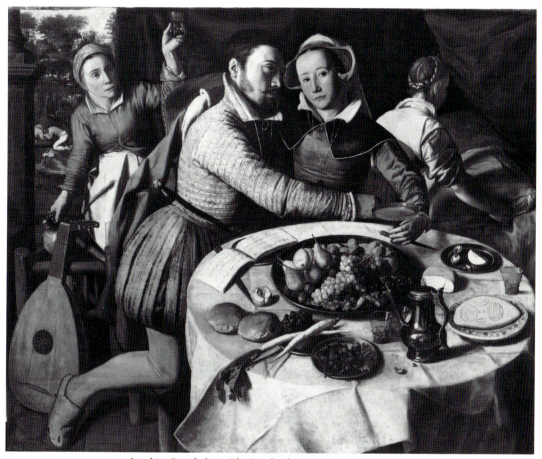

156. Joachim Beuckelaer, *The Prodigal Son*. Brussels, Musées Royaux
des Beaux-Arts de Belgique.

VV. D. HOOFTS

Heden-daeghsche

VERLOOREN SOON.

Ghespeeld' op de

AMSTERDAMSCHE
ACADEMI.

Op den 3. Februario, ANNO 1630.

t'AMSTERDAM,

Door Cornelis VVillemsz Blaeu-laecken, Boeckverkooper inde
Sint Jans-straet, invergulde ABC. ANNO 1630.

158. Title page to W. D. Hooft, *Heden-daeghsche Verlooren Soon,*
Amsterdam, 1630. The Hague, Koninklijke Bibliotheek.

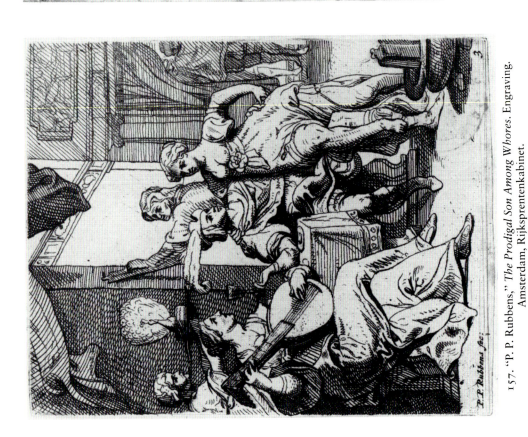

P. P. Rubbens fec:

157. "P. P. Rubbens," *The Prodigal Son Among Whores.* Engraving.
Amsterdam, Rijksprentenkabinet.

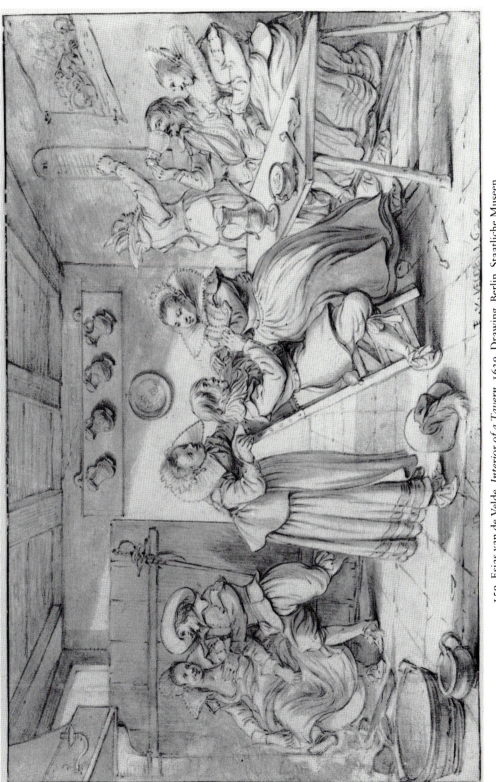

159. Esias van de Velde, *Interior of a Tavern*, 1629, Drawing, Berlin, Staatliche Museen Preussischer Kulturbesitz, Kupferstichkabinet.

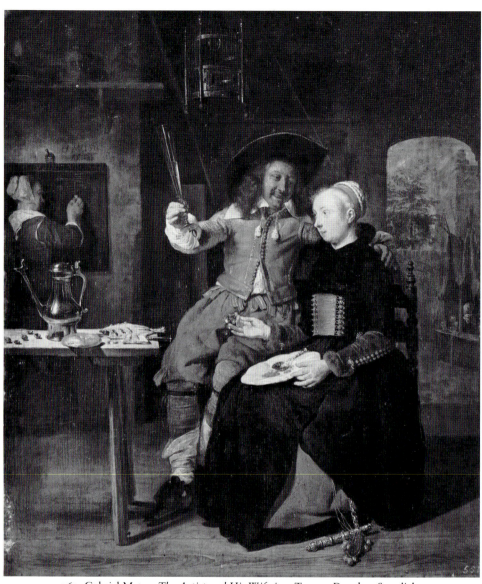

160. Gabriel Metsu, *The Artist and His Wife in a Tavern*. Dresden, Staatliche Kunstsammlungen, Gemäldegalerie.

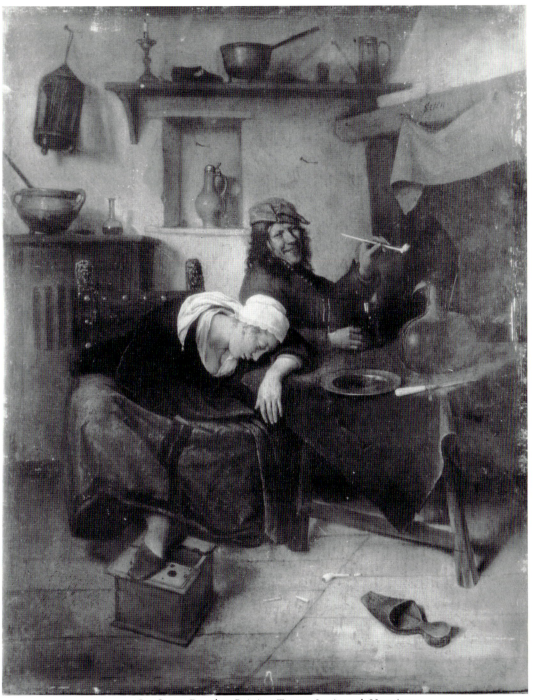

161. Jan Steen, *Drunken Pair in a Tavern*. Leningrad, Hermitage.

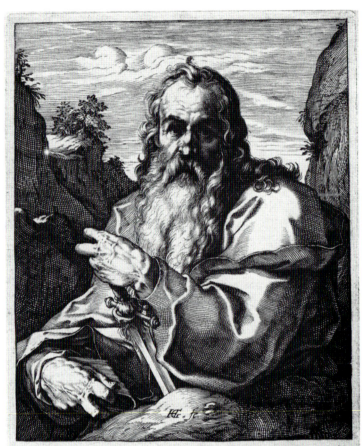

NAM MIHI VITA CHRISTVS
EST, & MORS LVCRVM .

162. Hendrick Goltzius, *The Apostle Paul*. Engraving.
Amsterdam, Rijksprentenkabinet.

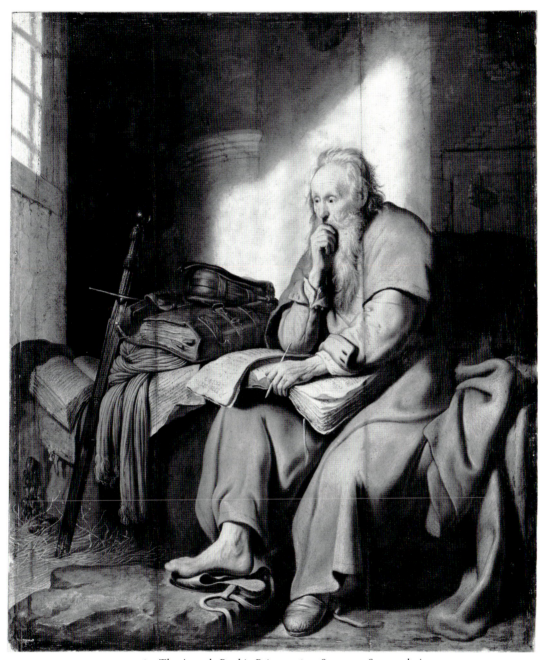

163. *The Apostle Paul in Prison*, 1627. Stuttgart, Staatsgalerie.

166. *Portrait of a Man as the Apostle Paul*. London, National Gallery.

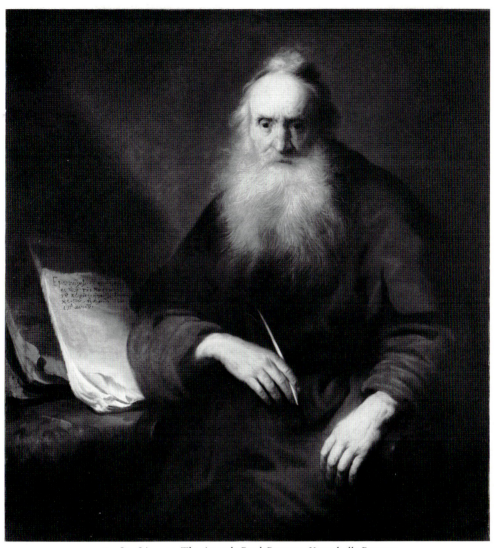

167. Jan Lievens, *The Apostle Paul*. Bremen, Kunsthalle Bremen.

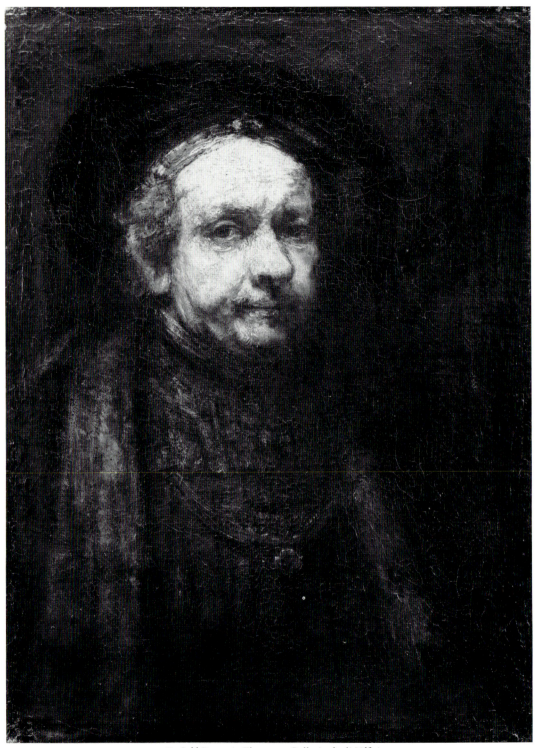

168. *Self-Portrait*. Florence, Galleria degli Uffizi.

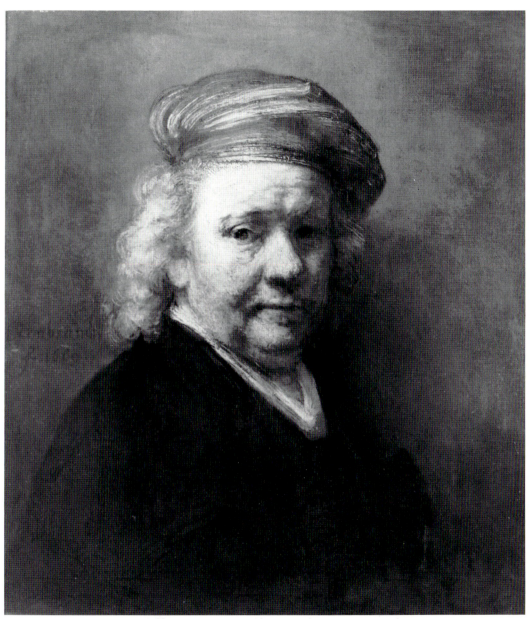

169. *Self-Portrait in Later Life*, 1669. The Hague, Mauritshuis.

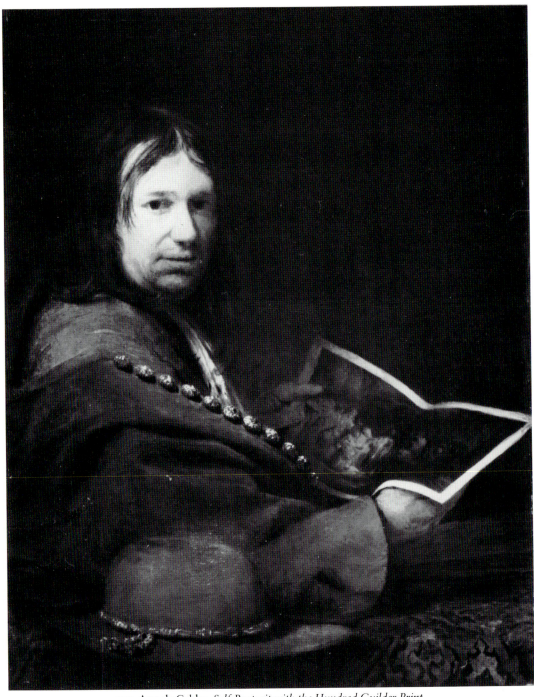

170. Aert de Gelder, *Self-Portrait with the Hundred Guilder Print*.
Leningrad, Hermitage.

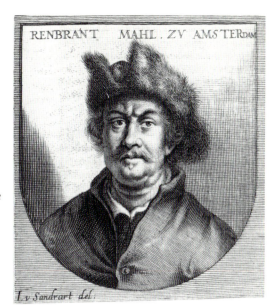

RENBRANT MAHL . ZV AMS TERDAM

I. v Sandrart del.

171. *Rembrandt*. From Joachim von Sandrart, *L'Academia Todesca della architectura, scultura & pittura: oder Teutsche Academie der edlen Bau-, Bild- und Mahlerey-Künste*, Nuremberg, 1675. Amsterdam, Rijksprentenkabinet.

172. *Rembrandt*. From Arnold Houbraken, *De groote schouburgh der Nederlantsche konstschilders en schilderessen*, Amsterdam, 1718. Amsterdam, Rijksprentenkabinet.

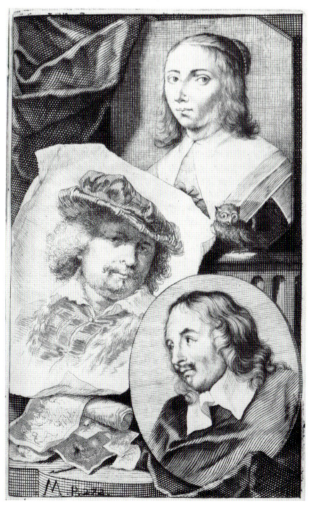

is unmistakably Rembrandt. His features are particularized in contrast to those of the bystanders and other henchmen, whose faces are in shadow. He is also distinguished by his elegant sixteenth-century chemise and jerkin with slashed sleeves, which are defined in greater detail than the other figures' exotic garb. Moreover, as in many of his self-portraits he wears the black beret that by this early date already identified him as a painter.

Rembrandt's brazen, proprietary inclusion of himself in the *Raising of the Cross* suggests that this self-portrait had a significance beyond those in some of his other history paintings. Earlier I discussed the participant self-portrait both as signature and, more importantly, as reflection of the Horatian adage that the artist must live through his subjects' actions in order to make their presentation emotionally convincing.[24] But here, in contrast to his earlier self-portraits as a passive bystander, Rembrandt's involvement as executioner is central to the meaning of the painting. No longer content to play a peripheral part, he displays a new self-consciousness that can be connected to seventeenth-century Protestantism. Indeed, his disconcerting presence has all the certainties of a Calvinist confessional statement. He knows exactly what he is saying about human nature and the human condition.

To shed light on the complexity of this portrait it is necessary to examine the circumstances under which it was produced and the theological perspective from which Rembrandt's contemporaries might have viewed it. The *Raising of the Cross* is one of five paintings of scenes from the Passion of Christ that were in the collection of the Stadholder Frederik Hendrik by 1639.[25] Because of their owner's prominence, the series was one of the most important undertakings of Rembrandt's early career. These paintings are also his most extensively documented works: they form the subject of his only extant letters, written to Constantijn Huygens in the years 1636 and 1639.[26] Despite this documentation, exactly how the *Raising of the Cross* came to be painted is not known.

In the first letter, of February 1636, Rembrandt wrote that he was

> very diligently engaged in proficiently completing the three Passion pictures which His Excellency has personally commissioned me [to do]: an Entombment, a Resurrection and an Ascension of Christ. These are companion pictures to Christ's Elevation and His Descent from the Cross.[27]

He went on to say that the *Ascension of Christ* had been completed and the *Entombment* and *Resurrection* were half finished. His words suggest that these last three paintings were commissioned personally by Frederik Hendrik and that they were conceived to complement, or form a series with, the *Raising* and the *Descent from the Cross* (Fig. 149), which he already owned.

Unfortunately, we have no record of a commission and no mention of how Frederik Hendrik acquired the first two paintings. They entered his collection at some time between August 1632, when an inventory that does not include them was drawn up, and February 1636, when Rembrandt mentioned them in his letter.[28] Presumably Huygens acted as agent in their acquisition, as he was

CHAPTER 5

to do with the three later paintings.²⁹ Huygens, it should be recalled, had praised Rembrandt in his autobiography of about 1631, and the two men must have been in contact in 1632 when Rembrandt painted portraits of Maurits Huygens, Constantijn's brother, and Amalia von Solms, the Stadholder's wife.³⁰ The latter work, which is mentioned in the 1632 inventory, was commissioned as a pendant to the profile portrait of Frederik Hendrik painted by Gerard van Honthorst in 1631.

A likely scenario for the origin of the Passion paintings goes as follows. Rembrandt probably first painted the *Descent from the Cross* in 1632 and 1633 as an independent work, either for the Stadholder or, perhaps, on speculation with the aim of selling it at court. That in 1631 Rembrandt and Lievens had each painted a *Christ on the Cross* (Fig. 13) after a composition by Rubens and in a similar arched format, raises the possibility that Huygens organized a competition for the commission. Upon acquiring the *Descent* the Stadholder commissioned the *Raising of the Cross* as a companion-piece, or he may even have ordered the remaining pictures as well.³¹

Certain features of the *Descent* suggest it was not initially conceived as part of a pair or series. It is the only painting from the group on panel rather than canvas, and it was the only one that Rembrandt reproduced in a print, dated 1633 (Fig. 150).³² Other features seem calculated to accord with the particular tastes of the Stadholder and Huygens. By 1632 Rembrandt's somewhat smaller *Presentation in the Temple* of 1631, or possibly another version, was already in the Prince's collection.³³ His *Descent*, like the other Passion paintings, exhibits the same concern for strong illumination, exotic costumes and dramatic narration found in the *Presentation* and in the earlier *Judas Returning the Thirty Pieces of Silver* (Fig. 8), which Huygens praised so effusively in his autobiography. The *Descent*'s larger size and relatively unusual arched format also suggest it was made with a special client in mind.

Moreover, the Prince and Huygens were great admirers of Rubens, and Rembrandt seems to have been well aware of this. His *Descent* is closely modeled on Rubens' great altarpiece of the same subject in Antwerp, which had been engraved by Lucas Vorsterman in 1630 (Fig. 151). It is at one and the same time his most slavish emulation of Rubens and an astute visual criticism of its prototype. His reproductive etching of the *Descent* underscored his desire to pattern himself on Rubens. Such prints were usually made after an artist's most important works. In the case of the *Descent*, its importance may have derived in part from its owner. This unique instance in which Rembrandt made a copyrighted reproduction of one of his own paintings might be explained partly by the special circumstances of a commission for the Prince of Orange.

Although it is often assumed that Rembrandt painted the *Raising of the Cross* (Fig. 148) in direct response to another altarpiece by Rubens, the central panel of the *Elevation* triptych in Antwerp (Fig. 152), this was not the case. Word of this renowned altarpiece may have reached Amsterdam, but it was not engraved until 1638, and there is no indication that its design was known there before then.³⁴ More to the point, Rembrandt's painting bears little resemblance

to Rubens'. To be sure, Rembrandt's style at this time was heavily influenced by Rubens' dynamic exuberance. He may have deliberately played upon this to appeal to Huygens and the Prince. Yet he did not rely on Rubens' work for his composition. Rembrandt's *Raising of the Cross* exhibits much greater independence from Rubens than his *Descent*. Perhaps the work's originality helps explain why he included his own likeness so aggressively.

Rembrandt's insertion of his own self-portrait into both the *Raising* and the *Descent* is further evidence that the paintings must have been commissioned. Contrary to what we would expect today, in the seventeenth century the participant self-portrait was rarely a feature of a private or personal work of art. Rather, as in the Renaissance, self-portraits were customarily placed in major works, as for example Michelangelo's self-portrait as the flayed skin of St. Bartholomew in the *Last Judgment*. Rembrandt had already included his own likeness in one of his most important history commissions prior to the Passion series, *The Stoning of St. Stephen* and the Leiden *Historical Scene*. Later he, like other artists who painted militia companies for the *Kloveniersdoelen*, would include himself in the *Nightwatch*.

Rembrandt's self-portrait in the *Raising of the Cross* was a kind of advertisement, which, like his self-portraits in black berets and gold chains of honor painted in the same year (Figs. 96 and 97), dignified him and legitimated his claim to the princely attention being lavished on him. Just when he was most concertedly striving to surpass Rubens and, perhaps, make a place for himself at the court, he used this self-portrait to convey his standing in the grand tradition of history painting.

Yet the humanist ideal of the virtuoso artist is not easily reconciled with Rembrandt helping to raise the cross. Indeed, the portrait's presumed promotional purpose is directly contradicted by the message of man's utter sinfulness and depravity conveyed by Rembrandt's behavior. His position as the most prominent executioner shifts the meaning of the work from the customary compassion for Christ's suffering to mankind's nature in bringing about his crucifixion, thereby imparting an extraordinary confessional character to the painting.[35] Moreover, in shifting from peripheral witness to central protagonist Rembrandt also induces the beholder to experience the work at a higher level of moral and emotional involvement.

Rembrandt was by no means the first to include a portrait in a crucifixion scene. Portrait-figures, usually donors, had since the fifteenth century participated as pious witnesses who quietly reflect upon Christ's suffering and who symbolically identify with the sorrow and compassion of the Virgin Mary and her companions.[36] Reformation iconography employed portraits to emphasize the importance of the crucifixion for the salvation of mankind. The most dogmatic example is the Lutheran *Allegory of Redemption* (Weimar, Stadtkirche) painted between 1553 and 1555 by Lucas Cranach the Elder and completed by his son. The elder Cranach included himself to the right of the cross. Beside him stands Martin Luther, who points to a passage in his translation of the Bible referring to the blood of Christ, "which frees us from all sin." Blood flows from

Christ's side directly on to Cranach's head, illustrating a basic tenet of Lutheran doctrine, that no priestly intercession is needed for the individual's salvation. In another Crucifixion by Cranach historical figures who oppose Luther are portrayed among those who refuse to recognize Christ's divinity.[37]

The idea of man as Christ's tormentor, whose sins cause Christ's wounds to bleed, is conveyed in the late medieval devotional image of the Man of Sorrows. This sentiment, which gained increasing importance during the Reformation, is eloquently expressed in the text on the title page of Dürer's *Large Passion* of 1511 and its accompanying *Man of Sorrows Mocked by Everyman* (Fig. 153):

> These cruel wounds I bear for thee, O man,
> And cure thy mortal sickness with my blood.
> I take away thy sores with mine, thy death
> With mine—a God who changed to man for thee.
> But thou, ingrate, still stabbst my wounds with sins;
> I still take floggings for thy guilty acts.[38]

Calvinism also placed tremendous emphasis on man's total corruption, thereby making God's loving grace, upon which man is dependent for salvation, all the more an unearned gift. While the idea of man as Christ's tormentor is an old one, of Catholic origin, Rembrandt's unique expression of it is fully in keeping with the Dutch Protestantism that informed his world. The immediacy of his involvement reflects the Calvinist's increasingly personal approach to the Bible, which he was constantly encouraged to regard as a commentary on his own life and spiritual condition.[39] By making himself the executioner at the crucifixion he transforms what had been an abstract notion into a literal image and thereby intensifies the confessional nature of his sentiment. He turns attention from Christ's dismay at man's sinful nature to man's own guilty knowledge and experience.

Direct, passionate, and personal religious sentiment is characteristic of the devotional poetry of Jeremias de Decker, Heiman Dullaert, and Constantijn Huygens, all members of the Reformed Church and all acquaintances of Rembrandt.[40] For example, Jeremias de Decker, whom Rembrandt portrayed twice, interjected his personal reactions to Christ's Passion into his long poem *Goede Vrydagh*, which recounts the events from the Last Supper to the Ascension. Right from the opening stanza he develops an emotional and confessional persona who relives Christ's Passion in direct speech throughout the poem:

> Since on this mournful day no comic strain
> But tragic note should rise:
> O Lord, I now must mourn your bitter pain
> And [through it] for my sin be moved to sighs.[41]

Perhaps the most compelling literary parallel to Rembrandt's Passion paintings is a set of poems by the metaphysical poet and Reformed theologian Jacobus Revius, *Over-Ysselsche sangen en dichten*, which are arranged according to the sequence of the Bible. One poem in particular, entitled "Hy droeg

onse smerten" (He Bore Our Griefs), expresses a remarkably analogous confessional sentiment:

> No, it was not the Jews who crucified,
> Nor who betrayed you in the judgment place,
> Nor who, Lord Jesus, spat in your face,
> Nor who with buffets struck you as you died.
>
> No, it was not the soldiers fisted bold
> Who lifted up the hammer and the nail,
> Or raised the cursed cross on Calvary's hill,
> Or, gambling, tossed the dice to win your robe.
>
> I am the one, O Lord, who brought you there,
> I am the heavy cross you had to bear,
> I am the rope that bound you to the tree,
>
> The whip, the nail, the hammer, and the spear,
> The blood-stained crown of thorns you had to wear:
> It was my sin, alas, it was for me.[42]

Revius's strikingly personal poem, like Rembrandt's *Raising of the Cross*, centers on the crucifixion to convey as graphically as possible man's responsibility for Christ's death. The poet, like the painter, inserts himself into the sacred event, thereby implicating not only himself but also his audience. Revius addresses Christ personally: "It was I who crucified you." In contrast, the earlier verse accompanying Dürer's symbolic *Man of Sorrows* conveyed mankind's sinfulness more abstractly. There Christ's reproach to man is simply "I take away thy sins with mine, thy death with mine." Revius, however, localizes his confession to a specific historical event, the crucifixion, and employs a more personal, emotional tone to heighten its impact. Above all, his first-person voice and concrete imagery shift the emphasis to the individual's relation to Christ: "*I* am the cross . . . *I* am the rope . . . the nail, the hammer, and the spear."

The self-portrait in Rembrandt's *Raising of the Cross* is analogous to the "I" in Revius's poem. As agent in—and witness to—the crucifixion, each is a testimony of faith that heightens the work's emotional appeal. Rembrandt's combination of the literal rendering of Christ's suffering with his own readily identifiable face rivets our attention as firmly as the poet's declaration that he is the nails, the spear, and the crown of thorns. The moralizing, confessional tone of both poem and painting is permeated with a personal quality that reflects a Protestant self-consciousness new in the seventeenth century.

Yet it is a convention-bound self-awareness in which the painter and the poet, although they may be expressing their personal feelings, see themselves as Everyman. Rembrandt's inclusion of himself is a personal and emotional profession of faith. It is also a statement that, by virtue of its being in a well-defined convention of Protestant confessional expression, proclaims not the painter's individuality but his identity with all men. Still, the very tension be-

tween his roles as representative voice of man and the virtuoso painter Rembrandt sets him apart from the beholder.

THE PRODIGAL SON

Just a few years later, probably in 1636, Rembrandt again assumed a Protestant confessional role, this time with a more personal, even ironic, tone. In the monumental *Self-Portrait with Saskia* in Dresden[43] (Fig. 155) he represented himself as the Prodigal Son carousing in the tavern, a seemingly odd and unflattering guise for the largest of all his self-portraits, the only painted double-portrait of himself and Saskia.[44] Its subject—both as a self-portrait and in light of Rembrandt's continuing interest in the Prodigal Son theme—certainly suggests that he made the picture for himself and not on commission. Perhaps it is the same "conterfeytsel van Rembrandt van Rijn en sijn huysvrouw" that appeared in the 1677 inventory of the estate of the widow of Lucas Crayers, the man appointed Titus's guardian after Rembrandt's insolvency.[45]

The tavern setting is identified by the richly laid table and the chalkboard on the wall at left, used for tallying up drinks. Rembrandt is seated on a bench with his arm around Saskia, who sits on his knee. Both figures look back over their shoulders as if conscious of their audience, but each acknowledges the beholder in a different way. Rembrandt toasts us, raising his tall drinking glass or *fluit*. His momentary laugh, thrown-back head, and upraised glass invite us to join in the merrymaking. In contrast to Rembrandt's abandon, Saskia's upright rigid posture and stern, expressionless face convey a warning. The couple's conflicting attitudes make explicit the moral ambiguity of the many seventeenth-century Dutch genre paintings that simultaneously entice and admonish the viewer.[46]

Their luxurious, old-fashioned garments emphasize the worldliness of the scene. These costumes would have been familiar from contemporary theatrical productions and from paintings by artists of the Utrecht school. Some of their garments are based on Renaissance clothing, known through prints, but with added fanciful elements. Rembrandt's long hair, slashed velvet beret ornamented with a chain and two large white plumes, white gathered shirt, elegant jerkin, and sword identify him as a wealthy bravo or cavalier. Saskia too wears lavish Renaissance clothing of velvet and satin. The heavy curtain, peacock pie, and pearl-handled knife on the table add to the effect of sumptuous luxury.

Critics have long been puzzled by the mood and tone of the picture. Nineteenth-century writers, predisposed to seeing Dutch art as a mirror of nature and self-portraits as a reflection of the sitter's actual circumstances, interpreted it as a realistic portrayal of the couple's prosperity and happiness shortly after their marriage in 1634. Bode, for example, read it as a paradigm of joyousness in which "the exuberance of happy wedded love laughs out at us gaily from the canvas."[47] Early twentieth-century critics, however, found Rembrandt's pleasure in his own prosperity distasteful and incompatible with their vision of him as the independent, rebellious artist-genius.[48] They still saw the painting as a reflection of his life, but now it acquired qualities of an orgy, and Rembrandt's

laughter was seen as unnatural or forced. They reconciled sumptuous feasting and drinking with their image of bohemian genius in several ways. Either the picture captured, and mocked, the wealthy Dutch *burgerlijk* life that Rembrandt may have lived but did not condone, or it was a boisterous tavern scene that celebrated the luxurious life he lived in defiance of Dutch middle-class austerity. This last appreciation, though rejected in recent years, seems closest to the mark.

Valentiner, Weisbach, and, later, Bergström fundamentally altered our understanding of the work when they identified it as an episode from the parable of the Prodigal Son.[49] To those who found Rembrandt's prosperous way of life distasteful, this moralizing interpretation provided verification that he too disapproved of it. Yet as long as he was treated in isolation as an independent interpreter of the Bible it was difficult to understand this performance: for one thing, it left the artist treating his well-bred wife as a harlot. Recently, increased understanding of the moralizing artistic conventions governing Dutch art and the place of pictorial tradition in Rembrandt's art has set the stage for a more persuasive interpretation of the painting as a portrait in the role of the Prodigal Son.

According to the biblical parable told by Christ in the Gospel of Luke:

A certain man had two sons: And the younger of them said to his father, Father, give me the portion of goods that falleth to me. And he divided unto them his living. And not many days after the younger son gathered all together, and took his journey into a far country, and there wasted his substance with riotous living. And when he had spent all, there arose a mighty famine in that land; and he began to be in want. And he went and joined himself to a citizen of that country; and he sent him into his fields to feed swine. And he would fain have filled his belly with the husks that the swine did eat: and no man gave unto him. And when he came to himself, he said, how many hired hands of my father's have bread enough to spare, and I perish with hunger! I will arise and go to my father, and will say unto him, Father, I have sinned against heaven, and before thee. And am no more worthy to be called thy son: make me as one of thy hired servants. And he arose, and came to his father. But when he was yet a great way off, his father saw him, and had compassion, and ran, and fell on his neck, and kissed him. And the son said unto him, Father, I have sinned against heaven, and in thy sight, and am no more worthy to be called thy son. But the father said to his servants, Bring forth the best robe, and put it on him; and put a ring on his hand, and shoes on his feet: And bring hither the fatted calf, and kill it; and let us eat and be merry: For this my son was dead, and is alive again; he was lost and is found.

Traditionally an allegory of the fall and redemption of man, this parable acquired special meaning in the Protestant North, for it conveyed the Reform-

ers' central message—that God extends his grace to all and is merciful and willing to forgive the repentant sinner. According to Calvin, it taught the "boundless goodness and inestimable forbearance of God, that no crimes, however aggravated, may deter us from the hope of obtaining pardon."[50] To him, God is like the father: "As this father, therefore, is not merely pacified by the entreaties of his son but meets him when he is coming, and before he has heard a word embraces him, filthy and ugly as he is, so God does not wait for a long prayer, but of his own free will meets the sinner as soon as he proposes to confess his fault."[51] The sinner's confession, or repentance, is itself a gift of God. For the new kind of Protestant individual, a literal reading of the parable provided both a moral exemplar and comforting assurance of God's grace.

The moralizing import of the parable is reflected in the art of the period. Two traditions have been recognized as providing prototypes for Rembrandt's picture: Northern sixteenth- and early seventeenth-century graphics, and the newer convention of moralizing "merry-company" paintings popular in Utrecht.[52] A tradition of depicting the life of the Prodigal Son had been firmly established in the sixteenth century. Many artists, including Cornelis Anthonisz., Crispijn van de Passe (after Marten de Vos) and Karel van Mander, illustrated the entire parable in a series of images, usually prints, or in a single print or painting in which all or some of the following episodes were shown simultaneously: the younger son, having been given his inheritance, sets off from home; he squanders his money in reckless living, cavorting in a tavern with loose women; having spent his entire inheritance, he is thrown out of the inn; poverty-stricken and in rags, he is reduced to feeding swine or even feeding with them from a trough; and finally, having repented, he is forgiven by his father, who warmly receives him back into his household with a feast. Rembrandt himself represented this last episode in his 1636 etching *The Return of the Prodigal Son* (Fig. 154) just at the time he was painting his self-portrait as the Prodigal Son.

What interests us most is the growing tendency at the time to contemplate one particular episode, the Prodigal Son squandering his patrimony on wine and women. Often the bordello scene occupies almost the whole picture, while the later episodes—the son being driven from the inn, or among swine, or being received by his father—are reduced to a much smaller scale and relegated to the background. For example, in a painting attributed to Joachim Beuckelaer (Fig. 156) the elegantly attired Prodigal Son sits at a well-laden table with his arms around a woman, whose admonishing outward gaze is strikingly similar to Saskia's silent rebuke in Rembrandt's Dresden painting.[53] The couple is attended by two serving women, one holding a glass and jug, the other preparing a bed, who represent the two vices specifically connected with prodigality, drunkenness and lust. In the background the Prodigal Son feeds from a trough with the swine, a reminder of the outcome of such a life.

Later prints confirm that the popularity of the theme of the Prodigal Son in the tavern lasted well into the seventeenth century. An engraving of about 1609 by Cornelis Jansz. Visscher after David Vickboons shows the *Prodigal*

Son in the Arbor of a Tavern as an outdoor scene with elegantly attired couples feasting, drinking, and dancing. In the background the Prodigal, now in tattered clothes, is driven from the inn. Another engraving (Fig. 157), from a series signed "P. P. Rubbens" and published by P. van den Berge in Amsterdam around 1630, resembles Beuckelaer's painting in that the carousing takes place in an interior with figures limited to the Prodigal Son, a woman in his lap, several servants, and a musician.

Characteristically, Rembrandt transformed this pictorial tradition when he painted his own version of the Prodigal Son theme as a double-portrait (Fig. 155). To call attention exclusively to himself and Saskia he eliminated all subsidiary scenes and accessory figures. X-rays show he did not initially envisage such total concentration: a lute-playing woman who originally stood between the two principal characters was subsequently painted out.[54] In condensing the scene he drew, as he had for the theatrical costumes, on the life-size, half-length genre paintings popularized by the Utrecht Caravaggisti Hendrick ter Brugghen, Gerard van Honthorst, and Dirck van Baburen. Many of the Utrecht images of illicit love, drinking, and music-making, though still moralizing, are completely secular, and it is difficult to accept the suggestion that they all derive from the tradition of the Prodigal Son in the tavern. This secular version, and the fact that Rembrandt eliminated the customary references to other episodes from the parable, have raised some question as to whether the Dresden *Self-Portrait with Saskia* had not also lost its biblical meaning and become secularized as well.

Stronger evidence indicates, however, that the painting must have been associated with the Prodigal Son theme. Unlike many of the Utrecht paintings, it retains essentials of the pictorial tradition. It is a picture of worldliness in which the sins of luxury, pride, intemperance, lust, and wastefulness are central features that distinguish it from the parallel tradition of tavern scenes populated by lower-class, sometimes brawling, men. As in the engraving by "P. P. Rubbens" (Fig. 157), a well-dressed man with a plumed beret sits at a table, holding a glass of wine, with a woman on his lap. The setting is a tavern or brothel, identified by the scoreboard on the wall, a motif found in the images described above that also signifies wasting money. Peacock pies are common to Prodigal Son scenes, including the prints by Rubbens and Visscher, for the peacock symbolized *Superbia* (Pride) and *Voluptas* (Lust), and these elaborately constructed pies were regarded as items of conspicuous consumption, served more "uyt pompeusheyt, als om de leckerheyt" (for show than for taste).[55]

Just how thoroughly the biblical parable permeated contemporary morality is reflected in W. D. Hooft's play *Heden-daeghsche Verlooren Soon* (The Present-Day Prodigal Son), first performed in Amsterdam in 1630. The Prodigal Son had been a popular theatrical subject since the late Middle Ages.[56] This updated version of the parable, in which a rich young Amsterdammer named Juliaen squanders his inheritance but is ultimately forgiven, demonstrates that the dramatic tradition continued to keep the biblical story very much alive, and

that the issue of prodigality was considered relevant to everyday life. However, the play does not strictly admonish against leading a life of sin. Rather, like contemporary merry-company paintings, it provided a delightful and entertaining remainder that folly is an inevitable part of man's condition. Its title-page illustration (Fig. 158) contains the main elements of the pictorial tradition: a young man, well dressed in the latest fashion, drinks and carouses, his glass raised, in the company of loose women, while an old procuress picks his pocket. The setting is a bordello, as indicated by the woman at the right chalking up drinks on a slate and, beside her, a curtained bed. In the background three women play conventionally lascivious musical instruments, and the feast on the table includes a peacock pie. A drawing of 1629 by Esias van de Velde of the *Interior of a Tavern* (Fig. 159) similarly suggests that the Prodigal Son of the Bible was inseparable from more secular themes of worldliness and merry-making: in this boisterous tavern a picture of the Prodigal Son eating with the swine hangs on the wall.

For Rembrandt, too, such a scene must have retained strong associations with the biblical parable. Considering his contemporary etching of the *Return of the Prodigal Son*, his attachment to the Bible, and his already vast knowledge of earlier art, especially prints, we must assume he was well acquainted with the pictorial tradition that informs his double-portrait. He probably also knew that a few earlier artists had portrayed themselves as the Prodigal Son or as participants in thematically related merry companies. Albrecht Dürer may have been the first to assume the part as a confessional statement. According to van Mander, he gave his own features to the Prodigal Son who kneels, praying, amongst the swine in his engraving of 1498.[57] Van Mander also praised a self-portrait by Hans van Aachen in which the artist portrayed himself laughing and drinking with a lute-playing woman.[58] Closer to Rembrandt's own time, the *Prodigal Son* of 1629 by the Utrecht painter Jan van Bijlert included a portrait of the artist, standing and looking out at the viewer.[59] Later, Gabriel Metsu, Jan Steen (Figs. 160 and 161), and probably Jan Vermeer (in his Dresden *Procuress*) would all portray themselves in tavern scenes. Moreover, especially during the 1620s and 1630s the vogue for moralizing self-portraits in the role of *pictor vulgaris*, showing artists indulging in various vices, sometimes as personifications of the senses, provided an alternative to the refined virtuoso self-portrait type. Adriaen Brouwer, Joost Cornelisz. Droochsloot, and Anthonie Palamedesz. portrayed themselves as drinkers. Others depicted themselves smoking.[60]

Artists have long had a love-hate relation with wine and women, and Dutch painters of this period were obviously no exception. As early as Aristotle it was customary to liken the inspired ecstasy and madness of the melancholic genius to drunkenness.[61] And drunkenness, like smoking in the seventeenth century, seems a fitting analogy for the melancholic artist's precarious psychic balance. On the one hand, he might benefit from the inspirational effects of Bacchus. On the other, drinking, like lust, was a dangerous vice that distracted the artist from his work, rendering him idle, unproductive, even mad. A further

consideration was that indecorous behavior threatened the dignity of a profession that, especially in the Netherlands, still had not achieved its due status. A recurrent theme in theoretical writing by van Mander and Philips Angel is the artist's vices, drunkenness, lust, and pride, the same vices embodied in Rembrandt's Dresden painting. Van Mander devotes the first chapter of *Den grondt der edel vry schilder-const* to the character and behavior of the "true painter." He warns against lust and, most seriously, drunkenness, which he says can lead to murder.[62] He singles out these "enemies" of art that give painters a bad name, and against which they must wage constant battle. This long admonition reflects his concern not only with the individual painter's reputation but also with the dignity of the profession.[63]

With the exception of Jan Steen's debauched portrayal of himself and his wife in the *Drunken Pair in a Tavern* (Fig. 161), Rembrandt's double-portrait is unrivaled in outrageously embracing drinking, luxury, worldliness, and sin. To be sure, his identification with the Prodigal Son suggests a Calvinist acknowledgment of man's inherently sinful, wicked nature and an affirmation of faith in God's grace, a message like that conveyed in the *Raising of the Cross*. Yet the image is more immediately enticing and glamorous. Rembrandt takes obvious delight as a profligate, at the same time as he confesses his sins.

Here Rembrandt is less Everyman than he was in the *Raising of the Cross*. His role as sinner now seems to have a great deal more to do with his personal and professional circumstances. The mid 1630s was a period of great change when Rembrandt was enjoying his newfound freedom, fame and fortune. His paintings were in great demand, and he was still (or again) working on the Passion series for the Prince of Orange. In 1634 he had married Saskia. Their first child, Rombertus, was born in December 1635 and died in February 1636. Marriage increased Rembrandt's wealth and possibly brought him greater freedom, for it was then that he moved out of Uylenburgh's house. The newlyweds must have been living well, but perhaps too ostentatiously. Saskia's relatives accused the couple of squandering her inheritance, whereupon Rembrandt sued them for libel in 1638.[64] In 1639 he would buy the grand house on the Sint Anthoniebreestraat, incurring a large debt that was to contribute significantly to his eventual financial demise.

Modern critics have accused Rembrandt of social climbing. But even during his most successful period, in the 1630s, there is little evidence of the kind of ingratiating behavior that goes along with trying to better one's standing with a certain segment of society. He did not, like some painters, become a full-fledged member of the class for which he was then painting portraits. If anything, he seems to have regarded his social standing with ambivalence. The *Self-Portrait with Saskia* (Fig. 155) would hardly have ingratiated him with wealthy Amsterdam merchants. It flouts their *burgerlijk* sober austerity and strict morality. Particularly, it mocks the new vogue for chaste pastoral portraits of men and women playing at being shepherds and shepherdesses. Ever since Honthorst had painted pastoral portraits of the King and Queen of England in 1629, wealthy Dutch burghers had sought to have themselves painted in a sim-

ilar way. Rembrandt's portraits of Saskia as Flora in Leningrad and London are particularly poetic transformations of this theme. That they must have been painted as a heartfelt act of love is made all the more apparent by Govert Flinck's superficial portraits of Rembrandt and Saskia in pastoral guise.[65] The raucous double-portrait in Dresden seems calculated to offend precisely the sensibility to which pastoral portraits appealed.

Certainly Rembrandt sought wealth and renown and had high aspirations, but these seemed to be more for his artistic standing than his social status. Moreover, his artistic ambitions had the effect of distancing him from his immediate milieu. As discussed in chapter 3, his role models in this period were international in scope. His 1633 self-portraits with chains of honor (Figs. 96 and 97), like the grander 1640 *Self-Portrait at the Age of 34* (Pl. IV), separate him from the world of Dutch artists by proclaiming his place among the great masters like Rubens and Titian. In contrast, the Dresden portrait, in which Rembrandt boldly and irreverently flaunts his wealth and independence, comments ironically on his own pretentions to the virtuoso gentleman-artist ideal.

THE APOSTLE PAUL

Both the self-portrait in the *Raising of the Cross* (Fig. 148) and the ironic *Self-Portrait with Saskia* (Fig. 155) were, on one level, confessional statements in which Rembrandt's identification with a biblical sinner served as a metaphor for the wretchedness of man, who can be redeemed solely through the grace of God. On another level, each asserted his artistic identity. Later in his life, Rembrandt portrayed himself as St. Paul, the thinker who most clearly expressed the concept of grace and salvation that informed seventeenth-century Dutch Protestantism. The *Self-Portrait as the Apostle Paul* (Pl. VII), painted in 1661 when Rembrandt was fifty-five years old, is one of his most moving self-images, and represents the culmination of his confessional statements of his faith.[66] His deeply personal, heartfelt identification with Paul, an archetypal persona vastly different from that of the sinner, suggests that Rembrandt had now gained greater understanding of his religion. But Paul also provided profound inspiration for Rembrandt's artistic self, for Paul's religious genius, embodying as it did the extremes of near-godly ecstasy and earthbound humility, made him the ultimate melancholic hero of his age.

The *Self-Portrait as the Apostle Paul*, with its heavy impasto, thick brushstrokes, and rich tonalities, is a superb example of Rembrandt's late style. A directed but atmospheric light draws the figure from the enveloping darkness but is focused most strongly on his expressive face. His penetrating gaze forcefully engages the eyes of the beholder. Upon close inspection, however, this seeming immediacy gives way to an inscrutably complex facial expression. As in his finest late portraits, Rembrandt conveys the sense of a vivid presence, through which the full complexities of character are only slowly revealed. Even after lengthy contemplation, the subtleties of his facial gesture are difficult but not impossible to read. His deeply furrowed forehead, arched eyebrows, and wide-open eyes reveal a thoughtful, questioning mind. His slightly pursed lips

and the muscles that tighten at the corners of his mouth betray an element of uncertainty. Strong illumination supports this pensive mood and imparts specific meaning to Rembrandt's expression by isolating not only his head but also the papers he holds in his hand. This selective lighting suggests that his expression is closely related to what is written on the papers.

Rembrandt's heavy brown mantle and white turban enhance the sense of the biblical past. It has been suggested that Paul's Oriental heritage led Rembrandt to take the unusual step of portraying him in a turban.[67] Yet this turban does not resemble the more elaborate silk headdresses in which he usually clothed his biblical figures, as for example in *King Uzziah Stricken with Leprosy*, *Belshazzar's Feast*, or the *Disgrace of Haman*. Nor is it like the dark turban in his *Portrait of a Man as the Apostle Paul* (Fig. 166). Rather, it resembles the white painter's turban he wears in his nearly contemporary self-portraits in Kenwood House and the Louvre (Pl. VI and Fig. 139). In other words, Rembrandt's choice of cap in the Rijksmuseum *Self-Portrait as the Apostle Paul* visually underlines his own identification with the saint. The effect is analogous to that of the staff in the Frick self-portrait (Pl. V), which alludes to both a king's scepter and the painter's mahlstick.

Schmidt-Degener, in 1919, and Valentiner, in 1920, were the first to identify Rembrandt's guise as that of the Apostle Paul on the basis of his two traditional attributes, the book and the sword, the handle of which protrudes from the folds of his cloak.[68] The discovery that the painting, long recognized as a self-portrait, also represented Paul was made in conjunction with studies of the half-length paintings of Apostles and Evangelists to which Rembrandt turned his attention in the late 1650s and early 1660s. These include, from 1661 alone, *St. Matthew and the Angel* in the Louvre, the *Apostle Bartholomew* in Malibu, and the *Apostle Simon* in Zurich. Critics have hypothesized that the self-portrait may have belonged to a series of Apostles, like earlier series by Goltzius (Fig. 162), Rubens, and van Dyck.[69] But, considering the differences in size, quality, and execution among the single-figure biblical "portraits" of this period, the likelihood that they arose from a single commission—and one for which there exists no documentary evidence—is remote.[70] Furthermore, the few records of Rembrandt's pictures of saints in inventories from his lifetime indicate that they were owned separately.[71] Very likely, then, most if not all were produced as independent works to be sold singly.

To treat individually subjects traditionally found in series would be in keeping with Rembrandt's concerns in the late 1650s and 1660s. Then he tended to focus on the essence of a biblical story by concentrating its narrative or extracting figures from their customary settings, so that the contemplative face became his sole expressive means and the difference between portrait and history painting became increasingly difficult to discern. Thus the *Self-Portrait as the Apostle Paul* should be viewed as an independent work, produced during a period when Rembrandt was engaged almost exclusively with this one particular type of painting.

Although it has not always been recognized as such, the self-portrait fits

firmly within the tradition of the historicized portrait, or *portrait historié*, that began in the late fifteenth century and was still thriving in the seventeenth, especially in the Netherlands. Whether portrayed in the form of a saint or as a participant in an Old or New Testament episode, the biblical historicized portrait served to convey the sitter's faith and devotion. One of the earliest types of historicized portrait was also the earliest type of artist-portrait: it showed the artist as St. Luke, his patron saint, drawing the Virgin.[72] Saintly guises, which originated in donor portraits, were widespread in the sixteenth century, as evidenced by the numerous portraits of women as Mary Magdalen by such artists as Jan Gossaert and Joos van Cleve. A self-portrait in the guise of St. Paul by Antonis Mor is documented but not known.[73] Van Mander mentions Goltzius's portrait of a man as St. Sebastian, Jan van Scorel's paintings of his wife as St. Agatha and Mary Magdalen, and a painting by Cornelis Ketel of St. Paul "naer t'leven van Rutger Jansz. gedaen."[74] And he tells us that Ketel also painted *tronies* or heads of Christ and the twelve Apostles whose faces are portraits of painters and collectors.[75]

By Rembrandt's time, however, portraits in religious guises had yielded in popularity to mythological and pastoral historicized portraits like Flinck's portraits of Rembrandt and Saskia. Biblical portraits of individuals were seldom done after the 1630s and had been all but abandoned by the 1650s. David Bailly's *Portrait of a Priest as St. Jerome* is a rare seventeenth-century portrait in saintly guise.[76] The few such works from the second half of the century are almost exclusively portraits of women as Mary Magdalen or group portraits in which entire families appear in biblical scenes, such as Jan de Bray's *Christ Blessing the Children* and Barent Fabritius's *Peter in the House of Cornelius* of 1653.[77]

In the context of seventeenth-century historicized portraiture, Rembrandt's *Self-Portrait as the Apostle Paul* is a highly individual interpretation of a pictorial convention that was already outmoded by the time it was painted in 1661. As discussed in the previous chapter, his Kenwood *Self-Portrait* and *Self-Portrait at the Easel* (Pl. VI and Fig. 139) of about the same date revived a portrait type more prevalent in the previous century. Thus Rembrandt's portrayal of himself as the Apostle Paul is one of several instances in which he drew on the art of the previous century rather than of his own time. But pictorial tradition, while it suggests precedents for the Rijksmuseum painting, does not explain why he chose to represent himself as Paul.

The *Self-Portrait as the Apostle Paul* was the culmination of Rembrandt's lifelong attachment to this saint. Like the Prodigal Son and the Presentation in the Temple, Paul was a subject that had occupied him early in his career and to which he returned many years later. Rembrandt's interest was not in the most frequently represented episode from Paul's life, his conversion on the road to Damascus.[78] Instead he concentrated almost exclusively on Paul the apostle, the inspired yet humble author of the epistles, an emphasis in keeping with contemporary Protestant theology.

Paul was the single most important source for the formulation and devel-

opment of Reformation theology, and his teaching remained central to the beliefs of not only the Reformed Church but also other sects of Dutch Protestantism. Luther and Calvin had looked to his writing and life as their primary authority in returning to the ideals of the apostolic church. Paul's conversion, according to Calvin, was an archetypal Christian experience, for it exemplified grace received completely independently of merit:

> In this history we have a universal figure of that grace which the Lord showeth forth daily to us all. All men do not set themselves so violently against the gospel; yet, nevertheless, both pride and also rebellion against God are naturally engendered in all men. We are all wicked and cruel naturally; therefore, in that we are turned to God, that cometh to pass by the wonderful and secret power of God contrary to nature.[79]

Above all, Paul's message of grace and unmerited redemption became the essential truth about which Protestant theology revolved. The early reformers regarded Paul as the *stylus dei* through which God's Word had been communicated. Their theology emphasized the total helplessness of inherently sinful man, who must have faith in the mercy of the all-powerful divinity. For them Paul's epistles provided the basis for the doctrine of justification by faith, which holds that men's souls are saved by God's grace alone, and that the actions or works of men are of no consequence in achieving salvation.

Like the early reformers, theologians from the various Protestant sects in Rembrandt's Holland looked to Paul as the primary authority in interpreting the gospel. Numerous sermons—preaching was the central focus of the Protestant service, and sermons once delivered reached a wider audience in pamphlet form—reveal the current understanding of Paul. A series of nine sermons on the Epistle to the Ephesians by the Delft preacher Jan Barentsz. van Voorburch, published in 1612, presents a long defense of predestinarian Calvinism.[80] Paul's authority was also invoked in a New Year's letter by the Remonstrant minister Edwardius Poppius, whose less rigid variety of Calvinism questioned the doctrine of predestination.[81] The mainstream interpretation of Paul's teaching, which very closely follows that of Calvin, is found in the extensive annotations to the *Staats Bibel*, the official Bible of the Dutch Reformed Church.

Rembrandt's earliest painting of Paul, the *Apostle Paul in Prison* (Fig. 163) of 1627, concentrates on his role as *stylus dei*.[82] Presumably this was an important painting for Rembrandt, for it was his first single-figure composition on such a large panel. It was also iconographically innovative. Departing from the usual generalized setting, Rembrandt took the unusual step of placing the elderly Paul in a bare prison cell with a grated window, leg irons, and straw on the floor. By localizing the scene in this way he gave it novel narrative immediacy. Paul had four periods of imprisonment, during which he wrote his epistles. Most likely he is shown here in his Roman captivity, writing his Epistle to the Ephesians. In that letter Paul explained his mission and reason for writing:

When ye read, ye may understand my knowledge in the mystery of
Christ . . . [Of this gospel] I was made a minister, according to the gift
of the grace of God . . . Unto me, who am less than the least of all
saints, is this grace given, that I should preach among the Gentiles the
unsearchable riches of Christ; and to make all men see what is the
fellowship of the mystery, which from the beginning of the world hath
been hid in God.[83]

Paul's bearing and his face, with its deeply creased brow and wide-open eyes,
suggest his overwhelming mission and what Erasmus called "the great mind of
Paul hidden in the Scriptures."[84] In a moment of divinely inspired meditation
he pauses from his writing and raises his hand to his mouth. He directs his gaze
not toward the manuscript on his lap, but beyond his physical surroundings to
a wholly spiritual realm.[85]

The imagery of the Epistle to the Ephesians accords with, and helps ex-
plain, certain aspects of the painting. Paul uses light as a metaphor for God's
grace: "For ye were sometimes darkness, but now are ye light in the Lord."[86]
The light that streams through the prison window, striking Paul's face and
forming a backdrop of illumination, connotes the divine source of his privi-
leged rapture. It is important to note that Rembrandt made an analogous use
of light in his nearly contemporary *Artist in His Studio* (Fig. 117): there
strongly directed illumination, together with a suspension of the physical activ-
ity of creation, served as a metaphor for the inspired artistic imagination.

Paul's sword, propped prominently against his pile of books and papers,
signifies the Word with which he does spiritual battle: "Put on the whole ar-
mour of God, that ye may be able to stand against the wiles of the devil . . . the
breastplate of righteousness . . . the shield of faith . . . the helmet of salvation,
and the sword of the Spirit, which is the word of God."[87] As in earlier images
of the Apostle by Lucas van Leyden and Jacques de Gheyn III, Paul rests his
foot on a large rock, which may allude to his description of the community of
the faithful as "built upon the foundation of the apostles and prophets, Jesus
Christ himself being the chief corner stone."[88] Moreover, in the same epistle
Paul refers to his own imprisonment, calling himself "the prisoner of the
Lord,"[89] and contrasts his physical bondage with his spiritual freedom from
law and sin, symbolized by his unshackled foot resting on the cornerstone of
faith. Since he is a man of true faith, armed with the sword of the Holy Spirit,
the chains of the law can no longer bind his soul.

Rembrandt characterized Paul as the teacher of the true faith in another
way in his *Two Old Men Disputing* (Fig. 164) of 1628, which Tümpel has
identified as Peter and Paul in conversation.[90] Among the numerous sixteenth-
and seventeenth-century depictions of Peter and Paul conversing, Lucas van
Leyden's engraving of 1527 (Fig. 165) is the closest prototype for this painting.
Typically, Rembrandt wrought an utter transformation of this traditional sub-
ject. He moved the figures from a landscape setting to a study, prompting Tüm-
pel to suggest that the scene represents Paul's visit to Peter in Jerusalem as de-

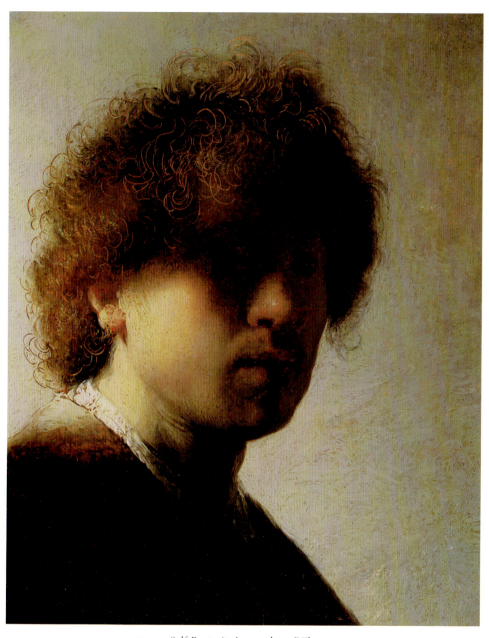

PLATE 1. *Self-Portrait*. Amsterdam, Rijksmuseum.

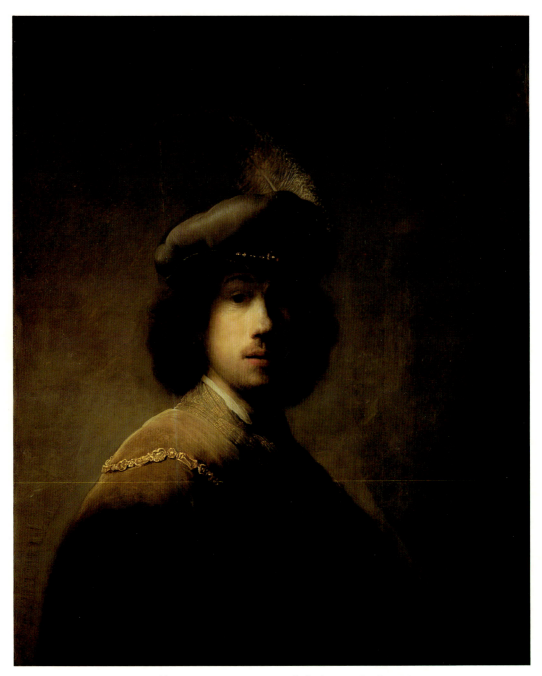

PLATE 11. *Self-Portrait*, 1629. Boston, Isabella Stewart Gardner Museum.

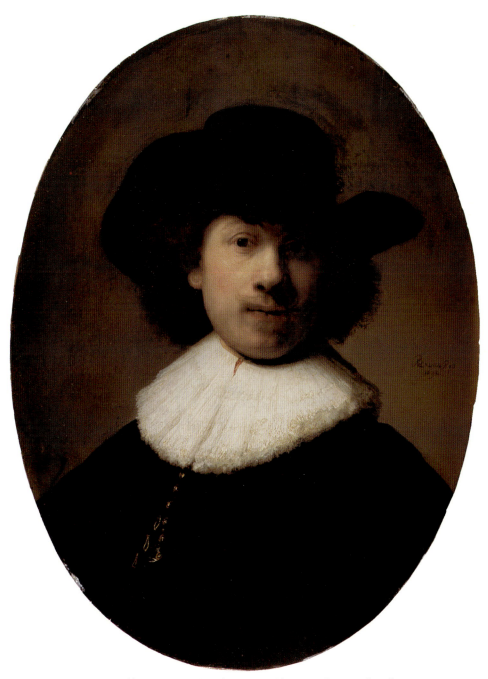

PLATE III. *Self-Portrait as a Burgher*, 1632. Glasgow, The Burrell Collection, Glasgow Museums and Art Galleries.

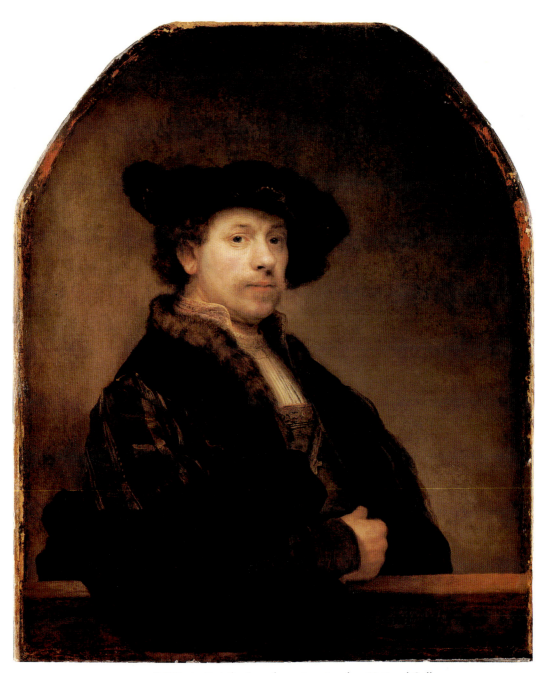

PLATE IV. *Self-Portrait at the Age of 34*, 1640. London, National Gallery.

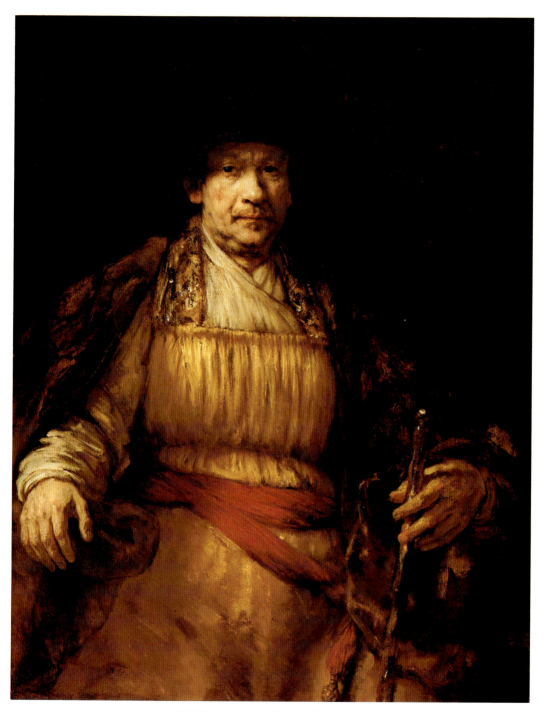

PLATE V. *Self-Portrait*, 1658. New York, The Frick Collection.

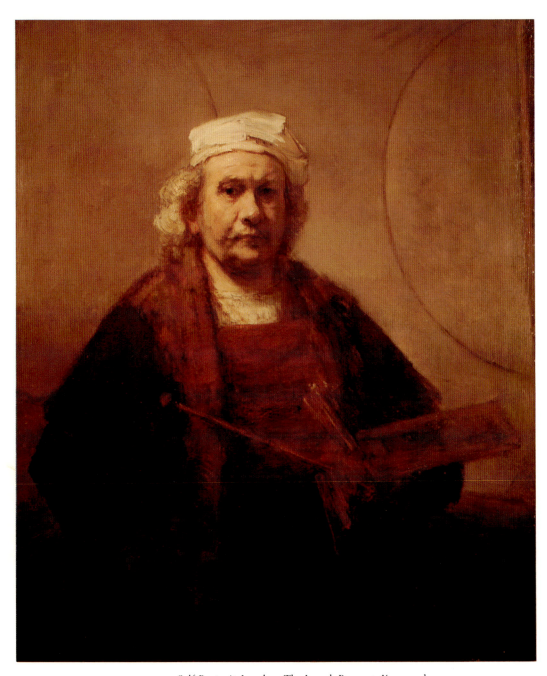

PLATE VI. *Self-Portrait*. London, The Iveagh Bequest, Kenwood.

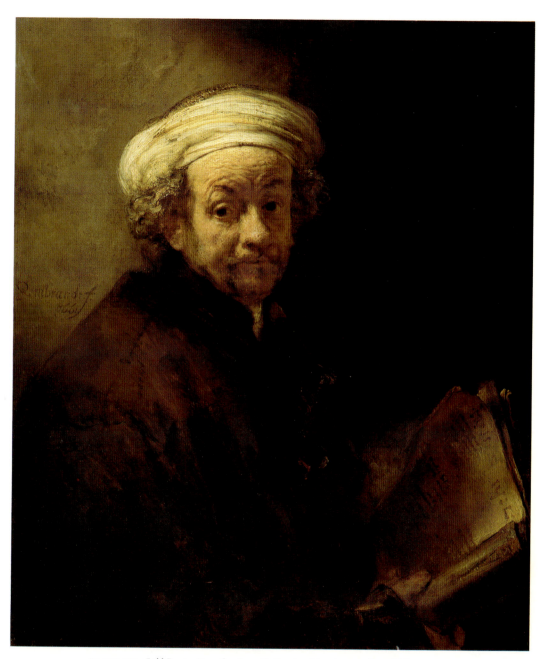

PLATE VII. *Self-Portrait as the Apostle Paul*, 1661. Amsterdam, Rijksmuseum.

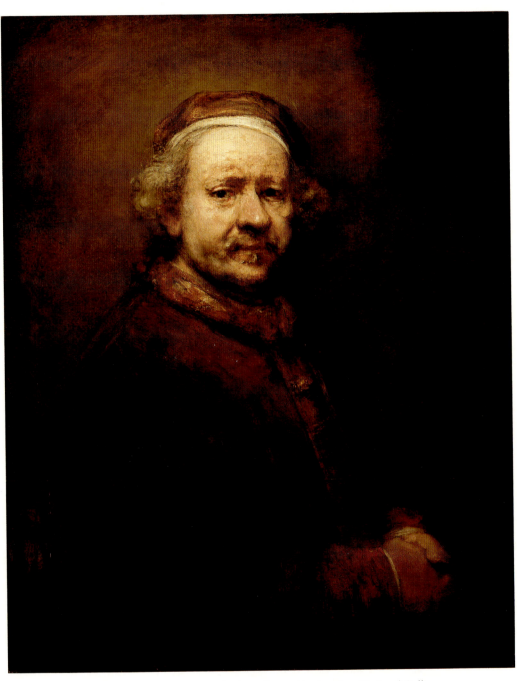

PLATE VIII. *Self-Portrait at the Age of 63*, 1669. London, National Gallery.

scribed in Galatians 1:18. More significantly, he gave Paul a clearly dominant position. Light strikes him as he looms over Peter, who is seen only in lost profile, left in darkness. And it is Paul, not Peter as in Lucas's print, who forcefully points to the open book as if making a particular point. Generally speaking, Paul's prominence reflects his importance to Protestant theology. More specifically, it seems incompatible with a conversation among equals in Peter's study and suggests instead that he is teaching Peter a lesson, as happens later in Galatians. In the "Antioch incident," which occurred during Peter's visit to Paul in Antioch, Peter at first ate with Gentile Christians until the criticisms of the Jewish Christians caused him to shun the Gentiles. Paul rebuked him for this hypocrisy, saying, "a man is not justified by the works of the law, but by the faith of Jesus Christ."[91] Rembrandt's Paul seems similarly to instruct the insecure and humanly wavering Peter in the true message of God.

When Rembrandt again turned to Paul in the late 1650s he revived a type, the half-length apostle, that was by then old-fashioned. In the historicized *Portrait of a Man as the Apostle Paul* (Fig. 166) of about 1659 Paul is seated at his desk, his hands clasped in an attitude of meditative faith with his sword beside him.[92] A framed monochrome roundel on the wall to his left shows the Sacrifice of Isaac in much the same way as Rembrandt's 1655 etching of this subject.[93] In his letter to the Hebrews Paul points to this Old Testament episode not as a typological illustration but for its human and spiritual significance.[94] Abraham is the supreme example of faith:

> By faith Abraham, when he was tried, offered up Isaac: and he that had received the promises offered up his only begotten son . . . accounting that God was able to raise him up, even from the dead.[95]

This allusion to Abraham's test of faith provides insight into the deeply introspective historicized portrait, for Protestantism encouraged the individual to meditate on his own tests of faith, just as Paul had done. As Calvin put it,

> It remains for every one of us to apply this example to himself. The Lord, indeed, is so indulgent with our infirmity that he does not thus severely try our faith: yet he intended in the father of all the faithful [Abraham], to propose an example by which he might call us to a general trial of faith.[96]

Abraham also features in Paul's argument that the freedom of the Gospel must be independent of the law, the idea—central to Reformation theology—that "a man is justified by faith without the deeds of the law."[97] Thus he exemplifies grace and freedom from the law:

> For the promise, that he should be the heir of the world, was not to Abraham, or to his seed, through the law, but through the righteousness of faith . . . Therefore it is of faith, that it might be by grace.[98]

Rembrandt's London *Paul* is evidence of a sophisticated appreciation of the Apostle that paved the way for his *Self-Portrait as the Apostle Paul* (Pl. VII). Perhaps the legal troubles stemming from his near bankruptcy at this period

strengthened Rembrandt's sympathy for Paul's attitude towards the law.[99] And quite possibly Rembrandt, having throughout his life repeatedly depicted the events and the lessons of the scriptures, perceived his artistic mission as explicator of the Bible as akin to Paul's teaching mission. However, I am inclined to seek a fuller explanation for his identification with Paul in the broader meaning of the Apostle's message and in his introspective nature or temperament as messenger.

In his self-portrait, as in his earlier representations of Paul, Rembrandt stressed the Apostle's personal contribution as vehicle for the Word. He conveys this clearly and economically through his two attributes. The sword that he holds close to his heart is not that of his martyrdom but "the sword of the Spirit, which is the word of God."[100] His bundle of papers is his epistles, through which he explicates the Word.[101] Attempts to identify the particular letter have not been successful. Its text is illegible, probably intentionally, like that in some of Rembrandt's other paintings[102] and unlike that in several earlier paintings of Paul by artists from his circle, for example the *Apostle Paul* attributed to Jan Lievens in Bremen (Fig. 167), which shows the beginning of the Epistle to the Thessalonians.[103] The body of the text is only summarily indicated and contains large gaps. As it exists today, the large heading across the top of the page is vague and indistinct: most likely it was never intended to be read, though many have certainly tried.[104]

Perhaps it is unwise to expect Rembrandt to summarize Paul in one particular epistle, just as it would be unwise to seek a single reason for his identification with the Apostle. By this time in his life, Rembrandt was fully steeped in Paul's teaching. He must have had a profound understanding of his message of faith, trust in God's grace, and freedom from the law. He also must have appreciated Paul's human complexity, a complexity that derived in large part from Paul's constant self-examination.

Two moving sermons by Willem Teellinck, one of the most influential Reformed preachers, forcefully convey how the period perceived Paul's self-exploratory, self-questioning nature as essential to his message of grace.[105] Entitled *De Clachte Pauli, over sijne natuerlijcke verdorventheyt* (The Lamentations of Paul over His Natural Depravity), Teellinck's sermons explicate Romans 7:24: "Wretched man that I am, who will deliver me from this body of death?" This verse, Teellinck explains, is Paul's cry for help in his battle with his own flesh and natural corruption, a never-ending struggle that in many ways hindered his service to God. Here Paul's lamentation that he is wretched, and that he wishes to be freed of "this body of death," or sin, is a yearning for the final severance of soul from body that is union with God. Paul similarly expressed his frustrated earthbound longing for spiritual release when he wrote elsewhere of his "desire to depart [i.e. to die], and to be with Christ."[106]

Teellinck's *De Clachte Pauli* emphasizes Paul's confession of his own human weakness, whose contrast with the gift of divine mercy makes salvation all the more awesome. His sinfulness is likened to that of Everyman, who is equally dependent on the grace of God for forgiveness. In focusing on Paul's

intensely personal expression of self-doubt, which is central to the Calvinist scheme of salvation, Teellinck captures the human aspect of his religious genius.

Paul's deeply human and self-revelatory cast of thought, which Teellinck's sermon so effectively captures, must have been at the root of the Apostle's appeal for Rembrandt. His earlier self-portraits in biblical roles accord with the Protestant view of man as inherently sinful and totally dependent on God's grace for salvation. The self-portrait in the *Raising of the Cross* (Fig. 148) and the self-portrait as the Prodigal Son (Fig. 155) are colored by a similar confessional tone. In both, the artist's identification with the biblical sinner serves to mark the enormity of Christ's sacrifice and our dependence on divine mercy. The Apostle Paul, however, embodies to an even greater degree the Calvinist insistence on reconciling one's own sinfulness with faith in God's love and grace. Faith and devotion are Paul's central message; yet they are nothing, he tells us, without humility and self-awareness.

It was precisely that self-awareness, that contrast between Paul's near-divinity and his utter humility, that must have made him so compelling to Rembrandt. As a young man Rembrandt had portrayed himself as a melancholic, an introspective, self-absorbed artistic personality prone to inspiration and enthusiasm yet painfully conscious of the limitations of human intelligence. In the sixteenth century, before the popularization of melancholy, Paul had embodied the wisest type of melancholic genius. Dürer represented him as a gloomy, fiery-eyed melancholic in his *Four Apostles*.[107] Marsilio Ficino had classed divinely inspired poetic *furor* with Paul's ecstasy.[108] Paul may have suggested to Rembrandt a profound analogy to his conception of his own artistic personality; moreover, Rembrandt had devoted much of his career—indeed, the majority of his works—to portraying subjects from the Bible. In identifying with Paul he could boldly, yet respectfully, claim to be an inspired yet humble vehicle for God's Word.

But Rembrandt's identification with the saint, I propose, went beyond this to an even deeper affinity for the self-searching nature of Paul's writing. Self-examination, and the profound humility which it engenders, played a central role in Paul's thought. Though supremely gifted, he described himself as "rude in speech" and "the least of the saints," which might have appealed to Rembrandt in the years around 1660, when he had cast off the pretensions of his earlier self-portraits to portray himself as the painter in his studio. As we have seen, Rembrandt too, in his self-portraits, was constantly reexamining his place in the world. In the *Self-portrait as the Apostle Paul* he identified not just with Paul, but with the Apostle's own conception of his calling.

Epilogue

BOOKS ON Rembrandt often end dramatically with his late (though un-dated) *Self-Portrait, Laughing* in Cologne (Fig. 145).[1] It may well be that this disturbing image in the guise of Zeuxis, with its haunting allusion to death, was among his last. But two other self-portraits dated 1669, the year Rembrandt died, probably reflect more closely how he would have preferred to be remembered by posterity. The dignified paintings in London and The Hague (Pl. VIII and Fig. 169) are fitting conclusions to his lifetime of self-scrutiny. Whether or not Rembrandt sensed that they were to be his last, they proudly affirm for the final time his mastery of his profession and of his self. Through them Rembrandt, just as he had many times before, rose above his immediate circumstances.

Rembrandt died on 4 October 1669 and was buried four days later in the Reformed Westerkerk. His family—what little was left of it—scraped together 20 guilders for a more than respectable funeral with, according to church records, sixteen pallbearers.[2] In the Westerkerk were already the graves of his son Titus, who had died the previous year, and of Hendrickje Stoffels, his companion of many years, who had died in 1663. Rembrandt was survived only by Cornelia, his daughter by Hendrickje, now almost fifteen years old, by Titia, Titus's infant daughter, and, briefly, by Magdalena van Loo, Titus's wife. He had spent his final years virtually alone, without the comfort and protection of the family members who previously had, among other things, taken charge of his business affairs.

At the time of his death Rembrandt was much poorer than he had been at the height of his success. After his near bankruptcy and the sale of his grand house he had rented a considerably more modest dwelling on the Rozengracht in the Jordaan.[3] In 1662 he sold Saskia's grave plot in the Oude Kerk, presumably out of financial need.[4] According to his servant, he had taken to drawing on Cornelia's inheritance for household expenses.[5] The inventory of Rembrandt's estate, compiled the day after his death, includes not much that is fancy or extravagant but consists mainly of mundane necessities—beds and bed linens, silk and lace curtains, several tables and chairs, pewter platters and bowls, jugs with pewter lids, iron and brass candlesticks, earthenware dishes, pots and pans, "other odds and ends not worth specifying," a strongbox, and a Bible. Tantalizingly, however, the notary recorded that "the remaining prop-

erty, including paintings, drawings, rarities, antiquities, and other objects," had been locked and sealed in three separate rooms. This was at the request of Magdalena van Loo and Christiaen Dusart, Cornelia's guardian, who apparently hesitated to accept the legacy unless they could recover from it the expenses of Rembrandt's funeral.[6] What treasures, if any, lay behind these doors remains unknown. But this and other documents clearly indicate that despite his financial troubles Rembrandt had continued to collect art and antiquities.

The inventory also lists twenty-seven finished and unfinished paintings, none identified by subject or artist. This is probably not an indication of a fully active studio, for by 1669 Rembrandt's output of paintings had fallen off to a trickle, and he had long stopped etching and drawing altogether. His last great flurry of work had ended in 1662. The year 1661 had been tremendously productive. He began the *Oath of Claudius Civilis* for the town hall, perhaps the most important public commission of his career. He painted his moving biblical half-lengths, the *Risen Christ* in Munich, the *Evangelist Matthew Inspired by an Angel*, and the various Apostles, as well as his *Self-Portrait as the Apostle Paul* (Pl. VII). His monumental portraits of Margaretha de Geer and Jacob Trip were both presumably done in 1661. And in that year he sent the painting of *Alexander the Great* to Don Antonio Ruffo in Messina. In 1662 he executed his last important group-portrait commission, the *Syndics of the Drapers' Guild*.

That same year, though, his fortunes took a turn for the worse, when the *Oath of Claudius Civilis* was removed from the Amsterdam town hall because it failed for some reason to please the officials who had commissioned it. The next year, 1663, Hendrickje died, and, perhaps not coincidentally, from this point on the number of dated paintings declines precipitously. In 1663 Rembrandt completed the *Homer* for Ruffo, having sent it to him unfinished two years earlier.[7] He did few large-scale historical works in these years: two versions of *Lucretia* are dated 1664 and 1666, and most likely the greatest of his late works—the *Jewish Bride* (which probably represents Isaac and Rebecca), the *Return of the Prodigal Son*, and the *Disgrace of Haman*—date from the early to mid 1660s. The largest number of paintings from after 1663 are portraits; among these, the few identifiable sitters are people he knew, like the painter Gerard de Lairesse and the poet Jeremias de Decker.

This review of Rembrandt's last years may seem bleak. But such a conclusion is perhaps to be expected in the old age of an artist whose energy and health were declining and who never developed a head for financial matters. Despite his slowing down and departing even farther from the taste of the Amsterdam picture-buying public, Rembrandt was still regarded there as the most famous living painter. He continued to attract pupils: Aert de Gelder, who came to study with him in the early 1660s, was his most loyal follower of all. Poems were written in praise of his works: as late as 1667 Jeremias de Decker lauded him as the Apelles of his day.[8] Attention from abroad, especially Italy, attested to his international fame: Ruffo, who had purchased three paintings in the late 1650s and early 1660s, appears to have ordered a complete set of his

etchings shortly before Rembrandt's death.[9] Cosimo de' Medici, future Grand
Duke of Tuscany, visited his studio in 1667, when he may have bought a self-
portrait.[10] Cardinal Leopoldo de' Medici most likely acquired another self-por-
trait, that now in the Uffizi (Fig. 168), in these years.[11]

Though no documentary evidence exists, it is tempting to think that Rem-
brandt painted the Uffizi likeness specifically for the Cardinal, who was re-
nowned for his extensive collection of artists' portraits in the Pitti Palace. In it
he returned to the favored persona of his middle years, that of the romanticized
virtuoso-artist. His chain of honor (now with a medallion), his elegant histori-
cized garb, and his black beret seem calculated to appeal to the illustrious Ital-
ian nobleman. They mark a person of elevated substance destined to join the
company of distinguished artists whose self-portraits were already in the Car-
dinal's gallery.

THE FINAL YEAR

The only works certainly dated to Rembrandt's last year, the imposing
self-portraits in London and The Hague (Pl. VIII and Fig. 169), are more in
keeping with the concerns of his old age than is the elegant portrait from Car-
dinal Leopoldo's collection. Frequently they are thought to reflect the misery
and even senility of his final days. Of course, they reveal the ravages of age.
Rembrandt is an old man now. In his nearly white hair and in his face deeply
lined with wrinkles we perhaps glimpse traces of the ordeals he has lived
through. Yet these paintings hardly seem to show a man complaining that he
has been wronged and has suffered great hardship. If anything, they mask his
cares, in order to voice his self-esteem. Despite his age, they still powerfully
project inner confidence and self-assurance. Moreover, these last self-portraits
confirm that a drive to self-exploration continued to motivate Rembrandt until
the very end of his life.

Notably, both paintings echo compositions of his earlier self-portraits. Af-
ter a career of grappling with artistic tradition, Rembrandt now draws on his
own inner artistic repertory. His portraits have become formally self-reflective.
Self-mastery is revealed in his now total self-sufficiency.

In pose and pyramidal format his *Self-Portrait at the Age of 63*[12] in Lon-
don (Pl. VIII) is reminiscent of his 1640 *Self-Portrait at the Age of 34* (Pl. IV),
painted almost thirty years before. This had been Rembrandt's most famous
and successful self-portrait, and it inspired imitations by many members of his
circle, including Hoogstraten, Bol, Flinck, and Aert de Gelder, who would pay
final homage to his teacher by alluding to this work and holding the *Hundred
Guilder Print* in his self-portrait of about 1700 (Fig. 170).

X-rays of the *Self-Portrait at the Age of 63* indicate that Rembrandt orig-
inally held a palette and brushes. These he painted out in favor of having his
hands clasped as if resting on a ledge or the arm of a chair, as in the *Self-Portrait
at the Age of 34*. Also as in the earlier portrait, Rembrandt romanticized and
historicized his image to divorce himself from his everyday world. His clothing
is not contemporary but old-fashioned: his red jacket with its small fur collar

is similar to garb worn by some of the artists, Jan van Eyck and the Cock brothers for example, in Hieronymus Cock's series of portrait prints. In contrast to the 1640 portrait, however, his image is simpler, more direct, and less pretentious. Rembrandt's attire, though colorful, is less elegant and more subdued. Light is heavily concentrated in the area of his head, holding our attention on his face and piercing black eyes. A somewhat weaker pool of illumination creates a secondary focal point of his rather crudely painted hands. The warm, reddish-brown tonal unity that pervades the canvas emphasizes his face at the expense of his clothes and body.

The self-portrait dated 1669 in the Mauritshuis (Fig. 169) may have been Rembrandt's last.[13] Painting his puffy, perhaps ailing, face as a painfully truthful record of what he saw in the mirror, he achieved a directness seen only in some of his very first etchings (Figs. 14 and 16). As in the London painting, light strikes his face while the rest of the canvas recedes, making us acutely aware of his penetrating gaze. Again this portrait brings to mind another much earlier one, the *Self-Portrait as a Young Man* (Fig. 41) of 1629. We see similarities in the bust-length format, pose, relatively simple garments, and long hair. Rembrandt's colorful silk turban, which he painted over a simple white painter's cap, imparts to the late self-portrait an imaginary exoticism not found in the earlier Mauritshuis painting; but this aspect of his image is in keeping with his romanticized self-portraits of the late 1620s and early 1630s, like that in Boston (Pl. II).

It was characteristic of the very late Rembrandt to return to concerns of his early career: coming full circle, as if to confirm the validity of his youthful pursuits and achievements, he again concentrated on non-narrative, single biblical figures, which, though now in half-length, reflect a type that had occupied him in the Leiden and early Amsterdam years. He also returned to biblical narratives that he had treated early on and that seem to have had special significance for him. *The Return of the Prodigal Son* in Leningrad revived an interest of the mid 1630s. *Simeon and the Christ Child in the Temple*, which was left unfinished in his studio at his death, recalls two earlier versions of the *Presentation* from about 1628 and 1631—though now Rembrandt, at sixty-three perhaps inclined to identify with the aged Simeon, has reduced the scene to three figures, intensifying his focus on the old man's realization that he had seen the Lord and could die in peace.

That his self-portraits of 1669 also recall his earlier inventions and interests suggests a heightened self-consciousness in his last year. From the late 1620s to the early 1640s Rembrandt had alluded to or drawn on portraits by artists like Lucas van Leyden, Rubens, Raphael, and Titian. Since the late 1640s he had become more independent in inventing his self. Now, as if summing up his career, he emulates himself. The London *Self-Portrait at the Age of 63* seems strongly self-referential. That in The Hague too relies on the repertory of forms Rembrandt had stored in his mind. Moreover, both revive that tendency to romanticize his image that had been partially eclipsed by his self-portraits as the painter in the studio. They confirm that, from beginning to end, his

self-portraits revealed selves quite different from those of his contemporaries, selves through which he affirmed his individuality.

REMBRANDT'S REPUTATION RECONSIDERED

The persistence with which Rembrandt, through his self-portraits, laid claim to his unique identity has important implications for our understanding of the vicissitudes of his critical reputation. Posterity has not always been kind to Rembrandt. Immediately after his death the prevailing classicist style and theoretical stance prompted harsh criticism of both his art and his character. In recent years he has again come under fire. Though his early critics had little or nothing to say about his self-portraits, they had a lot to say about his character, and they found his insistence on individual integrity and authenticity highly suspect.

Thanks to Slive and Emmens, the classicist critique of Rembrandt is well known.[14] In the eyes of his late seventeenth- and early eighteenth-century critics he refused to follow the rules of art. The Amsterdam poet and playwright Andries Pels, in his treatise *Gebruik en misbruik des toneels* (The Use and Abuse of the Theater) of 1681, was among the first to chastise Rembrandt for his slavish fidelity to nature, in these famous lines:

> He chose no Greek Venus as his model
> But rather a washerwoman or treader of peat from a barn,
> And called this whim "imitation of nature."
> Everything else to him was idle ornament. Flabby breasts,
> Ill-shaped hands, nay, the traces of the lacings
> Of the corselets on the stomach, of the garters on the legs,
> Must be visible, if Nature was to get her due:
> This is *his* Nature, which would stand no rules,
> No principles of proportion in the human body.[15]

Samuel van Hoogstraten, Gerard de Lairesse, Filippo Baldinucci, Joachim von Sandrart, and Arnold Houbraken followed suit, criticizing Rembrandt's neglect of drawing, anatomy, noble subject matter, and classical art, and backhandedly praising his command of emotional expression, shadows, and color. We know that their oft-made charge that Rembrandt was ignorant of artistic tradition is patently false. Yet in their minds he did ignore tradition, for he responded to earlier art not with classicist orthodoxy but in his own unique, sometimes irreverent, way. These complaints are at least partly attributable to the period's preference for an idealized classical style and proper academic studio practice.

But Rembrandt's critics did not stop at his art. They found the flaws in his character intimately tied to failings in his style and artistic practice. Joachim von Sandrart, a German painter and writer who had spent five years in Amsterdam around 1640, was the first openly to criticize Rembrandt at length, in his *L'Academia Todesca, oder . . . Teutsche Academie der edlen Bau-, Bild- und Mahlerey-Künste*, a treatise on the arts of architecture, sculpture, and

painting published in 1675. In Sandrart's statements that Rembrandt was "guided by nature and by no other rules" and that he painted "subjects that pleased him" rather than noble histories we detect distrust of his willfulness.[16] Sandrart's explicit disapproval of his character and way of life comes across in his accusations that Rembrandt had trouble handling money and that he associated with common people.

The Florentine writer and connoisseur Filippo Baldinucci included a biography of Rembrandt in his book on the history of engraving and etching. He held Rembrandt in "high esteem," certainly higher than had Sandrart, and he appreciated his "most bizarre manner" of etching, "which may be called entirely his own." Yet he had difficulty with the fact that Rembrandt was "different in his mental makeup from other people as regards self-control." He accused him of "pride and self-conceit" and described him as "a most temperamental man [who] despised everyone." To Baldinucci we owe the indelible image of Rembrandt with an "ugly and plebeian face" and "untidy and dirty clothes, since it was his custom, when working, to wipe his brushes on himself." It seems Baldinucci was truly puzzled and disturbed that "when [Rembrandt] was at work he would not have granted an audience to the first monarch in the world."[17] To Baldinucci this disrespect for nobility epitomized Rembrandt's disdain for both authority and decorum.

Arnold Houbraken, who was Hoogstraten's pupil, sums up the classicist critique in the lengthy and surprisingly enthusiastic biography of Rembrandt included in his *De groote schouburgh der Nederlantsche konstschilders en schilderessen* of 1718, the first collection of lives of the seventeenth-century Dutch painters.[18] Despite his seemingly high estimation of Rembrandt and the numerous works, including self-portraits, singled out for mention, the most positive thing Houbraken could say was that Rembrandt was "prolific in ideas" and "inexhaustible" in regard to facial expression and costumes, in which "he surpassed all others." As a classicist, Houbraken found much to criticize in Rembrandt's idiosyncrasy. He dwelt at length on what he saw as Rembrandt's undisciplined inability to complete so many paintings and etchings, especially late in his life, which he claimed Rembrandt capriciously justified by saying that a picture was finished when the master had achieved in it what he wanted. And Houbraken related a curious incident to illustrate Rembrandt's "whimsicality" and his disregard for his client's wishes. Supposedly, once while Rembrandt was working on a large family portrait his monkey died:

> As he had no other canvas available at the moment, he portrayed the dead ape in the aforesaid picture. Naturally the people concerned would not tolerate that the disgusting dead ape appeared alongside of them in the picture. But no: he so adored the model offered by the dead ape that he would rather keep the unfinished picture than obliterate the ape in order to please the people portrayed by him.[19]

Whether this anecdote, which comments emblematically on what Houbraken perceived to be Rembrandt's slavish aping of nature, has any validity to it we

shall never know. But it must have seemed to embody the unconventionality of a man who tried to frighten away visitors to his studio by saying "the smell of the colors will bother you," who was secretive about his idiosyncratic etching method, and who, above all, "would not be bound by any rules made by others."[20]

The portraits of Rembrandt published with these early biographies appear to reflect the biases of the authors. Sandrart (Fig. 171) shows him in a simple fur hat and in his ordinary working attire to illustrate his supposed lowly birth, lack of education, and preference for common folk. Houbraken, who emphasized Rembrandt's singularity, chose to picture him as a moody sort with his eyes shaded (Fig. 172), and he placed beside him an owl, alluding presumably to the poet Vondel's criticism of painters who are "sons of darkness, who like to live in shadow like an owl."[21] Yet both likenesses, it is important to note, are closely based on Rembrandt's own self-portraits. Houbraken's draws on Rembrandt's image as melancholic, specifically his etched self-portrait with Saskia (Fig. 115); and Sandrart's is indebted to his image in working attire (Fig. 123).

The extent to which these likenesses reflect images that Rembrandt projected of himself reminds us that the classicists' unflattering, surely exaggerated, and sometimes apocryphal anecdotes should not be mistaken for simple fabrications. Emmens and Slive trace several of the anecdotes to their origins in Antiquity, and they attribute their application to Rembrandt to his critics' theoretical bias: because they disapproved of his rough, undisciplined style and his lack of professionalism, they exaggerated his personal peculiarities. But legends like that which has Rembrandt trying to pick up coins painted on his studio floor by his pupils were revived not because they were classical topoi but because they reflected more than a grain of truth. There is ample evidence that Rembrandt had serious financial troubles and may, indeed, have been more than normally avaricious.[22] Other tales highlight his unorthodox studio practices, difficulties with clients, and increasing distance from Amsterdam society.

The strength of the classicists' critique has been viewed as prompted by their fear that Rembrandt, the most famous artist of his day, lowered the status of his profession. Yet Rembrandt's detractors cannot have been motivated solely by concern for the artist's social and professional status, for by this time the battle to have painting accepted as a liberal art had been sufficiently won. Rather, I suspect that underlying their particular scorn for Rembrandt was a deep-seated mistrust of his extreme individuality. During the first half of the century when melancholia was fashionable, even glorified, Rembrandt's differentness was not cause for alarm. But after mid-century unconventional behavior increasingly conflicted with the classicist ideal of the artist. Unbridled exploration of the potentialities of genius found no place in academic doctrine.

Unbeknownst to himself or his critics, the artist whom Andries Pels called "the foremost heretic of the art of painting" (*de eerste ketter in de Schilderkunst*)[23] was fighting a new battle for artistic independence, one that was only beginning and that would not be fully won until the Romantic age. In its aftermath early twentieth-century scholars, most notably Schmidt-Degener and

Neumann, would glorify Rembrandt for precisely the same qualities that had earlier brought him under attack.[24] In keeping with the Romantic ideal of the artist they exaggerated his nature as isolated genius. Specifically, they conceptualized his art and life as divided into two opposing parts: an "extroverted" phase when Rembrandt was wealthy and successful and his art was concerned with dramatic, baroque exuberance, with theatrical physical gesture, and with rich surface textures; and a truer "introverted" period in which Rembrandt— now impoverished, cast out by society, and alone—turned to more spiritual values and a fascination with the emotions and inner life. The turning point they identified as the supposed critical rejection of the *Nightwatch* in 1642.

In the 1950s and 1960s the romanticized Rembrandt came under scrutiny, most notably in the scholarship of Slive and Emmens. We now recognize that this view of him as a misunderstood genius, who rose to tremendous popular success and then suffered a crashing decline, is a distorted one. There is no evidence that the *Nightwatch* was a failure,[25] and Rembrandt was never the impoverished outcast of the myth. He continued to receive commissions and collect art, and though he severed relations with the likes of Constantijn Huygens and Jan Six he seems always to have associated with painters, poets, and other like-minded individuals. But scholars who have tried to put this myth into perspective go too far when they deny it altogether. Emmens in particular tried to dispel the myth of the alienated Rembrandt by tracing its origins to Rembrandt's earliest biographers, for in his eyes the classicist critique reflects alienation between Rembrandt and the younger generation, not between Rembrandt and his contemporaries. A simplistic reading of Emmens' important study has led more recent scholars to go still farther, transforming Rembrandt into a social climber and trying to fit him neatly into the world of seventeenth-century Dutch painters. But if there is truth to the independence and nonconformity that made Sandrart, Baldinucci, and Houbraken so uneasy, to that extent there must be some validity to the Romantic myth.

Even the modern two-part Rembrandt cannot be dismissed quite so readily, for, as I have shown, his self-portraits support the notion that he underwent fundamental change. After the elegant *Self-Portrait at the Age of 34* (Pl. IV) and a hiatus in self-portrayal during the 1640s, Rembrandt radically recast his self: in his etched *Self-Portrait Drawing at a Window* and his paintings in Paris and Kenwood (Figs. 112 and 139; Pl. VI) he discarded his Renaissance virtuosity for a more honest, more independent identity as an artist working with his tools. In what is, to be sure, a greatly modified version of the two-part Rembrandt we can recognize a pattern of conceptualizing selfhood consistent with seventeenth-century thought. Since its earliest beginnings autobiographic writing has often chronicled a conversion experience, whether a radical change brought on by a crisis or a gradual one. Thinkers like St. Augustine, Descartes, and later Rousseau constructed their lives around turning points or around renouncing an earlier self. Montaigne ascribed meaning to his life by examining it as a series of changes.[26] Rembrandt's near contemporaries attributed a similar pattern of change to him: Houbraken, for example, noted that

135

his early finished manner, which Houbraken preferred, differed from his later inability to complete his paintings, and he contrasted his early wealth and success with his later frugality and preference for keeping company with "common people and such as practiced art."[27] Painted self-portraits cannot offer the retrospective view of written autobiography. But if Rembrandt's contemporaries could conceptualize their lives (and his) around change, turning points, or conversions, it is possible that he too may have conceived of himself in this way. He did, after all, identify with the Apostle Paul, the archetypal conversion figure. Of course, there is exaggeration in the Romantic two-part Rembrandt; but his self-portraits suggest that, contrary to current opinion, the exaggeration lies not so much in the "introverted" second part as in the "extroverted" first part.

More recently, a revisionist view of Rembrandt has come full circle and revived the classicists' critique with notable vitriol. Like his forerunners, Schwartz couples criticism of Rembrandt's art with criticism of his personality. He finds Rembrandt an "arrogant" man with a "nasty disposition and an untrustworthy character."[28] As evidence of his cruel nature he cites the Geertge Dircx affair, in which Rembrandt had his former mistress committed to an institution for delinquent women.[29] Never mind that this is the only such incident in Rembrandt's life, that we do not know what kind of behavior on either Rembrandt's or Geertge's part precipitated it, and that otherwise the documentary evidence suggests nothing but ordinary domestic tranquility; and never mind, too, that Rembrandt's paintings, drawings, and etchings, a number of which include his wife Saskia and his companion Hendrickje, support a very different picture of a man deeply devoted to his family and profoundly moved by human nature.

Above all, Schwartz criticizes Rembrandt for breaking the rules of art, especially the rules of patronage. Rembrandt, he concludes, was a failed Rubens who "sabotaged his own career" by alienating his patrons. Schwartz's contribution is in bringing to light Rembrandt's pattern of tenuous relations with his clients, which is supported by the documents. Yet he fails to appreciate the most crucial fact about these relations: that Rembrandt loathed being a dependent. His refusal to bow to his clients' wishes—by producing works slowly, by delivering them unfinished or otherwise unacceptable, and by distancing himself from popular taste—was part of his strategy for autonomy. Like Sandrart, Baldinucci, and Houbraken, and in contrast to the proponents of the Romantic view, Schwartz is deeply suspicious of Rembrandt's individuality.

Though they differ greatly in their judgment of it, all three of these views—the classicist, the Romantic, and the revisionist—share a recognition of something that has been lost sight of in recent years: that Rembrandt was a highly independent artist. His self-portraits provide the firmest evidence of this. They prove the Rembrandt myth to be not such a myth after all, for they show us a man who marched to a different drummer. From the very beginning, Rembrandt used his self-portraits to label himself an outcast or an outsider, to set himself apart from the world of his contemporaries. In some of his earliest images he cast himself as a solitary melancholic. In others he romanticized his

image with imaginary, exotic costumes and guises. As he matured he likened himself to cosmopolitan artists such as Rubens, Titian, and Raphael, who stood for a noble, virtuoso ideal not yet familiar in the seventeenth-century Netherlands. Even when he abandoned these elegant masks, his self-portraits in the studio just as surely distanced him from the gentlemanly *burgerlijk* ideal to which his contemporaries adhered. In short, Rembrandt was an acutely self-conscious individual who had to estrange himself not only from the prevailing taste for classicism but from his society and from his fellow artists and their ideals. It would seem to be this estrangement that led to his decline in popularity and to his not receiving commissions he otherwise might have. But his gain was greater than his loss—or so his self-portraits seem to say. The paintings of 1669 show us a man who could die with dignity and grace. According to both de Piles and Houbraken, Rembrandt is supposed to have said, "If I want to give my mind diversion, then it is not honor I seek, but freedom."[30] He had indeed found freedom. In his quest for autonomy he had invented a new idea of the artist as an independent, self-governing individual.

Notes

INTRODUCTION

1. Ruth Saunders Magurn, *The Letters of Peter Paul Rubens* (Cambridge, Massachusetts, 1955), 101–2.

2. Erwin Panofsky, *The Life and Art of Albrecht Dürer* (Princeton, 1955), 9.

3. A.W.H. Adkins, *From the Many to the One: A Study of Personality and Views of Human Nature in the Context of Ancient Greek Society, Values and Beliefs* (London, 1970); Jacob Burckhardt, *The Civilization of the Renaissance in Italy* (1860), translated by S.G.C. Middlemore (London, 1955); Max Weber, *The Protestant Ethic and the Spirit of Capitalism* (1904–5), translated by T. Parsons (London, 1930); C. B. MacPherson, *The Political Theory of Possessive Individualism: Hobbes to Locke* (Oxford, 1962). On individualism, see Steven Lukes, *Individualism* (Oxford, 1973); Louis Dumont, *Essays on Individualism: Modern Ideology in Anthropological Perspective* (Chicago, 1986); *Reconstructing Individualism: Autonomy, Individuality and the Self in Western Thought*, edited by Thomas C. Heller et al. (Stanford, 1986).

4. John W. Chapman, "Toward a General Theory of Human Nature and Dynamics," in *Human Nature in Politics* (Nomos XVII), edited by J. Roland Pennock and John W. Chapman (New York, 1977), 292–319; MacPherson, *Possessive Individualism.*

5. On seventeenth-century self-awareness and its expression in religion, literature, and autobiography, see Margaret Bottrall, *Every Man a Phoenix: Studies in Seventeenth-Century Autobiography* (London, 1958); Joan Webber, *The Eloquent "I." Style and Self in Seventeenth-Century Prose* (Madison, Wisconsin, 1968); Paul Delaney, *British Autobiography in the Sev-*enteenth Century (New York, 1969); Zevedei Barbu, *Problems of Historical Psychology* (New York, 1960); Louis L. Martz, *The Poetry of Meditation. A Study in English Religious Literature of the Seventeenth Century,* rev. ed. (New Haven and London, 1962), especially chapter 3, "Self Knowledge: The Spiritual Combat"; Paul A. Jorgensen, *Lear's Self-Discovery* (Berkeley and Los Angeles, 1967), chapter 2, "Some Renaissance Contexts," discusses sixteenth- and seventeenth-century books on how to know oneself; Barbara Kiefer Lewalski, *Protestant Poetics and the Seventeenth-Century Religious Lyric* (Princeton, 1979).

6. For the astonishing range and numbers of Dutch self-portraits, see Hans-Joachim Raupp, *Untersuchungen zu Künstlerbildnis und Künstlerdarstellung in den Niederlanden im 17. Jahrhundert* (Hildesheim, 1984); Götz Eckardt, *Selbstbildnisse niederländischer Maler des 17. Jahrhunderts* (Berlin, 1971); and H. van Hall, *Portretten van nederlandse beeldende kunstenaars* (Amsterdam, 1963).

7. Jakob Rosenberg, *Rembrandt: Life and Work* (London, 1964), exemplifies the isolationist view of Rembrandt. Compare Washington, National Gallery of Art, *Gods, Saints and Heroes: Dutch Painting in the Age of Rembrandt* (1980), which placed Rembrandt's biblical paintings—long considered anomalous in Dutch art—in the context of the many biblical, historical, and mythological works by his contemporaries. The scholarship of Christian Tümpel ("Ikonographische Beiträge zu Rembrandt," *Jahrbuch der Hamburger Kunstsammlungen* 13 [1968], 95–126; 16 [1971], 20–38; "Studien zur Ikonographie der Historien Rembrandts," *Nederlands Kunsthistorisch Jaarboek* 20 [1969], 107–

98) has been instrumental in bringing to light Rembrandt's dependence on artistic tradition, especially prints from the sixteenth-century North. Kenneth Clark, *Rembrandt and the Italian Renaissance* (New York, 1966) establishes Rembrandt's knowledge of the classical tradition. Egbert Haverkamp-Begemann's review (*Yale Review* 56 [1966/67], 302) criticizes Clark for presenting a confused "image of Rembrandt as an independent painter . . . who rebelled against society and who was rejected by it [that] does not conform at all with the concept of receptivity to Italian art of the Renaissance."

8. J. A. Emmens, *Rembrandt en de regels van de kunst* (Utrecht, 1968).

9. R. W. Scheller, "Rembrandt en de encyclopedische kunstkamer," *Oud Holland* 84 (1969), 132–45.

10. Gary Schwartz, *Rembrandt, His Life, His Paintings* (New York, 1985).

11. Svetlana Alpers, *Rembrandt's Enterprise: The Studio and the Market* (Chicago, 1988), chapter 4. Alpers had presented the first three chapters of her book in the Mary Flexner Lectures at Bryn Mawr College, but the last chapter, in which she formulates her theory of Rembrandt's economic individualism, was not available to me until after the text of the present study was in its final form.

12. Fritz Erpel, *Die Selbstbildnisse Rembrandts* (Berlin, 1967); Wilhelm Pinder, *Rembrandts Selbstbildnisse* (Leipzig, 1943), 3.

13. E. de Jongh, "The Spur of Wit: Rembrandt's Response to an Italian Challenge," *Delta* 12 (1969), 49–67; Scott A. Sullivan, "Rembrandt's *Self-Portrait with a Dead Bittern*," *Art Bulletin* 62 (1980), 236–43.

14. A stimulating exception is Eleanor A. Saunders, "Rembrandt and the Pastoral of the Self," in *Essays in Northern European Art Presented to Egbert Haverkamp-Begemann* (Doornspijk, 1983), 222–27.

15. Bob Haak, *Rembrandt, His Life, His Work, His Time* (New York, 1969), 34. De Jongh, "The Spur of Wit," 49, suggests that the notion that Rembrandt was preoccupied with his own inner life is unacceptable because it is anachronistically founded on modern psychology. See P. Vinken and E. de Jongh, "De boosaardigheid van Hals' regenten en regentessen," *Oud Holland* 78 (1963), 1–26, for an extreme and, I think, misguided argument that portraits are uninterpretable.

16. For a historian's viewpoint, see Peter Gay, *Freud for Historians* (New York and Oxford, 1985).

17. Karl Joachim Weintraub, *The Value of the Individual: Self and Circumstance in Autobiography* (Chicago, 1979), discusses profound cultural change as a stimulus to autobiography from Augustine to the eighteenth century.

18. James Olney, *Metaphors of Self: The Meaning of Autobiography* (Princeton, 1972), and Paul John Eakin, *Fictions in Autobiography: Studies in the Art of Self-Invention* (Princeton, 1985), conceptualize autobiography as a process of self-creation. I disagree with Eakin's calling this creation "fiction," for that implies some unknowable reality, which is exactly the premise these literary critics seek to abandon.

19. Weintraub, *Value of the Individual*, xiii–xiv and passim.

20. Johan Huizinga, *Dutch Civilization in the Seventeenth Century and Other Essays* (New York, 1969), 88.

21. Joachim von Sandrart, *L'Academia Todesca della architectura, scultura et pittura: oder Teutsche Academie der edlen Bau-, Bild- und Mahlerey-Künste* (Nuremberg, 1675), part II, book iii, chapter 22, 326; Filippo Baldinucci, *Cominciamento, e progresso dell'arte dell'intagliare in rame, colle vite di molti de' piu eccellenti Maestri della stessa Professione* (Florence, 1686), 78–80; Arnold Houbraken, *De groote schouburgh der Nederlantsche konstschilders en schilderessen*, I (Amsterdam, 1718), 254–74. Hereafter, translations from Sandrart, Baldinucci, and Houbraken are adapted from those in Ludwig Goldscheider, *Rembrandt Paintings, Drawings and Etchings* (London, 1960).

22. The documentary evidence concerning Rembrandt was originally published by C. Hofstede de Groot, *Die Urkunden über Rembrandt (1575–1721)* (The Hague, 1906) (hereafter cited as *Urk.*). Now standard is Walter L. Strauss and Marjon van der Meulen, *The Rembrandt Documents* (New York, 1979) (hereafter cited as *Documents*: citations by year and document number), which includes transcriptions and English translations of the documents up to the time of Rembrandt's death, and incorporates recent archival findings by I. H. van

Eeghen, H. F. Wijnman, and S.A.C. Dudok van Heel. These three archivists have also published their research in articles which are cited below in the appropriate places.

1. DISCOVERY OF THE SELF

1. Michel de Montaigne, *Les Essais de Michel de Montaigne publiés d'après l'exemplaire de Bordeaux . . . par Fortunat Strowski* (Bordeaux, 1906–19), III.2 (p. 29).

2. Christopher White, *Rembrandt* (New York, 1984), 17. See also *A Corpus of Rembrandt Paintings* by the Stichting Foundation Rembrandt Research Project, J. Bruyn et al. (The Hague, 1982–), I, 172 (hereafter cited as *Corpus*). Generally speaking, the very early self-portraits under consideration in this chapter have received little scholarly attention. The most extensive discussions of these works are to be found in *Corpus* I, 169–76 and 214–17; Christopher White, *Rembrandt as an Etcher: A Study of the Artist at Work* (University Park and London, 1969), 106–9; and Fritz Erpel, *Die Selbstbildnisse Rembrandts* (Berlin, 1967), 12–18.

3. The manuscript of Huygens' Latin autobiography is in the Koninklijke Bibliotheek, The Hague. The Latin text was first published, with a Dutch translation, by J. A. Worp in the *Bijdragen en Mededeelingen van het Historisch Genootschap* 18 (1897), 1–121. Unless otherwise indicated, references are to the Dutch translation by A. H. Kan (Constantijn Huygens, *De jeugd van Constantijn Huyghens* [Rotterdam, 1946]). On Huygens' life and writings, see Rosalie L. Colie, *Some Thankfulness to Constantine* (The Hague, 1956), and Hendrik Arie Hofman, *Constantijn Huygens (1596–1687)* (Utrecht, 1983).

4. Huygens, *Jeugd*, 17.

5. On Dutch self-portraits and portraits of artists, see Raupp, *Untersuchungen*; Eckardt, *Selbstbildnisse niederländischer Maler*; van Hall, *Portretten van nederlandse beeldende kunstenaars*; and K. G. Boon, *Het zelfportret in de Nederlandsche en Vlaamsche schilderkunst* (Amsterdam, 1947).

6. Leiden, Stedelijk Museum "De Lakenhal," dated 1568.

7. One of the earliest such collections was that of Giorgio Vasari. See Wolfram

Prinz, *Die Sammlung der Selbstbildnisse in den Uffizien*, I. *Geschichte der Sammlung* (Berlin, 1971), 17–28. The self-portraits in the collection of Charles I of England are discussed on p. 47.

8. Raupp, *Untersuchungen*, 18–44, discusses these engraved portrait series.

9. In 1609, within six months after the truce with Spain, the Leiden painters petitioned the civic authorities to prohibit foreigners from selling art works outside designated free-market days. The following year they reiterated this plea and requested permission to establish a guild. In 1642, their demands still not met, they petitioned for protection again, with greater success, although the painters' guild would not be officially recognized until 1648. On seventeenth-century Dutch painters' socioeconomic status and their guilds, see G. J. Hoogewerff, *De geschiedenis van de St. Lucasgilden in Nederland* (Amsterdam, 1947); Bernard Aikema, Hessel Miedema et al., "Schilderen is een ambacht als een ander," *Proef* June 1975, 124–44; John Michael Montias, *Artists and Artisans in Delft: A Socio-Economic Study of the Seventeenth Century* (Princeton, 1982). For the particular situation in Leiden, consult Hoogewerff, 175–77; Montias, 70–74; W.J.C. Rammelman Elsevier, "Iets over de Leidsche schilders van 1610, in verband met het geslacht der Elsevieren," *Berigten van het Historisch Gezelschap te Utrecht* I, no. 2 (1848), 35–45; A. Bredius and W. Martin, "Nieuwe bijdragen tot de geschiedenis van het Leidsche St. Lucasgild," *Oud Holland* 22 (1904), 122–24; Aikema, Miedema et al., 129. For documents regarding the recognition of the painters' guild in 1648, see F.D.O. Obreen, *Archief voor Nederlandsche kunstgeschiedenis* (Rotterdam, 1877–90), V, 187–90; and compare Aikema, Miedema et al., 130–31, where it is suggested that the relatively late recognition of the painters may have been due in part to the disruptive activities of the trouble-ridden linen guild in Leiden. If the authorities were wary of guilds for this reason, it was especially to the painters' advantage to convey the image not of malcontents but of refined, learned gentlemen.

10. J. J. Orlers, *Beschrijvinge der stadt Leyden* (Leiden, 1641), 375; cf. *Documents* 1641/8 (this and subsequent translations

from Orlers are adapted from those in *Documents*).

11. Ernst Jan Kuiper, *De Hollandse "Schoolordre" van 1625. Een studie over het onderwijs op de Latijnse scholen in Nederland in de 17de en 18de eeuw* (Groningen, 1958), reproduces and translates the text of the school order.

12. Orlers, *Beschrijvinge*, 375.

13. Philips Angel, *Lof der schilder-konst* (Leiden, 1642), 44.

14. B.P.J. Broos, "Rembrandt and Lastman's *Coriolanus*: The History Piece in 17th-Century Theory and Practice," *Simiolus* 8 (1975/76), 199–210.

15. *Corpus* A2 and A 5.

16. Leiden, Stedelijk Museum "de Lakenhal," *Geschildert tot Leyden anno 1626* (1976), 66–88; Schwartz, *Rembrandt*, 35–39.

17. Huygens, translated in *Corpus* I, 193.

18. *Corpus* A15.

19. Huygens, translated in *Corpus* I, 193.

20. Huygens, translated in *Corpus* I, 193.

21. *Urk.* 65; *Documents* 1639/2. The exact meaning of these words has been the subject of lengthy debate. Strauss and van der Meulen, *Documents*, 162, list the extensive literature on the subject. See in particular Horst Gerson, *Seven Letters by Rembrandt*, transcription by Isabella H. van Eeghen, translated by Yda D. Ovink (The Hague, 1961), 39–40; Lydia de Pauw-de Veen, "Over de betekenis van het woord 'beweeglijkheid' in de zeventiende eeuw," *Oud Holland* 74 (1959), 202–12; and Alpers, *Rembrandt's Enterprise*, 49. Hessel Miedema, *Kunst, kunstenaar en kunstwerk bij Karel van Mander* (Alphen aan den Rijn, 1981), 154–55, discusses van Mander's use of the term *beweeghlijckheyt*. On the seventeenth-century concern with "the passions of the soul," see John Rupert Martin, *Baroque* (New York, 1977).

22. Leon Battista Alberti, *On Painting*, translated by Cecil Grayson (London, 1972), 81.

23. Karel van Mander, *Den grondt der edel vry schilder-const*, edited by Hessel Miedema (Utrecht, 1973), I, 174–75 (vi.55). Volume I of this edition comprises a facsimile and a modern Dutch translation of van Mander's text; volume II contains Miedema's commentary.

24. Van Mander, *Grondt* I, 166 (vi.28).

25. B. 316.

26. Van Mander, *Grondt* I, 166–69 (vi.26–32).

27. Van Mander, *Grondt*, I, 167 (vi.29–30): "want krencken en groeven/ Daer bewijsen, dat in ons is verborghen/ Eenen bedroefden gheest, benout, vol sorghen./ Iae t'voorhooft ghelijckt wel de Lucht en t'weder,/ Daer somtijts veel droeve wolcken in waeyen,/ Als t'hert is belast met swaerheyt t'onvreder."

28. Van Mander, *Grondt* I, 158–59 (vi.5).

29. Franciscus Junius, *The Painting of the Ancients* (London, 1638), 2.

30. Junius, *Painting*, 234–35.

31. Montaigne, *Essais*, III.13 (p. 371), quoted in M. A. Screech, *Montaigne and Melancholy. The Wisdom of the "Essays"* (Selinsgrove, 1984), 101.

32. René Descartes, *The Philosophical Writings of Descartes*, translated by John Cottingham, Robert Stoothoff, Dugald Murdoch (Cambridge, 1985), I, 327.

33. B. 320.

34. B. 10.

35. B. 13.

36. Domenico Bernini, *Vita del Cavalier Gio. Lorenzo Bernino* (Rome, 1713); discussed in Howard Hibbard, *Bernini* (Harmondsworth, 1965), 29. It was perhaps no coincidence that this self-involvement for the sake of realism concerned a figure of his name saint.

37. G. P. Bellori, *Le vite de' pittori, scultori ed architetti moderni* (Rome, 1672), 347: "ragionare da se solo, e mandar voci di duolo, e d'allegrezza, secondo l'affettioni espresse."

38. Kuiper, "Schoolordre," 21.

39. *Ars Poetica*, 99–104, from Horace, *Satires, Epistles and Ars Poetica*, trans. by H. Rushton Fairclough (Cambridge, Mass., 1966), 459. For a discussion of this passage and its application to the art of painting, see Rensselaer W. Lee, *Ut Pictura Poesis. The Humanistic Theory of Painting* (New York, 1967), 23–32. For a formulation of this argument with regard to the self-portraits in Rembrandt's *Descent* and *Raising of the Cross*, see H. Perry Chapman, "The Image of the Artist: Roles and Guises in Rembrandt's Self-Portraits" (Ph.D. disserta-

tion, Princeton University, 1983), 243–45. Compare Alpers' assessment of the role of acting in Rembrandt's art, *Rembrandt's Enterprise*, chapter 2, "The Theatrical Model," especially 37–41.

40. Alberti, *On Painting*, 81.

41. Junius, *Painting*, 60.

42. Junius, *Painting*, 61–62.

43. Junius, *Painting*, 231.

44. Junius, *Painting*, 299.

45. Samuel van Hoogstraten, *Inleyding tot de hooge schoole der schilderkonst* (Rotterdam, 1678), 109: "Wilmen nu eer inleggen in dit alleredelste deel der konst, zoo moetmen zich zelven geheel in een toneelspeeler hervormen."

46. Hoogstraten, *Inleyding*, 110: "Dezelve baet zalmen ook in 't uitbeelden van diens hartstochten, die gy voorhebt, bevinden, voornaemlijk voor een spiegel, om te gelijk vertooner en aenschouwer te zijn. Maer hier is een Poëtische geest van noode, om een ieders ampt zich wel voor te stellen." See Peter Schatborn, *Dutch Figure Drawings from the Seventeenth Century* (The Hague, 1981), 11–12.

47. See above, chapter 1 note 20.

48. B. 5 and 54.

49. B. 4.

50. B. 27.

51. B. 12.

52. B. 338.

53. Portraits from the 1620s indicate that wearing a "lovelock" over one shoulder was the height of fashion at the courts of Louis XIII and Charles I. See Willem de Passe's portrait prints of Louis XIII, dated 1624 and 1628; Daniel Mytens' *Portrait of Charles I* of 1629 (New York, Metropolitan Museum of Art); Adriaen Hanneman, *Portrait of Constantijn Huygens with His Children* of 1640 (The Hague, Mauritshuis), illustrated in M. M. Toth-Ubbens, "Kaalkop of ruighoofd, historisch verzet tegen het lange haar," *Antiek* 6 (1972), 371–85, figs. 1, 2, and 4. Toth-Ubbens discusses the controversy, waged in sermons in England and the Netherlands, over long hair, which was considered by some to be an effeminate sign of frivolity and degeneracy.

54. *Corpus* A14. Neither signed nor dated, it can be placed in the year 1628, shortly after the *Goldweigher* of 1627, where Rembrandt first used the Utrecht Caravaggesque lighting scheme and close-

up figure, and contemporary with the *Two Old Men Disputing*.

55. The distinctive character of Rembrandt's early painting technique is discussed by van de Wetering in *Corpus* I, 11–34.

56. The Amsterdam version became known to the public only in 1959. See *Corpus* I, 173, and Kurt Bauch, "Ein Selbstbildnis des frühen Rembrandt," *Wallraf-Richartz-Jahrbuch* 24 (1962), 321–32.

57. On van Vliet, see J. Bruyn, "The Documentary Value of Early Graphic Reproductions," in *Corpus* I, 35–51; Martin Royalton-Kisch, "Over Rembrandt en van Vliet," *Kroniek van het Rembrandthuis* (1984), no. 1–2, 2–23. Bauch, "Selbstbildnis," 324–27, noted that the etching was made after the Amsterdam version, as indicated by similar contours in the cast shadows and on the side of Rembrandt's face.

58. *Corpus* A19; Br. 2.

59. Ben. 54; Peter Schatborn, *Tekeningen van Rembrandt, zijn onbekende leerlingen en navolgers in het Rijksmuseum* (Amsterdam, 1985), no. 1.

60. Ben. 53.

61. B. 17; *Corpus* A96.

62. Van Mander, *Grondt*, I, 167 (vi.26).

63. Gerard de Lairesse, *Het groot schilderboek* (Amsterdam, 1707), II, 5.

64. Van Mander, *Het Schilder-boeck* (Haarlem, 1604), 281r: "soo dat den meesten deel, door het aensoeten des ghewins, oft om hun mede t'onderhouden, desen sijdwegh der Consten (te weten, het conterfeyten nae t'leven) veel al inslaen, en hene reysen, sonder tijt oft lust te hebbe, den History en beelde-wegh, ter hooghster volcomenheyt leydende, te soecken, oft na te spooren."

65. Continuing the Renaissance *paragone* or comparison of poetry and painting, the poet thus argues for the superiority of the word over the image. A variant of this is Vondel's challenge to Rembrandt to paint the voice—a "speaking likeness"—of the preacher Cornelis Anslo. See J. A. Emmens, "Ay Rembrandt, maal *Cornelis* stem," *Nederlands Kunsthistorisch Jaarboek* 7 (1956), 133–65.

66. Xenophon, *Memorabilia* 3.10, 3 and 5; translated in J. J. Pollitt, *The Art of Greece 1400–31 B.C. Sources and Documents* (Englewood Cliffs, New Jersey, 1965), 161.

67. Ann Jensen Adams, "The Paintings of Thomas de Keyser (1596/7–1667): A Study of Portraiture in Seventeenth-Century Amsterdam" (Ph.D. dissertation, Harvard University, 1985), 313–19, discusses the ideal of *tranquillitas*. On Dutch seventeenth-century portraiture, see H. Gerson, *Hollandse portretschilders van de zeventiende eeuw* (Maarssen, 1975); William H. Wilson, *Dutch Seventeenth Century Portraiture* (Sarasota, Florida, 1980); Bob Haak, *The Golden Age: Dutch Painters of the Seventeenth Century* (New York, 1984), 98–114, 229–36, and 273–81; E. de Jongh, *Portretten van echt en trouw. Huwelijk en gezin in de Nederlandse kunst van de zeventiende eeuw*, (Haarlem, 1986), 14–26.

68. Hoogstraten, *Inleyding*, 110: "Het gelaet des aengezichts wort wel te recht den spiegel van het hart genoemt; waer in gunst en wangunst, liefde en haet, vlijt en traegheit, vreugd en droefheit, en zoo veel hartstochten, als 'er in 't gemoed zich oyt beweegen kunnen, gezien en als geleezen worden."

69. Huygens, *Jeugd*, 80.

70. Huygens *Jeugd*, 82; translated in Schwartz, *Rembrandt*, 76.

71. Francois H. Lapointe, "Who Originated the Term 'Psychology'?" *Journal of the History of the Behavioral Sciences* 8 (1972), 328–35.

72. H. Schüling, *Bibliographie der psychologischen Literatur des 16. Jahrhunderts* (Hildesheim, 1967); idem, *Bibliographisches Handbuch zur Geschichte der Psychologie des 17. Jahrhunderts* (Giessen, 1964).

73. Raymond D. Clements, "Physiological-Psychological Thought in Juan Luis Vives," *Journal of the History of the Behavioral Sciences* 3 (1967), 219–35.

74. George Mora, review of Juan Huarte, *The Examination of Men's Wits*, *Journal of the History of the Behavioral Sciences* 13 (1977), 67–78.

75. According to Raymond Klibansky, Erwin Panofsky, and Fritz Saxl, *Saturn and Melancholy* (London, 1964), 231–32, melancholy "is essentially enhanced self-awareness," and during the late sixteenth and early seventeenth centuries "there was scarcely a man of distinction who was not either genuinely melancholic or at least conceived as such by himself and others." On the history of humoral theory and melancholy, see Stanley W. Jackson, *Melancholia and Depression* (New Haven and London, 1986), especially 99–101, for the distinction between the melancholy temperament and the disease melancholia. Screech, *Montaigne and Melancholy*, has recently analyzed Montaigne's *Essais* as fully characteristic of this solitary, introspective mode of thought. A very widely read seventeenth-century popular medical handbook, Jan van Beverwijck's *Schat der gesontheyt* (Dordrecht, 1637), devotes an entire chapter to *droeftheyt* (sadness), a variant of melancholy.

76. Panofsky, *Dürer*, 156–71.

77. The Wisdom of Solomon 11:20.

78. Rudolf and Margot Wittkower, *Born Under Saturn. The Character and Conduct of Artists: A Documented History from Antiquity to the French Revolution* (New York, 1963), fig. 1.

79. *Problemata* xxx, 1.

80. Quoted in Klibansky et al., *Saturn and Melancholy*, 253.

81. Andreas Laurentius (André du Laurens), *A Discourse on the Preservation of Sight; of Melancholike Diseases; of Rheumes, and of Old Age*, translated by Richard Surphlet (London, 1599), 85–87.

82. Laurentius, *Discourse*, 85.

83. Juan Huarte, *The Examination of Men's Wits* (London, 1594), 67.

84. Just Emile Kroon, *Bijdragen tot de geschiedenis van het Geneeskundig Onderwijs aan de Leidsche Universiteit 1575–1626* (Leiden, 1911), 35–37.

85. *Corpus* A17, C14, and C15.

86. Robert Burton, *The Anatomy of Melancholy*, edited by Holbrook Jackson (London, 1932), 301.

87. B. 148.

88. Held, *Rembrandt's "Aristotle," and other Rembrandt Studies* (Princeton, 1969), 29–32.

89. R. Alberti, *Trattato della nobilità della pittura* (Rome, 1585), translated in Wittkower, *Born Under Saturn*, 105.

90. Klibansky et al., *Saturn and Melancholy*, 232.

91. On artists and melancholy, see Wittkower, *Born Under Saturn*. J. F. Moffitt, "Painters 'Born Under Saturn': The Physiological Explanation," *Art History* 11 no. 2 (June 1988), 195–216, presents an interesting, but overstated, case for lead-poisoning as the explanation for artists' melancholy.

92. Laurinda Dixon discusses the relation between smoking and melancholy in her forthcoming book on artistic reflections of popular and medical ideas of melancholy in the seventeenth century. I am grateful to her for providing me with this unpublished material. For attitudes toward tobacco and smoking, see Simon Schama, *The Embarrassment of Riches. An Interpretation of Dutch Culture in The Golden Age* (New York, 1987), 193–208, with extensive bibliography.

93. Raupp, *Untersuchungen*, 229, and 226–41, on melancholic imagery in Dutch artists' portraits.

94. Raupp, *Untersuchungen*, 271. On the relation between vanitas imagery and melancholy, see Klibansky et al., *Saturn and Melancholy*, 387–93.

95. Burton, *Anatomy of Melancholy*, 121. See, especially, Bridget Gellert Lyons, *Voices of Melancholy. Studies in Literary Treatments of Melancholy in Renaissance England* (London, 1971).

96. Burton, *Anatomy of Melancholy*, 11.

97. For example, Oliver's *Edward, 1st Lord Herbert of Cherbury* (The Earl of Powis) and *Unknown Young Man* (H.M. the Queen, Windsor Castle).

98. Roy Strong, *The English Icon: Elizabethan and Jacobean Portraiture* (London, 1969), 35–37; idem, "The Elizabethan Malady: Melancholy in Elizabethan and Jacobean Painting," *Apollo* 89 (1964), 264–69; Claire Pace, " 'Delineated Lives': Themes and Variations in Seventeenth-Century Poems About Portraits," *Word and Image* 2 (1986), 1–17.

99. Junius, *Painting*, 45.

100. See above, chapter 1 note 27.

101. Junius, *Painting*, 292.

102. Laurentius, *Discourse*, 96.

103. The effect of the shadow cast by Lorenzo's peaked headgear is clearly visible in James S. Ackerman, *The Architecture of Michelangelo* (Harmondsworth, 1971), fig. 23.

104. Klibansky et al., *Saturn and Melancholy*, 320. Dürer used a similar device to convey the melancholy aspect of the Apostle Paul in his *Four Apostles*. See Klibansky et al., 366–73.

105. Dürer (from the printed *Theory of Proportion*), cited in Klibansky et al., *Saturn and Melancholy*, 365.

106. Br. 478 (New York, Metropolitan Museum of Art) and Br. 276 (Amsterdam, Six Foundation).

107. Huygens, *Jeugd*, 15.

108. "De Milte, die mij veeltijd soo quellyck, sonder andere oorsaeck, maeckt." Cited in Colie, *Thankfulness to Constantine*, 132.

109. June 1618: "God wet dat ik reeds vroegtijdig het besluit genomen heb, het hoofd te beiden aan de hevigste aanvallen van melancholie, waaraan ik van nature ten sterkste onderhevig ben, hoezeer ik mij ook voor de wereld uiterlijk goed houd." Cited in H. J. Polak, "Constantijn Huygens, eene nalezing," *De Gids* 53 (1889), 46.

110. "Ick ben wel eens somber gestemd, maer ick recht ertegen." Hofman, *Huygens*, 52.

111. Jacob Burckhardt, "Rembrandt" in *Kulturgeschichtliche Vorträge* (Leipzig, n.d.), 118.

112. Burton, *Anatomy of Melancholy*, 305.

113. See, for example, "The Planet Saturn," in *The Housebook* by the Master of the Amsterdam Cabinet (Rijksprentenkabinet). Rembrandt's beggars are discussed by Hessel Miedema, "Grillen van Rembrandt," *Proef* 3 (1974), 74–75; J. Bruyn, "Problemen bij Grillen," *Proef* 3 (1974), 82–84; Kahren Jones Hellerstedt, "A Traditional Motif in Rembrandt's Etchings: The Hurdy-Gurdy Player," *Oud Holland* 95 (1980), 16–30; Julius S. Held, "A Rembrandt Theme," *Artibus et Historiae* 6 (1984), 21–34; and Robert W. Baldwin, " 'On earth we are beggars, as Christ himself was,' The Protestant Background of Rembrandt's Imagery of Poverty, Disability and Begging," *Konsthistorisk Tidskrift* 56 (1985), 122–35.

114. Cited in Colie, *Thankfulness to Constantine*, 50.

115. B. 174.

116. B. 363. Baldwin, " 'On earth we are beggars,' " 122, is one of the few to suggest a connection between the self-portrait and the beggars on this plate. But his assertion that they are related as studies in the passions fails to develop the self-referential aspect of this juxtaposition and is, in my view, incorrect.

117. B. 363. Such so-called "sheets of studies" are rare enough in Rembrandt's etched oeuvre to suggest that they merit more serious thought as whole images

rather than unrelated studies. Another, which juxtaposes Saskia lying sick in bed, twice, with several incomplete studies of old beggars (B. 369, ca. 1638), possibly alludes to "female" melancholy. This ailment, as Dixon discusses in her forthcoming study (see above, chapter 1 note 92), afflicted many women at the time including Jan Steen's "lovesick" women. Burton, *Anatomy of Melancholy*, 414–15, wrote that "women's melancholy" afflicts "barren women." Saskia and Rembrandt were married in 1634; their first child, born in December 1635, lived only two months, and their second child, born in 1638, lived only two weeks.

118. J. A. Emmens, review of R. and M. Wittkower, *Born Under Saturn*, *Art Bulletin* 53 (1971), 427–28.

2. THE SELF FASHIONED

1. Baldinucci, *Arte dell'intagliare*, 79; cf. Goldscheider, *Rembrandt Paintings, Drawings and Etchings*, 23.

2. Urk. 169; *Documents*, 1656/12. Scheller, "Rembrandt en de encyclopedische kunstkamer," 132–45, places Rembrandt's collection in the context of the seventeenth-century *kunst en rariteitenkabinet*.

3. *Corpus* A4, A25, and A7.

4. Emmens, *Rembrandt*, 124 and 145.

5. On biblical painting, see Washington, *Gods, Saints and Heroes*; for the *portrait historié*, see Rose Wishnevsky, "Studien zum *Portrait historié* in den Nederlanden" (Ph.D. dissertation, Munich, 1967). *Tronies* are discussed in *Corpus* 1, 40; Albert Blankert, *Ferdinand Bol (1616–1680): Rembrandt's Pupil* (Doornspijk, 1982), 26–28, 57–59; Miedema, *Kunst, kunstenaar*, 104, 126, 215–17; Lydia de Pauw-de Veen, *De begrippen "schilder," "schilderij" en "schilderen" in de zeventiende eeuw* (Brussels, 1969), 190–93; Kurt Bauch, *Der frühe Rembrandt und seine Zeit: Studien zur geschichtlichen Bedeutung seines Frühstils* (Berlin, 1960), 178–80.

6. Stephen Greenblatt, *Renaissance Self-Fashioning From More to Shakespeare* (Chicago, 1980), 2. See also Barbu, *Historical Psychology*, 169–71; and Thomas Greene, "The Flexibility of the Self in Renaissance Literature," in *The Disciplines of Criticism*, ed. Peter Demetz, Thomas

Greene, and Lowry Nelson, Jr. (New Haven, 1968), 241–64.

7. Huygens appears to have shared the "profound mobility" embodied by the late sixteenth-century British writers whom Greenblatt identifies as particularly sensitive to the construction of identity.

8. Hofman, *Huygens*, 19–69.

9. Schama, *Embarrassment of Riches*, especially chapter 2, "Patriotic Scripture." K. W. Swart, *The Miracle of the Dutch Republic as Seen in the Seventeenth Century* (London, 1969), argues for the coexistence of strong local patriotism and a pronounced sense of Dutch nationalism and rejects the view expressed by G. J. Hoogewerff, "Uit de geschiedenis van het Nederlandsch nationaal besef," *Tijdschrift voor Geschiedenis* 44 (1929), 134, that local interests drowned out national patriotic sentiment. See also E. H. Kossmann, "The Dutch Case: A National or Regional Culture?" *Transactions of the Royal Historical Society* 5th series, 29 (1979), 155–68, who argues that the initially regional culture of the province of Holland became the culture of the Dutch nation as a whole; see also Kossmann, *In Praise of the Dutch Republic: Some Seventeenth-Century Attitudes* (London, 1963); and S. Groeneveld, "Natie en nationaal gevoel in de zestiende-eeuwse Nederlanden," *Nederlands Archievenblad* 84 (1980), 372–87. The primary study of Dutch political imagery is H. van de Waal, *Drie eeuwen vaderlandsche geschied-uitbeelding, 1500–1800, een iconologische studie* (The Hague, 1952).

10. Br. 476.

11. Br. 482. Wolfgang Schöne, "Rembrandt's *Mann mit dem Goldhelm*," *Jahrbuch der Akademie der Wissenschaften in Göttingen, 1972* (Göttingen, 1973), 33–99, presents a case for seeing Rembrandt as a *homo politicus*. See Egbert Haverkamp-Begemann, *Rembrandt: "The Nightwatch"* (Princeton, 1982); and Margaret Deutsch Carroll, "Civic Ideology and Its Subversion: Rembrandt's *Oath of Claudius Civilis*," *Art History* 9 (1986), 12–35.

12. Huygens, *Jeugd*, 82–83, translated in Schwartz, *Rembrandt*, 76.

13. Angel, *Lof*, 36–37, 53.

14. *Corpus* A12. Another version of this painting, in the John Herron Art Museum, Indianapolis, probably originated in Rembrandt's studio. See A. Ian Fraser, *A Cata-*

logue of the Clowes Collection (Indianapolis, 1973), 82; Br. 3; Bauch, *Rembrandt*, no. 289.

15. *Corpus* A8.

16. Colie, *Thankfulness to Constantine*, 46–51.

17. Walter Strauss, *Hendrik Goltzius 1558–1617: The Complete Engravings and Woodcuts* (New York, 1977), I, 282. Schama, *Embarrassment of Riches*, 106–8, discusses patriotic themes in Goltzius's work.

18. *Corpus* A21; A. B. de Vries, Magde Toth-Ubbens, and W. Froentjes, *Rembrandt in the Mauritshuis* (Alphen aan den Rijn, 1978), 41–47, no. 1; *The Hague, Mauritshuis, The Royal Cabinet of Paintings, Illustrated General Catalogue* (1977), 198, no. 148; Br. 6. Comparison with the etched *Self-Portrait, Bareheaded* (B. 338) of 1629 and Rembrandt's two earliest self-portrait drawings, in the British Museum (Ben. 53) and the Rijksmuseum (Ben. 54), helps establish the date of his *Self-Portrait as a Young Man.* A copy thought to come from Rembrandt's immediate circle is in the Germanisches Nationalmuseum, Nuremberg.

19. De Vries et al., *Rembrandt*, 45; Victor de Stuers, *Notice historique et descriptive des tableaux et des sculptures exposés dans le Musée Royal de la Haye* (The Hague, 1874), 123–24, cat. no. 117.

20. For a discussion of the technical data see de Vries et al., *Rembrandt*, 41–42; *Corpus* I, 225–28.

21. Huygens, *Jeugd*, 78–80.

22. On portraits in armor, see Marianna Duncan Jenkins, *The State Portrait, Its Origin and Evolution*, CAA Monographs on Archaeology and Fine Arts, 3 (New York, 1947); John Pope-Hennessy, *The Portrait in the Renaissance* (New York, 1963), chapter 4, "The Court Portrait"; Werkgroep Staatsieportret Nijmegen, *Het Nederlands staatsieportret* (The Hague, 1973).

23. Giorgio Vasari, *Le vite de' più eccelenti pittori, scultori ed architetti*, ed. G. Milanesi (Florence, 1906), III, 169.

24. Cesare Ripa, *Iconologia* (Rome, 1603), 165–69. Ripa's Fortezza is a female figure armed with a cuirass and shield.

25. Job, chapter 8.

26. See, for example, Pierre de la Primaudaye, *The French Academie* (1586; reprint Hildesheim and New York, 1971), 265–73.

27. Cesare Ripa, *Iconologia, of uytbeeldinghe des verstands*, translated by Dirck Pietersz. Pers (Amsterdam, 1644), 299–304.

28. Though militia companies were originally formed to protect their cities and had played an important role in the revolt against Spain, they now left fighting to the large standing armies of mercenary soldiers. See Haverkamp-Begemann, *Nightwatch*, passim.

29. *Corpus* A53; Schwartz, *Rembrandt*, 69. The identification of the sitter rests on a document of 1654 (*Urk.* 156; *Documents*, 1654/9).

30. The Hague, *Mauritshuis*, 153–54, 190–97, nos. 96–101, 134–44, 412–27, 438, 439, 455–57.

31. *Corpus* A40.

32. Amsterdam, Rijksmuseum, *All the Paintings in the Rijksmuseum* (1976), 698–706, cat. nos. A505, 506, 516–65, and C1516.

33. *Corpus* A97. Much of the octagonal panel has been repainted, and only the head, helmet, scarf, and gorget can be considered authentic. What now appears as a parapet at the bottom of the panel is part of what was once a painted octagonal frame enclosing the originally oval portrait. The breadth of Rembrandt's shoulders and bust is the result of later alterations, which account for much that is disconcerting about the painting.

34. Haverkamp-Begemann, *Nightwatch*, 73–101.

35. De Vries et al., *Rembrandt*, 114–19, no. 7; The Hague, *Mauritshuis*, no. 149; Br. 24.

36. For example, soldiers are so attired in the Leiden *Historical Scene* (Fig. 7) and the painting and etching of *Christ Before Pilate* (London, National Gallery, and B. 77) of 1634 and 1635–36 respectively.

37. J. A. Emmens, "Ay Rembrandt, maal Cornelis stem."

38. Raupp, *Untersuchungen*, 200–205.

39. B. 23.

40. Werkgroep Staatsieportret Nijmegen, *Het Nederlands staatsieportret*, 31–32; van de Waal, *Drie eeuwen vaderlandsche geschied-uitbeelding*, I, 33. Philips Galle's engravings, after drawings by William Thybaut, are based on a fifteenth-century series of portraits painted on the wall of the Carmelite cloister in Haarlem. Though the wall

paintings are lost, they are reproduced in sixteenth-century copies now in the Haarlem Stadhuis.

41. Erasmus, *Adagiorum Chiliades* (Basel, 1536), IV, VI, XXXV, pp. 974–75, translated by Margaret Mann Philips as *The "Adages" of Erasmus: A Study with Translation* (Cambridge, 1964), 209–11. On the formation of a Dutch national character, see Schama, *Embarrassment of Riches*, 77–82.

42. Br. 23, 20, and 25, respectively.

43. Schwartz, *Rembrandt*, 56, has, I think correctly, suggested that Jouderville's *Laughing Young Man* in the Bredius Museum, The Hague, is a self-portrait. Blankert, *Ferdinand Bol*, no. 65; Christopher Brown, *Carel Fabritius* (Ithaca, New York, 1980), no. 6; Werner Sumowski, *Gemälde der Rembrandt-Schüler* (Landau, 1983–), no. 805.

44. Terisio Pignatti, *Giorgione* (London, 1971), no. CI, considers the Braunschweig painting to be a copy of the lost original. Giorgione's painting, which is described by Vasari, was in Antwerp when it was engraved by Wenzel Hollar in 1650.

45. See, for example, Sumowski, *Gemälde der Rembrandt-Schüler*, nos. 261, 262, and 267.

46. Minerva's association with art education and her defense of painting had both been taken up in the Netherlands, and first of all in Haarlem, where the approach to the visual arts was relatively theoretical and where van Mander, Cornelis Cornelisz. van Haarlem, and Hendrick Goltzius are supposed to have founded an "academy" for drawing "naer het leven" (from life). On Minerva and the arts, see Matthias Winner, *Die Quellen der Pictura-Allegorien in gemalten Bildergalerien des 17. Jahrhunderts zu Antwerpen* (Cologne 1957); A. Pigler, "Neid und Unwissenheit als Widersacher der Kunst," *Acta Historiae Artium* 1 (1953–54), 215–35; E.R.M. Taverne, "Pictura: enkele allegorieen op de schilderkunst," in Nijmegen, De Waag, *Het schilders atelier in de Nederlanden 1500–1800* (1964), 31–46; Thomas DaCosta Kaufmann, "The Eloquent Artist: Towards an Understanding of the Stylistics of Painting at the Court of Rudolf II," *Leids Kunsthistorisch Jaarboek* 2 (1982), 123–39; E. de Jongh, "The Artist's Apprentice and Miner-va's Secret: An Allegory of Drawing by Jan de Lairesse," *Simiolus* 13 (1983), 201–17.

47. This is confirmed by a number of prints from around 1600. For example, an engraving by Egidius Sadeler after Hans van Aachen of *Minerva Introducing Painting into the Circle of the Liberal Arts* reflects the ideal of the academy, in which painting is elevated to the status of a liberal art and all the arts are united by their basis in theory and humanistic learning.

48. Van Mander, *Grondt*, 1, 84–87 (i.40–50).

49. Van Mander, *Schilder-boeck*, 299v: "Dewijl den Const-verderbenden roeck-loosen *Mars* onse Landen met donderende geschutten verschrickt en verbaest, en den Tijdt zijn graeu hayren te berghe doet stijghen."

50. Frederik Muller, *De Nederlandsche geschiedenis in platen: Beschrijving van Nederlandsche historieplaten, zinneprenten en historische kaarten* (Amsterdam, 1863–82), no. 1174 and 1255; *Atlas van Stolk: Katalogus der historie, spot en zinneprenten betrekkelijk de geschiedenis van Nederland* (Amsterdam 1895–1933), no. 1126 and 1224.

51. Amsterdam, *All the Paintings in the Rijksmuseum*, 182, attributed to Antonie Jansz. van Croos and Jan Martszens II.

52. On the title page, see H. Perry Chapman, "A *Hollandse Pictura*: Observations on the Title Page of Philips Angel's *Lof der schilder-konst*," *Simiolus* 16 (1986), 233–48.

53. *Urk.* 177; *Documents*, 1657/2. On the term *antijks*, see de Pauw-de Veen, "*Schilder*," "*schilderij*," 59 and 113; Miedema, *Kunst, kunstenaar*, 22, 75–76, 120–21; and Wishnevsky, "*Portrait historié*," 14. See also below, chapter 3 note 53.

54. The self-portrait is valued at fl 150. Other paintings by Rembrandt in the inventory included "Christ and the Woman Taken in Adultery," the most expensive at fl 1,500, a "Raising of Lazarus" at fl 600, a "Descent from the Cross" at fl 400, a "contrefeijtsel" at fl 250, an "antije troni" at fl 50, and a "moor" at fl 12.

55. *Corpus* A20; Seymour Slive, "The Young Rembrandt," *Allen Memorial Art Museum Bulletin* 20 (1963), 148; Br. 8; Boston, Isabella Stewart Gardner Museum, *European and American Paintings in the Isabella Stewart Gardner Museum* (Boston,

1974), 199. There are traces of a monogram and a date (which ends in "9") at the right. Stylistic evidence also places the painting in 1629.

56. Oliver Millar, ed., "Abraham van der Doort's Catalogue of the Collection of Charles I," *Walpole Society* 37 (1958–60), 57.

57. On the date of the inventory, see Millar, "Abraham van der Doort's Catalogue," xxii. A label on the back of the *Bust of an Old Woman* (Br. 70; *Corpus* A32) at Windsor Castle reads "given by Sir Robert Kerr." Since Kerr was made Lord Ancram in 1633, it is likely that the painting was in Charles's collection by that year.

58. Ursula Hoff, *Rembrandt und England* (Hamburg, 1935), 33, was the first to identify Fig. 70 with the picture in Charles's collection. *Corpus*, A33, presents recent technical findings, scholarship, and documents regarding the self-portrait. See also Seymour Slive, *Rembrandt and His Critics 1630–1730* (The Hague, 1953), 27–28; Christopher White, "Did Rembrandt Ever Visit England?" *Apollo* 76 (1962), 177–84; Br. 12; Liverpool, Walker Art Gallery, *Foreign Catalogue* (1977), 184–85.

59. The dimensions of the self-portrait in Liverpool are 69.7 × 57 cm. The measurements recorded by van der Doort are 28 × 23 inches, or about 71 × 58 cm.

60. Millar, "Abraham van der Doort's Catalogue," 37; Hans Gerhard Evers, *Rubens und sein Werk. Neue Forschungen* (Brussels, 1943), 328; Max Rooses, *L'oeuvre de P. P. Rubens* (Antwerp, 1886–92), IV, no. 1043.

61. *Corpus* I, 326–28. The signature in the upper left corner is a later addition. X-ray photographs reveal that a picture of a standing man, similar to Rembrandt's *The Artist in Oriental Costume, with a Poodle at His Feet* (Fig. 50), is painted underneath the portrait.

62. Hoff, *Rembrandt und England*, 33 ff.; White, "Did Rembrandt Ever Visit England?" 177–84; Br. 12; Oliver Millar, *The Queen's Pictures* (London, 1977), 38.

63. Millar, *The Queen's Pictures*, 37, 38, 44. The inventory also lists self-portraits by Giorgione, Titian, Dürer, and others.

64. Wolfram Prinz, *Die Sammlung der Selbstbildnisse in den Uffizien*, I, 17–28.

65. Compare the assessment of these in *Corpus* I, 326–28, as "experiments in dealing with the bust of a young man," in contrast to the Glasgow self-portrait of 1632 (Pl. III), which is "conceived as a true portrait."

66. On seventeenth-century Dutch costume, see Frithjof van Thienen, *Das Kostüm der Blütezeit Hollands 1600–1660* (Berlin, 1930); idem, *The Great Age of Holland 1600–1660* (London, 1951); and J. H. der Kinderen-Besier, *Spelevaart der mode. De kleedij onzer voorouders in de zeventiende eeuw* (Amsterdam, 1950).

67. As suggested in *Corpus* I, 223.

68. Compare, for example, the absence of vanitas symbols in Rembrandt's *Musical Allegory* in the Rijksmuseum, *Corpus* A7, with their presence in Jan Molenaer's more overtly allegorical *Family Making Music* in Haarlem.

69. Sullivan, "Rembrandt's *Self-Portrait with a Dead Bittern*," 236–43.

70. Amsterdam, Rijksmuseum, *Tot lering en vermaak* (1976), 59–61.

71. Ripa's personifications of *Capriccio* or *Fantasyen* and *Docilità* or *Leersamheyt* (Studiousness) wear feathers in their caps, signifying fantasy and intellectual industry respectively. Ripa, *Iconologia, of uytbeeldinghe des verstands*, 129 and 284; discussed in Raupp, *Untersuchungen*, 177. Later relevant images with feathered caps or berets include the figure of Fame in Giovanni Benedetto Castiglione's etching *The Genius of Castiglione* and the muse Terpsichore, "the poetess," on the title page to the chapter of this title in Hoogstraten's *Inleyding*.

72. For the most part Rembrandt's "artist's" beret is relatively small and black. Thus it differs from the feathered, slashed berets in paintings by Gerard van Honthorst, Hendrick ter Brugghen, and other Utrecht masters, and by Pieter Lastman and other Amsterdam history painters.

73. Van der Helst, Flinck, Eliasz., and Backer included their likenesses in the militia-company portraits they painted for the same hall. See Haverkamp-Begemann, *Nightwatch*, 81; W. Martin, "Rembrandt zelf op de Nachtwacht," *Oud Holland* 41 (1923), 1–4.

74. Stradanus's print, titled "COLOR OLIVI. Colorem olivi commodum pictoribus invenit insignis magister Eyckius," is one of nineteen illustrating such new inventions and discoveries as gunpowder, print-

ing, and the New World. Reprint edition: Jan van der Straet, *New Discoveries* (Norwalk, Conn., 1953). On Jan van Eyck as the inventor of oil paint, see J. A. Emmens, "De uitvinding van de olieverf. Een kunsthistorisch probleem in de zestiende eeuw," *Mededelingen van het Nederlands Historisch Instituut te Rome* 31 (1961), 233–45. Berets are also worn by the draftsman demonstrating a perspective device in Albrecht Dürer's *Underweysung der Messung* (Nuremberg, 1525) (Panofsky, *Dürer*, fig. 310); and the painter in Hans Sachs's *Eygentliche Beschreibung aller Stände* (1568), reprinted as Hans Sachs, *Das Standebuch* (Frankfurt am Main, 1976) and *The Book of Trades* (New York, 1973).

75. On the status of the artist, see Paul Oskar Kristeller, "The Modern System of the Arts," in *Renaissance Thought II* (New York, 1965), 178–88; Anthony Blunt, *Artistic Theory in Italy, 1450–1600* (Oxford, 1956), 48–58.

76. For more on this, see chapter 4.

77. Zirka Zaremba Filipczak, *Picturing Art in Antwerp, 1550–1700* (Princeton, 1987), 14 and 21–23.

78. *Corpus* A18; Ben. 390, now in the J. Paul Getty Museum, Malibu; and B. 192, respectively. See chapter 4 for a more extensive discussion of these works. Recent scholarship has shown that the studio scenes once thought to be accurate records of the artists' working conditions are actually governed by pictorial and allegorical conventions. Some of the most illuminating discussions of Dutch atelier scenes are found in J. G. van Gelder, *De schilderkunst van Jan Vermeer*, with commentary by J. A. Emmens (Utrecht, 1958); Nijmegen, *Het schildersatelier in de Nederlanden*; Delft, Stedelijk Museum "Het Prinsenhof," *De schilder in zijn wereld* (1965); Raupp, "Musik im Atelier: Darstellungen musizierender Künstler in der niederländischen Malerei des 17. Jahrhunderts," *Oud Holland* 92 (1978), 106–29; and Raupp, *Untersuchungen*.

79. S. J. Gudlaugsson, *De komedianten bij Jan Steen en zijn tijdgenooten* (The Hague, 1945), identified Vermeer's artist's attire as Burgundian theater costume. More recent scholarship has questioned this association with the theater. See Alison McNeil Kettering, *The Dutch Arcadia: Pastoral Art and Its Audience in the Golden Age* (Mont-

clair, New Jersey, 1983), 114–19; Hessel Miedema, "Johannes Vermeers schilderkunst," *Proef*, September 1972, 67–76. On Vermeer's allegory of Clio, see below, chapter 4 and note 97.

80. See the portraits of Leiden professors in Johannes van Meurs, *Illustris Academia Lugd-Batavia: id est Virorum clarissimorum icones, elogia, ac vitae, qui eam scriptis suis illustrarunt* (Leiden, 1613). W. N. Hargreaves-Mawdsley, *A History of Academical Dress in Europe until the End of the Eighteenth Century* (Oxford, 1963), 9, 17, 20, 43–47, 73–77, 176, and pl. 2c.

81. The reclining figure of Fame in Giovanni Benedetto Castiglione's etching *The Genius of Castiglione* of 1648 wears a plumed beret. Philadelphia, Philadelphia Museum of Art, *Giovanni Benedetto Castiglione* (1971), cat. no. 142. The personification of *Capriccio* in Ripa, *Iconologia*, 48–49, wears a feathered cap (see above, chapter 2 note 71). In the eighteenth century the "bonnet" was called "le symbole de la liberté, dont on y représente le génie," D. Diderot and J. le R. D'Alembert, *Encyclopédie* (Paris, 1751), II, 324.

82. On the history and meaning of the chain, see Held, *Rembrandt's "Aristotle,"* 32–41; Emil Wolf, *Die goldene Kette: Die Aurea Catena Homeri in der englischen Literatur von Chaucer bis Wordsworth* (Heidelberg, 1947); A. O. Lovejoy, *The Great Chain of Being* (Cambridge, Mass., 1936); Margaret Deutsch Carroll, "Rembrandt's *Aristotle*: Exemplary Beholder," *Artibus et Historiae* 10 (1984), 48–50.

83. Van Mander, *Schilder-boeck*, 67v, reported that Zeuxis was rewarded with a chain, which he then gave up to Parrhasius who deceived him with a painted curtain. His source (Pliny, *Natural History* 35. 65), however, does not specify that a chain or collar was given as a reward. Hoogstraten, *Inleyding*, 356, repeats this story.

84. Harold E. Wethey, *The Paintings of Titian*, II. The Portraits (London, 1969), cat. no. 105. Giovanni Britto's engraving of Titian from around 1550 probably reflects a lost self-portrait. A drawing by Rubens in the Louvre, presumably also after a lost self-portrait, shows Titian wearing a three-strand chain with a portrait medal and, notably, a beret.

85. See T.S.R. Boase, *Giorgio Vasari.*

The Man and the Book (Princeton, 1978), 325.

86. Van Mander, *Schilder-boeck*, 230v–231, 284v–285, and 273v.

87. On Rubens as court artist, see Hugh Trevor-Roper, *Princes and Artists. Patronage and Ideology at Four Habsburg Courts 1517–1633* (New York, 1976), chapter 4, "The Archdukes and Rubens." His self-portraits are discussed most extensively in Frances P. Daugherty, "The Self-Portraits of Peter Paul Rubens: Some Problems in Iconography" (Ph.D. dissertation, University of North Carolina, 1976), and Filipczak, *Picturing Art in Antwerp*, 98–104.

88. R. R. Wark, "A Note on Van Dyck's Self-Portrait with a Sunflower," *Burlington Magazine* 98 (1956), 52; Christopher Brown, *Van Dyck* (Ithaca, New York, 1983), 147–49; and Filipczak, *Picturing Art in Antwerp*, 104–8. Compare J. Bruyn and J. A. Emmens, "The Sunflower Again," *Burlington Magazine*, 99 (1957), 96–97. In some of his youthful self-portraits van Dyck wears chains he received from Duke Ferdinando Gonzaga of Mantua and from Isabella, Regent of the Netherlands. A final portrait of van Dyck wearing a chain, based on the incomplete self-portrait for the *Iconography*, was engraved by Lucas Vorsterman.

89. Held, *Rembrandt's "Aristotle,"* 35, cites as evidence that the chain was used as a symbol of servitude an emblem from Alciati in which a courtier is shown wearing a chain and with his legs in stocks. Sidney Anglo, "The Courtier. The Renaissance and Changing Ideals," in A. G. Dickens, ed., *The Courts of Europe. Politics, Patronage and Royalty 1400–1800* (New York, 1977), 44–51, discusses this emblem as part of a larger anti-courtier tradition in literature.

90. Magurn, *Letters of Rubens*, 52.

91. Filipczak, *Picturing Art in Antwerp*, 101–3.

92. Van Mander, *Schilder-boeck*, 273v.

93. Ripa, *Iconologia*, 404: "Donna bella ... con una catena d'oro al collo, dalla quale penda una maschera, & habbia scritto nel la fronte, *imitatio*." This allegorical concept is behind Artemisia Gentileschi's self-portrait of about 1630 at Kensington Palace, which was in the collection of Charles I, and in which the artist wears a gold chain with a mask. See Mary D. Garrard, "Artemisia Gentileschi's Self-Portrait as the Art of Painting," *Art Bulletin* 62 (1980), 97–112, and Michael Levey, "Notes on the Royal Collection, II. Artemisia Gentileschi's *Self-Portrait* at Hampton Court," *Burlington Magazine* 104 (1962), 79–80.

94. On painting gold, see Jan Białostocki, "Ars auro prior," in *Mélanges de littérature comparée et de philologie offerts à Mieczyslaw Brahmer* (Warsaw, 1967), 55–63; E. H. Gombrich, "Visual Metaphors of Value in Art," in *Meditations on a Hobby Horse* (London, 1971), 15–17. Alberti, *On Painting*, 93, cautioned the painter: "Even if I wished to paint ... [things] of gold ... I would try to represent [them] with colors rather than with gold ... there is greater admiration and praise for the artist in the use of colors [to depict precious metals]." Van Mander, *Grondt*, I, 280–81 (xiv.16), repeated this advice, as did Junius, *Painting*, 278. For the golden chain of Homer, see Carroll, "Rembrandt's *Aristotle*," 48–50, and Lovejoy, *The Great Chain of Being*.

95. Ripa, *Iconologia*, 202–3, 404–5.

96. Van Mander, *Schilder-boeck*, 230v: "Ghemeenlijck zijn twee sake oft eynden, waer door den Mensch tot Const te leeren en oeffenen wort beweeght en ghetrocken, te weten, eere en gewin. Als dan de moedighe Jeught bevoelt de Natuere te baet te hebben, en siet eenigh voorbeeldt van een uytnemende Constnaer, die in goeden graet der eeren is gheclommen, en by den grooten in groot aensien en in weerden ghehouden, ghecrijghtse oft bevoeltse een prickelinghe van vyerighe lust tot naevolghen, om sulck uytmuntende Man ghelijck te worden." Miedema, *Kunst, kunstenaar*, 63–64, discusses the meaning of honor in van Mander's *Schilder-boeck*. See also Miedema's commentary in *Grondt*, II, 356, 364, 366, and 368.

97. To illustrate his motto Goltzius devised an emblem in which a brightly lit winged seraph's head, symbolizing honor, the highest form of recognition, is suspended over a pile of gold coins and a chain, implying that the chain is primarily a monetary reward. Goltzius's equating of the chain with monetary reward was an apt illustration for his motto, but it did not reflect common opinion. E.K.J. Reznicek, *Die Zeichnungen von Hendrick Goltzius*

(Utrecht, 1961), 200–201, 315–16, cat. no. kl96, fig. 354.

98. Van Mander, *Grondt*, I, 78–81 (i.26–28).

99. Angel, *Lof*, 35–58.

100. Angel, *Lof*, 57–58.

101. Hoogstraten, *Inleyding*, 345–62.

102. The idea that profit is the least worthy goal can be traced to Alberti, *On Painting*, 95, who wrote that "The aim of the painter is to obtain praise, favor and goodwill for his work much more than riches." Although Cornelis Ketel, in a poem on the goals of art quoted by van Mander, warns against avarice, actually profit was readily accepted, not scorned. As Scheller, "Rembrandt en de encyclopedische kunstkamer," 133, has pointed out, earning an income, associated with the trades, had to be theoretically justified for painting to be included among the liberal arts. Thus Angel, *Lof*, 28, argued that painting is superior to poetry because the painter is paid as well as honored for his art, whereas the poet, who is only honored, starves. As evidence he quotes extensively from Jacob Cats's *Trouwring* of 1637, where it is stated that "The true art of painting earns greater praise/ Because aside from pleasure, profit comes of it." Ironically, Angel inverts Cats's intention to contrast the base, material inclinations of the painter with the purer motivation of the poet. This glorification of the painter's wealth is in contrast to the traditional idea of the poet who practices his art solely out of love of art and desire for honor. Emmens, *Rembrandt*, 135–36, argues mistakenly that gain and honor are considered of equal value in Dutch art theory.

103. Hoogstraten, *Inleyding*, 356: "Zeker, eene miltheit, die meer spoorslagen dan vernoeging geeft." The idea that honor inspires the artist is expressed earlier in Vasari's life of Ghiberti.

104. Hoogstraten's self-portrait in Vaduz dates from 1645, well before he actually received a chain in 1651.

105. Amsterdam, Rijksmuseum, *Catalogus van Goud en Zilverwerken* (1952), cat. nos. 24–26, figs. 6–8; Margaret Deutsch Carroll, "Rembrandt's *Nightwatch* and the Iconological Traditions of Militia Company Portraiture in Amsterdam" (Ph.D. dissertation, Harvard University, 1976), 210–11; Haverkamp-Begemann, *Nightwatch*, 42.

3. THE VIRTUOSO IDEAL TRANSFORMED

1. Weintraub, *Value of the Individual*, 18.

2. Between 1600 and 1700 Amsterdam's population grew from 50,000 to 200,000 inhabitants. Fernand Braudel, *Civilization and Capitalism, 15th–18th Century*, III: *The Perspective of the World* (New York, 1984), 187, and also 175–276.

3. Orlers, *Beschrijvinge*, 375; cf. *Documents*, 1641/8.

4. *Documents*, 1628/2.

5. This document in the Utrecht state archives, Huydecoper-archief no. 30, was discovered in 1983 by E.A.J. van der Wal and is discussed in Schwartz, *Rembrandt*, 132–38.

6. On the circle of Mennonites who patronized Rembrandt, see S.A.C. Dudok van Heel, "Doopsgezinden en schilderkunst in de 17e eeuw: Leerlingen, opdrachtgevers en verzamelaars van Rembrandt," *Doopsgezinde Bijdragen* N.S., 6 (1980), 105–23, and Schwartz, *Rembrandt*, 146–47.

7. *Urk.* 20; *Documents*, 1631/4. Since in this document of 20 June 1631 Rembrandt is described as "wonende tot Leyden," it has been assumed that he did not move to Amsterdam until after this date.

8. *Urk.* 25; *Documents*, 1632/2.

9. Ernst van de Wetering, "Problems of Apprenticeship and Studio Collaboration," in *Corpus* II, 56–60, provides a fuller discussion of relevant guild regulations. On painters' guilds in general, see Montias, *Artists and Artisans in Delft*, and Hoogewerff, *De geschiedenis van de St. Lucasgilden in Nederland*.

10. Filippo Baldinucci, *Notizie de' professori del disegno* (Florence, 1728), IV, 511.

11. H. F. Wijnman, "Rembrandt als huisgenoot van Hendrick Uylenburgh te Amsterdam (1631–35). Was Rembrandt doopsgezind of libertijn?" in *Uit de kring van Rembrandt en Vondel* (Amsterdam, 1959), 2; B.P.J. Broos, review of *Documents*, *Simiolus* 12 (1981–82), 252. Compare *Corpus* II, 59–60.

12. Broos, review, 253.

13. Van Mander, *Schilder-boeck*, 281r.

14. Compare Schwartz, *Rembrandt*, 69–71, 359–63, who views Rembrandt as a failed Rubens who might have decorated

the Stadholder's palaces and the Amsterdam town hall had he not repeatedly sabotaged his own career, beginning with his unsuccessful attempt to become court painter at this time.

15. The 1632 inventory of the Stadholder's collection in The Hague mentions "A painting in which Simeon, in the Temple, has Christ in his arms, done by Rembran[d]t or Jan Lievensz." ("Een schilderije daerinne Symeon, sijnde in den tempel, Christus in sijne armen heeft, door Rembrants oft Jan Lievensz. gedaen"), which is perhaps to be identified with either *Corpus* A12 or A34 (*Presentation in the Temple*, now in Hamburg and The Hague respectively). The same inventory lists "a painting of Melancholy" ("Een stuck schilderij de Melancholij . . .") and "a large piece in which Pluto carries off Proserpina" ("Een groot stuck schilderie daer Pluto Proserpina ontschaeckt . . .") by Jan Lievensz., which are probably the paintings now attributed to Rembrandt in Berlin, Staatliche Museen Preussischer Kulturbesitz, Gemäldegalerie (*Corpus* A38 and A39). For the inventory, see S.W.A. Drossaers, with notes by C. Hofstede de Groot and C. H. de Jonge, "Inventaris van de meubelen van het Stadhouderlijk kwartier met het Speelhuis en van het Huis in het Noordeinde te 's-Gravenhage," *Oud Holland* 47 (1930), 193–236, 241–76, especially 203–5; and S.W.A. Drossaers and Th. H. Lunsingh Scheurleer, ed., *Inventarissen van de inboedels in de verblijven van de Oranjes . . . 1567–1795,* I (Rijks Geschiedkundige Publicatiën, large series 147) (The Hague, 1974), 184–86. The Passion series is discussed further in chapter 5 below.

16. *Corpus* II, 97.

17. B. 7; White, *Rembrandt as an Etcher*, 109–112; and Leonard J. Slatkes, review of Christopher White and K. G. Boon, *Rembrandt's Etchings*, and of White, *Rembrandt as an Etcher*, *Art Quarterly* 36 (1973), 255.

18. In the eleventh state the signature and background were burnished out.

19. The evidence of Rembrandt's *Self-Portrait in a Soft Hat and Embroidered Cloak* suggests that the impact of van Dyck and Rubens on Rembrandt's early portrait style merits further investigation. Although Gerson ("Rembrandt and the Flemish Baroque: His Dialogue with Rubens," *Delta*

12 [1969], 20; and Br. 145 and 146) and others have recognized a Flemish influence, the authors of the Rembrandt *Corpus* II, 119 and 127, tend to deemphasize it.

20. White, *Rembrandt as an Etcher*, 109.

21. Broos, review of *Documents*, 251. See also Broos, "Rembrandt: Werk in uitvoering," *NRC-Handelsblad*, Cultureel Supplement no. 543 (1 May 1981), 1.

22. *Corpus* A58; Br. 17. Rembrandt painted this portrait on a used panel, something he frequently did with self-portraits and less important works. X-rays reveal that the painting underneath was probably a self portrait, bareheaded, on a slightly larger scale. The lack of beveling on the back of the panel raises some doubts as to whether it was originally oval. However, the painting's composition, from the curved contour of Rembrandt's hat to the simple sweeping curve of his collar, seems to have been determined by the oval format, suggesting it was in this shape when he painted the image we now see.

23. *Corpus* A72.

24. For example, in Albrecht Dürer's self-portrait of 1498 in the Prado, and the portraits of Lucas van Leyden and Jan van Scorel from the *Pictorum aliquot celebrium Germaniae Inferioris effigies*.

25. Van Mander, *Grondt*, I, 166–69 (vi.28–32). Raupp, *Untersuchungen*, 21–22, discusses the furrowed brow in portraits of artists.

26. *Corpus* A71.

27. See especially Gerson, "Rembrandt and the Flemish Baroque."

28. Huygens, *Jeugd*, 73.

29. *Corpus* A9, 134; H. Debrunner, *Rembrandts frühes Schaffen* (Zurich, 1929), 46–47; J.L.A.A.M. van Rijckevorsel, *Rembrandt en de Traditie* (Rotterdam, 1932), 70; and C. G. Campbell, "Studies in the Formal Sources of Rembrandt's Figure Compositions" (Ph.D. dissertation, University of London, 1971), 40–41.

30. *Corpus* I, 380.

31. *Corpus* I, 343–45; Kurt Bauch, "Rembrandts Christus am Kreuz," *Pantheon* 20 (1962), 137–44; Schwartz, *Rembrandt*, 86–89.

32. Suggested by Arthur K. Wheelock in Washington, *Gods, Saints and Heroes*, 138.

33. Huygens' refusal of the gift is interpreted by Cynthia Lawrence, " 'Worthy of

Milord's House?' Rembrandt, Huygens and Dutch Classicism," *Konsthistorisk Tidskrift* 54 (1985), 16–18, as a shift in taste toward the classicist style.

34. E.K.J. Reznicek, "Opmerking bij Rembrandt," *Oud Holland* 91 (1977), 88–91.

35. B. 114, 115, and 116. C. Hofstede de Groot, "Rembrandt Imitator," *De Nederlandsche Spectator* 37 (1893), 421; idem, "Entlehnung Rembrandts," *Jahrbuch der Königlichen Preussischen Kunstsammlungen* 15 (1894), 175.

36. *Urk.* 169; *Documents*, 1656/12.

37. *Urk.* 54; *Documents*, 1637/6. Rembrandt bought the painting from Trojanus de Magistris, who acquired it from Jan Jansz. Uyl as security for his debts, for 424 guilders, 10 stuivers, and 8 pence, and sold it to Lodewijk van Ludick for 530 guilders in 1644. See I. H. van Eeghen, "Jan Jansz. Uyl en Rembrandt als 'tamme eend,' " *Maandblad Amstelodamum* 64 (1977), 123–26. Rubens' *Hero and Leander* is in the Yale University Gallery, New Haven, and a later version is in Dresden.

38. J.D.P. Warners, "Translatio–Imitatio–Aemulatio," *De Nieuwe Taalgids* 49 (1956), 289–95; 50 (1957), 82–88, 193–201; van Mander, *Grondt*, II, 389–90, 564–65; de Jongh, "The Spur of Wit," 54–60.

39. Hoogstraten, *Inleyding*, 73–74: " 't Is ons onmogelijk ergens in uit te munten, zegt *Chrysostomus*, ten zy dat wy met d'alleruitmuntenste om'strijt daer nae trachten. En voorwaer het en kan twee loopers tot geen schade gedijen, datze uit Eeryver tegen elkander om strijd rennen. Dees Edele nijd zal braeve geesten ten top voeren. Zoo streed *Rafaël* tegen *Angelo*, en *Angelo* tegen *Rafaël*, en *Pordenone* met de grooten *Titiaen*."

40. Hoogstraten, *Inleyding*, 215: "Laet d'eerzucht vry uw slaepen verhinderen, want de deught heeft ook dien aert, datze 't gemoet tot een yver verwekt om de voorste voorby te stappen."

41. Huygens, *Jeugd*, 77, 82, translated in *Documents*, 1630/5.

42. Peter Paul Rubens, "On the Imitation of Statues," in J. R. Martin, *Baroque*, 271. The manuscript of Rubens' *De Imitatione Statuarum* was owned by Roger de Piles, who published it in his book *Cours de peinture par principes* (Paris, 1708), 139–

47, trans. *The Principles of Painting* (London, 1743), 86–92.

43. In Norman Bryson's words (*Tradition and Desire. From David to Delacroix* [Cambridge, 1984], 15–16), we are "dealing not with the improvement of details, but rather with the radical effacement of the principles of the precursor's work." See also Michael Baxandall, *Patterns of Intention. On the Historical Explanation of Pictures* (New Haven and London, 1985), 58–62, on artistic borrowing.

44. Angel, *Lof*, 56.

45. See above, chapter 2, p. 51–53.

46. Van Mander, *Schilder-boeck*, 208v: "Waer op den Keyser antwoorde, dat Albert edel, oft meer als een Edelman was, om de wille zijner uytnemender Const, dat hy wel con van een Boer oft Slecht Persoon make een Edelman, doch van geen Edelman een sulcken Constnaer."

47. Hoogstraten, *Inleyding*, 355. See also Angel, *Lof*, 22.

48. Junius, *Painting*, 141.

49. Huygens, *Jeugd*, 77–78; translated in *Documents*, 1630/5.

50. On the nobility and the regent class in the Netherlands, see Huizinga, *Dutch Civilization in the Seventeenth Century*, 33–40; D. J. Roorda, "The Ruling Classes in Holland in the Seventeenth Century," in *Britain and the Netherlands*, ed. J. S. Bromley and E. H. Kossman (Groningen, 1964), II, 109–32; Johannes Gerard van Dillen, *Van rijkdom en regenten. Handboek tot de economische en sociale geschiedenis van Nederland tijdens de Republiek* (The Hague, 1970), 284–90; Peter Burke, *Venice and Amsterdam. A Study of Seventeenth-Century Elites* (London, 1974), 16–24, 30–32, 59–66, and 87; J. L. Price, *Culture and Society in the Dutch Republic during the Seventeenth Century* (New York, 1974), 64–82. Fokke Veenstra, *Ethiek en moraal bij P. C. Hooft. Twee studies in renaissancistische levensidaalen* (Zwolle, 1968), is particularly good on the seventeenth-century Dutch adaptation of Renaissance social and moral values. Kettering, *The Dutch Arcadia*, 7–18, discusses the Dutch taste for aristocratic symbols of status.

51. Stefano Guazzo, *The Civile Conversation of M. Steeven Guazzo, the first three books translated by George Pettie anno 1581 and the fourth by Barth. Young anno 1586* (London, 1925; reprint New York,

1967), I, 181. In contrast to the prolifera-
tion of courtesy books in Italy, France, and
England, few such works were written or
printed in the Netherlands. Guazzo's was
one of the few that had been translated by
the mid-seventeenth century. Castiglione's
Libro del cortegiano was not published in
Dutch until 1662. Just about the only com-
parable work written by a Netherlander,
Thomas de Rouck's *Den Nederlandtsche
Herault ofte Tractaat van Wapenen*, pub-
lished in Amsterdam in 1645, 1672, and
1673, is, not surprisingly, a book of her-
aldry, which includes a history of the Dutch
nobility and a discussion of honor.

52. *Documents*, 1634/6; *Urk.* 33: "Een
vroom gemoet/ Acht eer voor goet." Rem-
brandt's words are discussed by Held, *Rem-
brandt's "Aristotle,"* 43–44; Broos, review
of *Documents*, 254; and Alpers, *Rem-
brandt's Enterprise*, 105–6.

53. *Urk.* 177; *Documents*, 1657/2. The
word "Conterfeycel" written on the sill be-
low Rembrandt's signature appears to be by
a different hand; see David Bomford, Chris-
topher Brown and Ashok Roy, *Art in the
Making: Rembrandt* (London, National
Gallery, 1988), 80. There is insufficient evi-
dence to identify the painting with that in
de Renialme's collection. See also above,
chapter 2 note 53.

54. These views are expressed, on the
one hand, by de Jongh, "Spur of Wit," 49,
and Sullivan, *"Self-Portrait with a Dead
Bittern,"* 238–39, and, on the other, by Da-
vid R. Smith, " 'I Janus': Privacy and the
Gentlemanly Ideal in Rembrandt's Portraits
of Jan Six," *Art History* 11 (1988), 42–63.
Egbert Haverkamp-Begemann, "The Pres-
ent State of Rembrandt Studies," *Art Bulle-
tin* 53 (1971), 90, and Walter L. Strauss,
letter to the Editor, *Art Bulletin* 63 (1981),
313, dispute the claim that Rembrandt was
a social climber.

55. C. Hofstede de Groot, "Rembrandt
Imitator," 421–22, first connected Ra-
phael's *Castiglione* with the etched self-por-
trait. Wilhelm von Bode, review of W. R.
Valentiner, *Rembrandt und seine Umge-
bung, Kunstchronik* 16 (1904–5), 339, first
identified Titian's portrait as the source of
Rembrandt's painting. See Clark, *Rem-
brandt and the Italian Renaissance*, 124–
27. B.P.J. Broos, *Index to the Formal
Sources of Rembrandt's Art* (Maarssen,
1977), 21 and 37, lists published opinions

regarding the sources of these works. On
Raphael's painting, see John Shearman, "Le
Portrait de Baldassare Castiglione par
Raphael," *Revue du Louvre et des Musées
de France* 29 (1979), 261–70, and for Ti-
tian's, see Wethey, *Titian*, cat. no. 40.

56. Schwartz, *Rembrandt*, 194, probably
exaggerates the extent to which the decline
in productivity shows that "at the age of
thirty, Rembrandt lost the drive that had
propelled the first ten years of his career."

57. *Urk.* 65–70; *Documents*, 1639/2–7.

58. Haverkamp-Begemann, *Nightwatch*,
14.

59. Peter Mundy, *The Travels of Peter
Mundy in Europe and Asia: 1608–1667*,
ed. Sir Richard Carnac Temple (London,
1925), IV, 70; *Documents*, 1640/16; Slive,
Rembrandt and His Critics, 28.

60. *Urk.* 59; *Documents*, 1638/7.

61. *Urk.* 64; *Documents*, 1639/1.

62. *Urk.* 78 and 80; *Documents*, 1640/
5, 6, and 8.

63. B. 21; White, *Rembrandt as an
Etcher*, 120–22.

64. Br. 34; Neil MacLaren, *National
Gallery Catalogues. The Dutch School*
(London, 1960), 320–22. As is the case
with virtually all of Rembrandt's self-por-
traits, there is no extant documentary evi-
dence to shed light on the painting. It has,
however, received more scholarly attention
than most of Rembrandt's self-portraits,
notably de Jongh, "Spur of Wit," 49–67,
and Christopher Brown, *Second Sight. Ti-
tian: Portrait of a Man; Rembrandt: Self-
Portrait at the Age of 34* (London, 1980),
with a bibliography of earlier literature.

65. On sixteenth-century dress, see C. H.
de Jonge, "Bijdrage tot de kennis van de
kleederdracht in de Nederlanden in de XVIᵉ
eeuw, naar archivalische en litteraire gege-
vens en volgens de monumenten der beel-
dende kunst in chronologische ontwikkel-
ing der afzonderlijke kleedingstukken
gerangschikt," *Oud Holland* 36 (1918),
133–69, and 37 (1919), 1–70, 129–68,
193–214; J. H. der Kinderen-Besier, *Mode-
metamorphosen, De kleedij onze voorou-
ders in de zestiende eeuw* (Amsterdam,
1933); and Rotterdam, Museum Boymans-
van Beuningen, Prentenkabinet, *Van wam-
buis tot frac. Het kostuum in de prentkunst
circa 1450 – circa 1800* (1978).

66. For example, those in Boston, Liver-

pool (Pl. II; Figs. 70, 96, and 97), and the Louvre.

67. H. van de Waal, "Rembrandt at Vondel's Tragedy *Gijsbrecht van Aemstel*," *Miscellanea J. Q. van Regteren Altena* (Amsterdam, 1969), 145–49, identified drawings of players in the roles of Gysbrecht van Aemstel (Ben. 312; London, Victoria and Albert Museum) and Badeloch (Ben. 318; New York, Pierpont Morgan Library) from Vondel's tragedy. S.A.C. Dudok van Heel, "Enkele portretten 'à l'antique' door Rembrandt, Bol, Flinck en Backer," *Kroniek van het Rembrandthuis* 32 (1980/81), 2–9.

68. Lucas's portrait is based on a drawing made by Albrecht Dürer when he visited the Netherlands in 1521.

69. The formal dependence of Rembrandt's portraits on these models continues to be debated. It has been widely accepted that he drew on both Raphael's *Castiglione* and Titian's *Ariosto* for each. However, de Jongh, "The Spur of Wit," 50, dismissed the prevailing view and concluded that the *Ariosto* was the only necessary model. He also questioned whether Rembrandt would have been interested in Raphael's painting since it "contained little that would be new to him."

70. By contrast, Rembrandt charged 500 guilders for the portrait of Andries de Graeff and 1,600 guilders for the *Nightwatch*.

71. On the collections of van Uffelen and Lopez, see E. Maurice Bloch, "Rembrandt and the Lopez Collection," *Gazette des Beaux-Arts* 6th series, 29 (1946), 175–86; Frits Lugt, "Italiaansche kunstwerken in Nederlandsche verzamelingen van vroeger tijden," *Oud Holland* 53 (1936), 112–15; Brown, *Second Sight*, 8–11.

72. Sandrart, *L'Academia Todesca*, i.iii, introduction, 55–56.

73. Ben. 451; *Urk.* 71; *Documents*, 1639/8: "de Conte batasar de Kastijlyone van raefael/ verkoft voor 3500 gulder/ het geheel caergeson tot Luke van Nuffeelen heeft gegolden f. 59456:–: Ano 1639." See Shearman, "*Castiglione*," 268; Colin Campbell, "Raphael door Rembrandts pen herschapen," *Kroniek van het Rembrandthuis* 27 (1975), 20–32; Reznicek, "Opmerkingen bij Rembrandt," 75.

74. B. 268.

75. Van Mander, *Grondt*, I, 83 (i.34).

76. Van Mander, *Schilder-boeck*, 123r.

77. Van Mander, *Grondt*, II, 380.

78. Huygens, *Jeugd*, 82.

79. *Corpus* A12 and A30.

80. *Urk.* 169; *Documents*, 1656/12, nos. 196, 205, 206, 214, 67, and 114.

81. Smith, "Jan Six," 44, overestimates the applicability of Castiglione's courtly Renaissance ideals to the lives of even Amsterdam's most sophisticated merchants.

82. Sandrart's drawing is now in Paris, Institut Néerlandais.

83. Bomford et al., *Art in the Making: Rembrandt*, 82.

84. Sandrart himself engraved Titian's *Flora* (Florence, Uffizi), which Rembrandt drew on for his *Saskia with a Flower* of 1641 in Dresden and *Hendrickje as Flora* in New York. The engravings by Sandrart and Persijn are reproduced in Bloch, "Lopez Collection," figs. 3, 8, and 10. See also Wolfgang Stechow, "Rembrandt and Titian," *Art Quarterly* 5 (1942), 138.

85. On Rembrandt's response to Venetian painting, see Clark, *Rembrandt and the Italian Renaissance*, chapter 4, "Rembrandt and the Venetians"; and Amy Golahny, "Rembrandt's Paintings and the Venetian Tradition" (Ph.D. dissertation, Columbia University, 1984).

86. In his biography of Tintoretto. See Golahny, "Rembrandt's Paintings," 25–48.

87. Van Mander, *Schilder-boeck*, 174v: "tiziano begon nae t'leven te schilderen sonder teyckene: doch wil schilderen met het teyckenen vereenight sijn."

88. Van Mander, *Grondt*, I, 260 (xii.25): "met arbeydt ghedaen zijn, schijnen sonder arbeydt ghedaen."

89. Van Mander, *Schilder-boeck*, 176v–177 (a close translation of Vasari, *Vite*, VII, 452): "en ten lesten wrocht hy zijn dinghen met cloecke pinceel-streken henen, en ghevleckt, soo dat het van by geen perfectie, maer van verre te sien, goeden welstandt hadde. En dit is oorsaeck gheweest, dat vele, die dit hebben willen volghen, willende hun bewijsen te hebben veerdighe handelinge, hebben gemaeckt dingen, die plomp, en onbequaem te sien waren." See Golahny, "Rembrandt's Paintings," 45.

90. Hoogstraten, *Inleyding*, 233–34: "De vroege dingen van *Titiaen* zijn zeer in een vloejende geschildert, 't welk nochtans met een vol pinseel gedaen is, maer in zijne laetste, toen hem de scherpheit van 't gezicht faelde, heeft hy de vlakke plaets-

NOTES TO CHAPTER 4

treeken onverwerkt, welke uit de hand staende, ook dies te grooter kracht hebben."

91. Rembrandt employed this device in other portraits from around 1640, for example that of Nicolaas van Bambeek in Brussels (Br. 218).

92. De Jongh, "Spur of Wit," 52, argues that he copied the *Castiglione* only after completing the etching and, moreover, that the copy's deviations from Raphael's original reflect his self-portrait. Shearman, "Castiglione," 268, I think correctly, proposes that the Albertina sketch still reflects Rubens' Windsor self-portrait (Fig. 93), which Rembrandt had studied so closely for his self-portraits of 1631 and 1632 (Fig. 88 and Pl. III). In other words, when Rembrandt drew Raphael's *Castiglione* he was predisposed by his own earlier self-portraits and that of Rubens to reinterpret it along lines similar to the 1639 etching.

93. Hoogstraten, *Inleyding*, 5: "Een zelve geest heerscht over alle vrye Konsten, die zelve geest, die de Poeten tot dichten verwekt, drijft de Schilders tot het verbeelden der zichtbaerlijke dingen; die door de dichters alleen met woorden worden uitgedrukt."

94. Raupp, *Untersuchungen*, 174–80.

4. THE ARTIST IN THE STUDIO

1. *Urk.* sub. 202; *Documents*, 1647/6.

2. In 1649 Geertge Dircx summoned Rembrandt to appear before the court of the Chamber of Marital Affairs, claiming he had broken his promise to marry her, *Urk.* 118; *Documents*, 1649/3. Rembrandt retaliated by persuading her neighbors to testify against her, with the result that she was committed to the reform institution, *Urk.* 130; *Documents*, 1650/5, 1652/4, and 1655/2. See A. Bredius, "Nieuwe Rembrandtiana," *Oud Holland* 17 (1899), 5; Dirck Vis, *Rembrandt en Geertje Dircx* (Haarlem, 1965); H. F. Wijnman, "Een episode uit het leven van Rembrandt: De geschiedenis van Geertje Dircx," *Jaarboek Amstelodamum* 60 (1968), 103–18; Haverkamp-Begemann, *Nightwatch*, 91; Schwartz, *Rembrandt*, 242–48. See also p. 89 below.

3. Haverkamp-Begemann, *Nightwatch*, 3–8; Baldinucci, *Arte dell'intagliare*, 78; Hoogstraten, *Inleyding*, 176.

4. On the portrait of de Graeff, see *Urk.* 208; *Documents*, 1659/21. On the decoration of Huis ten Bosch, see below, p. 103 and n. 110.

5. For example, the etchings *Nude Man Seated before a Curtain* (B. 193), *Two Male Figures* (*Het Rolwagentje*) (Fig. 120) (B. 194), and *Nude Man Seated on the Ground* (B. 196), all of 1646.

6. Saunders, "Rembrandt and the Pastoral of the Self," 225–26; Kettering, *Dutch Arcadia*, 26–27, 73–75.

7. Haverkamp-Begemann, *Nightwatch*, 113 n. 3.

8. See Bol's self-portraits in Los Angeles and Dordrecht, and the one sold in New York in 1980, all from the 1640s (Blankert, *Ferdinand Bol*, nos. 63, 60, and 62); and Flinck's self-portrait recently in the London art market (J. W. von Moltke, *Govert Flinck 1615–1660* [Amsterdam, 1965], no. 434). Samuel van Hoogstraten's self-portrait of about 1645 in Wassenaar also reproduces the pose of Rembrandt's, as does Aert de Gelder's considerably later *Self-Portrait with the Hundred Guilder Print* in Leningrad (Fig. 170).

9. B. 22; White, *Rembrandt as an Etcher*, 132–34; Boston, Museum of Fine Arts, *Rembrandt: Experimental Etcher* (1969), 23–27.

10. Carol Louise Janson, "The Birth of Dutch Liberty: Origins of the Pictorial Imagery" (Ph.D. dissertation, University of Minnesota, 1982), 2, 110–17.

11. Pope-Hennessy, *Portrait in the Renaissance*, 54–60.

12. Florence, Galleria degli Uffizi, *Gli Uffizi, Florence* (1979), inv. no. P907, p. 343, previously considered a self-portrait by Perugino (in the seventeenth century it was thought to be a portrait of Martin Luther).

13. B. 19. Critics remain at odds on the issue of whether he is etching or drawing: White, *Rembrandt as an Etcher*, 119, "drawing on paper or copper"; Erpel, *Die Selbstbildnisse Rembrandts*, 165, drawing on paper; David R. Smith, "Rembrandt's Early Double Portraits and the Dutch Conversation Piece," *Art Bulletin* 64 (1982), 275–79, using an etching needle. In support of the argument for drawing on paper, it should be added that the surface on which he draws is not raised, as a copper plate probably would be.

14. Interestingly, he draws with his left hand, though had he sketched what he saw in the mirror directly onto the plate the printed image would show him correctly drawing with his right hand, as in the *Self-Portrait Drawing at a Window*. This suggests he may have drawn the earlier portrait on paper first, and then transferred it to the prepared plate. Or perhaps he wanted the viewer to see him as he saw himself in the mirror, thereby emphasizing that this is a self-portrait.

15. Critics remain divided about his activity in this portrait as well. Most likely he is drawing not on loose sheets of paper but on a copper plate, which we cannot see and which rests on a folded cloth and a thick book.

16. White, *Rembrandt as an Etcher*, 134 n. 34.

17. Preparatory drawings for the etched portrait of Jan Six (B. 285) indicate that Rembrandt conceived of representing Six as a scholarly melancholic type from the start: in the first drawing (Amsterdam, Six Collection), he stands with his arms folded in the melancholic attitude of the Lothian portrait of John Donne (Fig. 34), and he is accompanied by his dog—a traditional attribute of the scholar, because both scholar and dog are intelligent yet prone to fits of madness, Klibansky et al., *Saturn and Melancholy*, 321. In another drawing (Amsterdam, Fodor Museum) Rembrandt seems to have considered shading Six's eyes with a hat, as in the later painting of 1654.

18. On the iconography of St. Luke painting the Virgin, see D. Klein, *St. Lukas als Maler der Maria* (Berlin, 1933); Nijmegen, *Het schildersatelier in de Nederlanden*; Delft, *De schilder in zijn wereld*; Colin Eisler, "Portrait of the Artist as St. Luke," *Art News* 58 (1959), 55.

19. Nijmegen, *Het schildersatelier in de Nederlanden*, 31–43; Baden-Baden, Staatliche Kunsthalle, *Maler und Modell* (1969), cat. nos. 5–15.

20. *Corpus* A18. On the subject of the artist in the studio in Dutch art, see van Gelder, *De schilderkunst van Jan Vermeer*; Nijmegen, *Het schildersatelier in de Nederlanden*; Delft, *De schilder in zijn wereld*; Miedema, "Johannes Vermeers schilderkunst"; Raupp, *Untersuchungen*.

21. His ankle-length garment is an accurate example of the type of tabard with long decorative sleeves worn in the sixteenth century. In Johannes Stradanus's *The Art Academy*, engraved by Cornelis Cort in 1578, the painter wears a similar long robe, the sleeves of which he has fastened under his belt to facilitate working.

22. Miedema, *Kunst, kunstenaar*, 6.

23. Leiden, *Anno 1626*, 25–29.

24. Van Mander, *Schilder-boeck*, 225r: "Die Schilder-const, die haer eerste baringhe heeft in den gheest, oft ghedacht door inwendighe inbeeldinghen, aleer sy met der handt opgheroedt, en ter volcomenheyt ghebracht can worden."

25. Van Mander, *Grondt*, I, 104 and 126–29 (ii.16 and v.1–8), and commentary, II, 439 and 461–65; de Pauw-de Veen, "Schilder," "schilderij," 238–48.

26. Hoogstraten, *Inleyding*, 237–38.

27. Hoogstraten, *Inleyding*, 238: "Het scheen in 't eerst, dat hy moedewillens den tijdt verquiste, of niet en wist, hoe te beginnen: en dit quam, om dat hy eerst in zijn inbeelding 't geheele bewerp van zijn werk formeerde, en in zijn verstandt een schildery maekte, eer hy verw in 't penseel nam." Emmens, *Rembrandt*, 133–34, discusses the painting competition in the context of later seventeenth-century art theory. This recommendation to form a mental image of the work derives from sixteenth-century art theory, in which the Neoplatonic concept of *idea* plays a central role. Dutch authors characteristically couched this notion in more practical terms.

28. Rembrandt uses similar means to express inspired mental activity in biblical paintings of the Leiden period. In the *Apostle Paul in Prison* (Fig. 163) dramatic illumination and Paul's pose, with his pen at his side, convey divine inspiration.

29. Ben. 390.

30. Leiden, *Anno 1626*, 28; Hoogstraten, *Inleyding*, 238.

31. B. 192.

32. Ben. 423r.

33. Van Mander, *Grondt*, I, 99 (ii.1). Van Mander devotes the second chapter of *Den grondt* to "het teyckenen oft Teyckenconst." See Miedema's commentary, II, 423–43.

34. Slatkes, review of White and Boon, 259.

35. Emmens, *Rembrandt*, 160, also suggests that Rembrandt deliberately left the

plate unfinished. Compare White, *Rembrandt as an Etcher*, 162–63.

36. First suggested by Fritz Saxl, "Zur Herleitung der Kunst Rembrandts," *Mitteilungen der Gesellschaft für Vervielfältigende Kunst* 1910, 42. See White, *Rembrandt as an Etcher*, 161.

37. Rembrandt's etching conforms, more than did his earlier *Artist in His Studio* (Fig. 117), to the kind of allegorizing content commonly found in Dutch studio scenes. Objects like the shield, sword, and quiver with arrows were valued not so much as functional studio props but for their allegorical significance, as in Gerard Dou's numerous paintings of artists' studios. The nude model's enormous palm branch may transform her into a personification of Victory or Truth.

38. P. Yver, *Supplement au Catalogue raisonné de MM. Gersaint, Helle et Glomy* (Amsterdam, 1756), 61, no. 184.

39. On the goals of the artist, see above, chapter 2, pp. 103–6.

40. Van Mander, *Schilder-boeck*, 286v: "Pigmalions, die op hun eyghen dinghen blindlijck verlieven, en onwetens dickwils verder te rugge zijn als sy meenen, en worden by den Const-verstandighen tot ghespot en belacchinghe, en voor geen cleen ghecken, maer wel van de treflijckste ghehouden te wesen."

41. According to Emmens, *Rembrandt*, 159 and 163, the distinction between self-love and love of art was not clarified until Houbraken. However, the self-satisfied artist was clearly regarded by van Mander and other seventeenth-century writers as misguided. Moreover, Emmens failed to take visual tradition into account when he proposed that the classicistic view of Rembrandt as an artist motivated by self-love led to the etching's being called "Pygmalion."

42. On the development of Dutch "academies" in which drawing from models was a central activity, see Peter Schatborn's introduction to Amsterdam, Museum het Rembrandthuis, *Bij Rembrandt in de leer/Rembrandt as Teacher* (1984); Schatborn, *Dutch Figure Drawings*, 19–22; and E. Haverkamp-Begemann, "Rembrandt as Teacher," in Chicago, Art Institute of Chicago, *Rembrandt After Three Hundred Years* (1969), 22–26.

43. Emmens, *Rembrandt*, 154–58; Ste-

phanie S. Dickey, " 'Judicious Negligence': Rembrandt Transforms an Emblematic Convention," *Art Bulletin* 68 (1986), 253–56.

44. Br. 42; G. Glück, "Rembrandts Selbstbildnis aus dem Jahre 1652," *Jahrbuch der Kunsthistorische Sammlung in Wien* N.F., 2 (1928), 317–28; Slive, *Rembrandt and His Critics*, 93; Vienna, Kunsthistorisches Museum, *Holländische Meister des 15., 16. und 17. Jahrhunderts* (1972), 77–78, inv. no. 411.

45. Ben. 1171; J. P. Filedt Kok, *Rembrandt Etchings and Drawings in the Rembrandt House* (Maarssen, 1972), 19, no. 1; Schatborn, *Dutch Figure Drawings*, 60, cat. no. 87.

46. "Getekent door Rembrandt van Rhijn naer sijn selves sooals hij in sijn schilderkamer gekleet was." The inscription is not by Cornelis Ploos van Amstel, as was previously thought. See L.C.J. Frerichs, "Nieuwe licht op een oud opschrift," *Kroniek van het Rembrandthuis* 24 (1970), 35–44.

47. Brown, *Carel Fabritius*, 38–39, 123, cat. no. 4.

48. Br. 49; Vienna, Kunsthistorisches Museum, *Holländische Meister*, 79, inv. no. 414.

49. Maryan Wynn Ainsworth et al., *Art and Autoradiography: Insights into the Genesis of Paintings by Rembrandt, Van Dyck and Vermeer* (New York, 1982), 67–71.

50. The San Francisco portrait (Fig. 127) lacks the quality and looseness of Rembrandt's style in the 1650s. Weaker versions in Dresden and Oxford reflect the original rectangular composition of the San Francisco painting, which is also reproduced in an eighteenth-century mezzotint. Br. 47, 46, and 47A, respectively; Cornelius Müller Hofstede, "Rembrandts Selbstbildnis mit Skizzenbuch," *Pantheon* 26 (1968), 375–90.

51. Christopher White and K. G. Boon, *Rembrandt's Etchings. An Illustrated Catalogue*, s.379; White, *Rembrandt as an Etcher*, 149, fig. 210; K. G. Boon, "Rembrandt's laatste geetste zelfportret," *Kroniek van het Rembrandthuis* 23 (1969), 4–9.

52. Br. 50; *The Frick Collection*, I: *Paintings: American, British, Dutch, Flemish and German* (Princeton, 1968), 266–68.

At 133.7 × 103.8 cm. it is the largest of Rembrandt's self-portraits, with the exception of the double-portrait of Rembrandt and Saskia in Dresden (Fig. 155). Only four other paintings approach it in size: the *Self-Portrait with a Dead Bittern* (Fig. 72), measuring 121 × 89 cm.; the Kenwood self-portrait (Pl. VI), 114 × 94 cm.; the 1652 self-portrait in Vienna (Fig. 123), 112 × 82.5 cm.; and the Louvre *Self-Portrait at the Easel* (Fig. 139), 111 × 85 cm.

53. See above, chapter 4 note 2.

54. *Urk.* 157 and 167; *Documents,* 1654/11, 12, 14, and 15.

55. *Urk.* 140–43; *Documents,* 1653/1–3 and 5–7.

56. *Urk.* 183; *Documents,* 1655/7. See I. H. van Eeghen, " 'De Keizerskroon' een optisch bedrog," *Amstelodamum* 56 (1969), 167; idem, "Het Amsterdamse Sint Lucasgilde in de 17de eeuw," *Jaarboek Amstelodamum* 61 (1969), 83–84; and Haverkamp-Begemann, "Rembrandt Studies," 92.

57. *Urk.* 166 and 169; *Documents,* 1656/ 6, 10, 12, and 13.

58. *Urk.* 171; *Documents,* 1656/14.

59. *Urk.* 181, 188, and 196; *Documents,* 1656/15 and 22, 1657/6 and 7, 1658/5, 10, 12, 19, 21, 30, and 31. This last document records the purchase of plaster statues from Rembrandt's collection by the Elector Palatine Karl Ludwig. On the nature of Rembrandt's collection, see Scheller, "Rembrandt en de Encyclopedische kunstkamer," 81–147, and compare Haverkamp-Begemann, "Rembrandt Studies," 90.

60. *Urk.* 186; *Documents,* 1658/3; I. H. van Eeghen, "Het huis op de Rozengracht," *Maandbald Amstelodamum* 56 (1969), 180–83; Haverkamp-Begemann, "Rembrandt Studies," 91.

61. B. 36. See *Documents,* 1655/1; H. van de Waal, "Rembrandt's Etchings for Menasseh ben Israel," in *Steps Toward Rembrandt* (Amsterdam, 1974), 113–32.

62. Blankert, *Ferdinand Bol,* cat. no. 110.

63. Visual evidence from the sixteenth and seventeenth centuries suggests that painters often worked sitting down, at least when making small-scale easel paintings. See, for example, Joost Amman's woodcut illustration *Der Handmaler* from Hans Sachs, *Eygentliche Beschreibung aller Stände* (Frankfurt, 1568), and Theodore

Galle's engraving after Stradanus's *Invention of Oil Paint* from his *Nova Reperta* (Fig. 74).

64. Raupp, *Untersuchungen,* 179.

65. Rembrandt holds a mahlstick in his self-portraits in Kenwood House, the Louvre, and Cologne (Pl. VI; Figs. 139 and 145).

66. As Julius Held, *"Le Roi à la Ciasse,"* *Art Bulletin* 40 (1958), 147–49 (*Rubens and His Circle* [Princeton, 1982], 74–75), has demonstrated, the walking stick in Van Dyck's *Charles I at the Hunt* is a substitute for a regal staff that is appropriate to the seventeenth-century ideal of aristocratic grace. See also Max von Boehn, *Modes and Manners: Ornaments* (London, 1929), chapter 4, "Walking Sticks."

67. See above, p. 40.

68. *Urk.* 67; *Documents,* 1639/4: "Mij heer hangt dit stuck op een starck licht en dat men daer wijt ken afstaen soo salt best voncken."

69. On Venetian paintings in Amsterdam, see Bloch, "Rembrandt and the Lopez Collection;" A.-M.S. Logan, *The "Cabinet" of the Brothers Gerard and Jan Reynst* (Amsterdam, 1979); Frits Lugt, "Italiaansche kunstwerken in Nederlandsche verzamelingen van vroeger tijden," *Oud Holland* 53 (1936), 97–135.

70. Pliny, *Natural History,* xxxv.50; van Mander, *Grondt,* 1, 207 (viii.12–13). See Golahny, "Rembrandt's Paintings and the Venetian Tradition," 221–24.

71. *Portrait of a Bearded Man, called Raffaele Grassi* (Florence, Uffizi) recently identified as by Sebastiano Florigerio. See Held, *Rembrandt's "Aristotle,"* 25, fig. 22; Golahny, "Rembrandt's Paintings and the Venetian Tradition," 143–45.

72. In particular Veronese's *Portrait of a Gentleman in Black* (Amsterdam, Goudstikker). Terisio Pignatti, *Veronese* (Venice, 1976), no. 144.

73. In Vermeyen's *Portrait of Cardinal Carondelet* (Brooklyn Museum) of about 1530 (which echoes Metsys's *Portrait of a Canon* in Vaduz) and in Floris's *Portrait of an Elderly Woman* of 1558 (Caen, Musée des Beaux-Arts) the frontal and seated conventions fully converge.

74. *Documents,* 1656/12, item 228: "Een boek, vol contrefijtsels soo van van Dijck, Rubens en verscheijde andere oude meesters."

75. See Meyer Schapiro, *Words and Pictures. On the Literal and the Symbolic in the Illustration of a Text* (The Hague, 1973), 39, for an illuminating discussion of frontality. Pieter Lastman's *David and Uriah* of 1619 provides an example, within Rembrandt's immediate milieu, of a frontally enthroned king.

76. On Dürer's self-portrait, see Panofsky, *Dürer*, 43. The frontal portrait became firmly established in northern Italy around 1500 in the half- and bust-length images by Jacopo de' Barbari and Lorenzo Lotto, whose *Portrait of a Gentleman* now at Hampton Court was accessible to Rembrandt in the Reynst collection. By the mid-sixteenth century the type had been disseminated to the Netherlands by Quentin Metsys and Jan Vermeyen, and to England, where Holbein employed it for his portraits of Henry VIII. Other precedents for the frontal self-portrait, such as that by Tintoretto in the Louvre, stem from the Venetian tradition.

77. Pliny, *Natural History*, xxxv.71; van Mander, *Grondt*, I, 83 (i.33), commentary, II, 379; van Mander, *Schilder-boeck*, 123r and 274r.

78. Magurn, *Letters of Rubens*, 62; Max Rooses and Ch. Ruelens, *Correspondance de Rubens* (Antwerp, 1898), II, 164–65. The source of Rubens' Latin phrase is Psalm 128.2.

79. Br. 53; Paris, Musée National du Louvre, *Catalogue sommaire illustré des peintures du Musée du Louvre, I. Ecole flamande et hollandaise* (1979), no. 1747.

80. Madeleine Hours, "Rembrandt: Observations et présentation de radiographies exécutées d'après les portraits et compositions du Musée du Louvre," *Bulletin du Laboratoire du Musée du Louvre* 6 (1961), 3–43.

81. Justus Müller Hofstede, "Zur frühen Bildnismalerei von Peter Paul Rubens," *Pantheon* 20 (1962), 284–86, fig. 11.

82. Quoted in Blunt, *Artistic Theory in Italy*, 55.

83. Emmens, *Rembrandt*, 30–38, 42, 45–48, 67–69, and 73–75.

84. Sandrart, *L'Academia Todesca*, II. iii, chapter 22, 326: "hat er doch seinen Stand gar nicht wiszen zu beobachten, und sich jederzeit nur zu niedrigen Leuten gesellet, dannenhero er auch in seiner Arbeit verhindert gewessen."

85. Baldinucci, *Arte dell'intagliare*, 79: "Lo scomparire, che faceva in lui una faccia brutta, e plebea, era accompagnato da un vestire abietto, e sucido, essendo suo costume nel lavorare il nettarsi i pennelli addosso, ed altre cose fare, tagliate a questa misura. Quando operava non avrebbe data udienza al primo Monarca del mondo, a cui sarebbe bisognato il tornare, e ritornare, finchè l'avesse trovato fuori di quella faccenda."

86. Houbraken, *Groote schouburgh*, I, 272–73: "Hy verkeerde in den herfst van zyn level wel meest met gemeene luiden, en zulke die de konst hanteerden. Misschien dat hy de wellevenswetten, door Gratiaan beschreven, gekent heeft; want die zeit elders: *Het is goet met uitstekende Persoonen te verkeeren, om zoodanig te worden, maar wanneerman dat is, moetmen zig by middelmatige roegen.* Ee hy gaf 'er deze reden van: Als ik myn geest uitspanninge wil geven, dan is het niet eer die ik zoek, maar vryheit."

87. Raupp, *Untersuchungen*, 311–28.

88. Van Mander, *Grondt*, I, 76–79 (i.20–22), and commentary, II, 369–70 and 372; Angel, *Lof*, 58.

89. Br. 52; Greater London Council, *The Iveagh Bequest, Kenwood. Catalogue of Paintings*, 3rd ed. (London, 1972), no. 57; Benedict Nicolson, editorial, "The Iveagh Bequest at Kenwood," *Burlington Magazine* 92 (1950), 183.

90. *Documents*, 1662/1.

91. J. G. van Gelder, "Rembrandt en de zeventiende eeuw," *De Gids* 119 (1956), 408–9.

92. Emmens, *Rembrandt*, 174.

93. B.P.J. Broos, "The 'O' of Rembrandt," *Simiolus* 4 (1971), 150–84; see also John F. Moffitt, " 'Più tondo che l'O di Giotto': Giotto, Vasari, and Rembrandt's Kenwood House 'Self-Portrait,' " *Paragone* 35 (1984), 63–70.

94. Van Mander, *Schilder-boeck*, 96v: "dat Giotto alle d'ander Schilders van zijnen tijdt in excellentie te boven gingh."

95. Br. 52; Kurt Bauch, *Rembrandt Gemälde* (Berlin, 1966), no. 331; H. van de Waal, "Rembrandt 1956," *Museum* 61 (1956), 199.

96. For Joos van Craesbeeck's *Five Senses* (Paris, Institut Néerlandais), see Raupp, *Untersuchungen*, fig. 201. Molenaer's allegory *Vrouw Wereld* (Toledo Mu-

seum of Art) even more explicitly attributes this meaning to a world map by strategically placing it above the head of Vrouw Wereld, the personification of worldliness who traditionally wore an orb on her head. Here, then, we see the symbolic meaning commonly attached to a globe transferred to a wall map. See E. de Jongh, "Vermommingen van Vrouw Wereld in de 17de eeuw," in *Album Amicorum J. G. van Gelder* (The Hague, 1973), 198–206.

97. On the map in Vermeer's painting, see Arthur K. Wheelock, Jr., *Jan Vermeer* (New York, 1981), 128; James A. Welu, "Vermeer: His Cartographic Sources," *Art Bulletin* 57 (1975), 536–40; Albert Blankert, *Vermeer* (Oxford, 1978), 48; Miedema, "Vermeers Schilderkunst," 74; van Gelder, *De schilderkunst van Jan Vermeer*, 10. Compare Alpers, *The Art of Describing*, 119–38.

98. Hoogstraten, *Inleyding*, 4: "Dat ik het ook de *Zichtbare Werelt* noeme, is, om dat de Schilderkonst al wat zichtbaer is, vertoont." He adds that he intends to publish another volume concerning the "invisible world."

99. Van Mander, *Schilder-boeck*, 211v and 246v. Miedema, *Kunst, kunstenaar*, 34–35, discusses the concept of universality as it appears in van Mander's *Schilderboeck*. See also van Mander, *Grondt*, II, 343, 348, 425, and 510.

100. Br. 61; Horst Vey and A. Kesting, *Katalog der Niederländischen Gemälde von 1550 bis 1800 im Wallraf-Richartz-Museum* (Cologne, 1967), 89–92, no. 2526; Herbert von Einem, "Das Kölner Selbstbildnis des lachenden Rembrandt," in *Festschrift für Gert von der Osten* (Cologne, 1970), 177–88.

101. *London and Its Environs Described, containing an Account of Whatever is Most Remarkable for Grandeur, Elegance, Curiosity or Use in the City and in the Country Twenty Miles Around It* (London, 1761), 271. The painting was then in the possession of the wealthy businessman and collector Samson Gideon at Belvedere House.

102. Jan Białostocki, "Rembrandt's Terminus," *Wallraf-Richartz-Jahrbuch* 28 (1966), 49–60.

103. Wolfgang Stechow, "Rembrandt-Democritus," *Art Quarterly* 7 (1944), 233–38.

104. Van Mander, *Schilder-boeck*, 278r.

105. See, for example, Jan Białostocki, "Der Sünder als tragischer Held bei Rembrandt. Bemerkungen zu neueren ikonographischen Studien über Rembrandt," in *Neue Beiträge zur Rembrandt-Forschung*, edited by Otto von Simson and Jan Kelch (Berlin, 1973), 137–50.

106. Albert Blankert, "Rembrandt, Zeuxis and Ideal Beauty," in *Album Amicorum J. G. van Gelder* (The Hague, 1973), 32–39.

107. Van Mander, *Schilder-boeck*, 67r.

108. Van Mander, *Schilder-boeck*, appendix, 301r; Hoogstraten, *Inleyding*, 78, 110.

109. Joh. Episcopius (Jan de Bisschop), *Paradigmata Graphices variorum Artificum. Voor-beelden der teken-konst van verscheyde meesters* (The Hague, 1671). See Slive, *Rembrandt and His Critics*, 83–103; Emmens, *Rembrandt*, 63–95.

110. The monumental decorative program of the Oranjezaal (the huge centralized reception hall of the Huis ten Bosch, which was conceived as a memorial to Frederik Hendrik, who died in 1647) was designed by Huygens and the architect of the palace, Jacob van Campen. See Washington, *Gods, Saints and Heroes*, 72–74 and 187; D. F. Slothouwer, *De paleizen van Frederik Hendrik* (Leiden, 1945), 179–224; and J. G. van Gelder, "De schilders van de Oranjezaal," *Nederlands Kunsthistorisch Jaarboek* 2 (1948–49), 118–64. Neither Jacob Backer nor Jacob van Loo executed paintings for the Huis ten Bosch.

111. Carroll, "Rembrandt's *Oath of Claudius Civilis*."

5. REMBRANDT'S BIBLICAL ROLES

1. Baldinucci, *Arte dell'intagliare*, 79. The body of literature on Rembrandt's religious beliefs and affiliation is extensive. Along with that discussed in the following pages, see H. E. van Gelder, "Marginalia bij Rembrandt: III. Rembrandts kerkgenootschaap," *Oud Holland* 60 (1943), 36, and Hans Martin Rotermund, "Rembrandts Bibel," *Nederlands Kunsthistorisch Jaarboek* 8 (1957), 123–50.

2. Baldinucci, *Arte dell'intagliare*, 79.

3. On Rembrandt's Mennonite connections, see S.A.C. Dudok van Heel, "Doops-

gezinden en schilderkunst in de 17e eeuw"; Schwartz, *Rembrandt*, 139–41, 146–48. See also K. Vos, "Rembrandts Geloof," *De Gids* 73 (1909), 49–72; H. F. Wijnman, "Rembrandt als huisgenoot van Hendrick Uylenburgh te Amsterdam."

4. See *Documents*, 56–57; Leiden, *Anno 1626*, 66–68; Schwartz, *Rembrandt*, 24–25, 35–39.

5. *Corpus* A80; B. 279. Rembrandt's painting of Uytenbogaert was commissioned by Abraham Anthonisz. Recht, a supporter of the Remonstrants in Amsterdam. See *Urk.* 29; *Documents*, 1633/2; S.A.C. Dudok van Heel, "Mr. Johannes Wtenbogaert (1608–80) een man uit Remonstrants milieu en Rembrandt van Rijn," *Jaarboek Amstelodamum* 70 (1978), 146–69; idem, "Abraham Anthonisz. Recht (1588–1664) een Remonstants opdrachtgever van Rembrandt," *Maandblad Amstelodamum* 65 (1978), 81–89.

6. *Corpus* A77 and A81.

7. B. 266 and 280.

8. Br. 200 and 347.

9. B. 269.

10. Compare Schwartz, *Rembrandt*, 79, who suggests that Rembrandt "was marked by his association . . . with dissident Protestants."

11. Broos, review of *Documents*, 253; J. H. Besselaar, "Saskia's bruiloft," *Algemeen Handelsblad* (special issue) 18 May 1956, 8.

12. *Urk.* 37, 43, 60, 61, 78, 89, 96, 97. *Documents*, 1634/5, 1635/6, 1636/3, 1638/8–9, 1640/5–6, 1641/4, 1642/4–5.

13. *Urk.* 157; *Documents*, 1654/11. Hendrickje Stoffels, after failing to respond to three summonses, appeared before the local council of the Reformed Church and was "seriously punished, admonished to penitence and banned from the [celebration] of the Lord's Supper" for "having lived with Rembrandt the painter like a whore." Hofstede de Groot, *Urk.* 157, interpreted Rembrandt's omission from the reprimand as evidence that Rembrandt was not a member of the church. More likely the summons was directed only at Hendrickje. W. A. Visser 't Hooft, *Rembrandt and the Gospel* (Philadelphia, 1957), 67, suggested, probably correctly, that the summons was precipitated by Hendrickje's pregnancy because a child born out of wedlock could not be baptized until the mother

had appeared before the church council. This is confirmed by G.D.J. Schotel, *De Openbare Eeredienst der Nederl. Hervormde Kerk* (Haarlem, 1870). See also Hans Martin Rotermund, "Rembrandt und die religiösen Laienbewegungen in den Niederländen seiner Zeit," *Nederlands Kunsthistorisch Jaarboek* 4 (1952–53), 128, 129 n.1

14. *Urk.* 307; *Documents*, 1663/4, 1669/6.

15. A. Th. van Deursen, *Het kopergeld van de Gouden Eeuw,* IV. Hel en hemel (Assen, 1980), 1.

16. Schwartz, *Rembrandt*, 78 and 184–85.

17. Rotermund, "Rembrandt und die religiösen Laienbewegungen," 104–92.

18. Visser 't Hooft, *Rembrandt and the Gospel*, 18–21, 24–25, 60–70.

19. Christian Tümpel, "Religious History Painting," in Washington, *Gods, Saints and Heroes*, 48.

20. Tümpel, "Ikonographische Beiträge zu Rembrandt"; idem, "Studien zur Ikonographie der Historien Rembrandts"; Berlin, Staatliche Museen Preussischer Kulturbesitz, *Rembrandt legt die Bibel aus* (1970), with an introduction by Tümpel. Other discussions of the impact of the Reformation and Dutch Protestantism on Rembrandt's biblical subjects include Margaret Deutsch Carroll, "Rembrandt as Meditational Printmaker," *Art Bulletin* 63 (1981), 585–610, and William H. Halewood, *Six Subjects of Reformation Art: A Prelude to Rembrandt* (Toronto, 1981). See also Léon Wencelius, *Calvin et Rembrandt* (Paris, 1937). Compare J. Bruyn, *Rembrandts keuze van Bijbelse onderwerpen* (Utrecht, 1959).

21. Christian Tümpel, "The Iconography of the Pre-Rembrandtists," in Astrid Tümpel, *The Pre-Rembrandtists* (Sacramento, 1974), 127–50; Halewood, *Six Subjects of Reformation Art*, discusses specific themes of Protestant iconography.

22. Białostocki, "Der Sünder als tragischer Held bei Rembrandt," 137–50, explores Rembrandt's unique fascination with biblical sinners.

23. *Corpus* A69; Br. 548.

24. See above, pp. 16 and 19–21.

25. *Corpus* A65 and A69; Br. 548, 550, 557, 560, 561; Munich, Alte Pinakothek, *Holländische Malerei des 17. Jahrhunderts* (Munich, 1967), cat. nos. 394–98; Ernst

Brochhagen, "Beobachtungen an den Passionsbildern Rembrandts in München," *Munuscula Discipulorum. Kunsthistoriche Studien Hans Kauffmann zum 70. Geburtstag 1966* (Berlin, 1968), 37–44; Else Kai Sass, *Comments on Rembrandt's Passion Paintings and Constantijn Huygens' Iconography* (Copenhagen, 1971). In 1646 Rembrandt added two more paintings to the series, the *Adoration of the Shepherds* and the (no longer extant) *Circumcision*.

26. *Urk.* 47, 48, 65, 66, 67, 68, 69; *Documents*, 1636/1–2, 1639/2–6; Gerson, *Seven Letters*.

27. *Urk.* 47; *Documents*, 1636/1; Gerson, *Seven Letters*, 22: "dat ick seer naerstich doende ben met die drie passij stucken voorts met bequaemheijt aftemaeken die sijn excellensij mij selfs heeft geordijneert, een grafleg[ung] ende een verrijsenis en een Heemelvaert Chrisstij. De selvijge ackoordeeren met opdoening en afdoeningen vant Chruijs Chrisstij."

28. *Documents*, 1632/3. For the complete inventory, see Drossaers and Scheurleer, *Inventarissen van de inboedels in de verblijven van de Oranjes*, 184–86.

29. On other instances in which Huygens acted as representative for Frederik Hendrik in artistic matters, see Gerson, *Seven Letters*, 8.

30. *Corpus* A57 and A61; Br. 161 and 99, respectively. Horst Gerson, "Rembrandt's portret van Amelia von Solms," *Oud Holland* 74 (1969), 244–48; *Documents*, 1632/3, p. 87–89. As many as three other paintings by Rembrandt, including a "Simeon in the Temple," may have been in the Stadholder's collection by this time, although two now thought to be by Rembrandt were ascribed to Lievens and one to "Rembrandt or Lievens." See above, chapter 3 note 15; Sass, *Comments on Rembrandt's Passion Paintings*, 30; Schwartz, *Rembrandt*, 67–71.

31. *Corpus* II, 276–88, questions whether the *Descent* was originally intended to belong to any series at all and suggests it was the only Passion painting done as an independent work. Brochhagen, "Beobachtungen an den Passionsbildern," 38–39, suggests that the Stadholder or Huygens saw the *Raising* and *Descent* in Rembrandt's studio, implying that both were produced for the open market. His argument is based on the connection he perceives between them and Rembrandt's *Christ on the Cross* (Le Mas d'Agenais, Fig. 13) dated 1631. Though the *Christ on the Cross* has the same arched format and is nearly the same size, it is unlikely that it was originally part of the series. It was not owned by Frederik Hendrik, and the figure of Christ is much larger in scale. Furthermore, the image is of a devotional, rather than narrative, type that customarily functioned independently. See also Kurt Bauch, "Rembrandts Christus am Kreuz," *Pantheon* 20 (1962), 137–44.

32. B. 81 (II); The first version of the etching, in which Rembrandt reproduced the arched format of the painting, failed in the biting. The second version, on a different plate, carries the copyright: Rembrandt.f.cum pryvl°.1633. Martin Royalton-Kisch, "Over Rembrandt en van Vliet," *Kroniek van het Rembrandthuis* (1984), 3–23, argues that the etching is largely the work of Jan van Vliet. Brochhagen, "Beobachtungen an den Passionsbildern," 40, figs. 22 and 23, and *Corpus* II, 313–18, discuss X-ray photographs of the *Descent*, which reveal that parts of the painting Rembrandt repainted were originally more like the print, suggesting that he may have worked on the two simultaneously. See also White, *Rembrandt as an Etcher*, 33–36; *Documents*, 1633/4.

33. *Corpus* A34. See above, chapter 3 note 15.

34. A *Raising of the Cross* that draws on Rubens' painting was previously attributed to Jacob Backer and dated 1633. A recent cleaning has revealed it to be the work of Adriaen Backer, dated 1683.

35. Ingvar Bergström, "Rembrandt's Double-Portrait of Himself and Saskia at the Dresden Gallery: A Tradition Transformed," *Nederlands Kunsthistorisch Jaarboek* 17 (1966), 164–67.

36. Fra Angelico's *Crucifixion* for San Marco in Florence shows the biblical protagonists on one side of the cross and portraits of members of the Dominican order, for which it was made, on the other. Rogier van der Weyden's *Crucifixion* in Vienna includes two kneeling donors, and the *Crucifixion* from the *Triptych of the Passion* by the Master of the Virgo inter Virgines includes what appears to be a donor-portrait, possibly in the role of the good centurion.

37. Laurinda S. Dixon, "The Crucifixion

by Lucas Cranach the Elder: A Study in Lutheran Reform Iconography," *Perceptions* 1 (1981), 35–42.

38. Translated in Panofsky, *Dürer*, 139.

39. Lewalski, *Protestant Poetics*, 26.

40. Frank J. Warnke, *European Metaphysical Poetry* (New Haven, 1961), provides an excellent introduction to European metaphysical poetry. Henrietta ten Harmsel, "The Metaphysical Poets of Holland's Golden Age" in *Holland*, ed. Frank J. Warnke (Review of National Literatures 8), (New York, 1977), 70–96, discusses the Dutch contribution to seventeenth-century poetry. On seventeenth-century literary self-conciousness and the use of the first-person voice, see Warnke, 54–55, 82–83; Webber, *Eloquent "I,"* 3–13 and 255; Lewalski, *Protestant Poetics*, passim; and Martz, *Poetry of Meditation*, especially chapter 3, "Self-Knowledge: The Spiritual Combat." On Huygens' religious poetry, see Warnke, 68–69; ten Harmsel, 78–83; Colie, *Thankfulness to Constantine*. Carroll, "Rembrandt as Meditational Printmaker," 585–610, analyzes a different aspect of the parallel between Rembrandt's art and seventeenth-century devotional poetry.

41. Translated in ten Harmsel, "Metaphysical Poets," 89–92: "Nadien ons dese dag to noden sehijnt veeleer/ Tot klachten als tot kluchten:/ Soo voel ik my beweegt uw bitter lijden, Heer,/ En in uw lijden, laes, myn' sonden te besuchten."

Of Rembrandt's two portraits of de Decker only one is known (Br. 320). Several poems were written in praise of these portraits (*Urk.* 222, 290; *Documents*, 1660/26, 1667/9 and 10). De Decker himself wrote a poem in praise of Rembrandt, and another about Rembrandt's *Christ* and *Mary Magdalen* (*Urk.* 291 and 221; *Documents*, 1667/11 and 1660/23).

42. Translated in Henrietta ten Harmsel, *Jacobus Revius. Dutch Metaphysical Poet* (Detroit, 1968), 19: "T'en zijn de Joden niet, Heer Jesu, die u cruysten, / Noch die verradelijck u togen voort gericht, / Noch die versmadelijck u spogen int gesicht, / Noch die u knevelden, en stieten u vol puysten, / T'en sijn de crijchs-luy niet die met haer felle vuysten / Den rietstock hebben of den hamer opgelicht, / Of het vervloecte hout op Golgotha gesticht, / Of over uwen rock tsaem dubbelden en tuyschten: / Ick bent, o Heer, ick bent die u dit heb ge- daen, / Ick ben den swaren boom die u had overlaen, / Ick ben de taeye streng daermee ghy ginct gebonden, / De nagel, en de speer, de gessel die u sloech, / De bloet-bedropen croon die uwen schedel droech: / Want dit is al geschiet, eylaes! om mijne sonden." Originally published in Jacobus Revius, *Over-Ysselsche sangen en dichten* (Deventer, 1630). The poem is discussed by Visser 't Hooft, *Rembrandt and the Gospel*, 41.

43. Br. 30. The most significant recent studies of this painting are: Białostocki, "Der Sünder als tragischer Held"; Madlyn Kahr, "Rembrandt and Delilah," *Art Bulletin* 55 (1973), 252–58; Anneliese Mayer-Meintschel, "Rembrandt und Saskia im Gleichnis vom Verlorenen Sohn," *Jahrbuch Staatliche Kunstsammlungen Dresden* 1970–71, 39–57; Tümpel, "Ikonographische Beiträge zu Rembrandt," 116–26; and Bergström, "Rembrandt's Double-Portrait."

44. It is my contention that the Dresden painting is a historicized portrait, one in which the portrait quality predominates and the essential meaning is conveyed through the roles with which the sitters identify. Compare Tümpel, "Ikonographische Beiträge zu Rembrandt," 123, who maintains that the biblical subject is more important than the portraits.

45. *Urk.* 336 and 192.

46. Simon Schama, "The Unruly Realm: Appetite and Restraint in Seventeenth-Century Holland," *Daedalus* 108 (1979), 103–23, provides an insightful analysis of the seemingly dual, even hypocritical, nature of Dutch "moralizing" genre painting.

47. Wilhelm von Bode, *The Complete Works of Rembrandt* (Paris, 1899), III, 7. In his eyes the scene took place at breakfast, presumably the only meal at which a respectable young couple could behave in such a casual manner. See Bergström, "Rembrandt's Double-Portrait," 145–50, and Emmens, *Rembrandt*, 165–67, for a fuller discussion of earlier interpretations of this painting.

48. Notably, Carl Neumann, *Rembrandt* (Berlin and Stuttgart, 1912), 206, 212, 258, and 485; and Werner Weisbach, *Rembrandt* (Berlin and Leipzig, 1926), 49–50.

49. W. R. Valentiner, *Rembrandt. Des Meisters Handzeichnungen* (Stuttgart, 1925), no. 383; Weisbach, *Rembrandt*, 49–50; Bergström, "Rembrandt's Double-Portrait."

50. John Calvin, *Commentary on a Harmony of the Evangelists, Matthew, Mark and Luke* (Grand Rapids, 1949), II, 344–48.

51. Calvin, *Commentary*, II, 347.

52. Bergström emphasized the graphic tradition, while Tümpel stressed the importance of the Utrecht school as a direct source for the Dresden painting. On the iconography of the Prodigal Son, see Konrad Renger, *Lockere Gesellschaft. Zur Ikonographie des Verlorenen Sohnes und von Wirtshausszenen in der niederländischen Malerei* (Berlin, 1970); Barbara Haeger, "The Prodigal Son in Sixteenth and Seventeenth-Century Netherlandish Art: Depictions of the Parable and the Evolution of a Catholic Image," *Simiolus* 16 (1986), 128–38.

53. Brussels, Musées Royaux des Beaux-Arts, *De eeuw van Brueghel* (1963), 50; Detlev Kreidl, "Joachim Beuckelaer und der Monogrammist HB," *Oud Holland* 90 (1976), 162–83, fig. 1; Renger, *Lockere Gesellschaft*, 136–37. A centrally placed woman looks out at the viewer in several other examples: a woodcut by Jörg Bron; the painting *The Prodigal Son Among Whores* by Frans Pourbous I (Antwerp, Museum Mayer van den Bergh); J. Matham's first print in a series called *The Consequences of Drunkenness*; and a copy of *The Prodigal Son Among Whores* (French private collection) by Frans Francken II.

54. Mayer-Meintschel, "Rembrandt und Saskia im Gleichnis vom Verlorenen Sohn," 47, figs. 5 and 10. Technical investigations undertaken at the Dresden Gemäldegalerie indicate that the painting was cut down and reworked considerably.

55. Johan van Beverwyck, *Alle de wercken soo in de medecyne als chirurgye* (Utrecht, 1651), 132, quoted in Amsterdam, *Tot lering en vermaak*, 274.

56. J.F.M. Kat, "De Verloren Zoon als letterkundig motief" (dissertation, Nijmegen, 1952), 92–93; G. J. Boekenoogen, ed., *De Historie van de Verloren Zoon. Naar den Antwerpschen Druk van Godtgaf Verhulst uit het Jaar 1655* (Nederlandsche Volksboeken 11), (Leiden, 1908); Mayer-Meintschel, "Rembrandt und Saskia im Gleichnis vom Verlorenen Sohn," 40.

57. Van Mander, *Schilder-boeck*, 209v.

58. Van Mander, *Schilder-boeck*, 290r. On van Aachen's self-portrait, see Eliska

Fucikova, "Quae Praestat Juvenis Vix Potnere Viri: Hans van Aachens Selbstbildnis in Köln," *Wallraf-Richartz-Jahrbuch* 33 (1971), 122–23, fig. 82.

59. G. J. Hoogewerff, "Jan van Bijlert, schilder van Utrecht (1598–1671)," *Oud Holland* 80 (1965), 19, fig. 19.

60. Raupp, *Untersuchungen*, 311–28.

61. Screech, *Montaigne and Melancholy*, 31.

62. Van Mander, *Grondt*, I, 75–79 (i.13, 20–23); commentary, II, 366. On drunkenness and the painter, see Jochen Becker, "Dieses emblematische Stück stellet die Erziehung der Jugend vor. Zu Adriaen van der Werff, München, Alte Pinakothek, Inv. Nr. 250," *Oud Holland* 90 (1976), 94–96.

63. Van Mander, *Grondt*, I, 79 (i.25–26).

64. *Urk.* 59; *Documents*, 1638/7.

65. On the strong ambivalence in Dutch attitudes towards wealth, display, and ostentation, see Schama, *Embarrassment of Riches*. On the pastoral *portrait historié*, see Kettering, *Dutch Arcadia*, 63–82.

66. Br. 59; Amsterdam, *All the Paintings in the Rijksmuseum*, no. A4050, with full bibliography.

67. P.J.J. van Thiel, "*Zelfportret als de Apostel Paulus. Rembrandt van Rijn (1606–1669)*," *Openbaar Kunstbezit* 13 (1969), I.

68. F. Schmidt-Degener, "Rembrandt en Vondel," *De Gids* 83 (1919), 266; Wilhelm R. Valentiner, "Die vier Evangelisten Rembrandts," *Kunstchronik und Kunstmarkt* N.F., 32 (1920), 221.

69. Both Schmidt-Degener and Valentiner (see preceeding note) considered the painting to be part of a series of Apostles. On the Apostle paintings, see L. Munz, "A Newly Discovered Late Rembrandt," *Burlington Magazine* 90 (1948), 64–67; Otto Benesch, "Worldly and Religious Portraits in Rembrandt's Late Art," *Art Quarterly* 19 (1956), 335–54.

70. The paintings from around 1661, the year of Rembrandt's greatest flurry of activity in this type of subject, fall into two groups. The first may have been a series of Evangelists, possibly with Christ and Mary as well, and includes the Louvre *St. Matthew and the Angel*, dated 1661, the two paintings of *An Evangelist Writing* in Boston and Rotterdam, and, according to Valentiner, the undated *Christ* in Glens Falls,

New York. The second group includes paintings of identifiable Apostles, the *Apostle Bartholomew* in the Getty Museum, the *Apostle Simon* in Zurich, and the privately owned *Apostle James*, all dated 1661, and other unidentified saintly men, such as the *Old Man Praying* in Cleveland. Yet these vary too widely in size and quality to form a coherent series.

71. For example, the inventory of the estate of the Delft preacher Gerrit van Heusden (*Urk.*, 292; *Documents*, 1667/5) lists "Een stuckjen schilderij van Paulus door Rembrandt."

72. According to legend, St. Luke made several portraits of the Virgin Mary. Thus he was regarded as the first Christian painter and became the patron saint of artists. Rogier van der Weyden, Dirk Bouts, and Maerten van Heemskerck are among the numerous artists who portrayed themselves as St. Luke drawing or painting the Virgin. For bibliography on the artist as St. Luke, see above, chapter 4 note 18.

73. The following item by Antonis Mor was listed in the inventory of the collection of the Antwerp merchant Diego Duarte, drawn up in Amsterdam in 1682: "Een cleyn rondeken het Conterfeytsel van hemselven in de figure van S. Paulus" (a small roundel, the portrait of himself in the guise of St. Paul). Van Hall, *Portretten*, 1451.6; F. Muller, ed., "Catalogus der schilderijen van Diego Duarte, te Amsterdam in 1682, met de prijzen van aankoop en taxatie," *De Oude Tijd* (1870), 397–402, no. 47.

74. Van Mander, *Schilder-boeck*, 275v. Whether this last painting was intended to be a portrait of Rutger Jansz. or whether he just served as a model is impossible to say.

75. Van Mander, *Schilder-boeck*, 276r.

76. Bailly's painting is in Göttingen, Universitäts-Sammlung. A full-length drawing by Jan Lievens from around 1630 (Vienna, Albertina) may represent Rembrandt in the guise of St. Peter but is not, strictly speaking, an historicized portrait. J. G. van Gelder, "Jan Lievens (1607–1674)—Rembrandt Posing as St. Peter—Vienna, Albertina," *Old Master Drawings* 12 (1938), 59–60. Braunschweig, Herzog Anton Ulrich-Museum, *Jan Lievens ein Maler im Schatten Rembrandts* (1979), no. 53, rejects the identification of the figure as Rembrandt.

77. De Bry's painting is in Haarlem, Frans Halsmuseum. Fabritius's painting

(Braunschweig, Herzog Anton Ulrich-Museum) is a portrait of his family in which he includes a self-portrait. Wishnevsky, "*Portrait historié*," 31–71, discusses the biblical historicized portrait in the Netherlands, but, 105–8, considers Rembrandt's work as a separate case that falls outside the convention of the *portrait historié*. See Wishnevsky, 255–60, for a chronological table of themes in historicized portraits: while this catalogue is by no means complete, it nonetheless reflects the distribution of subject types over the course of the seventeenth century.

78. The drawing *A Wounded Warrior Falling, Supported by a Comrade* (Ben. 178) of about 1639 in Berlin may represent the Conversion of Paul. Benesch considers another drawing of the *Conversion of Saul* (Ben. C103) to be a replica of a lost drawing by Rembrandt from about 1660. Rembrandt also drew *St. Paul Preaching at Athens* (Ben. 138; London, British Museum) and, after Pieter Lastman, *St. Paul and Barnabas in Lystra* (Ben. 449; Bayonne, Musée, Collection Bonnat).

79. John Calvin, *Commentary upon the Acts of the Apostles*, trans. Christopher Fetherstone (1585) and ed. Henry Beveridge (Edinburgh, 1845), I, 372.

80. Van Voorburch, *Neghen Predicatien ofte wtlegghingen ghedaen wt den Sentbrief Pauli tot den Ephesen aen het eerste Capittel veers 4, 5, 6, 7 ende 8. Waerinne dat duydelijcken ende op het aldereen voudichste ghehandelt wort van de Predestinatie ofte eeuwighe verkiesinghe Gods* (Dordrecht, 1612).

81. Gerard Brandt, *The History of the Reformation and other Ecclesiastical Transactions in and about the Low-Countries* (London, 1723), IV, 77–78.

82. *Corpus* A11. I would like to acknowledge the contribution of Gail Husch, whose insightful seminar paper stimulated my thinking on Rembrandt's early representations of Paul.

83. Ephesians 3:4, 7–9.

84. Erasmus, *Handbook of the Militant Christian* (1518), trans. John P. Dolan (Notre Dame, Indiana, 1962), 110.

85. Rembrandt's *Apostle Paul at His Desk* in Nuremberg (*Corpus* A26), the closely related etching (B. 149), and its preparatory drawing in the Louvre (Ben. 15)

are all colored by a similar mood of divinely inspired contemplation.

86. Ephesians 5:8.

87. Ephesians 6:11–17.

88. Ephesians 2:19–20.

89. Ephesians 4:1.

90. *Corpus* A13; Tümpel, "Studien zur Ikonographie der Historien Rembrandts," 181–84, and idem, *Rembrandt in Selbstzeugnissen und Bilddokumenten* (Hamburg, 1977), 25 and 125.

91. Galatians 2:11–21.

92. Br. 297. MacLaren, *Dutch School*, 319, no. 243. The sitter has not been identified, although J. Q. van Regteren Altena, "Rembrandt's Persönlichkeit," in *Neue Beiträge zur Rembrandt-Forschung*, ed. Otto von Simson and Jan Kelch (Berlin, 1973), 186–88, suggests that he is the poet Vondel, whose son died in the year the portrait was painted.

93. On Rembrandt's treatment of the Sacrifice of Isaac, see David R. Smith, "Towards a Protestant Aesthetics: Rembrandt's 1655 *Sacrifice of Isaac*," *Art History* 8 (1985), 290–302. Rembrandt emblematically employed a picture within a picture in another work of the later period, the *Syndics of the Drapers' Guild* in Amsterdam. See H. van de Waal, "The Syndics and their Legend," *Oud Holland* 71 (1956), 61–107.

94. On Paul and the Old Testament, see W. D. Davies, *Paul and Rabbinic Judaism. Some Rabbinic Elements in Pauline Theology* (Philadelphia, 1980; first ed. 1948), xxxv and passim.

95. Hebrews 11:17–19. That the sacrifice of Isaac is cited in Dirck Pers's Dutch version of Ripa's *Iconologia*, 108, in conjunction with the personification of Faith suggests that the subject was widely recognized as a symbol of faith.

96. John Calvin, *Commentaries on the First Book of Moses Called Genesis*, trans. John King (Grand Rapids, n.d.), I, 564.

97. Romans 3:28.

98. Romans 4:13–17.

99. As suggested in Carroll, "Rembrandt as Meditational Printmaker," 604 n. 87.

100. Ephesians 6:17. Barbara Haeger, "The Religious Significance of Rembrandt's *Return of the Prodigal Son*: An Examination of the Picture in the Visual and Iconographic Traditions" (Ph.D. dissertation, University of Michigan, 1983), 182–83.

101. Since early Christian times Paul has been portrayed with either a Bible in the form of a bound book, which emphasizes the Word of God, or his own epistles, often in the form of a scroll, which stresses Paul's contribution. Often a particular epistle is indicated. That Rembrandt's partly rolled sheaf of papers is unbound strongly suggests Paul's epistles rather than the Bible. See Wolfgang Braunfels, ed., *Lexicon der Christlichen Ikonographie* (Rome, 1976–), VIII, 132–35.

102. Earlier examples of illegible texts in Rembrandt's art are in the Stuttgart *Apostle Paul in Prison*, *The Prophetess Hannah* (also called *Rembrandt's Mother*) of 1631 in the Rijksmuseum, and *The Holy Family with Angels* of 1645 in Leningrad.

103. Braunschweig, *Jan Lievens*, no. 23.

104. Van Thiel, "*Zelfportret als de Apostel Paulus*," 2, read three of the letters as "SIS," the last letters of "EFESIS," and thus identified the text as Paul's letter to the Ephesians. However, this reading of the letters does not stand up to close examination. Tümpel, *Rembrandt in Selbstzeugnissen*, 221; Valentiner, "Die vier Evangelisten Rembrandts," 221; and Rosenberg, *Rembrandt: Life and Work*, 52, identified the text as the Old Testament in Hebrew. While the writing has the vertical, angular quality of Hebrew script, there is not a single clearly identifiable Hebrew letter and certainly no legible word. Myron M. Weinstein, Chief of the Hebraic Division of the Library of Congress, who kindly examined a photograph of the painting for me, doubted that the writing is Hebrew. In Rembrandt's *Belshazzar's Feast* in London and his *Moses with the Tables of the Law* of 1659 in Berlin, the Hebrew writing is accurate and legible. But the illegible text in the Rijksmuseum *Prophetess Hannah* presents a problem similar to that in the self-portrait: the text in Hannah's book has been identified as Hebrew on the basis of just one supposedly identifiable letter; but the layout of the pages, with initials at the left margin indicating that lines are read from left to right, precludes its being Hebrew, which is read from right to left.

105. On Teellinck, see W.J.M. Engelberts, *Willem Teellinck* (Amsterdam, 1898); T. Brienen, *Prediking en vroomheid bij Reformatie en Nadere Reformatie* (Kampen, 1975), 36 ff.; *Biografisch lexicon voor de geschiedenis van het Nederlandse*

Protestantisme, ed. D. Nauta et al., 1 (Kampen, 1978), 373–75.

106. Philippians 1:23.

107. Panofsky, *Dürer*, 234–35; Klibansky et al., *Saturn and Melancholy*, 366–67.

108. Screech, *Montaigne and Melancholy*, 61, and also 28, 30–33, 42.

EPILOGUE

1. Horst Gerson, *Rembrandt Paintings* (Amsterdam, 1968), 143–44; Christopher Wright, *Rembrandt, Self-Portraits* (New York, 1982), fig. 98; Schwartz, *Rembrandt*, 357.

2. *Urk.* 307; *Documents*, 1669/6.

3. Van Eeghen, "Het huis op de Rozengracht," 180–83.

4. *Urk.* 254; *Documents*, 1662/9 and 10.

5. *Urk.* 314 and 315.

6. *Urk.* 306; *Documents*, 1669/5.

7. *Documents*, 1662/11.

8. The poems are discussed in Slive, *Rembrandt and His Critics*, 41–54.

9. *Urk.* 310.

10. Br. 45, now considered to be a copy.

11. Br. 60. See C. Ricci, *Rembrandt in Italia* (Milan, 1918), 54, and Slive, *Rembrandt and His Critics*, 65.

12. Br. 55; MacLaren, *Dutch School*, 317–18; Bomford et al., *Art in the Making: Rembrandt*, 140–43.

13. Br. 62; *Rembrandt in the Mauritshuis*, 179–87.

14. Slive, *Rembrandt and His Critics*; Emmens, *Rembrandt*; see also R. W. Scheller, "Rembrandt's reputatie van Houbraken tot Scheltema," *Nederlands Kunsthistorisch Jaarboek* 12 (1961), 81–118.

15. Andries Pels, *Gebruik en misbruik des toneels* (Amsterdam, 1681), 35–36, translated in T. Borenius, *Rembrandt, Selected Paintings* (London, 1942), 26.

16. Sandrart, *L'Academia Todesca*, II.iii, chapter 22, 326.

17. Baldinucci, *Arte dell'intagliare*, 78–80.

18. Houbraken, *Groote schouburgh*, I, 254–74.

19. Ibid., I, 259–60: "Hy geen anderen doek gereed aan de hand hebbende, schildert dien dooden aap in 't gemelde stuk, daar die luiden veel tegen hadden, niet willende dat hunne pourtretten by dat van een afschuwelyken stervenden aap zouden te pronk staan, maar neen: hy had zooveel liefde voor dat model van den dooden aap dat hy liever dat stuk onvoldaan wilde aan zig houden, dan hun ten gevallen de kwast 'er op zetten, gelyk ook geschiedde; waarom het gemelde stuk ook naderhant, tot een afschutting gediend heeft voor zyne leerlingen."

20. Ibid., I, 269, 271, and 267.

21. Joost van den Vondel, *De werken van Vondel*, ed. by J.F.M. Sterck et. al. (Amsterdam, 1927–40), X, 630; Slive, *Rembrandt and His Critics*, 70 and 194–95. Vondel's poem is on Philips Koninck's *Sleeping Venus*, which he praises for its clarity.

22. Alpers, *Rembrandt's Enterprise*, 106–13, discusses Rembrandt and money.

23. Pels, *Gebruik en misbruik des toneels*, 35.

24. F. Schmidt-Degener, *Rembrandt und der holländische Barock*, Studien der Bibliothek Warburg 9 (Leipzig, 1928); Carl Neumann, *Rembrandt* (Berlin and Stuttgart, 1905).

25. Haverkamp-Begemann, *Nightwatch*, 3 and 8.

26. Karl J. Weintraub, "Autobiography and Historical Consciousness," *Critical Inquiry* 1 (1975), 824–25; idem, *Value of the Individual*, passim.

27. Houbraken, *Groote schouburgh*, I, 272.

28. Schwartz, *Rembrandt*, 358–65.

29. See above, p. 89. Schwartz sets exaggerated store by the Geertge Dircx incident and brings to mind Tuchman's law: "the fact of being reported multiplies the apparent extent of any deplorable development by five- to tenfold." Barbara W. Tuchman, *A Distant Mirror. The Calamitous 14th Century* (New York, 1978), xviii.

30. Houbraken, *Groote schouburgh*, I, 273: "Als ik myn geest uitspanninge wil geven, dan is het niet eer die ik zoek, maar vryheit." Roger de Piles, *Abregé de la vie des peintres, avec des reflexions sur leurs ouvrages* (Paris, 1699), 433–38: "ce n'est pas l'honneur que je cherche, c'est la liberté."

Selected Bibliography

Alpers, Svetlana. *The Art of Describing: Dutch Art in the Seventeenth Century.* Chicago, 1983.

——. *Rembrandt's Enterprise: The Studio and the Market.* Chicago, 1988.

Angel, Philips. *Lof der schilder-konst.* Leiden, 1642. Reprint. Utrecht, 1969.

Baldinucci, Filippo. *Cominciamento, e progresso dell'arte dell'intagliare in rame, colle vite di molti de' piu eccellenti Maestri della stessa Professione.* Florence, 1686.

Barbu, Zevedei. *Problems of Historical Psychology.* New York, 1960.

Bartsch, Adam. *Catalogue raisonné de toutes les estampes qui forment l'oeuvre de Rembrandt.* 2 vols. Vienna, 1797.

Bauch, Kurt. *Der frühe Rembrandt und seine Zeit: Studien zur geschichtlichen Bedeutung seines Frühstils.* Berlin, 1960.

——. "Ein Selbstbildnis des frühen Rembrandt." *Wallraf-Richartz-Jahrbuch* 24 (1962), 321–32.

——. *Rembrandt Gemälde.* Berlin, 1966.

Bellori, G. P. *Le vite de' pittori, scultori ed architetti moderni.* Rome, 1672.

Benesch, Otto. *The Drawings of Rembrandt.* Enlarged and Edited by Eva Benesch. 6 vols. London, 1973.

——. "Worldly and Religious Portraits in Rembrandt's Late Art." *Art Quarterly* 19 (1956), 335–54.

Benkard, Ernst. *Das Selbstbildnis vom 15. bis zum Beginn des 18. Jahrhunderts.* Berlin, 1927.

Bergström, Ingvar. "Rembrandt's Double-Portrait of Himself and Saskia at the Dresden Gallery: A Tradition Transformed." *Nederlands Kunsthistorisch Jaarboek* 17 (1966), 143–69.

——. "Der Sünder als tragischer Held bei Rembrandt. Bemerkungen zu neueren ikonographischen Studien über Rembrandt." In *Neue Beiträge zur Rembrandt-Forschung*, edited by Otto von Simson and Jan Kelch (Berlin, 1973), 137–50.

Białostocki, Jan. "Rembrandt's Terminus." *Wallraf-Richartz-Jahrbuch* 28 (1966), 49–60.

Blankert, Albert. *Ferdinand Bol (1616–1680): Rembrandt's Pupil.* Doornspijk, 1982.

——. "Rembrandt, Zeuxis and Ideal Beauty." In *Album Amicorum J. G. van Gelder* (The Hague, 1973), 32–39.

Bloch, E. Maurice. "Rembrandt and the Lopez Collection." *Gazette des Beaux-Arts* 6th series, 29 (1946), 175–86.

Blunt, Anthony. *Artistic Theory in Italy 1450–1600.* Oxford, 1956.

Bode, Wilhelm von. "Die ersten Selbstporträts des Rembrandt van Rijn." *Zeitschrift für Bildende Kunst* 11 (1876), 125–26.

Boon, K. G. *Het zelfportret in de Nederlandsche en Vlaamsche schilderkunst.* Amsterdam, 1947.

——. "Rembrandt's laatste geetste zelfportret." *Kroniek van het Rembrandthuis* 23 (1969), 4–9.

Boon, K. G., and Christopher White: *see* White.

Bottrall, Margaret. *Every Man a Phoenix: Studies in Seventeenth-Century Autobiography.* London, 1958.

Bredius, A. *Rembrandt. The Complete Edition of the Paintings.* Revised by Horst Gerson. London, 1969.

Brienen, T. *Prediking en vroomheid bij Re-*

formatie en Nadere Reformatie. Kampen, 1975.

Brochhagen, Ernst. "Beobachtungen an den Passionsbildern Rembrandts in München." In *Munuscula Discipulorum. Kunsthistorische Studien Hans Kauffmann zum 70. Geburtstag 1966* (Berlin, 1968), 37–44.

Broos, B.P.J. *Index to the Formal Sources of Rembrandt's Art.* Maarssen, 1977.

———. "The 'O' of Rembrandt." *Simiolus* 4 (1971), 150–84.

———. "Rembrandt and Lastman's *Coriolanus*: The History Piece in 17th-Century Theory and Practice." *Simiolus* 8 (1975/76), 199–210.

———. Review of Walter L. Strauss and Marjon van der Meulen, *The Rembrandt Documents. Simiolus* 12 (1981–82), 245–62.

Brown, Christopher. *Second Sight. Titian: Portrait of a Man; Rembrandt: Self-Portrait at the Age of 34.* London, 1980.

Bruyn, J. *Rembrandt's keuze van Bijbelse onderwerpen.* Utrecht, 1959.

Bryson, Norman. *Tradition and Desire: From David to Delacroix.* Cambridge, 1984.

Burke, Peter. *Venice and Amsterdam. A Study of Seventeenth-Century Elites.* London, 1974.

Burton, Robert. *The Anatomy of Melancholy.* Edited by Holbrook Jackson. London, 1932.

Campbell, Colin. "Raphael door Rembrandts pen herschapen." *Kroniek van het Rembrandthuis* 27 (1975), 20–32.

Carroll, Margaret Deutsch. "Civic Ideology and Its Subversion: Rembrandt's *Oath of Claudius Civilis.*" *Art History* 9 (1986), 12–35.

———. "Rembrandt as Meditational Printmaker." *Art Bulletin* 63 (1981), 585–610.

Chapman, H. Perry. "The Image of the Artist: Roles and Guises in Rembrandt's Self-Portraits." Ph.D. dissertation, Princeton University, 1983.

Clark, Kenneth. *Rembrandt and the Italian Renaissance.* New York, 1966.

Colie, Rosalie L. *Some Thankfulness to Constantine.* The Hague, 1956.

A Corpus of Rembrandt Paintings. By the Stichting Foundation Rembrandt Research Project, J. Bruyn, B. Haak, S. H. Levie, P.J.J. van Thiel and E. van de Wetering. The Hague, 1982– .

Daugherty, Frances P. "The Self-Portraits of Peter Paul Rubens: Some Problems in Iconography." Ph.D. dissertation, University of North Carolina, 1976.

Delany, Paul. *British Autobiography in the Seventeenth Century.* New York, 1969.

Delft, Stedelijk Museum "Het Prinsenhof." *De schilder in zijn wereld.* 1965.

Dudok van Heel, S.A.C. "Doopsgezinden en schilderkunst in de 17e eeuw: leerlingen, opdrachtgevers en verzamelaars van Rembrandt." *Doopsgezinde Bijdragen* N.S., 6 (1980), 105–23.

———. "Enkele portretten 'à l'antique' door Rembrandt, Bol, Flinck en Backer." *Kroniek van het Rembrandthuis* 32 (1980/81), 2–9.

———. "Mr. Johannes Wtenbogaert (1608–80) een man uit Remonstrants milieu en Rembrandt van Rijn." *Jaarboek Amstelodamum* 70 (1978), 146–69.

Eckardt, Götz. *Selbstbildnisse niederländischer Maler des 17. Jahrhunderts.* Berlin, 1971.

Eeghen, I. H. van. "Het Amsterdamse Sint Lucasgilde in de 17de eeuw." *Jaarboek Amstelodamum* 61 (1969), 83–84.

Einem, Herbert von. "Das Kölner Selbstbildnis des lachenden Rembrandt." In *Festschrift für Gert von der Osten* (Cologne, 1970), 177–88.

Eisler, Colin. "Portrait of the Artist as St. Luke." *Art News* 58 (1959), 55.

Ellenius, Allan. *De Arte Pingendi. Latin Art Literature in Seventeenth-Century Sweden and Its International Background.* Uppsala, 1960.

Emmens, J. A. "Ay Rembrandt, maal *Cornelis* stem." *Nederlands Kunsthistorisch Jaarboek* 7 (1956), 133–65.

———. *Rembrandt en de regels van de kunst.* Utrecht, 1968.

———. Review of R. and M. Wittkower, *Born Under Saturn. Art Bulletin* 53 (1971), 427–28.

Erpel, Fritz. *Die Selbstbildnisse Rembrandts.* Berlin, 1967.

Filipczak, Zirka Zaremba. *Picturing Art in Antwerp 1550–1700.* Princeton, 1987.

Fuchs, R. H. "Rembrandt en Italiaanse kunst: opmerkingen over een verhouding." *Neue Beiträge zur Rembrandt-Forschung,* edited by Otto von Simson and Jan Kelch (Berlin, 1973), 75–82.

Gasser, Manuel. *Das Selbstbildnis*. Zurich, 1961.

Gelder, H. E. van. "Constantijn Huygens en Rembrandt." *Oud Holland* 74 (1959), 174–78.

———. "Marginalia bij Rembrandt: I. De pendant van Maurits Huygens. II. Rembrandts geest zelfportret 'teekenend aan een lessenaar'. III. Rembrandts kerkgenootschap." *Oud Holland* 60 (1943), 33–36.

Gelder, J. G. van. *De schilderkunst van Jan Vermeer*. With commentary by J. A. Emmens. Utrecht, 1958.

———. "Rembrandts vroegste ontwikkeling." *Mededeelingen der Koninklijke Nederlandse Akademie van Wetenschappen afd. Letterkunde* N.S. 16, no. 5 (1953), 273–300.

Gerson, Horst. *Hollandse portretschilders van de zeventiende eeuw*. Maarssen, 1975.

———. "Rembrandt and the Flemish Baroque: His Dialogue with Rubens." *Delta* 12 (1969), 7–23.

———. *Rembrandt Paintings*. Amsterdam, 1968.

———. *Seven Letters by Rembrandt*. Transcribed by Isabella H. van Eeghen, translated by Yda D. Ovink. The Hague, 1961.

Glück, Gustav. "Rembrandt's Selbstbildnis aus dem Jahre 1652." *Jahrbuch der Kunsthistorische Sammlung in Wien* N.F., 2 (1928), 317–28.

Golahny, Amy. "Rembrandt's Paintings and the Venetian Tradition." Ph.D. dissertation, Columbia University, 1984.

Goldscheider, Ludwig. *Rembrandt Paintings, Drawings and Etchings*. London, 1960.

Greenblatt, Stephen. *Renaissance Self-Fashioning from More to Shakespeare*. Chicago, 1980.

Greene, Thomas. "The Flexibility of the Self in Renaissance Literature." In *The Disciplines of Criticism*, edited by Peter Demetz, Thomas Greene, and Lowry Nelson, Jr. (New Haven, 1968), 241–64.

Haak, Bob. *Rembrandt, His Life, His Work, His Time*. New York, 1969.

The Hague, *Mauritshuis, The Royal Cabinet of Paintings, Illustrated General Catalogue*. The Hague, 1977.

Halewood, William H. *Six Subjects of Reformation Art: A Prelude to Rembrandt*. Toronto, 1981.

Hall, H. van. *Portretten van nederlandse beeldende kunstenaars*. Amsterdam, 1963.

Haverkamp-Begemann, Egbert. "The Present State of Rembrandt Studies." *Art Bulletin* 53 (1971), 88–104.

———. *Rembrandt: "The Nightwatch."* Princeton, 1982.

———. Review of Kenneth Clark, *Rembrandt and the Italian Renaissance. Yale Review* 56 (1966/67), 301–9.

Held, Julius S. *Rembrandt's "Aristotle" and other Rembrandt Studies*. Princeton, 1969.

Hofman, Hendrik Arie. *Constantijn Huygens (1596–1687)*. Utrecht, 1983.

Hofstede de Groot, C. *Die Urkunden über Rembrandt (1575–1721)*. The Hague, 1906.

Hoogewerff, G. J. *De geschiedenis van de St. Lucasgilden in Nederland*. Amsterdam, 1947.

Hoogstraten, Samuel van. *Inleyding tot de hooge schoole der schilderkonst*. Rotterdam, 1678. Reprint Utrecht, 1969.

Houbraken, Arnold. *De groote schouburgh der Nederlantsche konstschilders en schilderessen*. 3 vols. Amsterdam, 1718–21.

Huizinga, Johan. *Dutch Civilization in the Seventeenth Century and Other Essays*. New York, 1969.

Huygens, Constantijn. "Constantijn Huygens over de schilders van zijn tijd." Edited by J. A. Worp. *Oud Holland* 9 (1893), 106–36.

———. *De jeugd van Constantijn Huyghens*. Translated and edited by A. H. Kan. Rotterdam, 1946.

———. "Fragment eener autobiographie van Constantijn Huygens." Edited by J. A. Worp. *Bijdragen en Mededeelingen van het Historisch Genootschap* 18 (1897), 1–121.

Jonge, C. H. de. "Bijdrage tot de kennis van de kleederdracht in de Nederlanden in de XVIᵉ eeuw, naar archivalische en litteraire gegevens en volgens de monumenten der beeldende kunst in chronologische ontwikkeling der afzonderlijke kleedingstukken gerangschikt." *Oud Holland* 36 (1918), 133–69; 37 (1919), 1–70, 129–68, 193–214.

Jongh, E. de. *Portretten van echt en trouw*.

Huwelijk en gezin in de Nederlandse kunst van de zeventiende eeuw. Frans Hals Museum, Haarlem, 1986.

——. "The Spur of Wit: Rembrandt's Response to an Italian Challenge." *Delta* 12 (1969), 49–67.

Junius, Franciscus. *The Painting of the Ancients*. London, 1638. Reprint Westmead, 1972.

Kettering, Alison McNeil. *The Dutch Arcadia. Pastoral Art and Its Audience in the Golden Age*. Montclair, New Jersey, 1983.

Kinderen-Besier, J. H. der. *Mode-metamorphosen. De kleedij onze voorouders in de zestiende eeuw*. Amsterdam, 1933.

——. *Spelevaart der mode. De kleedij onzer voorouders in de zeventiende eeuw*. Amsterdam, 1950.

Klibansky, Raymond, Erwin Panofsky, and Fritz Saxl. *Saturn and Melancholy*. London, 1964.

Kris, Ernst, and Otto Kurz. *Legend, Myth and Magic in the Image of the Artist*. New Haven, 1979.

Kuiper, Ernst Jan. *De Hollandse "Schoolordre" van 1625. Een studie over het onderwijs op de Latijnse scholen in Nederland in de 17de en 18de eeuw*. Groningen, 1958.

Lairesse, Gerard de. *Het groot schilderboek*. Amsterdam, 1707. Reprint Soest, 1969.

Lee, Rensselaer W. *Ut Pictura Poesis. The Humanistic Theory of Painting*. New York, 1967.

Leiden, Stedelijk Museum "de Lakenhal." *Geschildert tot Leyden anno 1626*. 1976.

Lewalski, Barbara Kiefer. *Protestant Poetics and the Seventeenth-Century Religious Lyric*. Princeton, 1979.

Lugt, Frits. "Italiaansche kunstwerken in Nederlandsche verzamelingen van vroeger tijden." *Oud Holland* 53 (1936), 97–135.

MacLaren, Neil. *National Gallery Catalogues. The Dutch School*. London, 1960.

Mander, Karel van. *Den grondt der edel vry schilder-const*. Edited by Hessel Miedema. 2 vols. Utrecht, 1973.

——. *Het Schilder-boeck*. Haarlem, 1604. Reprint Utrecht, 1969.

Martin, John Rupert. *Baroque*. New York, 1977.

Martz, Louis L. *The Poetry of Meditation.*

A Study in English Religious Literature of the Seventeenth Century. Revised edition. New Haven and London, 1962.

Marzluf, Arnulf. "Selbstbewusstsein als Bildkategorie. Das Selbstbildnis bei Rembrandt." Ph.D. dissertation, Johann Wolfgang Goethe Universität, Frankfurt am Main, 1978.

Mayer-Meintschel, A. "Rembrandt und Saskia im Gleichnis vom Verlorenen Sohn." *Jahrbuch Staatliche Kunstsammlungen Dresden* 1970/71, 39–57.

Meier-Siem, Martin. *Rembrandt Selbstbildnisse im Röntgenbild*. Frankfurt am Main, n.d.

Miedema, Hessel. "Johannes Vermeers schilderkunst." *Proef* September 1972, 67–76.

——. *Kunst, kunstenaar en kunstwerk bij Karel van Mander. Een analyse van zijn Levensbeschrijvingen*. Alphen aan den Rijn, 1981.

Montias, John Michael. *Artists and Artisans in Delft: A Socio-Economic Study of the Seventeenth Century*. Princeton, 1982.

Müller Hofstede, Cornelius. "Rembrandts Selbstbildnis mit Skizzenbuch." *Pantheon* 26 (1968), 375–90.

Nicolson, Benedict. "The Iveagh Bequest at Kenwood." *Burlington Magazine* 92 (1950), 183.

Nijmegen, De Waag. *Het schildersatelier in de Nederlanden 1500–1800*. 1964.

Olney, James. *Metaphors of Self: The Meaning of Autobiography*. Princeton, 1972.

Orlers, Jan Jansz. *Beschrijvinge der stadt Leyden*, Leiden, 1641.

Panofsky, Erwin. *The Life and Art of Albrecht Dürer*. Princeton, 1955.

Pauw-de Veen, Lydia de. *De begrippen "schilder," "schilderij" en "schilderen" in de zeventiende eeuw*. Brussels, 1969.

——. "Over de betekenis van het woord 'beweeglijkheid' in de zeventiende eeuw." *Oud Holland* 74 (1959), 202–12.

Pigler, A. "Neid und Unwissenheit als Widersacher der Kunst." *Acta Historiae Artium* 1 (1953–54), 215–35.

Pinder, Wilhelm. *Rembrandts Selbstbildnisse*. Leipzig, 1943.

Pliny. *Natural History*. Translated by H. Rackham. Loeb Classical Library. Cambridge, Mass., 1952.

Pope-Hennessy, John. *The Portrait in the Renaissance*. New York, 1963.

Price, J. L. *Culture and Society in the Dutch Republic during the Seventeenth Century*. New York, 1974.

Prinz, Wolfram. *Die Sammlung der Selbstbildnisse in den Uffizien*. 1. *Geschichte der Sammlung*. Berlin, 1971.

Raupp, Hans-Joachim. "Musik im Atelier: Darstellungen musizierender Künstler in der niederländischen Malerei des 17. Jahrhunderts." *Oud Holland* 92 (1978), 106–29.

———. *Untersuchungen zu Künstlerbildnis und Künstlerdarstellung in den Niederlanden im 17. Jahrhundert*. Hildesheim, 1984.

Renger, Konrad. *Lockere Gesellschaft. Zur Ikonographie des Verlorenen Sohnes und von Wirtshausszenen in der niederländischen Malerei*. Berlin, 1970.

Reznicek, E.K.J. "Opmerkingen bij Rembrandt." *Oud Holland* 91 (1977), 88–91.

Ried, Fritz. *Das Selbstbildnis*. Berlin, 1931.

Riegl, Alois. *Das Holländische Gruppenporträt*. Vienna, 1931.

Rijckevorsel, J.L.A.A.M. van. *Rembrandt en de Traditie*. Rotterdam, 1932.

Ripa, Cesare. *Iconologia*. Rome, 1603. Reprint Hildesheim and New York, 1970.

———. *Iconologia, of uytbeeldinghe des verstands*. Translated by Dirck Pietersz. Pers. Amsterdam, 1644. Reprint Soest, 1971.

Rosenberg, Jakob. *Rembrandt: Life and Work*. London, 1964.

Rotermund, Hans Martin. "Rembrandt und die religiösen Laienbewegungen in den Niederländen seiner Zeit." *Nederlands Kunsthistorisch Jaarboek* 4 (1952/53), 104–92.

———. "Rembrandts Bibel." *Nederlands Kunsthistorisch Jaarboek* 8 (1957), 123–50.

Sandrart, Joachim von. *L'Academia Todesca della architectura, scultura et pittura: oder Teutsche Academie der edlen Bau-, Bild- und Mahlerey-Künste*, Nuremberg, 1675.

Sarasota, John and Mable Ringling Museum. *Dutch Seventeenth-Century Portraiture: The Golden Age*. Sarasota, 1980.

Sass, Else Kai. *Comments on Rembrandt's Passion Paintings and Constantijn Huygens' Iconography*. Copenhagen, 1971.

Saunders, Eleanor A. "Rembrandt and the Pastoral of the Self." In *Essays in Northern European Art Presented to Egbert Haverkamp-Begemann*. Doornspijk, 1983.

Schama, Simon. *The Embarrassment of Riches. An Interpretation of Dutch Culture in the Golden Age*. New York, 1987.

Schatborn, Peter. *Bij Rembrandt in de leer / Rembrandt as Teacher*. Amsterdam, Museum het Rembrandthuis, 1984.

———. *Dutch Figure Drawings from the Seventeenth Century*. The Hague, 1981.

Scheller, R. W. "Rembrandt en de encyclopedische kunstkamer." *Oud Holland* 84 (1969), 132–45.

———. "Rembrandt's reputatie van Houbraken tot Scheltema." *Nederlands Kunsthistorisch Jaarboek* 12 (1961), 81–118.

Schöne, Wolfgang. "Rembrandt's *Mann mit dem Goldhelm*." *Jahrbuch der Akademie der Wissenschaften in Göttingen, 1972*. (Göttingen, 1973), 33–99.

Schwartz, Gary. *Rembrandt, His Life, His Paintings*. New York, 1985.

Screech, M. A. *Montaigne and Melancholy: The Wisdom of the "Essays."* Selinsgrove, 1984.

Slatkes, Leonard J. Review of Christopher White and K. G. Boon, *Rembrandt's Etchings. An Illustrated Catalogue*, and of Christopher White, *Rembrandt as an Etcher*. *Art Quarterly* 36 (1973), 255.

Slive, Seymour. "Art Historians and Art Critics, II: Huygens and Rembrandt." *Burlington Magazine* 94 (1952), 261–64.

———. *Rembrandt and His Critics 1630–1730*. The Hague, 1953.

———. "Rembrandt's *Self-Portrait in a Studio*." *Burlington Magazine* 106 (1964), 483–86.

———. "The Young Rembrandt." *Allen Memorial Art Museum Bulletin* 20 (1963), 120–49.

Smith, David R. "Rembrandt's Early Double Portraits and the Dutch Conversation Piece." *Art Bulletin* 64 (1982), 259–88.

Stechow, Wolfgang. "Rembrandt-Democritus." *Art Quarterly* 7 (1944), 233–38.

Strauss, Walter L., and Marjon van der Meulen. *The Rembrandt Documents*. New York, 1979.

Sullivan, Scott A. "Rembrandt's *Self-Portrait with a Dead Bittern*." *Art Bulletin* 62 (1980), 236–43.

Sumowski, Werner. *Gemälde der Rembrandt-Schüler*. Landau, 1983– .

Thiel, P.J.J. van. "*Zelfportret als de Apostel Paulus*. Rembrandt van Rijn (1606–1669)." *Openbaar Kunstbezit* 13, 1969.

Thienen, Frithjof van. *Das Kostüm der Blütezeit Hollands 1600–1660*. Berlin, 1930.

——. *The Great Age of Holland 1600–1660*. London, 1951.

Tümpel, Christian. "Ikonographische Beiträge zu Rembrandt." *Jahrbuch der Hamburger Kunstsammlungen* 13 (1968), 95–126; 16 (1971), 20–38.

——. *Rembrandt in Selbstzeugnissen und Bilddokumenten*. Hamburg, 1977.

——. "Studien zur Ikonographie der Historien Rembrandts." *Nederlands Kunsthistorisch Jaarboek* 20 (1969), 107–98.

Vasari, Gorgio. *Le vite de' più eccellenti pittori, scultori ed architetti*. Edited by Gaetano Milanesi. 9 vols. Florence, 1906.

Veenstra, Fokke. *Ethiek en moraal bij P. C. Hooft. Twee studies in renaissancistische levensidaalen*. Zwolle, 1968.

Vinken, P., and E. de Jongh. "De boosaardigheid van Hals' regenten en regentessen." *Oud Holland* 78 (1963), 1–26.

Visser 't Hooft, W. A. *Rembrandt and the Gospel*. Philadelphia, 1957.

Vries, A. B. de. "Rembrandtiana. Rembrandt en het St. Lucas gilde in Amsterdam." *Kroniek van het Rembrandthuis* 24 (1970), 96–101.

Vries, A. B. de, Magde Toth-Ubbens, and W. Froentjes. *Rembrandt in de Mauritshuis*. Alphen aan den Rijn, 1978.

Waal, H. van de. *Drie eeuwen vaderlandsche geschied-uitbeelding, 1500–1800, een iconologische studie*. 2 vols. The Hague, 1952.

Warners, J.D.P. "Translatio—Imitatio—Aemulatio." *De Nieuwe Taalgids* 49 (1956), 289–95; 50 (1957), 82–88, 193–201.

Washington, National Gallery of Art. *Gods, Saints and Heroes. Dutch Painting in the Age of Rembrandt*. 1980.

Webber, Joan. *The Eloquent "I." Style and Self in Seventeenth-Century Prose*. Madison, Wisconsin, 1968.

Weintraub, Karl J. "Autobiography and Historical Consciousness." *Critical Inquiry* 1 (1975), 821–48.

——. *The Value of the Individual: Self and Circumstance in Autobiography*. Chicago, 1979.

Wencelius, Leon. *Calvin et Rembrandt*. Paris, 1937.

White, Christopher. *Rembrandt*. New York, 1984.

——. *Rembrandt as an Etcher. A Study of the Artist at Work*. University Park and London, 1969.

White, Christopher and K. G. Boon. *Rembrandt's Etchings. An Illustrated Catalogue*. 2 vols. Amsterdam, 1969.

Wijnman, H. F. "Rembrandt als huisgenoot van Hendrick Uylenburgh te Amsterdam (1631–35). Was Rembrandt Doopsgezind of Libertijn?" In *Uit de kring van Rembrandt en Vondel* (Amsterdam, 1959).

Wishnevsky, Rose. "Studien zum *Portrait historié* in den Nederlanden." Ph.D. dissertation, Munich, 1967.

Wittkower, Rudolf, and Margot Wittkower. *Born Under Saturn. The Character and Conduct of Artists: A Documented History from Antiquity to the French Revolution*. New York, 1963.

Wright, Christopher. *Rembrandt, Self-Portraits*. New York, 1982.

General Index

Aachen, Hans van, 118, 148 n.47
aemulatio, 65. *See also* emulation
affecten, 17
affetti, 17, 19
Alberti, Leon Battista, 17, 152 n.102
Alberti, Romano, 28, 51
Alpers, Svetlana, 7
Amsterdam, 5, 36, 56, 68, 74; civic guard, 45; collections and art market, 56, 69, 70, 72, 77, 93, 129; Italian paintings in, 69, 70, 72, 77; Oude Kerk, 106, 107, 128; painters' guild, 57; Prodigal Son play performed in, 117; religious freedom in, 106–7; Rembrandt in, 6, 36, 40, 54–58, 67, 79–80, 103, 106; Sandrart in, 132; *schouwburg* (town theater), 72; taste for classicism in, 103–4; town hall, 37, 81, 90, 104, 129; Uylenburgh in, 24, 57; Westerkerk, 107, 128
Ancram, Lord, 46, 47, 149 n.57
Angel, Philips, 45, 67; on artistic borrowing, 37; on Dürer, 67; on emulation, 65; on painters' drunkenness, 97, 119; on painters' honor and virtue, 52–53
Anslo, Cornelis Claesz., 106
Anthonisz., Cornelis, 116
antijcks, 45, 69
Antwerp, 51, 110
Apelles, 64, 65, 66, 67, 73; allegory of Calumny, 44; fame in the Netherlands, 102; four-color system of, 92; legendary line of, 99; as prince of painters, 94; Rembrandt lauded as, 129
Ariosto, Ludovico, 69, 76, Figs. 104, 106
Aristotle, 26, 27, 118
armor, 34–36, 39–41; gorget, 37, 41, 63
ars, 97, 99
art: enemies of, 119; goals of, 52, 86, 152 n.102; moralizing conventions in, 114–15
artist in the studio, convention of. *See* studio scenes

artistic practice, 79–80, 84, 85, 86, 95, 98, 99, 101
artists: 6, 8, 17, 44; biographies of, 47; classicist ideal of, 134; collections of portraits of, 47, 130; as commoners ranked above nobility, 67–68; as craftsmen, 79, 84; drunkenness of, 119; known by first name, 60; learnedness of, 49–50; in Leiden, 13; and melancholy, 26–31; nationalism of, 13, 37; professional identity of, 13, 36; Romantic ideal of, 135; status of, 4, 50–51, 134. *See also* painters
Arundel, Earl of (Thomas Howard), 18
Augustine, St., 135
autobiography, 5, 7, 11–12, 55, 135, 136, 140 nn. 17, 18
autonomy, 4–5, 6, 8, 105

Baburen, Dirck van, 117
Backer, Adriaen, 164 n.34
Backer, Jacob, 29, 103, 149 n.73, 162 n.110, 164 n.34; *Self-Portrait*, 43, Fig. 63
Bailly, David, 13, 44, 122
Baldinucci, Filippo: biography of Rembrandt, 8, 132–33, 135–36; on Rembrandt's appearance, 96–97; on Rembrandt's buying of old clothes, 34, 72; on Rembrandt's religion, 105–6; on Uylenburgh's academy, 57
Barbari, Jacopo de', 161 n.76
Batavians, 37, 42
Bauch, Kurt, 99
Berckheyde, Job Adriaensz., 100
beret: as painters' attribute, 49–50, 91, 149–50 n.74; in Rembrandt's self-portraits, 37, 41, 46, 48, 63, 69, 71, 82, 87, 88, 95, 109, 114, 130, 149 n.72; symbolic significance of, 50, 85, 149 n.71, 150 n.81
Bernini, Gianlorenzo, 19, 142 n.36
Beuckelaer, Joachim, *Prodigal Son*, 116, Fig. 156
Beverwijck, Jan van, 144 n.75

Index

of Works by Rembrandt Mentioned in the Text